# Thoughtful Images

# Thoughtful Images

*Illustrating Philosophy Through Art*

THOMAS E. WARTENBERG

# OXFORD
UNIVERSITY PRESS

Oxford University Press is a department of the University of Oxford. It furthers
the University's objective of excellence in research, scholarship, and education
by publishing worldwide. Oxford is a registered trade mark of Oxford University
Press in the UK and certain other countries.

Published in the United States of America by Oxford University Press
198 Madison Avenue, New York, NY 10016, United States of America.

© Oxford University Press 2023

All rights reserved. No part of this publication may be reproduced, stored in
a retrieval system, or transmitted, in any form or by any means, without the
prior permission in writing of Oxford University Press, or as expressly permitted
by law, by license, or under terms agreed with the appropriate reproduction
rights organization. Inquiries concerning reproduction outside the scope of the
above should be sent to the Rights Department, Oxford University Press, at the
address above.

You must not circulate this work in any other form
and you must impose this same condition on any acquirer.

CIP data is on file at the Library of Congress

ISBN 978-0-19-765054-7

DOI: 10.1093/oso/9780197650547.001.0001

1 3 5 7 9 8 6 4 2

Printed by Integrated Books International, United States of America

*In memory of
my grandmother,
Rosa Oleynick Schiller,
who took me to see
The Responsive Eye
many years ago*

In memory of
my grandmother
Lena Olander Ashline
who was much of
the inspiration for
many of my life

# Contents

| | |
|---|---|
| *List of Illustrations* | ix |
| *Preface: How I Came to Write This Book* | xi |
| *Acknowledgments* | xv |
| 1. Introduction | 1 |
| 2. Theorizing Illustration as an Artform | 20 |
| 3. Pre-Modern Illustrations of Philosophy | 52 |
| 4. Frontispieces in the Seventeenth and Eighteenth Centuries | 77 |
| 5. Paintings that Illustrate Philosophy | 99 |
| 6. Modernist Art as Philosophy | 136 |
| 7. Art Inspired by Wittgenstein | 161 |
| 8. Mel Bochner Illustrates *On Certainty* | 211 |
| 9. Graphic Philosophy | 238 |
| 10. Conclusion | 290 |
| *Bibliography* | 301 |
| *Index* | 313 |

# Contents

| | |
|---|---|
| List of Illustrations | ix |
| Preface: How I Came to Write This Book | xi |
| Acknowledgments | xv |
| 1. Introduction | 1 |
| 2. Theorizing Illustration as an Artform | 20 |
| 3. Pre-Modern Illustrations of Philosophy | 52 |
| 4. Frontispieces in the Seventeenth and Eighteenth Centuries | 72 |
| 5. Paintings that Illustrate Philosophy | 99 |
| 6. Modernist Art as Philosophy | 136 |
| 7. Art Inspired by Wittgenstein | 161 |
| 8. Mel Bochner Illustrates On Certainty | 211 |
| 9. Graphic Philosophy | 238 |
| 10. Conclusion | 290 |
| Bibliography | 301 |
| Index | 313 |

# Illustrations

## Figures

| | | |
|---|---|---|
| Figure 1.1 | Plato's Cave | 2 |
| Figure 1.2 | The Duck-Rabbit | 4 |
| Figure 1.3 | Jan Saenredam, *Antrum Platonicum* | 7 |
| Figure 2.1 | John Tenniel, *The White Rabbit* | 26 |
| Figure 2.2 | Sandro Botticelli, *The Schismatics* | 28 |
| Figure 2.3 | Gustave Doré, *The Schismatics* | 29 |
| Figure 3.1 | Mosaic of Plato's Academy | 54 |
| Figure 3.2 | *Plato's "Timaeus"* | 57 |
| Figure 3.3 | Léonard Gaultier, *Artificiosa totius logices descriptio* | 67 |
| Figure 3.4 | Léonard Gaultier, *Clara totius physiologiae synopsis* | 68 |
| Figure 4.1 | Frontispiece by Abraham Bosse to Thomas Hobbes, *Leviathan* | 81 |
| Figure 4.2 | *Thetis*, Frontispiece to Book 1 of *Emile* by Jean Jacques Rousseau | 87 |
| Figure 7.1 | Sol LeWitt, *Wall Drawing 118* | 169 |
| Figure 9.1 | Barry Moser, *Adam and Eve in the Garden of Eden* | 244 |
| Figure 9.2 | POW! | 257 |
| Figure 9.3 | Nick Sousanis, *Unflattening* | 269 |
| Figure 9.4 | Scott McCloud, *This Is Not a Pipe!* | 273 |
| Figure 9.5 | Scott McCloud, *The Process of Abstraction* | 275 |

X    ILLUSTRATIONS

## Plates (located between pages 150 and 151)

Plate 1    Tom Phillips, "The Schismatics" from *Dante's Inferno*

Plate 2    Titian, *The Rape of Europa*

Plate 3    The Three Types of Friendship in Aristotle's
*Nicomachean Ethics*

Plate 4    The Nature of Justice in Aristotle's *Politics*

Plate 5    Raphael Santis, *School of Athens*

Plate 6    Rembrandt van Rijn, *Aristotle Contemplating a Bust of Homer*

Plate 7    Jacques-Louis David, *The Death of Socrates*

Plate 8    Raphael Santis, *Transfiguration*

Plate 9    Vincent Van Gogh, *Shoes*

Plate 10    Diego Velasquez, *Las Meninas*

Plate 11    Jackson Pollock, *White Light*

Plate 12    Adrian Piper, *Cornered*

Plate 13    Joseph Kosuth, *One and Three Chairs*

Plate 14    Joseph Kosuth, *On Color Blue*

Plate 15    Bruce Nauman, *A Rose Has No Teeth*

Plate 16    Mel Bochner, *If the Colour Changes #1*

Plate 17    Jasper Johns, *Seasons ("Spring")*

Plate 18    Maria Bußmann, *Drawing to Wittgenstein's "Tractatus"*

Plate 19    Maria Bußmann, *Tractatus 3.324*

Plate 20    Eduardo Paolozzi, *He Must, So to Speak . . .*

Plate 21    Eduardo Paolozzi, *Parrot*

Plate 22    Mel Bochner, *"T" Branch*

Plate 23    Mel Bochner, *Diamond Branch*

Plate 24    Mel Bochner, *Fourth Range*

Plate 25    Mel Bochner, *Range*

Plate 26    Albert Lewis Kanter, "Hist! Look There!," Classics Illustrated No. 4,
*Last of the Mohicans*

Plate 27    David Barsalou, *WHAMM!, Deconstructing Roy Lichtenstein*

# Preface: How I Came to Write This Book

The question lying at the heart of *Thoughtful Images* is this: Can the visual arts—painting, drawing, etching, sculpture, etc.—produce works that function as illustrations of philosophical texts? Since this book presents an affirmative answer to this question, a second issue emerges: What is involved in illustrating a given philosophical idea or theory? More specifically, can a visual artwork actually make an innovative contribution to philosophy? Spoiler Alert: The book also proposes an affirmative answer to this second question, for I see the arts as, among other things, a way to reflect upon philosophical questions or, to use Robert Pippin's pregnant phrase, philosophy done by other means (Pippin 2021).

Since few philosophers have written about illustration, I want to explain the circuitous path that led me to write this book. I first became interested in illustration as the result of my participation in the debate concerning whether films can make substantive contributions to philosophy. In reflecting upon that issue, I was struck by the fact that both the advocates for and the critics of the idea of "cinematic philosophy" claimed that a film that illustrated a philosophical theory or claim was not relevant to the debate, since *merely* illustrating a philosophical position was not the same thing as actually doing creative philosophy. In *Thinking on Screen: Film as Philosophy* (Wartenberg, 2007), I devoted a chapter to a discussion of the concept of illustration, arguing that an illustration can be a significant philosophical achievement, not something to be blithely dismissed by preceding it with the adjective "mere." My discussion of Charlie Chaplin's *Modern Times* (1936) as an illustration of Karl

xii PREFACE

Marx's theory of alienation seems to have struck a chord with many readers by demonstrating how a comedy could make a serious philosophical point.

As a result of his reading that chapter as well as subsequently talking with me about our shared interest in comics, Aaron Meskin asked me to write a chapter on visual images in comics for the anthology he was editing. The chapter that I wrote compared the images that grace the pages of illustrated books with those in comics. I wound up making the somewhat paradoxical sounding claim that comics do not standardly contain illustrations, a claim that I will explain and defend in the ninth chapter of this book.

Writing that essay fueled my interest in the topic of illustration itself. As I began to research the issue, I discovered that there was very little philosophical literature devoted to the topic. As a result, I decided to teach a seminar on the philosophy of illustration and was pleased that Mount Holyoke College agreed to hire Barry Moser, the well-known book illustrator, to co-teach with me. In preparing the course, I felt it incumbent on me to see whether there were original works of philosophy that included illustrations by established artists. Initially, I was able to find only one such book, Ludwig Wittgenstein's *On Certainty*; it was published in a beautiful edition by Arion Press that included Mel Bochner's illustrations of the text.

Although Bochner's illustrations were quite abstract and difficult to understand, after extended study I came to see them as providing illustrations of some of the central ideas Wittgenstein advanced in *On Certainty*. I wound up writing an essay on some of the images in the book (Wartenberg, 2015a) as well as the catalogue essay for the exhibition of Bochner's *Wittgenstein Illustrations* that I curated at the Mount Holyoke College Art Museum (Wartenberg, 2015b). I discuss Bochner's illustrations in chapter 8 of this book.

While preparing to teach the course and then writing the catalogue essay for the exhibition, I discovered other works of art that

illustrated philosophy, such as the famous frontispiece for Thomas Hobbes's *Leviathan* that the artist and printmaker Abraham Bosse created with input from Hobbes (see figure 4.1). At the same time, I discovered a number of book-length comics—I eschew the term "graphic novel" for reasons I explain in chapter 9—that illustrated philosophy in different ways.

Next, Noël Carroll and Jonathan Gilmore asked me to write a chapter about art as philosophy for their anthology on the philosophy of painting and sculpture (Wartenberg, 2023a). While writing that chapter, I realized that there was sufficient material to justify writing a book about art that illustrates philosophy. The one you are either holding in your hands or looking at on your device's screen is the result of that realization.

Although my initial idea had been to write a book on the philosophy of (book) illustration, I came to see that the real issue that interested me was the various different ways in which visual artists had engaged with philosophy from the time of the Ancient Greeks to the present. *Thoughtful Images* is my attempt to document and analyze the rich tradition of interaction between visual artists and philosophy (and philosophers!) that deserves more attention than it has received.

There is one terminological issue that I need to raise. This book includes both written text and images. This makes it problematic to refer to the *readers* of this book, for they are as much *viewers* as they are readers. I attempt to solve the problem of how to refer to the book's audience members by using a number of different terms. Sometimes, I say *reader-viewers* to emphasize the dual nature of the text; other times, I talk of the book's *audience* to avoid prioritizing either the text or the images. I do occasionally refer to viewers or readers when I am thinking primarily of a visual or a written text. But throughout, the audience for this book will be simultaneously viewers of its images and readers of its text who integrate both of those roles.

## xiv PREFACE

A brief caveat is also in order. The subtitle of this study, *Illustrating Philosophy Through Art*, suggests that it will be a comprehensive examination of how philosophy has been transformed into art. This is misleading in that both the works of art and the philosophical theories that will be considered belong exclusively to the Western tradition. There are, of course, traditions of philosophy other than the Western one, including those found in China, India, and Africa. I have not included illustrations of philosophy in such traditions primarily because of my own ignorance. I do not know enough about those traditions—either philosophical or artistic—for it to make sense for me to have attempted to include them in this study. I can only hope that others more conversant with those traditions will be inspired by this book to investigate how those philosophical traditions have been illustrated.

# Acknowledgments

I want to thank a number of people without whom this study would never have been written. First, thanks to my friend and co-teacher, the esteemed book illustrator Barry Moser, for many hours of fascinating discussions about the nature of art, as well as for introducing me to a range of illustrations I hadn't known about. Mel Bochner was extremely generous with his time and helped me as I tried to unpack the significance of his own illustrations of philosophy. Andrew Witkin of the Krakow-Witkin Gallery provided me with assistance at an early stage in this project and has continued to be very supportive of my efforts. The entire staff of the Mount Holyoke College Museum of Art assisted me along the way. Although John R. Stromberg, then the director of the museum, came to fear my increasingly demanding requests for his help with my project—what began with my simply asking whether the Museum could buy the Arion edition of *On Certainty* eventually turned into a request for an exhibition and then a catalogue—he and the entire museum staff remained supportive and enthusiastic about my work. Hannah Blunt deserves special praise for helping me curate the exhibition of Bochner's works as well as write the catalogue essay. Without the assistance and encouragement of everyone at the Museum, I would not have been able to develop this project.

Lucy Randall, my editor at Oxford, was convinced of the importance of this book and helped shepherd it into production. I am grateful for her perseverance and her guidance. Throughout the delays caused by COVID, she remained positive about the book. Her reassurances were crucial as I persevered in the writing

xvi ACKNOWLEDGMENTS

the manuscript and waited to receive permissions to publish the images.

My partner, Jane Garb, has been unflinchingly supportive during the lengthy process of revising the manuscript and getting permissions for the images. She also helped me devise the final title. Without her love and support, this project might not have been completed. I hereby express my gratitude for all she has done to help me, both to get this book into print and more generally.

A variety of grants from Mount Holyoke College provided funding for the images included in this book. Two students served as research assistants during the publication process. Julia Bender, a graduate student in Art at the University of Massachusetts-Amherst, helped secure permissions for the images and Vivian Dong, an undergraduate at Mount Holyoke College, provided help with the chapter summaries. Both of them were supportive and helpful during the final phases of this project.

A number of people read parts or all of this book in various stages. Jeffrey Strayer gave me the benefit of his vast knowledge of contemporary art and helped to strengthen many of the chapters. His assistance was invaluable. I am very grateful to the Propositional Attitudes Task Force for reading an entire draft of the book. Comments by the members of the group were very helpful: Ernie Alleva, Bruce Aune, Howard Burrows, John Connolly, Owen Freeman-Daniels, Lennie Kaumzha, Thomas McCarthy, and Bill Rohan. Robert Wicks gave me helpful suggestions for chapters 5 and 6. Alexander George helped me avoid misleading statements about Wittgenstein's philosophy in chapters 7 and 8. Some of my ideas were the results of conversations with my friends and colleagues, Joe Moore and Aaron Meskin. Thomas Khurana helped unpack the meaning of the German in *If the Color Changes*. A special word of thanks to my long-time friend and colleague Jay Garfield who read the entire manuscript, giving important advice about how to improve it. Roberta Israeloff gave me useful suggestions for improving the flow of the text. I have also benefitted immensely from the

ACKNOWLEDGMENTS  xvii

very detailed and erudite suggestions made by the anonymous reviewers for Oxford University Press. They have saved me from making many erroneous claims and have also suggested additional materials that I have incorporated into the book.

At different stages of its preparation, various portions of this manuscript were read at the American Society for Aesthetics, the British Society of Aesthetics, and the Philosophy Departments of Mount Holyoke College and the University of Georgia. The comments made at these readings were uniformly helpful to me.

The first half of chapter 9 was drawn from a previously published paper, "Wordy Pictures: Theorizing the Relationship between Image and Text in Comics" in Aaron Meskin and Roy Cook, eds., *The Art of Comics: A Philosophical Approach* (Blackwell, 2012), pp. 87-104. Some sections from the catalogue essay in *Mel Bochner: Illustrating Philosophy* (South Hadley: Mount Holyoke College Museum of Art, 2015) are included in chapter 8. Some of the ideas in chapters 3, 4, 5, 6, 7, and 8 are briefly discussed in "Philosophical Works of Art" in *The Routledge Companion to the Philosophy of Painting and Sculpture*, Noël Carroll and Jonathan Gilmore, eds. (New York: Routledge, 2022).

I want to thank Barry Moser, Mel Bochner, and Maria Bußmann for giving me permission to publish images based on their artworks.

# 1

# Introduction

Visual illustrations of philosophy abound. For example, virtually every introductory philosophy textbook that includes Plato's famous "Allegory of the Cave" also features a diagram of the Cave. Providing a visual rendering of the Cave helps beginning students understand the complex situation Plato describes in *The Republic*. (See an example in figure 1.1.) The diagram shows a group of prisoners bound together facing a wall of the Cave onto which a fire projects the shadows of various physical objects. Since Plato provides a clear verbal description of this scene (*Republic*, 514a–520a), the diagram is based on the description given in the written text. A visual rendering of the scene helps its audience easily and accurately envision it.

A skeptic about the possibility of visual illustrations of philosophy might respond as follows: Sure, it's possible to illustrate the Allegory of the Cave, but that's only because it's an *allegory*, a narrative that is itself an illustration of Plato's actual metaphysical and epistemological views. It's not possible, however, to illustrate Plato's actual metaphysics, with its claim that reality consists of purely intelligible objects rather than just the colorful literary tropes he introduces to make his views more accessible.

Consider, our skeptic might continue, another of Plato's well-known literary images, the Divided Line. The passage in *The Republic* begins as follows: "It is like a line divided into two unequal parts, and then divide each section in the same ratio, that is, the section of the visible and that of the intelligible" (510d). Plato goes on to explain that the first section of the visible consists of images and

*Thoughtful Images.* Thomas E. Wartenberg, Oxford University Press. © Oxford University Press 2023.
DOI: 10.1093/oso/9780197650547.003.0001

2  THOUGHTFUL IMAGES

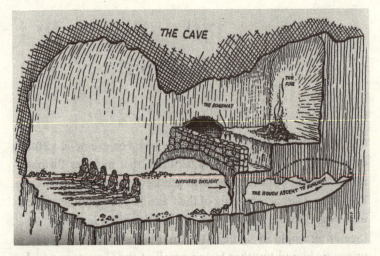

**Figure 1.1** Plato's Cave. *Great Dialogues of Plato*, W. H. D. Rouse, trans., Eric H. Warmington and Philip G. Rouse, eds., New York: Penguin, 1956 and 1984.

the second of ordinary objects like plants and manufactured things. He then comments that the division of visible objects corresponds to a distinction between imagination and opinion, two different mental operations.

The line segment that stands for intelligible objects has a similar division. Plato distinguishes between investigations that draw conclusions from hypotheses and those that lead to first principles, a distinction he characterizes as one between reasoning and understanding. Plato explains the distinction using geometry. Geometers assume the existence of geometrical objects like plane figures and then reason to conclusions. In doing so, they may use images, but these images are not the actual mathematical objects, for those are purely intelligible. Philosophical knowledge, on the other hand, is about the Forms, the intelligible objects that stand to ordinary objects in the same relationship as ordinary objects do to their images. These things

INTRODUCTION 3

cannot be known by vision but only by the intellect via the process Plato calls "dialectic."

Plato's division of knowledge into four levels, our skeptic would say, provides the materials for an argument against the possibility of illustrating philosophy. Certainly, it is possible to present an illustration that explains the Divided Line. In fact, many translations of *The Republic* do just that. (See, for example, Plato [1974, p. 164].) And it is possible to illustrate the different objects of imagination and opinion, images and ordinary things. But when it comes to purely intelligible objects, be they those of mathematics or those of metaphysics (the Forms), there is no way to illustrate these. Since the real subject matter of philosophy is the intelligible objects Plato calls "Forms," philosophy itself cannot be illustrated but only the literary tropes by means of which it is conveyed to less knowledgeable audiences.[1]

Our skeptic has provided a strong argument against the possibility of illustrating philosophy. The case could be strengthened even more by an examination of Anthony Kenny's *The Oxford Illustrated History of Philosophy* (1994). Although the book contains nearly 150 illustrations, most of them are simply portraits of famous philosophers in the Western tradition. It does include an illustration of the tree of knowledge from a scholastic textbook (Kenny, p. 114) and Kenny asserts that a drawing by M. C. Escher demonstrates the falsity of Frege's claim that the imagination is governed by the laws of geometry (Kenny, p. 249), indicating that some illustrations can serve philosophical purposes. But because the illustrations are mostly portraits, the book supports the skeptical claim that philosophy itself cannot be illustrated.

One might reply to the skeptic by noting that some well-known philosophical texts include visual images as a central feature of

---

[1] The Divided Line has actually been illustrated by Joseph Kosuth, *Intellect to Opinion* (2017). I discuss his work in chapter 7.

4 THOUGHTFUL IMAGES

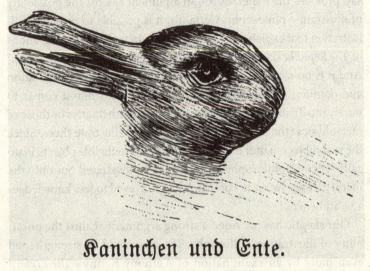

Figure 1.2 The Duck-Rabbit. October 23, 1892, issue of *Fliegende Blätter*.

their arguments. Probably the best known is the "duck-rabbit" in Wittgenstein's *Philosophical Investigations* (Wittgenstein, 2009, Part II, ¶118) (see figure 1.2). In part II of the *Investigations*, while discussing the nature of seeing-as or aspect seeing, Wittgenstein introduces this drawing—it is actually one of several occurring in this section of the *Investigations*—as an example of an image that can be seen in two different ways, i.e., as a duck or as a rabbit, but never both simultaneously.

In my remarks, the following figure, derived from Jastrow, will be called "the duck-rabbit." It can be seen as a rabbit's head or as a duck's. And I must distinguish between the "continuous seeing"

of an aspect and an aspect's "lighting up." (Wittgenstein, 2009, Part II, ¶118)

I will discuss this image more fully in chapter 7. For now, I want to point out that this image plays an integral role in Wittgenstein's argument. He uses it to explain the phenomenon to which he is drawing the reader's attention, not to illustrate a point he makes in the text independently of the image. The duck-rabbit is a visual image that Wittgenstein uses to get readers to understand his philosophical thesis concerning seeing an aspect. It suggests that philosophy can indeed be illustrated.

There is an even more significant problem with the skeptics' argument. Their challenge gains traction by illicitly taking a particular type of illustration as definitive of the notion as a whole. Most of us are used to thinking of illustrations as *text-based*, as literally presenting a picture whose central features are specified by a text. The diagram of Plato's Cave (figure 1.1) is a good example of such an illustration, for it consists of a picture whose central features—the bound prisoners, the wall on which images are projected, etc.—are derived from Plato's description of the Cave. The skeptic assumes there are only illustrations of this type, making the idea of illustrating an abstract philosophical claim appear completely implausible.

There are, however, other types of illustrations. One type I discuss in this book is what I call a *concept-based illustration*. A concept-based illustration does not attempt to illustrate a segment of text but an abstract philosophical concept or idea.[2] I will argue that a

---

[2] The distinction I draw between different types of illustration is related to the distinction that James O. Young makes between semantic and illustrative representation (Young, 2001, p. 26). However, Young fails to see the possibility of semantic representations functioning as illustrations, probably because he takes all illustrations to be pictorial. Koen Vermeir (2005) discusses the notion of an "analogical demonstration" in the late seventeenth century. He claims that Pierre le Lorraine, Abbé de Vallemont, used such demonstrations to render the invisible visible. This involves a similar strategy to the one I am attributing to artists like Phillips and Bochner.

## 6 THOUGHTFUL IMAGES

visual image is able to illustrate an abstract philosophical view because it presents an analogy to the position it illustrates. In the course of this book, I will have occasion to discuss a number of such concept-based illustrations, such as Tom Phillips's illustration of the Schismatics in Dante's *Inferno* (chapter 2) and Mel Bochner's illustrations of Ludwig Wittgenstein's *On Certainty* (chapter 8). Even if the skeptic was correct in claiming that it is not possible for there to be text-based illustrations of abstract philosophical claims—a view I dispute at various points in this book—they have not provided a justification for denying the possibility of concept-based illustrations of abstract philosophical claims. The apparent plausibility of the skeptic's position rests upon too narrow a conception of illustration.

But what's the difference between a typical textbook illustration of Plato's Cave and a work of art that also illustrates that section of *The Republic*? Characterizing a visual image as a work of art involves evaluating it, treating it as a distinct type of entity. This is what distinguishes works of art from drawings that serve a merely pedagogical, utilitarian, or heuristic function, such as the Cave diagram I have discussed. Those are not works of art because they primarily seek to convey information. Works of art attempt to do something else. Arthur Danto characterizes that "something else" as "embodying a meaning" (Danto, 2003, p. 25). Other philosophers of art see other properties as crucial for works of art. They all agree, however, that works of art do more than convey information.

An example of a work of art that is also an illustration of the Cave is *Antrum Platonicum* [*Platonic Cave*] (1604), an engraving by Jan Saenredam based on a lost painting by Cornelis Cornelisz of Haarlem (figure 1.3).[3] The work was commissioned and published

---

[3] This claim is made by the British Museum on the webpage for the work. See https://www.britishmuseum.org/collection/object/P_1852-1211-120. There is an earlier work that is attributed to the Flemish painter Michiel Coxie that is also an

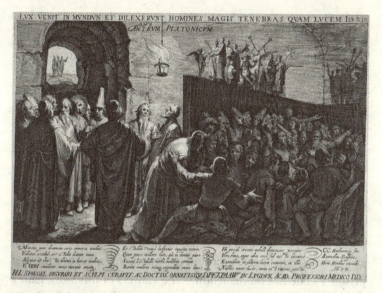

**Figure 1.3** Jan Saenredam, *Antrum Platonicum* (c.1640). © Trustees of the British Museum.

by the poet, Hendrik Laurenszoon Spiegel, who probably also gave detailed instructions about its composition and who is thus responsible for some of its deviations from Plato's description of the Cave (McGrath, pp. 228–232). The engraving illustrates a later passage from Plato's Allegory than that shown in the diagram. In it, Plato describes how, after having escaped his imprisonment in the Cave and having seen the world of real things illuminated by sunlight, one of the prisoners returns to the Cave to enlighten his fellow prisoners about the nature of reality. A tumult ensues among the prisoners who debate the veracity of their fellow's testimony. Most of the Cave dwellers are skeptical of his report and, as the supertitle

illustration of Plato's Cave, *De grot von Plato* (sixteenth century). This work depicts the same scene as that depicted in the diagram using the artistic techniques of the high Renaissance.

# 8 THOUGHTFUL IMAGES

to the illustration says, "the light has come into the world, and men loved darkness rather than the light."[4] Plato is here explaining the reticence of his fellow Athenians to accept his philosophy as well as their hostility to his teacher Socrates.

What is the difference between *Antrum Platonicum* and the textbook illustration of the Cave? The textbook diagram of the Cave serves primarily a utilitarian function: helping a reader understand the situation that Plato describes. For this reason, it is stripped of all details other than those that visually render the scene Plato describes verbally. Saenredam's work, in contrast, seeks to convey the impact that the escaped prisoner's return has on his fellows. He portrays the chaos resulting from the prisoner's message. In doing so, he uses spatial recession as well as the contrast between shadow and light to give a sense of the emotional impact the former prisoner's tale has on his fellows. The viewers of this work gain a clearer understanding of the prisoners' reactions even if the details of Plato's verbal description are rendered less prominently than in the diagram.[5]

Works of art that illustrate philosophy, like *Antrum Platonicum*, are not as numerous as drawings that serve the more utilitarian purpose of providing a visual rendition of verbal information conveyed by a text. Nonetheless, there is a significant tradition of visual

---

[4] This quotation comes from John 3.19 and allies Plato's myth with Christianity.

[5] Plato's Cave remains an interesting subject for artists to use in their work. One prominent example is Robert Motherwell's series *In Plato's Cave*. It has been suggested that Motherwell's works present viewers with the shadows that the inhabitants of the Cave take to be real. (Thanks to Jeffrey Strayer for bringing this series to my attention.) A recent exhibition at the Getty Museum, curated by Donatien Grau, *Plato in L.A.: Contemporary Artists' Visions* (2018), includes three works that employ the Cave: Mike Kelley's *Exploring from Plato's Cave, Rothko's Chapel, Lincoln's Profile* (1985), which depicts a more realistic cave than Plato's; Raymond Pettibone's modernization of the Cave, *No Title (Lightly, Swiftly, Absolutely)* featuring three people looking up through a tunnel into the light; and Huang Yong Ping's *Caverne 2009* (2009) in which the viewer looks into a cave in which there are statues of Buddhas and Talibans. It's not clear to me that the cave pictured in all of these works is Plato's, and those that do portray Plato's Cave seem to use it more as a reference point than as an image to be illustrated. Unfortunately, I found out about this exhibition too late to incorporate all of the works exhibited in it into this book. I hope to discuss illustrations of Plato in future work.

INTRODUCTION 9

works of art—etchings, drawings, prints, paintings, sculptures, installations, etc.—that illustrate philosophy. This bald statement may come as a surprise to many readers. To make it more plausible, consider a work that clearly is an illustration of philosophy, Raphael Sanzio's *School of Athens* (Plate 5), the marvelous fresco located in the Vatican. It is one of the best-known works of art with clear philosophical content, depicting virtually all the great Ancient Greek philosophers. The painting is claimed to depict the difference between the metaphysical positions of its two central figures, Plato and Aristotle, as Plato, the idealist, is pointing to the heavens while Aristotle, the empiricist, gestures to the earth.[6] This fresco is a *good* example of a work of art that provides a pictorial illustration of philosophy, though it is not text-based. I will discuss it in more detail in chapter 5.

It's not at all obvious what is required for a painting or other visual artwork to illustrate a philosophical thesis or theory. Is it sufficient to show famous philosophers gesturing in significant ways as Raphael has done? If not, what more is required for an image to count as one that illustrates philosophy? Answering these questions is the central task I undertake in *Thoughtful Images*.

Given the existence of a rich tradition of visual illustrations of philosophy, it is surprising that it has not received more attention from philosophers. That there is such a tradition will be demonstrated in the balance of this book. Art historians have focused on visual works that illustrate philosophy more than philosophers have. For example, Susanna Berger's *The Art of Philosophy* analyzes "visual thinking in Europe from the Late Renaissance to the Early Enlightenment," as the book's subtitle says. (That book will be discussed in chapter 3.) Another example is Claire Richter Sherman's (1995) examination of the illustrations of Aristotle's ethical and political treatises, a work that I also

---

[6] Paul Taylor argues that the fresco presents the philosophers in a negative light, as more interested in arguing than discovering the truth. See, especially, pp. 187–189.

# 10 THOUGHTFUL IMAGES

discuss in the third chapter. But these art historical studies focus on a limited set of works that illustrate philosophy and not the entire tradition.

There is only one book I know of devoted to illustration as a *philosophical* topic. It's *Illustration* by the deconstructionist literary critic J. Hillis Miller, and only the second half of it is actually devoted to the topic. While it contains a great deal of useful information, the book does not address the central question raised in this study: How can a work of visual art illustrate philosophy?

As I mentioned in the preface, there is a rich philosophical literature about the relationship between philosophy and other artforms. While the thesis that literature can provide important philosophical insight has been hotly debated, numerous philosophers and literary scholars have argued for the relevance of literature to philosophy. Martha Nussbaum is probably the best known (see Nussbaum, 1992, for example). But there are others. Gilbert Ryle's wonderful essay on Jane Austen (1966) is a classic example of a philosopher demonstrating the philosophical significance of a literary work.

Similarly, there is a rich debate focused on the question of whether films can actually contribute to philosophy. The debate's initial focus was Stephen Mulhall's claim that film is "philosophy in action" (Mulhall, 2002, p. 2). Paisley Livingston rejected what he called "the bold thesis," namely, that films can make innovative contributions to philosophy that are not possible via the written word (Livingston, 2006, p. 11). Many others responded and a significant debate ensued that continues to this day.[7] Like literature, film is an artform that has spawned a great deal of discussion as to its philosophical relevance.

So, it is surprising that philosophers have not provided more discussions of whether works of visual art can illustrate philosophy, let alone actually provide innovative philosophical insights that are

---

[7] One example of this debate are the contributions by Murray Smith and myself to Thomson-Jones (2016).

## INTRODUCTION    11

independent of written philosophical texts.[8] This, despite the fact that one of the most important philosophers of art of the twentieth century, Arthur Danto, argues that some of Andy Warhol's most significant works of art are genuine works of philosophy. (For more on Danto and Warhol, see chapter 6.)

Art historians, as I have said, have discussed the topic of the relationship between works of art and philosophy. Hanneke Grootenboer (2020) argues that certain works of art, those that she characterizes as *pensive images*, actually are an embodied form of thinking. She attempts to clarify that notion through reference to Caravaggio's *Death of the Virgin* (1606) and Jean-Luc Nancy's essay on it. Nancy proposes that the figure of John the Evangelist represents "the 'thought' of this painting." Grootenboer rejects this, saying, "This would be thought expressed *in* an image, or *as* image. What I have in mind is pensiveness as a quality of the image that causes it to remain inexpressive" (p. 24). Her idea is that there are certain images that resist our attempt to find meaning in them but that nonetheless give rise to thinking.

Grootenboer is an example of an art historian who has been influenced by the writings of Continental philosophers like Heidegger and Derrida. She sees her idea of pensive images as derived from the work of these philosophers who do see art as capable of philosophical insights. (I discuss some of them in chapter 5.) But Grootenboer is not interested in the types of works of art I discuss in this book, that is, works that have philosophy *in* them, as she makes clear in the previous quotation. These are precisely the works that form the subject matter of *Thoughtful Images*, which focuses on visual works of art that have clear philosophical content embodied *in* them.

In raising the question of visual artworks that illustrate philosophy, this book addresses three fundamental issues. First, is it

---

[8] Although philosophers have not discussed this relationship very much, the same cannot be said of historians, many of whom have written about the relationship between visual art and philosophy. Among the art historians who have written on this topic are Horst Bredekamp, Elizabeth McGrath, and W. J. T. Mitchell.

possible for a work of visual art to illustrate a philosophical claim or thesis? As we have seen, this claim is controversial and requires the defense I undertake in chapter 2.

If philosophy can be illustrated visually, as I maintain, are there limitations to the types of philosophical claims or theses that can be illustrated? While intuitively it seems more plausible to hold that a claim about justice can be illustrated visually than to hold a similar belief about a metaphysical or epistemological claim, I maintain that it is possible to illustrate such theoretical claims, and I will provide many examples of artworks that do so in the coming pages.

The final issue discussed in this book is this: Can the visual arts actually make a substantive contribution to philosophy by means of a visual image? Such a claim will, no doubt, raise the hackles of many reader-viewers, but I think it is defensible and, once again, the book will provide examples to support it.

In general, the aim of this book is to bring more recognition to the tradition of visual works that illustrate philosophy as well as to explore the variety exhibited by such works. In making the case for this, I have employed two different "frames" for presenting the material.

First, after chapter 2, *Thoughtful Images* is structured historically. It begins with the Ancient Greeks and traces the history of illustrations of philosophy up to some quite recent comics or so-called graphic novels that have philosophical content. This seemed like the best way to justify my thesis that there is an *historical tradition* of visual illustrations of philosophy stretching all the way back to the Greeks that is still vibrant today.

I was not satisfied, however, with a merely historical survey for I also wanted to think about that tradition more analytically. As a result, *Thoughtful Images* also investigates the different relationships between text and image in illustrations of philosophy. In addition to characterizing these relationships, I show how they developed over the course of Western history.

INTRODUCTION 13

The second chapter is the most theoretical in this book. It begins with an account of text-based illustrations of literary texts and then extends that account to illustrations of philosophy texts. Using an analogy with translation, it presents two fundamental, conflicting norms that govern illustrations: fidelity and felicity. It explains how these norms function in visual works, providing a framework that I apply in the following chapters. In addition to discussing text-based illustrations, it explains the idea of concept-based illustration and how such illustrations function. The chapter also rebuts what I term "the denigration of illustration," the characterization of illustration as an inferior artform, arguing in deconstructive fashion that this claim lacks justification. To justify this claim, it examines two important works, Titian's *Rape of Europa* and Norman Rockwell's *Freedom of Speech*, arguing that their status as illustrations does not contradict their also being works of art.

After this theoretical discussion, the book moves to a consideration of different ways in which the visual arts have been deployed as vehicles for the transmission of philosophical claims and theories. Each chapter focuses on a specific way that visual artworks have been used to illustrate philosophy.

The third chapter begins with a cursory survey of illustrations of philosophy and philosophers in the Western tradition going back to Ancient Greece. It then discusses medieval manuscripts with beautiful colored illustrations of Aristotle's *Nicomachean Ethics* and *Politics*, emphasizing the use of personification as a technique for illustrating philosophy. The balance of the chapter examines a set of large engravings made toward the beginning of the seventeenth century. The works were intended to be aids for students studying for oral examinations that required them to know the details of Aristotle's philosophy. These broadsides presented Aristotle's ideas in the form of a large garden with many walls and paths that wind through its flora. In so doing, the broadsides function in a manner similar to mnemonics that help people remember, say, the various forms of logical syllogisms distinguished by Aristotle. These

## 14 THOUGHTFUL IMAGES

etchings had a clear pedagogical function, enabling students to remember abstract relationships through their visual representation. I will also defend a more controversial claim that sometimes these works present novel philosophical ideas, so that they should be regarded as more than textbook diagrams of Aristotle's views.

Frontispieces to philosophical texts published in the seventeenth and eighteenth centuries are the subject of the fourth chapter. Although some frontispieces from this time period are portraits of the book's author, the ones that are most relevant to my project attempt to illustrate basic claims made in the books in which they appear. I provide a detailed discussion of three examples: Abraham Bosse's frontispiece to Thomas Hobbes's *Leviathan* and frontispieces to two of the six books of Jean-Jacques Rousseau's *Emile*. These frontispieces present philosophical theses in visual form. With Hobbes's assistance, Bosse was able to present a number of *Leviathan*'s central claims visually. The case of the *Emile* engravings is more unusual in that the images of education that form the frontispieces of each of the six books present *not* Rousseau's own educational theories but the theories Rousseau was attacking. It seems Rousseau wanted to use visual images so that his readers would recall received ideas about education and thus be willing to be taught about the proper nature of education.

The fifth chapter discusses a very different use of visual images in relation to philosophy. After discussing three works of art that have clear philosophical content, it focuses on three well-known philosophers who used works of art to clarify aspects of their philosophical theories. The works they consider were not intended by their makers to illustrate those theories and yet these philosophers believe that these works of art provide the audiences for their philosophical writing with an access point to their complex and difficult theories. Friedrich Nietzsche, Martin Heidegger, and Michel Foucault each use a painting to illustrate significant ideas from their philosophy in a manner that makes those ideas more easily accessible than they generally are taken to be in the philosophers'

INTRODUCTION    15

written texts. These examples provide additional support for my rejection of the claim that a great work of art cannot also function as an illustration. I introduce the notion of theory-based illustrations to explain how such works function as illustrations, thus adding a third term to the evolving theoretical framework for understanding illustration.

A number of philosophers and theorists of art see the advent of Modernism in the visual arts as signaling a philosophical turn in the arts. Most famously, Clement Greenberg argued that paintings in the Modernist tradition beginning with Manet made actual philosophical claims about the nature of art. Modernist paintings, according to Greenberg, employ only features of painting that are unique to it as an artistic medium and thereby do the philosophical work of specifying what the essence of painting is. Following in Greenberg's footsteps, Danto treated Warhol as continuing this tradition of philosophical works of art by creating works that were visually indistinguishable from ordinary things, thereby raising in a new and insightful manner the traditional aesthetics question, "What makes something a work of art?" Greenberg's and Danto's claims form the subject matter of the fifth chapter. What's of particular interest in this chapter is the notion, common to Greenberg and Danto, that certain works in this tradition are actually *doing* philosophy, making a unique contribution to the ongoing discussion within philosophy itself concerning the nature of art.

I conclude the chapter by looking at the works of the well-known artist and philosopher Adrian Piper. Piper is critical both of Greenberg's banishment of content from art and also of the artistic movement Greenberg champions, Abstract Expressionism. Both theoretically in her writings and visually in her own philosophically rich works of art, Piper pursues a project of demonstrating that reintroducing content into art does not entail an artistic failure but rather signals a renewed interest in the traditional mission of art to address significant social issues.

## 16 THOUGHTFUL IMAGES

Some artists have been interested in exploring the ideas of philosophers through creating works of art. The seventh chapter of this study focuses on artists who have attempted to make works that illustrate central ideas in the writings of Ludwig Wittgenstein, arguably one of the two most important philosophers in the twentieth century. Perhaps because of Wittgenstein's aphoristic writing style and unusual methodology, artists have been attracted to his ideas. I present a survey of some of the most significant artistic illustrations of Wittgenstein's ideas. Artists such as Joseph Kosuth and Bruce Nauman have created works employing phrases from Wittgenstein's writings. Such works present a new manner of illustrating philosophy, for by including a philosopher's actual words, these works present a new form of the word-image relationship in illustrations.

The eighth chapter focuses on the work of Mel Bochner, discussing a series of twelve illustrations he created for an edition of Wittgenstein's book *On Certainty* in addition to his series entitled *Range*. These Conceptual artworks do not indicate readily how they are meant to illustrate *On Certainty*, so a detailed analysis is required for a reader-viewer to understand how they function. I introduce the notion of a "numbers-game" as an analogy to Wittgenstein's notion of a language-game in order to explain how these works function as illustrations of Wittgenstein's claims.

In recent years, a new artform has developed that has made significant contributions to philosophy. What I call "graphic philosophy" uses the form of a comic to present important issues in philosophy. It is the subject of chapter 9. An early example of graphic philosophy is the comic artist Scott McCloud's book, *Understanding Comics*. In this comic, McCloud develops a theory of comics. The other works in this genre discussed in the chapter are *Logicomics*, *Unflattening*, and *Fun Home*. They extend the use of graphic literature as a means of philosophizing using both words and images.

INTRODUCTION 17

Even this short description of the book indicates that visual works of art have a number of different relationships to the discipline of philosophy. Sometimes, an artist, often working with a philosopher, creates a work intended to illustrate a specific philosophical issue or text. In other cases, philosophers themselves have turned to visual artworks to illustrate some of the basic ideas in their philosophy, believing that their ideas will be more accessible when seen in an artwork. There are also certain works of art, especially those in the Modernist tradition, that have a claim to be actually doing philosophy. Visual artists have their own philosophical interests and have attempted to use the ideas of philosophers in their art, thereby creating artworks that illustrate the ideas of philosophers like Wittgenstein. Finally, the new artform of graphic philosophy opens up a new field for visual artists to explore as a means of addressing philosophical issues.

By exploring in detail some of the different ways in which visual artworks bear a relationship to philosophy, I intend to make philosophers, art theorists, and the public in general more aware of the relationship between philosophy and the visual arts. What emerges from this study is a clear view of the visual arts as a cultural form through which philosophy has been done for centuries. Instead of seeing the visual arts as competing with philosophy in the pursuit of truth—as Plato did more than two millennia ago—this study shows that the two are better seen as proceeding hand in hand as different but related ways of understanding the world and its complex reality.

## Methodological Remarks

Reading this summary of the contents of *Thoughtful Images*, a reader might wonder how I came to discuss this specific set of works of art as illustrations of philosophy. Given that I know of no previous systematic study of illustrations of philosophy, there is

## 18 THOUGHTFUL IMAGES

no accepted canon of works to discuss. As a result, I had no clear guidance on how to find illustrations of philosophy to include in this study.

My method of proceeding has been largely empirical. As I mentioned in the preface, prior to beginning this book project I had already taught a course on illustration and curated an exhibition of Mel Bochner's *Counting Alternatives: The Wittgenstein Illustrations*, the topic of chapter 8. In the course of preparing both of those, as well as writing the catalogue essay for the exhibition (Wartenberg, 2015b), I came across various works of art that illustrated philosophical theories or claims. As I began to focus on writing a book-length study of illustrations of philosophy, I searched for examples of works of art that purported to be such illustrations. As I read various books and essays about visual works that had some relationship to philosophy, I accumulated a list of works that were relevant to my project. I am not sure if there was any way to avoid such a piecemeal and empiricist manner of proceeding, but that is the only alternative I could see available to me. The problem with it, of course, is that it cannot guarantee that it provides a comprehensive set of works illustrating philosophy. And, indeed, I continue to discover additional artworks illustrating philosophy beyond those included in this study.

As a reader-viewer will soon notice, there are certain notable characteristics of the works included in this study. For the most part, they were created by white men. This is not because I do not think it important to include women artists and artists of color in philosophical studies of art. Rather, the topic of this study— illustrations of philosophy— meant that I had to include, in the first instance, works that were clearly intended to illustrate philosophy. It turned out that there were comparatively few philosophical works by women that were illustrated, though there are some exceptions mentioned in chapter 4 as well as a number of women artists whose attempts to illustrate philosophy I discuss in chapters 6, 7, and 9. The case with artists of color is similar. With the

INTRODUCTION    19

exception of Adrian Piper, I was not able to find any artists of color whose work could be clearly identified as specifically attempting to illustrate philosophy.

We can ask, "Why is there such a paucity of work by women artists that attempt to illustrate philosophy?" One key is suggested by Linda Nochlin in her groundbreaking 1971 essay, "Why Have There Been No Great Women Artists?" Among the many institutional factors Nochlin mentions is education. For example, women were not allowed to attend live drawing sessions featuring naked men, one of the essential elements of nineteenth-century artistic education. Could there have been similar obstacles to women pursuing an interest in philosophy? Or, at least, could women artists have been pushed toward more acceptable subjects, as suggested by the case of the celebrated nineteenth-century artist, Rosa Bonheur, with her nearly exclusive focus on paintings of animals?

Similar things can be said about artists of color. Perhaps the pressure to achieve success made them avoid such relatively neglected subjects as illustrations of philosophy. Only when an artist could see racial issues as inherently philosophical, as Piper does, is there a reason for an artist to attempt to include philosophical ideas in their art.

*Thoughtful Images* is the first book-length study of the use of visual art to illustrate philosophy. By placing the artworks in this historical context and theorizing the different ways in which philosophical ideas have been illustrated, the book will assist reader-viewers in seeing the visual arts and philosophy as having a commonality that has not always been acknowledged. My hope is that *Thoughtful Images* will encourage these reader-viewers to reject a view of art as antithetical to philosophy and to see that visual artists have reflected on philosophical theories and ideas in their own, distinctive manner.

# 2

# Theorizing Illustration as an Artform

I set out to accomplish two things in this chapter. First, I develop a framework for understanding the nature of visual illustrations. In addition to providing a clear account of the characteristics that distinguish visual illustrations from other visual artforms, I develop a typology of different types of illustrations. This account will be employed throughout the book as I pursue an investigation into diverse illustrations of philosophical texts, ideas, arguments, and theories.

Second, this chapter undermines the standard assumption that illustration is a less significant form of art than such artforms as painting or sculpture. Often, the term "illustration" is paired with the word "mere," indicating an author's denigration of the achievement required for a successful illustration of a text. The goal of this section is to rehabilitate illustration by showing it to be a significant artform, one that deserves the respect and attention of philosophers of art and other scholars.

## The Nature of Illustration

Since the focus of this book is on the use of visual images to illustrate philosophical texts, ideas, arguments, and theories, it is important to provide an account of what makes a visual image an *illustration* in the sense I use the term in this study. The central aim of this book is to demonstrate that works of art have the capacity to serve as illustrations of philosophy.

The term "illustration" is derived from *illustratum*, the pluperfect form of the Latin verb *illustrare*. The Latin word means to light

*Thoughtful Images*. Thomas E. Wartenberg, Oxford University Press. © Oxford University Press 2023.
DOI: 10.1093/oso/9780197650547.003.0002

## THEORIZING ILLUSTRATION AS AN ARTFORM    21

up or illuminate, to make clear, to elucidate, to enlighten. An illustration therefore sheds light on something, such as, say, a textual passage. This provides us with a criterion for the success of an illustration: It must, in some sense, shed light on its source, that which it illustrates. To fail to do so is to fail as an illustration.

Although the term is general, in this study I focus on *visual* illustrations of philosophical ideas and/or theories. As we shall see, the means by which philosophical ideas are illustrated changes throughout history as new technical possibilities get introduced, making new types of illustrations possible.

There are some things that can be said about illustrations in general. An illustration is always related to some other thing, its *source*. The source is metaphysically primary; the illustration, the *target*, is subordinate. The source is that which the illustration attempts to shed light on. The manner in which that light is shed varies, but we can say that there standardly is an intention on the part of the creator of an illustration to elucidate its source in some way or other.[1]

I once thought the following line of thought showed the impossibility of developing a general theory of illustration. Because the term "illustration" and its cognate forms are used in a very wide variety of contexts, I doubted that it would be possible to find a unified meaning for the term. In baseball, for example, we speak of a coach illustrating to his team how to slide when stealing a base. Here, the coach might actually slide into the base, thereby illustrating the proper form to use when performing this action by actually doing it. In this sense, an illustration is an exemplar of what it illustrates. It *illustrates* the proper way to do something by actually *doing* it.

Even here, however, we can see that the fundamentals of the account I have just begun developing are satisfied. The source for the

---

[1] We shall see in chapter 5 that there are some illustrations that are not intended to be such by their creators.

22 THOUGHTFUL IMAGES

illustration is the coach's *idea*, gotten from experience, of what must be done to slide well. When the coach slides, he provides the illustration or instance of that general idea of how to execute a slide, which he attempts to communicate to his players. When well executed, the slide he does is an example or instance of the idea or concept of sliding that the coach has acquired through his years in the game. He has taken an idea and provided an instance of it, matching the sort of ontological situation I have claimed to be constitutive of illustration. His knowledge is the source that his action illuminates.[2]

Visual illustrations, form the subject matter of this book, are a subset of illustrations in general. My goal is to develop a unified account of illustration that also explains the different forms that visual illustrations take. This will involve developing an account of different types of visual illustration. I will discuss three: text-based illustrations, concept-based illustrations, and theory-based illustration. These three terms refer to the item that is the source of the illustration, viz. a text, a concept, or a theory. These types of illustrations are ideal types, so that we shall often see them mixed in empirical examples.

## Text-based Illustrations

As I mentioned in chapter 1, many illustrations are paired with a text for which they provide a visual image. For obvious reasons, I call these *text-based illustrations*. I begin with them because they are probably what most people think of when they think of an illustration, and they provide the framework I will use as the basis for understanding the other types of illustrations I discuss subsequently.

---

[2] An ongoing discussion about illustration with Jeffrey Strayer got me to modify my initial skepticism about a general theory of illustration. I am grateful to him for that.

To develop an account of text-based illustration, I begin by considering an analogy with translation. A translation of a literary text is itself a literary work—the *target text*—that transforms a given *source text* from its original language into another one. Translation is governed by two central, competing norms.[3] The first is *fidelity* or *faithfulness*. Translations are judged by their fidelity to the source text, for it is imperative that a translation communicate the meaning of the source text accurately. Being faithful to a source text is not just a matter of translating the meaning of individual sentences; it is also a question of reproducing the structure of the source text, as is evident in Aaron Poochigian's assessment of John Dryden's translation of the *Aeneid*:

> One could fault Dryden, like Douglas [the first translator of the *Aeneid* into an English-based language] for rhyming an un-rhymed poem, but his couplets certainly have *pomp and circumstance* and, to my mind, best match the original in *heft, stateliness and musicality*. (Poochigian, 2016, emphasis added)

Poochigian's assessment of Dryden's translation treats aesthetic features of the target text such as its "heft, stateliness and musicality" as aspects of its fidelity to its source text, showing that there is more to fidelity than simply the accurate translation of individual words and phrases.

The second norm governing translation is *felicity*. Although this term is less intuitive than fidelity, the idea is that a translation should read like it is an original work which, in some sense, it is. Perhaps a more perspicuous way to characterize the norm is as maintaining that a translation should conceal the fact that it is a translation so that its readers can view it as an independent work

---

[3] Marina Warner (2018) introduces one of the "fundamental quarrels" about translation as that between fidelity and felicity. She goes on to contrast fidelity with re-visioning, thereby creating an alternative dichotomy.

## 24 THOUGHTFUL IMAGES

rather than as the target of a source text. It amounts to what Marina Warner (2018) called a "re-visioning" of the original, an attempt to communicate its essence without necessarily being completely faithful to the letter of the source text.

When this latter norm dominates the norm of fidelity, the translator will make changes in their translation to make it appear more original and coherent. We find Dryden explaining that this is precisely what he did in the Preface to his translation anthology *Sylvae*:

> Where I have taken away some of [the original authors'] Expressions, and cut them shorter, it may be possible on this consideration, that what was beautiful in the Greek or Latin, would not appear so shining in the English. (Dryden, 1685)

Dryden clearly is using the norm of felicity to justify his translations' omission of passages in the source works, their violation of fidelity. He goes on to admit that he has also added to the source texts in a way that conceals what he has done:

> Where I have enlarged them [the original authors' text], I desire the false Criticks would not always think that those thoughts are wholly mine, but that either they are secretly in the Poet, or may be fairly deduc'd from him. (Dryden, 1685)

There can be, I think, no clearer statement of how the norm of felicity can justify modifying the source text to create a work that appears original rather than derivative.

These two norms governing translation, fidelity and felicity, receive justification with reference to the overarching goal of a translation. One reason there can be two competing norms is that the goals for translation are themselves contested. On the one hand, a translation might seek to provide the most accurate rendering in the target language of a text written in the source language. The norm of fidelity clearly derives from such a goal. On the other hand,

one could view the goal of a translation as providing a reader of the target text with as close an experience as possible to what they would have experienced had they been able to understand the source text in its original language. Here, the norm of felicity would come into play as what would enable a reader to have the requisite experience.

How does this discussion of the norms of translation help us in developing our account of text-based illustrations? Like a translation, a text-based illustration is derived from a source text. The difference is that, while the source is a written text as it is in the case of translation, the target is a visual image or object. This means that an illustration, unlike a translation, *transforms* a written text into something visual.

Nonetheless, a text-based illustration is governed, first of all, by the norm of fidelity. Since we are dealing with a transformation of verbal elements into visual or pictorial ones, we need to specify that a text-based illustration exhibits fidelity to a written text just in case all or most of the elements of the text are visually reproduced in the illustration.

To see this, consider the first of John Tenniel's famous illustrations of *Alice in Wonderland*, that of the white rabbit. Tenniel's drawing transforms Lewis Carroll's verbal description of the white rabbit into a visual image or picture in which the central elements of the description are represented (see figure 2.1). Here is Carroll's (Charles Dodgson's) verbal description of the white rabbit:

> Suddenly a white rabbit with pink eyes ran close to her [Alice]....
> When the Rabbit actually *took a watch out of its waist-coat pocket*,
> and looked at it, and then hurried on, Alice started to her feet.
> (Lewis Carroll, 1865, pp. 25–26, emphasis in original)

We learn a number of facts about the white rabbit from Carroll's description of it. It is wearing a waist-coat; it has pink eyes; it possesses a pocket watch; it can tell time; it's in a hurry; etc. These

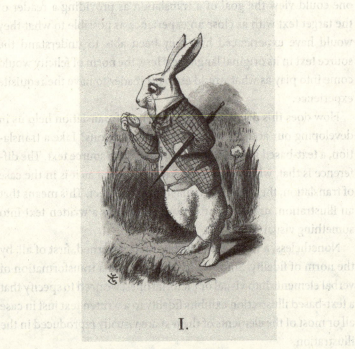

**Figure 2.1** John Tenniel, *The White Rabbit* from *Alice's Adventures in Wonderland*. The British Museum, Cup.410.g.74, I.

are all facts about the white rabbit that are specified by the text. For Tenniel's illustration to be faithful to Carroll's text, his picture needs to include visual elements representing the preponderance of these facts.

And, in fact, when we look at the illustration, we can see that the significant features mentioned in the text—the rabbit, his waistcoat, and the watch—are all rendered visually in the drawing. Each of these important elements in the verbal description has a corresponding visual representation in Tenniel's work.

The text's specification that the rabbit's eyes are pink is different, for this fact can't be represented in a black and white image. But a

## THEORIZING ILLUSTRATION AS AN ARTFORM   27

subsidiary norm derived from the fidelity condition requires that the image not have any features that contradict the fact about the color of the rabbit's eyes that is specified in this text. I call this the *consistency norm*. It states that a successful text-based illustration cannot have visual elements that contradict truths established by the verbal text.[4]

What of the fact that Tenniel's drawing also includes features that are not mentioned in Carroll's text? For example, the rabbit in the drawing is wearing a sport coat, something Carroll does not mention.

The inclusion of such elements points to an important feature of visual images that distinguishes them from verbal descriptions and that shows the limitations of the translation analogy with which our analysis began. A visual image will of necessity include many specific features that a verbal description does not, and indeed cannot, specify. It's not possible to draw a rabbit without showing it having a specific number of whiskers (unless they are blurred); but a verbal description of the same rabbit does not have to specify the number of whiskers that a rabbit has or even mention that feature at all. Visual illustrations must *supplement* the verbal description with features that are not specifically mentioned in the description but that the depicted objects have to have to be recognizable in their visual form, such as the rabbit's whiskers.

We can amplify this point by considering a number of illustrations of Dante's *Inferno*. This epic poem tells the story of Dante's visit to hell, guided initially by Virgil. Each Canto presents Dante's visit to a specific level of the afterlife, where he meets various characters. It is not hard to imagine illustrations for each of these scenes and all of the various characters that Dante encounters during them. And this is what we find in many

---

[4] This claim is similar to the one E. H. Gombrich makes in regard to a drawing of Tivoli: "those who understand the notation will derive no false information from the drawing" (Gombrich, p. 73).

**Figure 2.2** Sandro Botticelli, *The Schismatics*, from *The Inferno* (c.1480–1500). Mount Holyoke College Archives and Special Collections.

illustrations of Dante's masterpiece, for the book has been illustrated by outstanding artists going all the way back to Botticelli (figure 2.2) and including the masterful illustrations of Gustave Doré (figure 2.3), among many others.

Canto XXVIII is one of the most horrific in *The Inferno*. It portrays the punishment of the Schismatics, that is, people who have torn the social fabric in one way or another. Toward the end of Dante's description of all the horrors visited upon the Schismatics—for example, by having their chest and stomach sliced open—the poet encounters Bertram de Bron, who has been decapitated:

> I truly saw, and still I seem to see it,
> A trunk without a head walk in like manner
> As walked the others of the mournful herd.

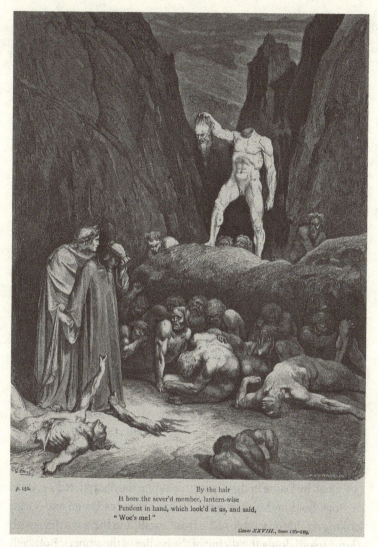

**Figure 2.3** Gustave Doré, *The Schismatics*, from Dante Alighieri's *Inferno* from the Original by Dante Aligheri and Illustrated with the Designs of Gustave Doré (New York: Cassell Publishing Company, 1890). Mount Holyoke College Archives and Special Collections.

## 30 THOUGHTFUL IMAGES

And by the hair it held the head dissevered,
Hung from the hand in fashion of a lantern,
And that upon us gazed and said: "O me!"
It of itself made to itself a lamp,
And they were two in one, and one in two;
How that can be, He knows who so ordains it.
When it was come close to the bridge's foot,
It lifted high its arm with all the head,
To bring more closely unto us its words,
Which were: "Behold now the sore penalty,
Thou, who dost breathing go the dead beholding;
Behold if any be as great as this.
And so that thou may carry news of me,
Know that Bertram de Born am I, the same
Who gave to the Young King the evil comfort.
I made the father and the son rebellious;
Achitophel not more with Absalom
And David did with his accursed goadings.
Because I parted persons so united,
Parted do I now bear my brain, alas!
From its beginning, which is in this trunk.
Thus is observed in me the counterpoise [*contrapasso*].

(Dante, 1867, 118–142)

Botticelli's illustration (figure 2.2) includes all the horrors described by Dante in this Canto, including the decapitated Bertram de Born holding his own head. It also shows us Dante and Virgil looking on this miserable scene from a wall, and there is a devil with a large sword doing the slicing of the bodies of the sinners. Botticelli derives all these details from Dante's text, thereby demonstrating that this image was made in accordance with the fidelity norm.

Doré takes a very different tack in figure 2.3, focusing on the climactic scene in the Canto in which Bertram de Born addresses

Dante and Virgil directly. In a heavily shaded image, de Born's body is remarkable for its whiteness, adding to the dramatic nature of the scene. Dante's horror at what he sees is depicted by his placing his hand upon his bent forehead. While we see others of the Schematics in the picture, Doré's emphasis on de Born is in keeping with the dramatic structure of the Canto and conveys more of its horror than does Botticelli's more inclusive drawing.

Both of these drawings satisfy the fidelity and consistency norms by including elements from Dante's verbal description and not including any features that contradict it. Doré is more selective in what he includes in his illustration, indicating that the fidelity condition does not determine all the artistic choices that an illustrator makes.

Doré's illustration also lets us see the necessity of *supplementation* in a visual illustration. He depicts de Born's severed head as bearded, a feature not mentioned by Dante. The inclusion of a bearded head has artistic precedents, such as Caravaggio's *David with the Head of Goliath* (1610) and Artemisia Gentileschi's *Salome with the Head of John the Baptist* (1610–1615). Doré's picture might have been influenced by these models, although he might also have thought that a bearded head would make more of an impact on viewers than a clean shaven one. But the important point is that illustrators, even when they work with various collaborators, must include many features in their illustrations that go beyond the specific features mentioned in the source text in order to complete the visual image in a compelling fashion. Supplementation is necessary for visual illustrations of written texts.

This brings us to an important constraint on supplementation: the *similarity heuristic*.[5] This heuristic specifies that when there are features included in a visual representation that are

---

[5] Rozen and Numeroff (2002) discuss various cases of similarity and how that leads to judgments of sameness. This is the basis of the similarity heuristic as I employ it.

## 32 THOUGHTFUL IMAGES

not specifically determined by a literary text, then those features must be as similar as possible to those that the object would have in the real world. For example, the text of *Alice in Wonderland* specifies that the white rabbit is able to tell time, although no real rabbit can do that. But since this feature of the white rabbit, though contrary to what rabbits are like in the real world, is specifically mentioned in the work, the fidelity norm specifies that a successful illustration of the white rabbit has to make it clear that he has this ability, and Tenniel's does just that by showing the rabbit looking at his pocket watch. On the other hand, the text does not specify that the rabbit has two long ears, though it does in the illustration. This is because the similarity heuristic requires the illustration to have this feature since real rabbits have two ears and there is no statement in the text that contradicts the rabbit's possession of them.

Illustrators of literary texts will be guided by the similarity heuristic. They must include features in their illustration that go beyond what a text specifies, and this heuristic gives an indication of how to do so. Roughly, where features are not mentioned, the illustration should be based on the real world. That's why Tenniel's rabbit looks, for most intents and purposes, like an actual rabbit, even though there are features of the rabbit that distinguish it from real rabbits, such as its having the ability to tell time and to talk.

We can sum up the results attained so far by saying that a visual image illustrates a literary text when it pictures the central feature(s) mentioned in the source text—the fidelity norm—and has no features that contradict it—the consistency norm. Which features an artist or illustrator includes depend on many different considerations, as the contrast between Botticelli and Doré demonstrates. But the presence of features of an image that can be traced back to the source text is necessary for an image to be an illustration.

It is worth pointing out that there are illustrations of literary works that do not satisfy these norms. For example, the early

THEORIZING ILLUSTRATION AS AN ARTFORM    33

illustrations by Robert Seymour of Dickens's *Pickwick Papers* actually predated the (serialized) novel, and Dickens was hired to write a story for which they could serve as illustrations. Here, the relationship between a text and its illustration(s) is inverted. The visual image actually preceded the text, so that the writer, Dickens, was constrained to write a story for which the visual images could serve as illustrations. This involves an inversion of the fidelity norm, with the verbal text or story, the target, having to be faithful to the images that are its source. But this case is an anomaly. For the most part, it is features of the written text's description that are the source for the illustration.

But what about the norm of felicity? How does a text-based illustration satisfy this norm? When it does so, what happens to the norm of fidelity?

A good example is provided by the illustrations of the Allegory of the Cave discussed in chapter 1. The Allegory is a type of thought experiment. Readers are meant to think about the narrative it presents in order to understand features of Plato's metaphysics in which the things they routinely take to be real, like tables and chairs, are seen to be appearances of a deeper reality, that of the Forms. As a thought experiment, the Allegory creates a type of imaginary world. It specifies a fictional location, the Cave, where prisoners are bound together. It even includes a story, albeit one without many details, about a prisoner who escapes the Cave and then returns to it. All of these features make the Allegory different from a more standard philosophical text that proceeds by stating a thesis and then presenting an argument to support it.

The diagrammatic presentation of the Cave that we looked at in chapter 1 (figure 1.1) is a good example of a text-based illustration of a philosophical work. It illustrates the fictional or hypothetical world that the Allegory creates by showing us the scene that Plato describes. It does not include a lot of realistic details in, say, the representation of the prisoners, including only enough features for us to recognize them as human and living in the situation described

# 34 THOUGHTFUL IMAGES

in the Allegory. This is what makes it a diagram and, as such, its overarching purpose is to help readers envision the Cave that Plato describes verbally.[6]

Although *Antrum Philosophicum* (figure 1.3) is a work of art, like the diagram, it is a text-based illustration. That is, it illustrates a moment in the narrative of the parable Plato tells in Book VII of his *Republic*.[7] We see the tumult that results when the escaped prisoner returns to the Cave and the disbelief with which he is greeted. Here is the source text for the illustration:

> And if he once more had to compete with those perpetual prisoners in forming judgments about those shadows while his vision was still dim, before his eyes had recovered . . . wouldn't he be the source of laughter, and wouldn't it be said of him that he went up and came back with his eyes corrupted, and that it's not even worth trying to go up? And if they were somehow able to get their hands on him and kill the man who attempts to release and lead up wouldn't they kill him? (Plato, 1974, 517a)

Anyone who knows the story of Socrates's persecution by the citizens of Athens will recognize the point of Plato's allegorical story. Rather than embrace the truth, the deluded Cave dwellers prefer their ignorance and are even willing to kill the person offering to enlighten them.[8]

In illustrating this portion of Plato's text, Saendedam's etching seeks to convey to the viewer the emotional reactions the other Cave dwellers have to the liberated prisoner upon his return to the

---

[6] Interesting viewer-readers might consider the contrast between these aspects of the diagram with the painting of the same scene I mentioned in the last chapter, Michiel Coxie's *De grot von Plato*.

[7] In a rather strange article, P. J. Vinken (1960) disputes that the engraving illustrates Plato's Cave. He does point out some discrepancies between the image and the literary description of the cave. I discuss some of them in what follows.

[8] Horst Bredekamp (2018, pp. 18–19) views the group of men on the left as the "experts" who understand the nature of the cave's setup. Plato does not explicitly mention them.

## THEORIZING ILLUSTRATION AS AN ARTFORM    35

Cave. As a result, the aim of the artist is quite different from that in the diagram of the Cave, and this means that he will feel free to reject the norm of fidelity in favor of that of felicity, including and subtracting elements of the text in order to convey the reactions of the cave dwellers more forcefully to viewers.

Contrary to what we see in the Allegory of the Cave, philosophical texts do not generally include stories. Instead, they make claims, present arguments, and develop theories. The question I now turn to is how, if at all, these aspects of philosophy can be rendered visually.

## Concept-based Illustrations

Because philosophy essentially involves abstract ideas, arguments, and theories, the question of how its central features can be illustrated appears more difficult to answer than it was in the case of narrative literary works. In order to understand how illustrating philosophy's abstract concepts is possible, I will introduce the idea of *a concept-based illustration*.

The example I will use to explain this notion comes from Dominic McIver Lopes. In his attempt to elucidate the possibility of evaluating pictures from an ethical point of view, Lopes discusses an illustration of Dante's *Inferno* by Tom Phillips. In presenting his audience with the eternal consequences of immoral behavior, Dante describes specific horrific scenes of the sufferings of various different categories of sinners in his *Inferno*. In making his case, Dante relies on the notion of *contrapasso*, according to which each sin will be punished in a manner specifically befitting it, so that each sinner's suffering takes the form of an allegory of his or her sin.

As we saw earlier, Canto XXVIII concerns the Schismatics, who by rebellion or some similar crime rend the social fabric. Dante tells us that the bodies of the Schismatics are cut open in a sort of metaphorical rendition of their crime, one that subjects their bodies to

36 THOUGHTFUL IMAGES

a rupture analogous to that they have visited upon the social network, and the Canto ends with his only use of the term *contrapasso* in the entire *Inferno*, introduced by Bertram de Born to explain his punishment.

An illustrator of *Inferno* faces an interesting intellectual challenge: Can they illustrate not only the specific scenes of Dante's visits to the different levels of hell—all of which would be text based—but also the concept of *contrapasso* that is part and parcel of Dante's argument for avoiding sin?

Lopes is critical of illustrations of Canto XXVIII like Doré's for simply presenting a gruesome scene of decapitation and bodily mutilation. His worry is that the repulsiveness of the content of such illustrations will keep viewers from understanding the intellectual point of the punishment. According to Lopes, a successful illustration of this Canto needs to devise a way of presenting viewers with a visual analogue of the idea of *contrapasso*.

One problem with Lopes's claim is that he considers only a single illustration of Doré's. In fact, however, Doré illustrated every Canto of Dante's work. The more appropriate question to ask, in my view, would be whether Doré's entire series of illustrations is able to convey the idea of *contrapasso*, though Lopes does not pose this question. That is, even if a single one of Doré's illustration does not capture the idea of *contrapasso*, it might be that the entire set of illustrations does provide a visual representation of that notion. Because Doré pictures the punishments meted out in each Canto, it is certainly plausible to hold that the entire set of illustrations embodies the Dantean notion of *contrapasso*.

Be that as it may, Lopes takes Tom Phillips's illustration of Canto XXVIII (see Plate 1) as a brilliant example of an illustration that captures the idea of *contrapasso*, and I will use this example to help grasp the idea of a concept-based illustration. But before proceeding, we need to acknowledge, as Lopes does not, that there are the four different illustrations of Canto XXVIII in Phillips's book.

THEORIZING ILLUSTRATION AS AN ARTFORM    37

The first (Plate 1) shows a set of interlocking paper figures of the type often made by and with children by folding a piece of paper multiple times and then cutting out a single figure, making sure not to completely sever the connections between the figures. When the piece of paper is opened, multiple identical figures are revealed. In the case of Phillips's illustration, though, many of the figures have been cut, though they all remain joined in a paper chain. Two have slices taken vertically from their genitals upward; three are missing legs; one's head is sliced; one is decapitated and its body is sliced from its neck to its leg; one has multiple slices taken out of its body; and one consists simply of the four limbs, without a head or body. The cutout appears to be made from a piece of white paper, although some of the background color—a deep brownish red, reminiscent of the color of blood—is smeared onto the figures, representing the blood they have shed as a result of their disfigurement. The presence of the background color adds to the work's depiction of the bloody scene described in the Canto.

In the book, this illustration is placed opposite the numeral XXVIII, thus serving as a frontispiece to the entire Canto (Phillips, p. 225). There are three other images, one opposite the translation of each page of the Canto. The first shows three bodies that have been cut apart, as specified in the text, with the feet of a fourth appearing on the bottom right side (Phillips, p. 227). There is also a fragment of text, familiar from Phillips's other works, that shows various words from the Canto but severed from their context: "They . . . now broken . . . rip . . . that break . . . man . . . him." The second is a sort of multicolored checkerboard, with some other images superimposed (Phillips, p. 229). It bears the title "Schism & Skin Game," signifying that we might be looking at a bizarre game based on the Canto. Around the image there is the following text: "THE SKIN GAME: BLACK IS BEAUTIFUL AND WHITE IS SOMEWHAT: FLORENCE BERLIN ULSTER & SOUTH AFRICA: LILY & CITY. PROVINCE & STATE. MANKIND DIVIDED. TIME NOW. CF EVERYWHERE." The final image

# 38 THOUGHTFUL IMAGES

is rendered in black and a slightly pinkish-white. It is the sort of image Lopes has criticized, for it shows Bertram de Born mostly in black, decapitated, holding his head straight up on an outstretched arm, although its abstractness makes is less horrifying than Doré's realistic illustration (Phillips, p. 231).

Given the placement of the first image, it is appropriate to see it as a concept-based illustration rather than one tied to any specific text in this Canto other than the one word, *contrapasso*. In Phillips's own translation, the final sentence of the Canto is "In me the rule of matching retribution [*contrapasso*] is shown" (Phillips, p. 230). It is the rule of *matching retribution* that Phillips illustrates with this image.

How are we to understand Plate 1 as an image of the punishment of the schismatics? Here is Lopes's explanation:

> The schismatics are not mutilated *because* they rend the fabric of society; they are mutilated because to rend the fabric of society just is to rend themselves. Phillips' picture expresses the idea visually. (Lopes, 175)

Lopes first makes a claim about the punishment of the Schismatics. The punishment that they suffer is an analogue to the harm they caused society. It cannot be separated from this harm as the effect of an independent cause. He thinks Phillips has managed to capture this in his illustration, for the only way to break the paper chain is to rend one of the figures that compose it. The paper chain is thus, according to Lopes, a brilliant means of illustrating Dante's claims about the Schismatics and the effect of their crimes on society and themselves.

On this interpretation, Plate 1 is clearly a *concept-based illustration*. The illustration works by creating an analogy between the ripping of the paper chain and the rending of the social fabric as well as a rip in a figure in the chain and the mutilation of a sinner's body. To grasp what the image illustrates, we have to understand that the

THEORIZING ILLUSTRATION AS AN ARTFORM   39

paper chain represents the connections between human beings established by society while also recognizing that the figures within it stand for individual human beings. Because of the analogy that the illustration creates between features of the scene as described by Dante and aspects of the objects depicted in the image, the print succeeds in illustrating the concept of *contrapasso* that Dante mentions in this Canto and that figures as the guiding notion of the entire poem.

The crucial feature of concept-based illustrations that we need to analyze is the role that the norms of fidelity and felicity play in their creation. For an illustration to successfully illustrate an abstract concept or theory, it must represent that idea faithfully. One strategy for so doing is to create an analogy between the image and the concept it is illustrating. This is what Phillips does through the image of a paper chain of mutilated human beings. Because the paper chain symbolizes the Schismatics and their punishment analogically, it is a faithful representation of that concept.

The norm of felicity is also applicable to concept-based illustrations. Because such an illustration requires the creation of a visual image that represents the abstract concept or theory, the norm of felicity applies. It might be helpful to recall that Warner dubbed felicity "re-visioning," which is exactly what such concept-based illustrations have to do to satisfy this norm.

It is worth pointing out that Phillips employs a specific type of concept-based illustration, what I call *an analogical illustration*. I have spelled out the analogy that he uses and a viewer must understand in order to see the illustration as being about *contrapasso*.

Phillips's frontispiece demonstrates that an illustration can illustrate a complex abstract idea by means of an analogy.[9] It helps

---

[9] Jeffrey Strayer pointed out to me that works of art can illustrate abstract ideas other than philosophical ones. One example he gave is Vincent Van Gogh's *On the Threshold of Eternity* (1890) as an illustration of despair. Strayer is right about the possibility of illustrating non-philosophical abstract ideas, although I am here emphasizing how illustrations illustrate abstract *philosophical* ones, a topic I return to in chapter 5.

## 40 THOUGHTFUL IMAGES

us understand why the denial by a skeptic of the possibility of illustrating philosophy that we mentioned in chapter 1 is based on an incomplete understanding of the nature of visual illustration. Once the possibility of concept-based illustration is acknowledged, space is opened up for a wide range of visual illustrations of philosophy.

Concept-based illustrations of philosophy are not text dependent in the way that all the previous examples of illustrations are. This does not mean that they have no relationship to philosophical texts, only that they are not illustrations of specific textual passages. Such illustrations focus on an abstract philosophical notion and attempt to illustrate it. In so doing, they may even make an important contribution to our understanding of the notion itself. This is possible because a visual image follows a different logic from that of a written text, the form that philosophical reflections standardly take. In the following chapters, we will see a number of interesting and complex examples of concept-based illustrations of philosophy.

I conclude this section by pointing out that text-based and concept-based are not mutually exclusive categories. It could be maintained that Phillips's illustration of Canto XXVIII is both text-based—since it illustrates a term in Dante's text, *contrapasso*—and concept-based—since it is illustrating an abstract idea, the suitability of a punishment to a crime. This helps us see why this single image illustrates the entire Canto, for what it shows is how the Schismatics received a punishment suitable to their crime. In so doing, it illustrates an instance of the concept that Dante views as governing the *Inferno* as a whole.

Although I have mentioned a third type of illustration, a theory-based one, I defer discussion of that notion until chapter 5, where I will explain it by means of three examples. For now, I turn to defending the artistic significance of illustrations from claims made by their detractors.

## Overcoming the Denigration of Illustration

There is an important prejudice that dominates thinking and writing about illustration which I term "the denigration of illustration." As this phrase indicates, I believe that the default assumption among philosophers of art and art theorists is that illustration is an inferior artform. The balance of this chapter is devoted to a critique of this assumption.

Discussions of illustration are almost always characterized by the presence of a hierarchical dichotomy. In many cases, illustrators are treated as second- or third-class artists, with the category of first-class visual artist being limited to painters and sculptors. This denigration of illustration has become imbedded, I believe, in the way that people think about illustrations, and it helps to explain why philosophers of art do not take them seriously as artworks.

To see this assumption in operation, I want to focus on a painting that most art historians would be loath to call an illustration: Tiziano Vecelli's (Titian) *The Rape of Europa* (1562) (see Plate 2). The first thing we should note is that there are aspects of this painting that clearly establish it as an illustration. The subject of the painting is a myth—Zeus's rape of Europa—that gives the painting its title. The most famous version of the myth is Ovid's, but we need to be careful in claiming that the painting illustrates Ovid's story, even though it is clear that Titian used it in painting his picture.

The myth of Europa's rape by Zeus existed prior to Ovid's retelling of it, and there are other retellings that alter some of the details. The earliest literary reference to Europa occurs in the *Iliad*, and there is a vase-painting from the mid-seventh century BCE that shows Europa and the bull. Titian's painting clearly illustrates *the myth* of the rape of Europa by Zeus; that it also illustrates Ovid's version of the myth is something over which art historians have disagreed.[10]

---

[10] Eaton (2003, p. 178–179, footnote 3) mentions the different opinions concerning the version of the Europa myth that Titian is attempting to illustrate. Silver (2021, p. 38) mentions Ovid's *Fasti* as well as an ekphrasis of Europa by Achilles Tatius. He claims that

## 42 THOUGHTFUL IMAGES

We can only determine what Titian was trying to illustrate by looking more carefully at Ovid's treatment of the myth. Here is one translation of it:

> Majesty is incompatible truly with love; they cohabit
> Nowhere together. The father and chief of the gods, whose right
>   hand is
> Armed with the triple-forked lightning, who shakes the whole
>   world with a nod, laid
> Dignity down with his scepter, adopting the guise of a bull that
> Mixed with the cattle and lowed as he ambled around the fresh
>   fields, a
> Beautiful animal, colored like snow that no footprint has
>   trodden
> And which no watery south wind has melted. . . . Agenor's
> Daughter was truly amazed that this beautiful bull did not
>   seem to
> Manifest any hostility. Though he was gentle she trembled at
>   first to
> Touch him, but soon she approached him, adorning his muzzle
>   with flowers.
> Then he rejoiced as a lover and, while he looked forward to
>   hoped for
> Pleasures, he slobbered all over her hands, and could hardly
>   postpone the
> Joys that remained. . . . As she gripped one
> Horn in her right hand while clutching the back of the beast
>   with the other,
> Meanwhile her fluttering draperies billowed behind on the sea
>   breeze. (Ovid, 2008, Book II, lines 846–875)

Titian "reconfigured Ovid's terrestrial story as a marine adventure," apparently failing to notice that the final line of Ovid's story—"Meanwhile her fluttering draperies billowed behind on the sea breeze"—locates Europa's abduction taking place near the sea.

## THEORIZING ILLUSTRATION AS AN ARTFORM   43

There are a number of features of Titian's painting that are plainly drawn from Ovid's text and that explain why I think that the painting is a visual illustration of Ovid's retelling of the myth. If we take the painting to be a visual illustration of Ovid's text, then these elements can be seen to conform to the norm of fidelity. But there are other features that are best thought of as deriving from the norm of felicity.

For example, although Europa is portrayed as clutching one of the bull's horns, she does so with her left and not her right hand, as Ovid states she did. Instead of clutching the bull's back with her other hand, Europa holds her "fluttering drapery" with it. This suggests that the painting is not a completely faithful illustration of Ovid's story, though it does not affect the claim that it is an illustration of the myth. The details that are not faithful to Ovid's description can be seen to be in accord with the norm of felicity, which specifies that Titian should not slavishly paint a completely accurate visual representation of his source. These departures from Ovid's description were made in the interests of creating a compelling visual work, and it's clear that Titian succeeded in this aim. It is worth noting that the painting even includes a representation of Ovid's statement that Europa was not afraid of the bull because it was so calm, an oddity in a depiction of a rape, lending credibility to the claim that the painting is an illustration of Ovid's version of the myth.[11]

One reason that art historians may be loath to call this work an illustration is that they consider it a masterpiece. A variety of features of the work are appealed to in order to justify that assessment. Anne Eaton talks of "its subtle modulations of luminous colors and its wide array of palpably sensual textures" (Eaton, p. 159).[12] By emphasizing the texture and feel of the painting, Eaton is pointing

---

[11] There are additional features of this painting that are derived from sources other than Ovid. For this, see Grimal (1991). But these do not show that the painting is not an illustration of Ovid's text.

[12] Eaton argues that the painting's depiction of a rape is an ethical flaw that detracts from its artistic merit.

## 44 THOUGHTFUL IMAGES

to aesthetic features of the work that account for its status as a masterpiece.

The painting is also highly dramatic with a deeply eroticized content. If we just concentrate on the figure of Europa, the lush red-orange of her garment is striking, as are its folds as she is in the process of shedding it.[13] She is captured at a dramatic moment, with her right leg raised and her left one extended, highlighting her vulnerability. Behind her and the bull, there is a rich mountainous landscape that recedes into a beautiful sunset as three putti—the one with a bow appears to be Cupid—watch Europa with their gazes focused on her genitalia. All of this contributes to the striking effect this painting has on viewers and to the erotic nature of this painting that was commissioned for Philip II. Viewers may even feel themselves present during a crucial moment in Europa's rape.

Recent scholars have emphasized that the painting is depicting a rape, arguing that it is important to acknowledge the assumed male viewer who would find Europa's position erotic and exciting. For our purposes, however, we need not discuss that aspect of the work, for the central issue I am addressing is whether this great painting should be considered an illustration.

Many art historians are uncomfortable calling a great painting such as this an illustration. Their hesitancy does not stem from the work's violation of the fidelity norm. Rather, they object to calling a painting as accomplished as this an illustration of a story. We can see this discomfort registered in the description of the painting formerly appended to it on the Gardner Museum website:

> Titian was no mere illustrator of Ovid. Instead, he deliberately sought to compete with him, pitting the resources of painting

---

[13] Cynthia Roe (2005) discusses Europa's pose in great detail, arguing that it is a departure from standard depictions of women during the Renaissance. She emphasizes the pose's eroticism as structured to appeal to a male viewer. But she also says that Europa's non-idealized body is a departure from the standard Renaissance conventions for depicting beautiful women.

against those of the word. The fact that Ovid had described Europa as the subject of a work of art only made this competitive dimension more charged. (Campbell, 2003, pp. 103-07)[14]

Note that Campbell assumes that the painting is derived from Ovid's text. His attempt to distance Titian from what he terms a *mere illustrator* is dependent on the assumption that an illustration is inherently inferior to an accomplished work of art. One reason for this view might be that an illustration is dependent on the story that it illustrates whereas a work of art is thought of as independent.

It is well known that in the *Critique of Judgment*, Kant attributed to works of art the idea of "purposiveness without a purpose." The idea is that we judge a work to be beautiful because it seems designed (for our apprehension of it), but we don't attribute any specific purpose to it. But illustrations do serve a purpose: They render a verbal description in visual terms and strive to do so in a way that makes the description clearer than it was when limited to verbal terms. The standard assumption is that since illustrations have this function, they are less of an artistic achievement than the creation of a genuine work of art, one that has no discernible purpose.

This is what Titian has resisted, at least in Campbell's opinion, by choosing to "compete" with Ovid's description of the myth. Indeed, the assertion is that Titian's painting is no mere illustration precisely because it includes elements that are not in Ovid's story and thus *competes* with the literary description.

Exactly how a painting can compete with a literary work is not at all clear and is not addressed in Campbell's description of *The Rape of Europa*. As I have already pointed out, *any* visual illustration of a written text, by virtue of its visual nature, must

---

[14] In July 2019, I discovered that the Gardner has deleted this passage from its site dedicated to the work.

46 THOUGHTFUL IMAGES

*supplement* a verbal description of a scene with elements that such a description cannot include. For example, the bull has two eyes and a nose. These are not features of the bull that Ovid specifically mentions. But if viewers are to understand that the creature on whom Europa is resting is a bull, then Titian has to include features that allow viewers to identify it as one. These features are justified by the similarity heuristic. The crucial idea is that it is not possible to paint a bull without giving it eyes and a nose. This doesn't amount, however, to "competing" with the literary description but is the result of a necessary supplementation required for a visual work that must include features not mentioned in the text being illustrated.

At this point, the reader might be wondering, "Is he really claiming that *The Rape of Europa* is an illustration of Ovid's poem?" My answer is that I am, but in so doing I do not intend to detract from its status as a great painting. Only if one believes that illustrations are inferior to "genuine" works of art would categorizing a work as an illustration affect our evaluation of it. What is needed is a reevaluation of the term "illustration" and what is entailed by characterizing a visual work as one.

There is no reason to see the creation of an illustration as a lesser achievement than the creation of a painting simply because an illustration is subject to certain specific constraints. Indeed, making a beautiful object—if I am allowed to speak in this possibly anachronistic manner about works of art—when one is subjected to a set of constraints seems more difficult than making a beautiful object without having faced any constraint. From this point of view, a successful illustration can be seen as an even more difficult achievement than the creation of a more standard painting or other work of art.

I realize that what I am here claiming about illustration as an artform will strike some readers as indicating my inability to understand the nature of great paintings. Works such as *The Rape of*

*Europa*, it might be claimed, transcend their origins as illustrations as they become independent works of art.

I simply do not see any justification for such a claim. Titian's work is certainly a wonderful painting (despite the problem of its sexist depiction of a rape as erotic), but that does not entail that it is not an illustration. Instead, we can see how its adherence to the norm of felicity allows it to rise above more routine renditions of the myth and achieve artistic greatness. Treating it as an illustration not only does not devalue the work but can even increase our understanding of many of its features, as when we trace them to the norms of fidelity and felicity. Deconstructing the "work of art/illustration" dichotomy does not result in the denigration of great art but may even increase a viewer's appreciation of what goes into its creation.

As well as playing a role in attempts to elevate the work of an artist like Titian, the denigration of illustration can also be seen to be operative in an effort to promote the reputation of one of America's greatest illustrators, Norman Rockwell. For all of his career, Rockwell was an illustrator. He is most famously associated with the 323 covers he made for the *Saturday Evening Post*. But Rockwell is not generally relegated to the category of a "mere" illustrator. Many critics regard him as an artist, with the *Saturday Evening Post* even claiming that he was "considered by many to be the greatest American artist of all time."[15]

This hyperbole by the magazine that published Rockwell's covers is perhaps excusable, but the same cannot be said when it is found in the *New Yorker*. In his review of Deborah Solomon's biography of Rockwell, *American Master*, Peter Schjeldahl employs the same trope to elevate Rockwell into the realm of artist: "Rockwell was no mere illustrator, though—modest to a fault, he staked no larger claim" (2013). Schjeldahl attributes Rockwell's status as an illustrator not

---

[15] http://www.saturdayeveningpost.com/artists-gallery/saturday-evening-post-cover-artists/norman-rockwell-gallery/norman-rockwell-biography#sthash.fTemb G4M.dpuf.

## 48  THOUGHTFUL IMAGES

to the actual works he produced, e.g., the 323 illustrations for the cover of the *Saturday Evening Post*, but to his great humility. Are there no modest painters and sculptors?

I don't share these writers' interest in elevating Rockwell into the pantheon of great artists. My concern is that their assessment of Rockwell is taken to require denigrating illustrators by appending to them the modifier *mere*—as if being an illustrator were inherently an inferior profession to that of being a fine artist.

There is one fact that may account for the desire to treat Rockwell as an artist rather than an illustrator. Unlike most illustrators, Rockwell actually created paintings rather than drawings or etchings and the *Saturday Evening Post* covers were based on those paintings. Consider what are among Rockwell's most famous covers: *The Four Freedoms*. These are four paintings that all measure approximately 46 inches x 36 inches, much larger than the size of the magazine whose covers they graced. Rockwell did not originally intend these works for the *Saturday Evening Post* but for the Office of War Information, which was to use the paintings to raise funds for supporting the war effort during World War II. When the Office of War Information rejected his offer despite its being offered gratis, Rockwell was told that for this war they wanted to use the work of "real artists" (Solomon, 203). On his return trip to Vermont, Rockwell showed his sketches to the editor of the *Saturday Evening Post* who immediately commissioned the four covers we now know. The four paintings were published in the *Post* on February 20, February 27, March 6, and March 13, 1943.

These paintings are illustrations of the four freedoms enumerated by Franklin Delano Roosevelt in his 1941 State of the Union Address: the freedoms of speech and worship, and the freedoms from want and fear. Here is how President Roosevelt described them:

> In the future days, which we seek to make secure, we look forward to a world founded upon four essential human freedoms.

# THEORIZING ILLUSTRATION AS AN ARTFORM 49

The first is freedom of speech and expression—everywhere in the world. The second is freedom of every person to worship God in his own way—everywhere in the world. The third is freedom from want—which, translated into world terms, means economic understandings which will secure to every nation a healthy peacetime life for its inhabitants—everywhere in the world. The fourth is freedom from fear—which, translated into world terms, means a world-wide reduction of armaments to such a point and in such a thorough fashion that no nation will be in a position to commit an act of physical aggression against any neighbor—anywhere in the world. (Roosevelt, 1941)

Although FDR's specification of the four freedoms entails that Rockwell's illustrations are text-based, the brevity of some of his descriptions suggests that any illustration of them would also be concept-based.

Rockwell had to envision scenes that could plausibly be interpreted as illustrating each of the four freedoms. In so doing, he followed the general strategy he used in creating illustrations that he characterized as follows:

Many illustrators of fiction look through a story to find the most dominant or dramatic incident and illustrate that. I prefer to discover the atmosphere of a story—the feeling behind it—and then to express this basic quality. (Perry, 2015)

As he explains, Rockwell developed images that illustrated the essence of each of the four freedoms that FDR described. In so doing, he was tacitly applying the norm of felicity to his art, saying that the crucial thing was to get to the feeling behind the work rather than being faithful to every detail.

Incidentally, Rockwell's claim that he tries to paint the "feeling behind" a story rather than its most significant moment helps us understand why an illustration might depart from the description

# 50 THOUGHTFUL IMAGES

of the incident or scene it illustrates in contradiction to the norm of fidelity. If an illustrator is aiming at depicting the "atmosphere" of a story—thereby honoring the norm of felicity—they would likely not be as concerned in faithfully rendering every element of the story in the work. Of course, the Four Freedoms enunciated by FDR are not a story but abstract concepts.

*Freedom of Speech* is generally regarded as the best of the four pictures. Given the terseness of FDR's description, Rockwell had a great deal of leeway in choosing an image with which to illustrate it. The setting he chose is a large room, though we see almost none of it except for a large dark expanse in the background, perhaps a blackboard. A group of people are sitting in the room in pews, indicating that it is likely a church. The two men we see most clearly are wearing suits and ties. They are both focused on a man who is standing and speaking. From his dress—a worn and faded leather jacket and a plaid shirt—and his worn, dirty hands, we recognize him as a member of the working class. He has a folded document in the pocket of his jacket and we can make out the words "report" and "town" on a copy of the report that one of the other men is holding. This suggests that we are witnessing a traditional New England town meeting, one of the last traces of genuine democracy in the United States.

Rockwell wants us to see that in the best tradition of a democratic society, anyone can speak and be listened to by others regardless of their class. (Rockwell has been faulted for portraying only white people, though he later did make memorable covers featuring African Americans, such as *The Problem We All Live With* that graced the January 14, 1964, centerfold of *Look*.) The rapt attention the two well-dressed older men pay to this working-class man provides a visual rendering of the idea that all people are created equal and have an equal right to express their beliefs.

The point of invoking Rockwell is to undermine the idea that paintings are essentially superior to illustrations—indeed, to demonstrate that, as in the case of the Titian painting, the same work

THEORIZING ILLUSTRATION AS AN ARTFORM    51

can be both a painting and an illustration. Rockwell's image is a very effective honoring of the tradition of free speech. The fact that it is an illustration does not detract from its achievement.

In pairing Titian and Rockwell, I am not putting them on a par as artists. Rockwell's sentimentality is clearly a flaw, but so is Titian's sexism. That the latter is the greater artist does not mean that illustration is inherently an inferior artform, for, as I have pointed out, Titian himself is both a skilled painter and an illustrator.

Perhaps part of the problem is the failure to recognize that the distinction between painting and illustration is not a mutually exclusive one. The same work can be both, as I have argued is the case with *The Rape of Europa*. It is a great, albeit flawed, oil painting while also an illustration of Ovid's poem. Perhaps, recognizing the fluidity of this distinction among artforms will help restore illustration to its rightful place among the fine arts.

# 3
# Pre-Modern Illustrations of Philosophy

This chapter begins my exploration of the long tradition of visual illustrations of Western philosophy. The tradition extends back to Ancient Greece and Rome and continues to the present. The manner in which philosophy has been illustrated has changed with the introduction of different technologies for reproducing images and altering historical contexts.

In this chapter, I explore a number of different ways in which philosophy was illustrated prior to the Modern Age. My aim is not to provide a complete catalogue of such illustrations but rather to explore the development of such illustrations during this time period. For my purposes, the Modern Age begins around 1650. I will examine how illustrations developed prior to that time.

## Greek and Roman Illustrations

If ones includes images of philosophers as well as of their theories, there is a long history of visual illustrations of philosophy.[1] There are many Greek and Roman busts of famous philosophers, such as Socrates, Plato, and Aristotle. A bust of a philosopher like Socrates does not tell us much about the content of Socrates's philosophical

---

[1] Anthony Kenny's *The Oxford Illustrated History of Philosophy* (1994) is filled with pictures of philosophers, as I mentioned in the first chapter.

*Thoughtful Images.* Thomas E. Wartenberg, Oxford University Press. © Oxford University Press 2023.
DOI: 10.1093/oso/9780197650547.003.0003

PRE-MODERN ILLUSTRATIONS OF PHILOSOPHY 53

theories, even if it does give us a sense of what he was supposed to have looked like. This explains why, for example, a snub nose is featured in busts purporting to be of him, for his nose was one of Socrates's distinguishing physical traits.

What a portrait of a philosopher can contribute to our understanding of his works is an interesting question. In general, there is no obvious connection between a person's visual appearance and their character or intellect, so just showing an audience what a philosopher looked like does not provide any insight into their ideas or theories. So, even though there are busts of most of the famous Greek philosophers, these do not provide a great deal of information about them—other than what they looked like, at least hypothetically—or their theories.

There were, of course, other artforms in Ancient Greece. Among the most well known is pottery. Vases were often adorned with scenes, some of which represented the drinking parties known as symposia at which philosophy was discussed. Plato's dialogue *Symposium* (1989) presents a vivid picture of the activities that took place at such gatherings, which included a great deal of eating and drinking as well as philosophical discussions. Vases were painted with scene depicting the philosophical discussions that took place at such gatherings.

More content is added to the illustrations of philosophy in the Ancient World when we move to Ancient Rome. In particular, the widespread use of mosaics resulted in more complex representations of philosophers and philosophy. Figure 3.1 presents a Roman mosaic from the first century BCE that came from a house in Pompeii and is now in the National Museum of Archaeology in Naples. This finely detailed mosaic shows seven men gathered in what appears to be a room of a Roman villa that is represented by columns. The lovely scene is depicted with an attempt at perspective, creating a spatial recession. Although the identification of the men cannot be established with certainty, it has been conjectured that the third man from the left is Plato

54 THOUGHTFUL IMAGES

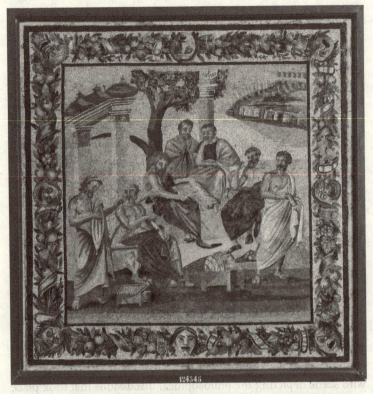

**Figure 3.1** Mosaic of Plato's Academy (from Pompeii), 1st century BCE. Museo Archeologico Nazionale di Napoli, Inv. 124545.

because of the color of his toga and the fact that he is speaking and pointing. If this is so, the scene represents him discussing philosophy with the six other men shown in the mosaic. The poses of the men tell us something about Plato's practice of philosophizing. First, the second man from the left, who appears to be holding a tablet in his hands, listens to the first figure to his right. The other five men, one of whom is shown in the characteristic philosopher's pose of stroking one's beard while reflecting on what is being said, are all looking at the two leftmost figures,

# PRE-MODERN ILLUSTRATIONS OF PHILOSOPHY  55

again representing how learning took place in the Academy. The mosaic is notable for the naturalism of its depiction of the men's bodies and their garments. This is most apparent in the rightmost figure, for we see him represented with his head turned slightly to his right and his right leg bent, causing a slight shift in the folds of his toga. The figures other than Plato have been thought to be other Greek philosophers, including Thales, Anaxagoras, Pythagoras, Xenophanes, and Democritus. However, such identification is not certain.[2]

This mosaic provides some evidence about how philosophy was practiced in Ancient Greece (and Rome). Although it may present an idealized view of Plato's school, the mosaic suggests that philosophy was pursued in small groups of men under the tutelage of an acknowledged master, Plato in this case. In this respect, it accords with the sense we get of Plato's practice from his *Dialogues*. One feature of that practice is an emphasis on philosophy taking place through face-to-face conversation rather than via written texts, and the mosaic represents just such a philosophical discussion. Even though it does not tell us a great deal about what took place in Plato's Academy, the mosaic does illustrate this feature of the practice of philosophy at that time. As such, this artform is able to tell us more about nature of philosophical practice than the busts of philosophers from Ancient Greece. Because it is not tied to any specific philosophical text but is faithful to the manner in which Plato's *Dialogues* present his practice of philosophizing, I would classify it as a concept-based illustration.

This mosaic is a fine example of how philosophy was illustrated in Ancient Rome. There are other instances of philosophers depicted in mosaics and also on pottery. However, the range of

---

[2] For an interesting discussion of different identifications of the figures, see Katherine Joplin.

## 56 THOUGHTFUL IMAGES

philosophical ideas and theories that could be represented in this manner is quite limited, since the illustrations depict human bodies engaged in philosophizing rather than the abstract claims made by philosophers.

## Illuminated Manuscripts

The next artform that contains illustrations of philosophy is the illuminated manuscript. From antiquity until the fifteenth century when printing began to replace hand-lettered manuscripts, illuminated manuscripts were an important artform.

In order to preserve important works—literary, religious, scientific, and philosophical—manuscripts had to be copied by hand. The copying was generally done by monks, and the manuscripts they created were housed in the libraries of their monasteries. The illuminations, as the illustrations that graced these manuscripts were called, were done to emphasize the value of the works being copied. Although many of the illuminations were simply fancy designs of, for example, the first letter of a chapter, many manuscripts also contain a variety of pictures. Because each of the works was done by hand, they are unique works of art.

Beginning in the twelfth century, with the growth of cities, the secular production of texts increased. This was also due in part to the growth of universities, for the manuscripts were used by students and professors in their teaching. Since philosophy was one of the subjects taught in medieval universities, it makes sense that there would be secular manuscripts produced to be used by members of the academic community. In addition, some manuscripts were produced for royalty who stored them in libraries in their palaces where they could consult them for advice about ruling. These manuscripts were also read by advisors to the rulers to gain knowledge about how to rule.

PRE-MODERN ILLUSTRATIONS OF PHILOSOPHY 57

**Figure 3.2** *Plato's "Timaeus"* (twelfth century). MS Digby 23, fol. 52v, Bodleian Library, University of Oxford.

A first example of an illustration of philosophy from that time period is from an illuminated manuscript of Plato's *Timaeus*, a work that describes the structure of the world (see figure 3.2). The illustration is a presentation of the structure of the universe. This is

## 58 THOUGHTFUL IMAGES

clearest in the central figure, where we can see the ocean on which the earth is floating and all the rest of the heavens, represented just as Plato describes them in his dialogue, *Timaeus*. This visual representation of Plato's description is a text-based illustration that helps readers understand the complex structure of the world as Plato describes it in the dialogue.

This illustration is the first we have seen that makes use of text as well as images. The text here does not appear to be a quotation from the *Timaeus*, but rather serves to identify different elements in the image that correspond to Plato's description of the world. These linguistic items function to demonstrate the fidelity of the drawing to the manner in which Plato characterizes the structure of the universe. Text occurs in illustrations of philosophy quite frequently as we shall see, although the function of the text will vary.

A philosophically and artistically more complex and interesting set of illustrations is found in a fourteenth-century French manuscript translation of Aristotle's *Nicomachean Ethics* and *Politics*. These translations were based on the existing Latin translations of Aristotle but were needed to bring Aristotle's ideas to a broader readership. Illustrated editions of translations of the *Nicomachean Ethics* and *Politics* were produced at the request of Charles V of France in the 1370s with translations by Nicole Oresme, a French philosopher.[3] Charles was a well-known bibliophile, but the editions he commissioned for his library served a practical a well as a decorative function.

Charles had a council of some two hundred advisors made up of members of the nobility and upper ranks of the bourgeoisie. He wanted the council members to use Aristotle's ideas to improve their ability to govern (see Grant, 1997, p. 189). Because Charles's advisors were generally not sufficiently proficient in Latin to be able

---

[3] Oresme also produced a translation of a work on economics mistakenly attributed to Aristotle at that time. Sherman's *Imaging Aristotle* focuses on Oresme's manuscripts. It is a very detailed and highly informative study of their illustrations and includes many reproductions of them.

PRE-MODERN ILLUSTRATIONS OF PHILOSOPHY  59

to read the existing translations of Aristotle, these new translations were intended to acquaint them with Aristotle's ideas and demonstrate their relevance to the contemporary political situation in France.

Artistically, the illustrations of the French editions of Aristotle are quite innovative, because they attempt to illustrate aspects of a philosophical theory rather than the philosopher(s) who developed it.[4] Latin translations of Aristotle from that time period had only the more traditional illuminations of the initial letters of a chapter, perhaps because these manuscripts functioned as university textbooks. The rich illustrations in the French translations had an educative as well as an aesthetic function. Oresme had to introduce new words into the French language in order to translate Aristotle's philosophical terminology, because French, unlike Latin, had a limited vocabulary of such terms. (The vernacular was just coming into widespread use.) As a result, it was imperative that a means be found to help readers understand what these newly introduced terms signified. In addition to textual explanations, Oresme supervised the illumination of terms such as "virtue" for which a French equivalent was lacking. The illustrations functioned as what Claire Richter Sherman calls "visual definitions of subjects and unfamiliar terminology" in Aristotle's texts (Sherman, 1977, pp. 323–324). Because these illustrations occur at the top of a page of Aristotle's text discussing the relevant concepts, they are examples of text-based illustrations despite the fact that they illustrate key concepts in Aristotle's theory.

To provide what Sherman calls "visual definitions," the illustrations adopt a strategy of *personification* of abstract philosophical terms, thereby pioneering an important and innovative strategy for illustrating philosophy. It is not difficult to see how an illustration employs this strategy in order to provide visual

---

[4] There are a number of different versions of these illustrations. See Sherman (1995) for a discussion of the differences between different versions of the illustrations.

60   THOUGHTFUL IMAGES

representations of certain concepts in ethics. In Plate 3, we see the top half of a page of Oresme's translation of the *Nicomachean Ethics* that shows the three types of friendship that Aristotle describes in his treatise. The image shows three pairs of men engaged in conversation in front of a walled building with a large building behind it and a simple landscape with birds, the ocean, and a walled city in the background. The image uses bright colors and contrasts the bright blues with the orange of the bricks along with other colors.

Each pair of men represents one of the three types of friendship that Aristotle discusses. The first type of friendship is that of *utility*: "Those who love each other for utility," Aristotle says, "love the other not in himself, but in so far as they gain some good for themselves from him" (Aristotle, 1156a11–12). Aristotle goes on to characterize a second form of friendship, that of *pleasure*: "The same is true of those who love for pleasure; for they like a witty person not because of his character, but because he is pleasant to themselves" (Aristotle, 1156a12–14). Finally, Aristotle distinguishes those two forms of friendship from what he calls *complete* friendship: "But complete friendship is the friendship of good people similar in virtue; for they wish goods in the same way to each other in so far as they are good, and they are good in themselves" (Aristotle, 1156b6–9).[5] We do not need to go into the details of Aristotle's influential account of friendship since we are only interested in how these forms of friendship are represented in the images in Oresme's texts.

The two priests shown on the right exemplify a complete friendship. Since this type of friendship exists only between two good people, according to Aristotle, it makes sense to use priests to illustrate it, since it was widely assumed that priests were ethical people. They are shown engaged in conversation, each with their right arm raised and both wearing identical outfits, a simple white gown with a black robe over the gown.

---

[5] Alexander Nehamas claims that the first two types of friendship are not really friendships at all. See his *On Friendship* (2016, p. 24).

# PRE-MODERN ILLUSTRATIONS OF PHILOSOPHY 61

The pair in the middle exemplify a friendship of utility, one based on mutual benefit according to Aristotle. They are shown wearing fine robes, one reddish and one blue, with elaborate head coverings. They stand before a table covered in a green cloth on which there are two manuscripts and two other objects. The men seem to have prepared these objects for sale and thus have a relationship based on mutual benefit or the profit they will reap from selling the items on the table.

The final type of friendship, one formed for the pleasure it brings, is represented by the pair on the left, who are shown wearing more informal clothes than the others, including stylish pointed shoes. They are depicted proceeding arm and arm, as if making their way through the city. One of them holds a short sword. They both wear three-cornered hats. All of these features suggest that they are out to enjoy themselves and that this desire for pleasure is the basis of their friendship.

This picture is a good example of the use of personification to illustrate philosophical concepts. To illustrate the three types of friendship, the artist has used three different pairs of men, with each pair exemplifying a different type of friendship. These forms of friendship can be identified by the viewer's understanding of the nature of the relationship between the depicted individuals, thereby using personification to present a pictorial image that represents a specific form of human relationship. This visual representation of Aristotle's theoretical typology is designed to help readers of the translation understand and remember the three types of friendship Aristotelian theory distinguishes.

This manuscript contains many other interesting illustrations of Aristotle's ethical theory. Because Charles V was the primary audience for the translations, there was a natural emphasis on Aristotle's political writings and, in particular, on the nature of justice as the illustration shown in Plate 4 demonstrates. To illustrate the three types of justice that Aristotle distinguishes, the illustration uses three panels. In each panel, there are banners with writing

62  THOUGHTFUL IMAGES

on them that help identify what each person depicted in the panel represents.

The largest panel at the top depicts legal or universal justice. Aristotle says "what we call just is whatever produces and maintains happiness and its parts for a political community" (Aristotle, 1129b17–19). The unknown artist illustrates this form of justice with the image of a woman wearing a crown; she is dressed in a large red robe that she holds open to shelter six figures. Four figures represent derivative types of justice: fortitude, individual justice, gentleness, and conciliation. There are also two unnamed figures whose significance is not clear.

This is another example of the use of personification to represent an abstract philosophical concept. Universal justice is the overarching concept of justice from which all the more specific forms are derived. This is shown visually by representing each form of justice as a person wearing a brightly colored gown. The figure standing for universal justice wears a cape or shawl that she uses to enclose all the other figures, thereby using her sheltering gesture to pictorially represent the logical relationship between the different forms of justice.

The two lower panels also involve personifications of Aristotle's concepts of justice. On the left, distributive justice is depicted as a woman in a red dress with a white head covering standing in front of a table laden with food and drink. A group of individuals stand to her right, each bearing one of the products from the table. The woman is the personification of distributive justice, a fact indicated by the manner in which the goods she possesses are given to the others.

On the right side of the lower panel, the artist shows rectificatory or compensatory justice through picturing the righting of a wrong. This type of justice is called for when a crime or some other wrong has been committed. The victim of this type of injustice must be fairly compensated. The woman, wearing the same hooded robe as

PRE-MODERN ILLUSTRATIONS OF PHILOSOPHY    63

in the left-hand panel, holds the hands of the two parties to the dispute she is mediating. Behind her on the wall are a scale, a whip, and stocks. These are the tools of compensation that could be used to rectify a wrong. The scale indicates the need to reestablish a just distribution of goods while the other two objects are means of punishing a recalcitrant wrongdoer.

Again, because the illustration forms the top half of a page in which Aristotle discusses the nature of justice, it is text-based; it could be argued that it is also concept-based, since it includes images that illustrate key concepts in Aristotle's theory. The central means it uses to present Aristotle's abstract concepts is personification, for all the images in the illustration feature individuals who represent aspects of justice.

These two examples indicate the importance of illuminated manuscripts in the development of illustrations of philosophy. Elements of a philosophical work could be made more accessible and also memorable to readers of a text by including illustrations of its key ideas. The personification of the different terms that Aristotle uses in his theories and the use of symbols provide readers with concrete examples of Aristotle's abstract philosophical claims. This was particularly important when the French words used to translate Aristotle's Greek were newly introduced.

The illustrations that grace Oresme's translations thus helped lay readers understand the difficult theoretical concepts that Aristotle employs in his theory. Not only are they beautiful works of art, but they introduced Aristotle's claims to Charles and his court in a manner that was more memorable than Aristotle's dry prose.

These works use visual images to illustrate Aristotle's theory. They are tied to different theories that Aristotle presents in the *Nicomachean Ethics* and *Politics*. Some of the images contain text to help reader-viewers identify the concept the image illustrates, just as in the image from the *Timaeus*. The words help viewer-readers identify the various figures within the images as,

## 64 THOUGHTFUL IMAGES

for example, representations of different types of justice.[6] The distinction we drew earlier between fidelity and felicity can be used to characterize these illustrations. While they are faithful to Aristotle's theory, and hence conform to the norm of fidelity, their use of personification is definitely in accordance with the norm of felicity, for it is a creative invention of the unknown artist(s).

## Illustrating Aristotle's Logic and Metaphysics

The invention of printing and the discovery of movable type were technological innovations that radically altered the nature of illustration. Printing and printed books first appeared during the fifteenth century, with Gutenberg's "invention" of movable type occurring around 1450 and his famous *Bible* printed in 1455.[7]

These inventions had a profound effect on the nature of illustrations of philosophy. Whereas the illustrations in illuminated manuscripts were hand painted, those in printed books were printed. In the earliest examples—we already saw one example in Sandro Botticelli's illustrations of *The Inferno* (see figure 2.2)— the images were printed separately and had to be pasted into the printed text in the blank spaces specifically left for them. Eventually, techniques for simultaneous printing of text and images were perfected and the images were printed as part of the production of books.

The most important feature of printed books for our purposes is that multiple, less expensive copies of books could be produced,

---

[6] For an interesting survey of medieval illustrations, most of which were not specifically philosophical, see Evans. He introduces the term "diagrammatic representation" to distinguish these illustrations from pictorial ones.

[7] Gutenberg did not actually invent movable type. The Chinese had already done so in the first half of the eleventh century (http://afe.easia.columbia.edu/songdynasty-mod ule/tech-printing.html). Gutenberg did introduce this technology to Europe.

PRE-MODERN ILLUSTRATIONS OF PHILOSOPHY 65

making them available to a much wider readership.[8] Since prints could be made using this new technology, they could be disseminated more widely than individual works of art, such as the illuminations gracing medieval manuscripts. Printed illustrations were thus much more accessible than those in manuscripts housed in collections seen by only a limited circle of religious figures, royalty, and advisors to the court.

Because they were replete with visually suggestive myths and images, the Platonic *Dialogues* provided artists during the Renaissance with subjects for illustration. Among the myths that were illustrated with some frequency were the androgyne original beings that Aristophanes describes in the *Symposium*, Alcibiades's entrance as described in the *Symposium*, and the *Phaedrus*'s description of the soul as a charioteer controlling two unruly steeds. All of these tropes were presented as pictorial illustrations by Renaissance artists.[9] I have already discussed one similar image in the previous two chapters, *Antrum Platonicum* (see figure 1.3). Based on the Allegory of the Cave from *The Republic*, it is a text-based pictorial illustration. Neither this engraving nor any of the other illustrations of Platonic works, however, embodies a new relationship between the visual image and the philosophical text it illustrates.

Such is not the case with a remarkable set of illustrations of Aristotle's philosophy from the seventeenth century. One consequence of the new print technology was that some illustrations of philosophy, because they were printed in inexpensive forms, were affordable for students. As a result, these illustrations were created to serve a pedagogical function. They could be used by students to help them understand and remember the difficult philosophical texts they needed to master during their studies.

---

[8] Although most prints were widely distributed, David Freedberg (1980, p. 22) points out that some, such as those of Rembrandt and Hercules Segers, were not since each version was altered for artistic reasons.

[9] For a discussion of these illustrations of Plato, see McGrath.

## 66    THOUGHTFUL IMAGES

Between 1614 and 1618, with the assistance of the engraver Leonard Gaultier, a Franciscan professor of philosophy named Martin Meurisse created four large engravings that are visual representations of philosophy. The first, I will refer to it as *Descriptio*, is entitled *Artificiosa totius logices descriptio* (*Artful description of logic in its entirety*), and measures 22.4 x 11.4 inches (figure 3.3). Their second effort came the following year and is entitled *Clara totius physiologiae synopsis* (*Clear synopsis of physics in its entirety*) (figure 3.4). I will refer to this engraving as *Synopsis*. In 1616, the philosopher and engraver produced *Laurus metaphysica* (*Laurel of metaphysics*), and then in 1618 *Tableau industrieux de toute la philosophie morale* (*Artful table of moral philosophy in its entirety*) appeared. In addition, the *Descriptio* inspired another thesis print, *Typus necessitatis logicae ad alias scientias capessendas* (*Scheme of the necessity of logic for grasping other branches of knowledge*) that was also engraved by Gaultier although this engraving was designed by Jean Chéron, a Carmelite professor of philosophy.

As Susanna Berger notes in her groundbreaking study of these images (2017), they were only the most impressive of a variety of different forms in which illustrations of philosophical texts were produced and used during this time period. These different modes of illustration include "student lecture notebooks, *alba amicorum* (friendship albums), printed books, and broadsides" (Berger, 2017, p. 3).

The broadsides and other works derived from them were part of the culture of philosophical education in early modern Europe and functioned as useful tools in the preparation of students for their formal examinations or disputations. The broadsides were thus doubly removed from the idea of independent works of art. First, they were illustrations of Aristotle's philosophy; second, they were intended for students to use in preparing for their examinations. Given both of these factors, it is clear that the works had to satisfy the norm of fidelity, for students would have to use them to explain Aristotle's ideas during their examinations.

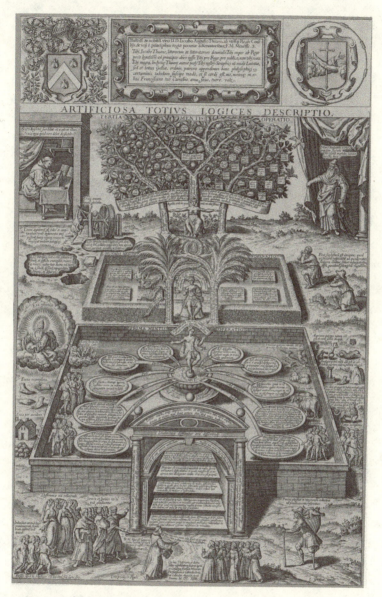

**Figure 3.3** Léonard Gaultier, *Artificiosa totius logices descriptio* (1614). Copyright KBR-Prints-S.IV 86231.

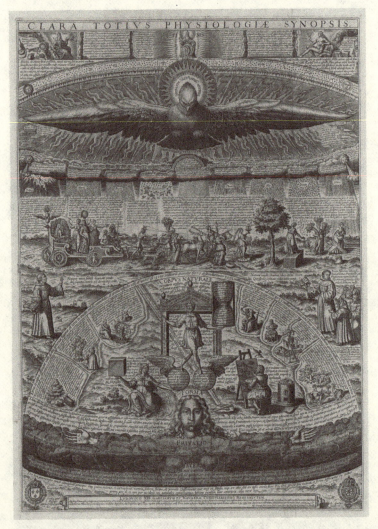

**Figure 3.4** Léonard Gaultier, *Clara totius physiologiae synopsis* (1615). Copyright KBR-Prints-S.IV 86229.

But, as I shall show, they also adhere to the norm of felicity in that they introduce a new metaphor that helps one grasp the complex interrelations among Aristotle's key ideas: Aristotelian logic as a garden.

It is difficult to convey how stunning these engravings of Aristotle's philosophy are. They are complex works that combine words and images in an attempt to render philosophical ideas visually. Berger calls them "plural images" to emphasize that the unity they exhibit is primarily conceptual rather than visual, so that a viewer's awareness of this unity only emerges through a careful viewing and interpretation of them. It is not something that would strike the casual viewer who just glances at them. It is worth pointing out, to the contrary, that there are elements of the images that do serve to provide visual unifications of the depicted material.

Consider, for example, the *Descriptio* print, figure 3.3. *Descriptio* is an analogical illustration, with a garden employed to graphically depict the different elements of Aristotelian logic and their relationship to one another. Using a garden in this way is an interesting choice. Formal gardens modeled on their Italian counterparts were introduced into France during the sixteenth century, after Charles VIII returned from a military campaign in Italy. These gardens, which departed from their medieval predecessors, were a recent development when the prints were made and thus would have attracted a great deal of attention. Meurisse's students would presumably have been familiar with such gardens, so their use in the broadside would have taken something well known to them and used it to help them understand a novel intellectual field they were attempting to master. The garden also gives the image visual unity. That is, the garden is a pictorial element that unifies all the diverse elements in the broadside into a single imaginary scene.

As its title indicates, this broadside presents all of Aristotelian logic in a single image. But the image itself is incredibly complex, with two walled spaces or gardens surrounded by a variety of different figures and a large multi-trunked tree at the top being revealed by a bearded figure on the right, Aristotle, carrying a book. On the left top, the medieval philosopher John Duns Scotus is portrayed sitting at a table writing. The idea that the presence of these two philosophers represents is that logic is a discipline first

70  THOUGHTFUL IMAGES

developed by Aristotle but then elucidated by Duns Scotus for later generations.

The architectural features shown in the etching stand for the different operations of the mind and they are presented sequentially in the different segments of the image. Each of these distinct mental operations is necessary for knowledge. The etching begins with a representation of the acquisition of concepts in the first stage, moves on to a depiction in the second of the formation of propositions that employ the terms acquired in the first before finally, in the third stage, showing the combination of propositions into syllogisms, the ultimate content of logic.

A plural image dictates to the viewer an appropriate sequence for understanding it. This sequence, determined by the conceptual relationships between the different parts, shows how the image, despite its multiple features, is unified. The unity is conceptual, requiring viewers to understand how the different elements of this very complex image are related to one another.

In her study, Berger claims that these engravings "feature rich visual commentaries that offer new interpretations of Aristotle's age-old system" (Berger, 2017, p. 109). One example she provides is how the *Descriptio* presents the creation of a proposition. In the middle of the engraving, two palm trees are shown with their branches entwined. Palm trees are dioecious, i.e., their male and female flowers grow on different plants. At the time, it was thought that Palm trees reproduce by intertwining the branches of different sexed trees. The engraving includes, among a vast amount of writing, labels of the trunks of the two trees as "noun" and "verb," in addition to giving further descriptions of their logical function. Furthermore, the two intertwined trees are shown producing a new type of entity, a piece of fruit, which is the analogue of a proposition formed from two parts of speech. This creates a visual and biological analogy to the formation of propositions. Berger contends that this image represents an

PRE-MODERN ILLUSTRATIONS OF PHILOSOPHY 71

advance over the typical textbook of the time, which defined a proposition as the sum of its two parts—noun and verb; the image shows that a proposition is a new unity created out of the two distinct parts, thereby advancing a new understanding of the nature of a proposition.

On this interpretation, the illustration moves beyond the achievement of the ones we have discussed previously. Because its conception of a proposition is novel, something not found in Aristotle, it would be an instance of philosophy actually done through visual imagery.

It is difficult to assess Berger's claim that the *Descriptio*'s visual representation of a proposition is a genuine advance over the inadequacies of traditional textbook definitions. Because I do not have detailed knowledge of medieval logic textbooks as well as of the entire tradition of logic as it was developed by medieval logicians including Duns Scotus (pictured and thus singled out as the most important logician after Aristotle), I am not in a position to judge the truth of her claim. Nonetheless, I can say that the visual representation of a proposition in this broadside presents a clear and perhaps novel conception of a proposition. The image of the piece of fruit does make it evident that a proposition is more than just a conjoining of noun and verb, for a new entity is produced by their union, as Berger contends. This qualifies the illustration as including a concept-based element, for its representation of the unity characterizing a proposition is not something to be found in Aristotle's texts.

This broadside also demonstrates how an image that combines words and pictures can give rise to an idea—in this case, of the *unity* that is a proposition—that is expressed visually. It thereby signals the need to develop a philosophical theory that accounts for the unity expressed by a proposition. Whether such a theory existed in, say, the writings of Duns Scotus or would have to wait for the account provided by Immanuel Kant in the *Critique of*

72  THOUGHTFUL IMAGES

*Pure Reason* is an issue that I am not in a position to adjudicate, as I have said.[10]

The thesis prints also include visual representations of concepts that it might seem impossible to illustrate. Take, for example, the idea of substantial generation, an important idea in Aristotle's metaphysics. The basic entities in Aristotle's metaphysics are substances, entities that are capable of existing independently of other things. In this respect, they have a different ontological status than their attributes or properties which exist only by being present in a substance. Aristotle's term for this relationship is "inherence."

Many changes that take place are simply changes in the attributes of a substance, as when, for example a man with a full head of hair goes bald or a tree loses its leaves in the fall. But there are also *substantial changes*, when the basic nature of a substance is altered. Through the process of electrolysis, for example, water is transformed into its constituent gases, hydrogen and oxygen. (This is not an example Aristotle would have known about.) This is a substantial change because the transformation is more fundamental than a simple change of properties, such as occurs when water freezes and becomes ice. Given the nature of Aristotle's metaphysics, substantial change is important.

There is a detail in the *Synopsis* broadside (figure 3.4) that illustrates this idea, as Berger points out (2017, pp. 201–202). At the bottom of this engraving, the head and hands of a woman are seen emerging from clouds that surround her arms, breasts, and torso. Above her head is written *"forma"* (form), the clouds

---

[10] One of the key elements of the *Critique of Pure Reason* is Kant's theory of judgment, something he claims was lacking in the work of his predecessors. As he puts it, "I have never been able to satisfy myself with the explanation that the logicians give of a judgment in general: it is, they say, the representation of a relation between two concepts. . . . I remark only that it is not here determined wherein this relation consists" (Kant, B140/141). Kant provides a table of judgments that shows different ways in which concepts can be united in judgments.

obscuring her breastplate bear the inscription "*privatio*" (privation), and her two breasts are connected with the inscription "*materia*" (matter). This portion of the engraving is intended to represent the important Aristotelian idea that the generation of a new substance from its material substrate takes place through the imposition of form. A good example of such generation that is quite relevant to the topic of this book is the creation of a statue from a pile of bronze. The bronze is the matter out of which the statue is composed. But this matter becomes a statue only through the imposition of form. In this example, an artist imposes form on the material and thereby creates a substantial change in the bronze. The image of the woman at the bottom of this broadside is a similar example of how a new substance is created by the imposition of form on matter, illustrating Aristotle's notion of substantial change.

One of the most important features of the different broadsides illustrating Aristotle's philosophy is that they are *analogical illustrations*. As the two examples I have just discussed demonstrate, the broadsides set up a complex analogy between features of the physical world that they represent visually and key concepts in Aristotle's philosophy that are referenced verbally. This had the pedagogical function of enabling students to better remember the fundamentals of Aristotle's theory and perhaps even understand its claims.

Empirical research supports the utility of using visual images to help students retain the complex details of Aristotle's theories. Researchers have shown that people remember information better if a verbal description is supplemented by visual images (Levie and Lentz, 1982). If one is thinking pedagogically, using visual images to supplement a written text assists people in recalling those ideas and helps explain the strategy Meurisse employed. By creating broadsides that placed excerpts from Aristotle's texts within the larger structure of a visual image, he found a way to

# 74 THOUGHTFUL IMAGES

help his students retain the complex theories they needed for their disputations. Because Aristotle's theories assumed pictorial form in the broadsides created by Gaultier, students had an easier job of recalling them.

The broadsides' utility was not limited to this pedagogical function. As Berger suggested, these analogical illustrations were also used to develop new concepts that enriched Aristotle's theory itself. In addition to illustrating Aristotle in a unique manner, the broadsides can be seen to have contributed to the development of philosophical theories, such as that of the nature of a proposition. But even if this claim cannot be validated, the broadsides represent a new and important development in the illustration of philosophy.

In this respect, the illustrations followed Aristotle's own example. Aristotle frequently used analogies as part of his philosophical reasoning, as Mary Hesse (1965) argues. The use of analogy in the broadsides can thus be seen as applying Aristotle's own philosophical methodology to the nature of illustrations of philosophical theories.

The *Descriptio* serves as a good example of how these broadsides provide innovative visual representations of the elements of logic through a combination of words and images. This broadside contains large swatches of text taken from works of logic, such as Aristotle's *Categories*. As they were intended for pedagogical use, it makes sense to include quotations from the texts that the students had to master for their examinations. As we shall see, the reproduction of a philosopher's claims in an illustration is a technique that many artists will use. This technique can be traced back to these impressive broadsides.

## Conclusion

In concluding this chapter, I want to reflect on the different types of word-image relationships exemplified by the various works we have

considered so far. The earliest Greek illustrations of philosophy were not text-based. The bust of Socrates was simply a supposed portrait of the great philosopher but made no explicit reference to any of his philosophical ideas. The mosaic we looked at, however, showed greater fidelity to Plato's texts. It illustrates the practice of philosophy in Ancient Greece, although without referencing any specific philosophical text or theory despite its fidelity to the practice of philosophy as described in Plato's *Dialogues*. In showing different philosophers interacting with one another, the mosaic did convey some sense of how philosophy was practiced in Ancient Greece and thus qualifies as concept-based.

The illuminated manuscripts we inspected were quite different. Each clearly presented a text-based, pictorial illustration of one of Aristotle's theories. Displayed on a page of the French translations of Aristotle's *Nicomachean Ethics* and *Politics*, they presented readers with a personification of the theory, thereby rendering the theories in a concrete visual image that is more easily remembered than the complexities of Aristotle's prose description of his theories. Their rhetorical strategy was in accordance with both the norms we earlier identified as characteristic of illustrations: fidelity and felicity.

The early modern printed broadsides generally present a unified image in which all the elements of an aspect of Aristotle's theoretical writings are depicted. They do so by means of analogical illustrations in which words are an important part of the image. Without the words, we would have no way of understanding how the analogical structure of the image should be interpreted for the image to illustrate Aristotle's views.

Like the illustrations in Oresme's translations, those in the broadsides are faithful to the theories they illustrate but they employ a different rhetorical strategy. Rather than using personification, the broadsides employ a biological metaphor—logic and metaphysics as gardens—that unifies their various parts. In so doing, they satisfy the norm of felicity without violating that of

## 76 THOUGHTFUL IMAGES

fidelity, perhaps even enabling them to contribute to the philosophical fields they are illustrating.

Our initial foray into illustrations of philosophy, then, has demonstrated not only the richness of the tradition of such images but also a variety of different rhetorical strategies and techniques such images employ. The word-image relationship takes a number of different forms in philosophical illustrations and we are well on our way to seeing examples of this diversity. In the chapters that follow, I shall show some of these relationships used again but also new ones introduced as the means for illustrating philosophy undergoes significant alteration even as earlier techniques are redeployed.

# 4

# Frontispieces in the Seventeenth and Eighteenth Centuries

At this point in our historical investigation of visual illustration of philosophy, we encounter the printed book. As I mentioned in chapter 3, Johannes Gutenberg brought movable type to Europe around 1440 and published his edition of the Bible in 1455. The use of print technology created a major transformation in how philosophical works could be accessed by the public. Previously, the vast majority of texts were handwritten manuscripts, and this meant that a very limited number of people had access to them. Once books were produced on a printing press, multiple copies of a single work could be created without the laborious process of transcription. A wider public could access printed philosophy texts, which meant that these works experienced broader circulation than was possible previously.

An interesting feature of the philosophical texts produced beginning in the early seventeenth century is the presence of printed frontispieces. Using the term "frontispiece" to refer to the printed image on the first page of a book is to employ an architectural metaphor. It requires imagining a book to be a building, with the frontispiece functioning as its entrance (see Skinner, p. 251). Many of the structural details of these images are derived from the metaphor, such as the columns and pedestals that often grace them.

Medieval manuscripts often had title pages that included illustrations. But in the early modern period, printed texts usually had a frontispiece that could either be the title page, as in the

*Thoughtful Images.* Thomas E. Wartenberg, Oxford University Press. © Oxford University Press 2023.
DOI: 10.1093/oso/9780197650547.003.0004

# 78 THOUGHTFUL IMAGES

frontispiece for Hobbes's *Leviathan*, or facing the title page, as in the frontispieces for Rousseau's *Emile*, the two works I concentrate on in this chapter. The frontispieces were predominantly engravings since using copper plates allowed for multiple copies to be made without the quality of the image deteriorating—as it tended to do with woodcuts, which were the dominant form earlier.

One problem arose because engravings are made by using a burin to remove a small slice of copper from the copper plate. This presented an issue for the printer because type, in contrast, is raised. This meant that a plate with text could not have an engraving inserted into it. As a result, many engravings were simply printed separately and attached to the text in which a space was left for them, as was the case with Botticelli's illustrations of *The Inferno* (see figure 2.2).[1] Of course, a frontispiece could have both word and image so long as both were created by the process of engraving, but this was a subsequent development.

Philosophical texts with engraved frontispieces began appearing in the early seventeenth century. For example, Francis Bacon's *The Great Instauration* (1620) was published with an engraving as its frontispiece. In it, we see two ships passing through the Pillars of Hercules, i.e., the Straits of Gibraltar, symbolizing the search for new knowledge. Thomas Hobbes's *De Cive* (1642) shows two different states or conditions—those of nature and of civil society—beneath a depiction of heaven, with the book's title on a large tapestry separating one state from the other. By way of contrast, Margaret Cavendish placed herself in the frontispieces of some of her works. In *Philosophical and Physical Opinions* (1655), the frontispiece shows Cavendish sitting in a sculptural niche between statues of Athena and Apollo with a caption that praises her beauty and her wit. It is notable that this noblewoman chose to have her

---

[1] Botticelli created more than one set of drawings of Dante's work. The one from which Baccio Baldini made engravings was published in 1481. Only some of the Cantos had engravings in this edition although Botticelli created ninety-two drawings.

portrait placed at the front of the book, as if to assure readers that she was a person worthy of being read.[2]

The tradition of illustrated frontispieces continued into the eighteenth century. Giambattista Vico's *The New Science* (1725) has a complex engraving in which Homer receives divine inspiration via the figure of Metaphysics, with many, highly symbolic objects scattered about. In the frontispiece to his *Elements to the Philosophy of Newton* (1738), Voltaire is depicted seated at a table writing, with Newton and a muse above him and various scientific objects scattered around him. Finally, *Institutions de Physique* (1740) by Gabrielle Émilie Le Tonnelier de Breteuil, Marquise du Châtelet, has a complex engraved frontispiece. The frontispiece depicts the Muses of the sciences seated on the ground as a female figure climbs toward the temple of Truth which is represented by the presence of a naked woman in the temple's niche. The three male scientists whose portraits adorn the top of the temple probably are Descartes, Newton, and Leibniz, the three theorists whose scientific and philosophical theories du Châtelet describes in her book.[3]

The role of the images in these frontispieces varies from one to the next. Some of them present the book's author in highly honorific terms, as if to encourage people to read the book. More often, the frontispieces are a symbolic representation of the content of the book. If we limit ourselves to images of the latter type, is there anything that can be said in general about the role that the frontispieces are supposed to play for readers of the book they introduce? This is the question I propose to answer in this chapter.

To do so, I will focus, as I have said, on the frontispieces of two important philosophical texts: Thomas Hobbes's *Leviathan* and

---

[2] Such frontispieces were common in scientific works in the seventeenth century. For a good survey of how they functioned, see Remmert.

[3] The only other frontispiece I have been able to find of a work by a female philosopher is William Blake's etching for the 1791 edition of Mary Wollstonecraft's *Original Stories from Real Life*, a children's book that was influenced by the educational theories of John Locke and Jean-Jacques Rousseau.

# 80 THOUGHTFUL IMAGES

Jean-Jacques Rousseau's *Emile*. I have chosen these works for different reasons. The frontispiece to *Leviathan* is probably the best known of all the frontispieces published in philosophical texts during this time period. Its complex structure also makes it worthy of examination to see what relation it has to the content of the book it illustrates. Rousseau, on the other hand, was the philosopher most intimately acquainted with engraving since he was apprenticed to an engraver as a young man. It is therefore significant that he chose to place an engraving at the head of each of *Emile*'s five books. Furthermore, as we shall see, there are paradoxical features of *Emile*'s engravings that require interpretation, making them a particularly interesting case study of how philosophical texts during this time period were illustrated.

## The Frontispiece to *Leviathan*

The most celebrated frontispiece during the seventeenth and eighteenth centuries graced Thomas Hobbes's *Leviathan* (1668).[4] Hobbes worked closely with the engraver, Abraham Bosse, to develop an engraving based on a drawing, now generally agreed to have been made by Bosse and not, as formerly thought, by Wenceslas Hollar. Bosse's striking engraving is a representation of claims Hobbes makes about the Leviathan or ideal commonwealth he describes in the book (see figure 4.1).[5] However, the image itself has a number of different elements that are often neglected in interpreting its significance. In part, this is because the work, like *Descriptio*, is a plural image, and interpreters have failed to see how important this fact is to understanding it.

---

[4] Quentin Skinner provides a detailed analysis of the frontispiece in his 2018, pages 225–315. Susanna Berger (2020) argues that Skinner has misinterpreted many features of the frontispiece. On the whole, I follow Berger's interpretation.

[5] For a detailed study of the frontispiece, see Keith Brown (1978).

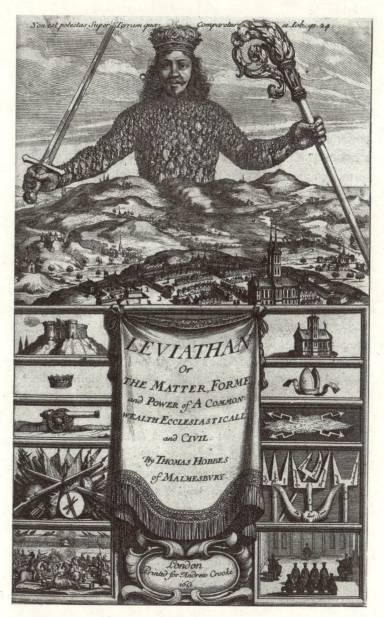

**Figure 4.1** Frontispiece by Abraham Bosse to Thomas Hobbes, *Leviathan* (London: Andrew Crooke, 1651).

## 82   THOUGHTFUL IMAGES

The image in the top half of the page grabs our attention. It shows a section of a walled city viewed from a distance, surrounded by a rising pastoral landscape of hills and rural buildings. Towering above the landscape is a huge figure, the sovereign, with a sword in his right hand and a scepter in his left, paralleling the objects in the two lower panels representing temporal and ecclesiastical power whose significance I will discuss in a moment. The giant has a crown on his head, clearly signifying his status as a ruler, a fact further emphasized by the implements in his hands.[6] As we look closer, we notice that his body is made up of hundreds of small human figures facing away from us.

This portion of the frontispiece symbolically conveys the main claim of *Leviathan*, namely, that the sovereign or ruler unites the disparate citizens into a whole, the Commonwealth or Leviathan. It is they who, in the engraving, literally make up the Leviathan's body, a claim that symbolically represents the thesis that Hobbes argues for in the book: that the Commonwealth is constituted by the people. This striking visual representation of the book's main thesis marks the frontispiece as an outstanding example of an illustration of a philosophical text. It is a literalization of the book's argument, achieved by visualizing the Leviathan's body as created out of the bodies of the citizens of the state.

Bosse's engraving is not a diagram, since it is not intended primarily to convey information. Rather, for the reader who understands Hobbes's contention about the source of the sovereign's power, it encapsulates that claim in a visual image symbolically encoding it.

The lower half of the engraving is also important for understanding the engraving's significance. It is divided vertically into thirds. In the middle third, the title of the book and the name of the author are engraved. Both the left and right thirds are divided into

---

[6] Corbett and Lightbown assert that the face of the Leviathan is Hobbes's (pages 229–230).

# FRONTISPIECES    83

five small horizontal panels. The left-hand images are all secular, while the right-hand ones are all religious, and there is a correlation between the images. At the bottom, there is a battle scene on the left and on the right a religious disputation of the sort for which the thesis prints like *Descriptio* might have been deployed (see chapter 3). Immediately above them are the tools used in the two different types of disputes, weapons of war and symbolic "weapons" of logic, respectively. A canon on the left is then matched with thunderbolts on the right. Next come a crown and a bishop's miter, symbols of secular and ecclesiastical power, respectively. Finally, a castle is paired with a church, two buildings that signify the institutions through which such power is exercised.

How are these disparate elements of the print to be understood? If we follow the logic of a composite image as discussed in the last chapter, we will recall that such plural images were meant to be viewed in a specific order, here from the bottom to the top.[7] If we begin at the bottom of the two columns of images, Bosse's image represents the process of generating the state out of the warring and disputing individuals shown in the bottom panels who exist in the state of nature.

Susanna Berger suggests that when interpreted in this manner, the *Leviathan* frontispiece depicts the process of substantial generation, with the substance generated being the commonwealth. As she puts it: "The sovereign, the soul of the commonwealth, functions to unify and animate the individual members, its matter, into a single body politic, transforming many into one" (Berger, 2017, p. 206). When interpreted in this manner, the engraving does more than simply illustrate some of the central claims made by Hobbes about the sovereign, for it also provides a visual analogue for the book's argument concerning the generation of the state. By

---

[7] Skinner refers to the frontispiece as presenting a "visual argument" (Skinner, page 278, for example). But he doesn't explain how an image can be an argument. It is better to view the frontispiece as *illustrating* philosophical *theses*, in my view.

# 84 THOUGHTFUL IMAGES

including this multiplicity of elements in a single engraved image, Bosse has provided a visual illustration of a number of different aspects of Hobbes's claims in *Leviathan*.

Bosse's etching is paradigmatic for the use of illustrations in the seventeenth and eighteenth centuries. First, the image serves as a reminder to readers of the content of the book. It is able to do so because it presents, in visual form, the essential thesis of the book about the generation of the state out of warring individuals.

Bosse's frontispiece is able to present this thesis so concisely because of the nature of visual images as opposed to characteristics of words. A visual image embodies a complex set of elements that a viewer apprehends more or less simultaneously. Unlike a written text, in which the ideas are taken in one at a time in sequence, a visual image can include an array of numerous elements that the viewer takes in essentially all at once. Of course, to analyze the image is to deconstruct its unity in order to be able to articulate its meaning verbally, as I have just done.

In a number of ways, Bosse's engraving resembles the plural images we investigated in chapter 3. However, the image in the upper half of the engraving depicts a single, unified scene, with the sovereign towering over the landscape that includes the city over which he rules. This portion of the image points toward an evolution in representational technique that we will explore in the next section, one in which all the diverse elements of an image are unified into a single, visually consistent picture.

## The Frontispieces to *Emile*

As a young boy, Jean-Jacques Rousseau was apprenticed to an engraver. Although he was mistreated and ran away, his experience gave him expertise in the process of engraving. It's no surprise, then, to find that many of his works included engravings, with his novel *Julie or the New Heloise* (1761) being the most lavishly illustrated.

The five engravings of his philosophical work *Emile* form the subject of this section of the chapter.

I focus on the engravings of *Emile* not simply because there are more of them than in any other previous philosophical work nor because Rousseau was intimately involved in their production, though this is important to bear in mind. Rather, what sparks my fascination with these engravings is the difficulty their interpreter faces. Unlike the frontispieces of other literary and philosophical works of the period such as *Leviathan*, the *Emile* engravings do not present the work's thesis in visual form. Their relation to the work is more complex and difficult to decipher. As a result, investigating how these images function as illustrations will result in our developing a more expansive conception of visual illustration.

*Emile* contains five engravings each of which serves as a frontispiece to one of the books that compose it. Each engraving, designed by Charles Eisen, presents a scene from Greek mythology in which an educational process is depicted. This is not surprising given that education is the subject of *Emile*. The first two engravings show scenes from Achilles's life; the third a mythic scene involving Hermes writing scientific knowledge on a pillar; the fourth depicts Orpheus singing of the gods to his fellow Greeks; and the fifth, Circe offering herself to Ulysses as his shipmates, transformed into pigs, look on.

The titles that Rousseau provides for each of the engravings— Thetis, Charon, Hermes, Orpheus, and Circé—are somewhat surprising as each refers to the mythic figure doing the "teaching" rather than the narrative of the event depicted. This initially suggests that the viewer of the engravings should focus on the teacher, or "preceptor" to use Rousseau's term, rather than the person being educated, the student. Rousseau also provides brief "explanations of the illustrations," though these are little more than descriptions of the scenes presented in the engravings. In addition, each illustration includes a reference to a page number of *Emile* in its top right-hand corner so that the attentive viewer of the engravings will find

## 86 THOUGHTFUL IMAGES

and read the text to determine what Rousseau had in mind. This poses the question of the nature of the relationship between the engraving and the textual passage cited. While one might expect the image to be a text-based one of the passage cited, surprisingly this is not the case.

There has been relatively little written about the *Emile* engravings. A notable exception is John T. Scott's excellent discussion of them. Scott argues that the engravings need to be read in conjunction with the text and will yield up their meaning only through a complex analysis that weaves the two together.

As we follow Scott's argument, we will see that these engravings function in an unexpected manner. The frontispiece to Book I, that also stands as an illustration of the book as a whole, does not illustrate a passage from *Emile*. Rather, it shows the position on education that Rousseau counters in the text of his book.

This engraving bears the title *Thetis* (see figure 4.2). It is placed opposite the title page of the first book of *Emile* and depicts the sea nymph Thetis dipping her son Achilles in the River Styx. As Scott points out, the fact that the title does not include a reference to Achilles is surprising, especially since it occurs in a book about the education of a young boy, Emile. Instead, the emphasis in the engraving is on Achilles's mother, a fact stressed by Rousseau's explication of the illustration: "The illustration, which relates to the first book and serves as a frontispiece to the work, represents Thetis plunging her son in the Styx to make him invulnerable" (Rousseau, p. 36). Rousseau's omission of Achilles's name is surprising, but the primary fact we learn from his explication of the image is that Thetis's intention in dunking her son is to make him immortal.[8]

There are other significant features of the engraving. In addition to the title *Thetis* inscribed underneath the image, there is a

---

[8] The origin of this myth about Achilles is the *Achilleid*, an incomplete epic poem by the Roman poet Publius Papinius Statius (c. 45–c. 96 CE).

**Figure 4.2** *Thetis*, Frontispiece to Book 1 of *Emile* by Jean Jacques Rousseau (1762). Lebrecht Music and Arts/Alamy Stock Photo.

# 88 THOUGHTFUL IMAGES

reference to page 37 in the upper right-hand corner outside the frame of the engraving. The engraving itself depicts a group of five women huddled together in an almost sculptural array in the bottom half of the engraving, slightly to the right of center. The four women surrounding the kneeling central figure are all in various states of undress, but all of their dresses are lowered exposing their breasts. Three of them focus their gazes upon the kneeling figure, who is wearing a more elegant dress and whose right arm is adorned with bracelets, while one woman's gaze is raised, apparently staring into the distance. Another woman is holding the central figure to keep her from falling into the river as she dips a young child into it, holding it by its left foot. The upper half of the engraving consists mostly of a vague landscape, suggesting that the figures are inside a cave or bower on the banks of a river. Around the middle of the print, on the left-hand side, there is a raft, with one man rowing a shrouded figure across the river.

The title, as well as Rousseau's explanation, identifies the engraving as showing Thetis, the sea nymph, dunking her infant son, Achilles, into the Styx to make him invulnerable and hence immortal, godlike. Although the general setting for this engraving is faithful to the description in its likely source, Statiad's *Achilleid* (Book I, pp. 217–242), there are some specific ways in which the engraving departs from it. Most prominent are the four women surrounding Thetis, who replace Charon as Thetis's "escort." In addition, the scene towards the left rear—Charon ferrying Death across the river—is not derived from Statiad's poem and so is a significant addition by Rousseau.

Based on this initial interpretation, we can see that this text-based illustration employs the norms of fidelity and felicity. On the one hand, many of the features of the depicted scene are faithfully derived from Statiad's text, such as Thetis dipping Achilles in the Styx. However, as I have pointed out, there are a number of significant changes in the engraving, and I shall show that these are consistent

FRONTISPIECES **89**

with the norm of felicity. More specifically, these departures from the source text are determined by Rousseau's use of the image, a creative use of the norm of felicity.

Since Rousseau characterizes this engraving as the frontispiece to the entire work, an initial interpretation might posit Thetis's attempt to make Achilles invulnerable as the model for the goal of Emile's education. Spelling out the analogy would involve claiming that Jean-Jacques's education of the young Emile should aim to make him as physically invulnerable as Thetis made Achilles. On this view, the engraving of Thetis would function as an allegory for the modern educator, suggesting the goal he should set for his young charge(s).

One feature of this illustration is that it appears based on two different texts. We have explored one, Statiad's description of Achilles being dunked in the river Styx. But Rousseau also puts a page reference on the engraving, suggesting that *Emile* is also its source. This double textual reference is unusual for a text-based illustration but also, as we shall see, quite complex.

In the passage referenced by the page number on the engraving, Rousseau makes his first explicit mention of Thetis in the text of *Emile* and he does so in a way that appears to support our initial interpretation of the engraving. He is discussing women who mother their children "to excess":

Thetis, to make her son invulnerable, plunged him according to the fable, in the water of the Styx. This allegory is a lovely one, and it is clear. The cruel mothers of whom I speak do otherwise; by dint of plunging their children in softness, they prepare them for suffering. (Rousseau, p. 47)

Rousseau appears to be endorsing Thetis's submersion of Achilles in the Styx as an example of good mothering practice as opposed to what many of his contemporary mothers do. This suggests that

## 90 THOUGHTFUL IMAGES

we should regard the engraving as providing a visual allegory of the appropriate goal of education.[9]

But no sooner does the attentive reader-viewer of this text and image complex consider this interpretation than they realize problems with it. First, there are the four women who appear to be wet nurses, employed by Thetis to feed Achilles. Their being wet nurses accounts for their dresses being lowered to expose their breasts. Presumably, they were engaged in feeding Achilles immediately prior to Thetis dunking him in the river. But in an early passage in *Emile*, Rousseau inveighs against wet nurses:

> Since mothers, despising their first duty, have no longer wanted to feed their children, it has been necessary to confide them to mercenary women who, thus finding themselves mothers of alien children on whose behalf nature tells them nothing, have sought only to save themselves effort. (Rousseau, p. 44)

Our interpretation of the *Thetis* engraving must take into account Rousseau's explicit condemnation of the use of wet nurses. Rousseau cannot simply be using this engraving as an allegory for the goal of education in so far as it presents wet nurses in a positive light.

There is more textual evidence to undermine our initial interpretation of the engraving. Indeed, another passage suggests that Thetis's attempt to render Achilles immortal is a mistake:

> One thinks only of preserving one's child. That is not enough. One ought to teach him to preserve himself as a man. . . . You may well take precautions against his dying. He will nevertheless have to die. And though his death were not the product of

---

[9] The frontispiece functions analogously to the interlocuter in the text of Wittgenstein's *Philosophical Investigations*, presenting a view that the author proceeds to criticize. I will discuss Wittgenstein's strategy in chapter 7.

your efforts, still these efforts would be ill conceived. It is less a
question of keeping him from dying than of making him live.
(Rousseau, p. 42)

This passage, although addressed to mothers, contains a clear, if in-
direct, rebuke of Thetis for attempting to make Achilles invulner-
able. It points out that it is impossible to render a man invulnerable,
as the Achilles myth actually shows, for even after being dunked in
the Styx Achilles remains vulnerable to Paris's deadly arrow.

There is additional reason to think that Rousseau considered
Thetis's attempt misguided. Achilles was generally thought of as the
paradigmatic Greek hero because of his courage on the battlefield.
Courage is, after all, the central virtue of a Greek warrior. Achilles
was thought to possess it despite also having the vices of exces-
sive pride and anger as elements of his character. But Rousseau
challenges this traditional conception of Achilles's valor.

It is the knowledge of dangers that makes us fear them; he who
believed himself invulnerable would fear nothing. By dint of
arming Achilles against peril, the poet takes away from him the
merit of valor; every other man in his place would have been an
Achilles at the same price. (Rousseau, p. 55)

Rousseau's point is that valor or courage is a virtue only when a
person is aware of their mortality. If one believed oneself invul-
nerable, as Achilles did, acting in a manner that ordinarily would
count as valorous or courageous would not actually be so. Such a
person would not be risking their life since they would know that
they did not have to face death. For this reason, Rousseau thinks
that Homer's portrayal of Achilles makes it impossible to think of
him as exhibiting valor in fighting at Troy.[10]

---

[10] This is true even though Homer does not mention Achilles's heel. For an inter-
esting discussion of the origin of the myth of Achilles' heel, see McDaniel (2020). I take

Of course, Achilles was not invulnerable; because Thetis held him by his left heel when she dipped him in the river Styx, this small anatomical part remained dry and hence vulnerable. Hence, death does loom over his life, and this is registered in the engraving by the other feature not found in the source text: Charon ferrying the shrouded figure of Death across the river. The presence of these two figures suggest that death continues to shadow Achilles despite Thetis's efforts to make him immortal.

This illustration of Homer's portrayal of Thetis's dunking Achilles has elements derived from the norms of both fidelity and felicity. While the basic composition of the illustration is faithful to the story as presented by Statiad, I have indicated that Rousseau has added a number of features in accordance with the norm of felicity. While the norm of felicity has generally been used to render an image that is more artistically satisfying, here Rousseau has used it to make the image more suitable for his philosophical purposes.

How, then, are we to understand the significance that Rousseau intended the engraving to have? The message he wanted attentive reader-viewers to take away from a complex process of interpretation that involves moving back and forth between the visual image and the verbal text is that a modern-day Thetis should be concerned with her charge's *soul*, not his body. As Rousseau says, the goal of education should not be simply to preserve the child, i.e., keep the young boy alive, but to preserve the man, i.e., to make him into a person who has as much autonomy as possible.

This interpretation is confirmed by another comment that Rousseau makes that critically invokes Thetis's attempt to render Achilles invulnerable. Late in Book V, Rousseau tells Emile, "It is in vain that I have dipped your soul in the Styx; I was not able to

---

Rousseau to be referring to Homer rather than Statius because the Homeric tale is the basis for Statius's work.

FRONTISPIECES 93

make it everywhere invulnerable" (Rousseau, p. 443). Rousseau is speaking metaphorically, of course, for he has not literally dipped Emile's soul in the river. Nonetheless, Rousseau is making an important point about Emile's vulnerability.

Emile is vulnerable to his own passions, particularly his love of Sophie. But what is significant from our point of view is Rousseau's reinvocation of Thetis's action; this time, however, he is not referring to the literal dipping of Achilles in the Styx but is using it to make a metaphoric assessment of Jean-Jacques's rearing of Emile.

The Thetis engraving thus provides an allegory of education but only when appropriately criticized for features that are inappropriate to a modern education. A reader who accepts a classical model of virtue and its concomitant implications for education needs to understand how that model must be changed, in Rousseau's view. Suitably interpreted, the engraving becomes both a positive model for the tutor-educator and a critique of more classical views.

Why might Rousseau have adopted such a convoluted method of illustrating *Emile*? In Book IV, Emile's governor makes a digression that helps illuminate Rousseau's use of engravings in the book. Because Emile is now a youth, it is important to "*engrave* it [i.e., his instruction] on his memory in such a way that it will never be effaced" (Rousseau, 321, emphasis added). Contrasting his contemporary society with that of the ancients, the governor states that "In neglecting the language of signs that speak to the imagination, the most energetic of languages has been lost." The reason that the language of signs is important is that, while "the impression of the word is always weak . . . one speaks to the heart far better through the eyes than through the ears. . . . It is with this language [of signs] that one persuades and makes others act" (Rousseau, p. 321). Although the governor cites examples in which physical objects functioned as signs for the ancients—such as when, in Livy's account, Tarquin cut off the tops of the poppies and this was taken as a message to kill the leaders of the city—this digression also suggests

# 94 THOUGHTFUL IMAGES

what Rousseau might have hoped to accomplish by including an engraving for each of the books of *Emile*.[11]

The issue I am raising is not whether my specific interpretation of this engraving is correct. The point is that a careful reader-viewer of *Emile* finds themself confronted with a visual image that refers to the text as if it were simply a visual rendering of a passage in the work but cannot adequately be understood in that manner. Instead, the attentive reader-viewer is forced to confront two puzzles: What is the significance of the engraving? and, How does it illustrate ideas from the first book of *Emile* as well as the work as a whole? Both of these puzzles are perplexing.

Scott (2014) suggests that the engravings form an important part of Rousseau's educative project. According to Scott, in *Emile*, Rousseau is trying to get his audience to see the world in a different light than they had previously, and the engravings, with their enigmatic presence, are part and parcel of that project. He calls the engravings "allegorical." In the case of *Thetis*, I don't think this term captures what is distinctive about it. At a first level, this illustration is certainly pictorial, that is, it presents the reader-viewer with a visual rendering of a scene from Greek mythology. Of course, reader-viewers are meant to see the image as an allegory for contemporary education, that is, to understand that its goal is to protect a young person from death, making them immortal, just as Thetis attempted to do.

But once they do this, reader-viewers are moving beyond the literal interpretation of the frontispiece. What becomes present to the minds of Rousseau's audience is a model of education that he believes they have previously accepted but which he wants them to reject. The mythological pictures in this and the other frontispieces call to the reader-viewers' minds their received understanding

---

[11] I follow Jeff J. S. Black (2013) in treating the language of signs as if it included visual images. It is not clear whether Rousseau believed this or limited signs to actual objects used to communicate messages.

of education and thus, in a sense, set them up to be receptive to Rousseau's critique of that view.

I have repeatedly used the notion of fidelity to characterize text-based illustrations. As I have argued, the *Thetis* illustration is faithful to its two source texts, albeit in an unusual manner. Many of its features reflect its fidelity to Statiad's *Achilleid* from which the story of Thetis dunking of Achilles is derived. It also coheres with Rousseau's reference to that fable in the passage he cites on the illustration itself. But as an illustration of *Emile*, this image has to be thought of differently, for it does not represent the ideas presented in the book but rather the view that Rousseau seeks to *counter*. We can therefore categorize this illustration as *counter-textual*, introducing a new category into our understanding of illustration. An illustration will be counter-textual just in case it represents the view the text is *opposed* to rather than the one it endorses. This is a very unusual type of illustration, and there are, to my knowledge, very few subsequent illustrations of this type.[12]

The example of *Thetis* demonstrates that the engravings for *Emile* are illustrations that elude our traditional understanding of the nature and function of such images. While the images are pictorial, they cannot be taken to simply present reader-viewers with analogues of Rousseau's claims in the book. The engravings have a complex relationship to the text in which they appear that is, I believe, unique in the history of illustrations of philosophy, in that they meld pictorial and symbolic aspects.

A brief consideration of *Circé*, the frontispiece to the fifth book of *Emile*, will confirm the unusual relationship the frontispieces of

---

[12] The one instance of counter-textual illustrations I know of are in Maurice Sendak's wonderfully imaginative *Where the Wild Things Are*. In that book, some of the illustrations counter the text's claims about the Wild Things. Although, for example, they are described as having "roared their terrible roars and gnashed their terrible teeth and rolled their terrible eyes and showed their terrible claws" (Sendak, 1963), the creatures we see in the illustrations are more like huge dolls that are more cute than terrifying. The illustrations thus counter the claims made in the text about the nature of the Wild Things.

*Emile* bear to Rousseau's text. Circé is pictured in this engraving against the background of a classical Greek scene, standing inside a large building with a number of columns. She is on the engraving's left side, holding her hands out to the armored Ulysses who stands across from her on the right side of the engraving. Her bodily pose—outstretched arms, tilted head, swaying body—indicate that she is offering herself to Ulysses, a fact confirmed by showing her staff and magic potion lying discarded at the front of the image. Ulysses has a sword in his right hand, though its tip is on the ground, and he is looking at Circé while appearing to bow. In his left hand, Ulysses is holding some moly, the herb that he used to protect himself from Circé's spell, according to Homer. Through a space created by Ulysses's right arm and his left leg, we see some of his shipmates transformed into swine by their sexual desire for Circé. We are meant to understand that Ulysses has not succumbed because of the moly.

Once again, viewers are presented with a mythological picture, this time one that illustrates an incident from Book X of Homer's *Odyssey*, although it is not completely faithful to that text. According to Homer, Hermes does give Odysseus moly, but Odysseus subdues Circé by threatening her with his sword, not by lowering it as he does in the engraving (see lines 400–430). As we shall see, Rousseau modifies the engraving to adjust the story for his own purposes, acting in accordance with the norm of felicity.

Reader-viewers of *Emile* would expect this engraving to be some type of allegory for education, and this proves to be the case. Rousseau points the way by stating in his "Explanations of the Engravings" that it "represents Circé giving herself to Ulysses, whom she was not able to transform [into a pig]" (Rousseau, p. 36). So, even though Circé has been unable to harm Ulysses, he remains vulnerable to her charms. Knowing the story from Homer, Rousseau's audience expects Ulysses to live with Circé for a year and father children by her.

FRONTISPIECES    97

How does this frontispiece function as an allegory for the result of Jean-Jacques's education of Emile? You will recall that Rousseau thought that the goal of Emile's education was to make him as invulnerable as possible. Yet Emile eventually falls in love with Sophie. As a result, he becomes dependent on her, and thus vulnerable. The frontispiece can be interpreted allegorically as showing the danger to which Jean-Jacques's young charge remains vulnerable. Rather than illustrating the goal of Emile's education, the frontispiece illustrates its central failure.

As in the *Thetis* frontispiece, the engraving has to be interpreted allegorically, but not in a straightforward manner. The *Circé* frontispiece shows us precisely what Emile lacks, the ability to withstand the charms of a beautiful woman. Although having a partner is something that Jean-Jacques admits is necessary for Emile, it also means that he never attains the invulnerability that was the intended goal of his education.

The frontispieces for *Emile* we have examined show that the relationship an illustration has to the philosophical text it illustrates does not have to be straightforward. An illustration can be related to a textual segment without simply providing a pictorial image of it. The puzzling scenes that the frontispieces of *Emile* present to the reader-viewer cannot be interpreted as showing the book's audience the content of the ideal education Rousseau presents in that book. In different ways, neither of the two frontispieces we have examined is a straight-forward illustration of the text they are meant to illustrate.

## Conclusion

The frontispieces we have discussed in this chapter function very differently from each other. This is not surprising, since they were created nearly a century apart. Whereas Bosse's engraving still retains traces of the medieval organization of visual representation,

## 98 THOUGHTFUL IMAGES

Eisen's engravings are more modern in that they involve a single, unified scene. Nonetheless, both serve as illustrations of the texts they adorn, though in radically different ways. While the frontispiece to *Leviathan* contains visual representations of two of the central theses of that work, the first frontispiece of *Emile* recalls for its audience their received understanding of education, while the frontispiece to Book V presents the vulnerability that Emile still retains despite his careful education.

Rousseau's frontispieces are unusual and have not been imitated. Hobbes's is less idiosyncratic, providing an exemplary model of how a visual image can present a complex conceptual content to its viewers, a content that uses pictorial images in innovative ways.

# 5
# Paintings that Illustrate Philosophy

All the illustrations of philosophy we have considered so far were intended by their creator(s) to illustrate specific philosophical texts or concepts. When, for example, Bosse engraved the frontispiece for Hobbes's *Leviathan*, he worked with Hobbes himself to ensure the accuracy of the engraving. The frontispiece is able to illustrate Hobbes's theory of the sovereign because Bosse intended it to do just that and was guided in his attempt by Hobbes to ensure its fidelity to the theory he developed in *Leviathan*.

This prompts one to ask whether all illustrations share this intentionality. That is, is it true that for a visual image to be an illustration of a philosophical claim or theory it must be designed as such by its maker?

Although this view might seem reasonable, there are some important counterexamples that demonstrate its falsity. In particular, certain philosophers have selected previously existing works of art as illustrations of their theories. Since those works were created prior to the philosophical work they are supposed to illustrate, it is evident that they could not have been created as illustrations of those works. If we find the claims made by these philosophers convincing, we will have to acknowledge that some works of art illustrate philosophical theories even though they were not created to do so.

As part of my justification of this view I will introduce a new category of illustration, viz., *theory-based illustrations*. A work of art is a theory-based illustration if there is a plausible interpretation of the work as an illustration of the theory in question. The plausibility of this view will emerge as we look at some examples of

*Thoughtful Images.* Thomas E. Wartenberg, Oxford University Press. © Oxford University Press 2023.
DOI: 10.1093/oso/9780197650547.003.0005

100   THOUGHTFUL IMAGES

theory-based illustrations in this chapter. It may seem remarkable that three significant Western philosophers—Friedrich Nietzsche, Martin Heidegger, and Michel Foucault—each used a previously existing painting as an illustration of their theories, but I will show that they did and that this lends support to the idea that there are theory-based illustrations that were not intended by their makers as such.

But before I get to those philosophers and their interpretations of the paintings they viewed as illustrations of their theories, I will examine three paintings that were intended by their creators to illustrate philosophy. These are all great works of art that illustrate philosophy. They demonstrate that a great painting can also be an illustration as I argued in the second chapter.

## Paintings of Philosophy

The three paintings singled out by Nietzsche, Heidegger, and Foucault are not obviously about philosophy, though the philosophers explain why they should be so regarded. The three paintings I consider now are by great European artists and are explicitly about philosophy. This will give us a point of comparison when we turn to the claims of the three aforementioned philosophers.

Most paintings made during the Middle Ages had religious subject matter. In the fourteenth century, a humanistic movement began that expanded the subjects that were considered appropriate for an oil painting or fresco. At the same time, a new system of representation was introduced: vanishing point perspective. This system replaced earlier modes of painting by creating a single, unified, receding space in which the entities represented were placed so as to present a realistic image.

One important aspect of this perspectival system was the elimination of written text and multiple scenes from paintings. The

## PAINTINGS THAT ILLUSTRATE PHILOSOPHY    101

frontispiece to *Leviathan* still has traces of the medieval mode of representation in that it is not a single, unified image but a multiple one. By the time of *Emile*, it was common for an image to be unified through the use of vanishing point perspective. Using this method allowed artists to create *realistic* images of objects in the external world, thereby realizing one of the ideals posited for art.

As a result of a commitment to realism, artists using the vanishing point perspectival system tended to avoid any elements that undercut it. To include written text within a painting undermined the realism of the depicted scene, for the natural world does not include writing.[1] For this reason, artists generally eschewed writing in their paintings, a norm that persisted until the advent of cubism in the early twentieth century. All six paintings I discuss in this chapter adhere to this norm.

Using vanishing point perspective, painters from the fifteenth through the eighteenth century intentionally created paintings that illustrated philosophy or philosophers. Three well-known examples are Raphael's *The School of Athens* (1509–1511), Rembrandt's *Aristotle Contemplating a Bust of Homer* (1653), and Jacques-Louis David's *The Death of Socrates* (1787).

Before I discuss these paintings, I want to remind reader-viewers that I have already argued that an oil painting can also be an illustration. In the second chapter, I discussed Titian's *Rape of Europa*, claiming that the painting was an illustration of a myth retold by Ovid in his *Metamorphosis*. The fact that *Rape of Europa* is a masterpiece does not prevent it from being an illustration. It's important to bear this in mind throughout my discussion of paintings in this chapter and chapter 6.

Also, the first two works I discuss here have no specific source text that they illustrate. Rather, they illustrate an idea that the artist

---

[1] Humans have changed this by placing objects with words on them into the environment. Street signs and billboards are two examples as are inscriptions on the pediments of buildings. Paintings can include these without violating their commitment to realism.

102 THOUGHTFUL IMAGES

had about the philosopher(s) depicted in the image that is derived from their understanding of the philosopher's works. As such, the paintings are concept-based illustrations. The norm of fidelity is still relevant to these works, but it is different from our previous encounters. These works will satisfy the norm of fidelity if the image of the philosopher presented by the artist is consistent with what we can find in the philosopher's actual writings.

## Raphael: *The School of Athens* (1509-1511)

We have already encountered Raphael Sanzio da Urbino's *School of Athens*, the well-known fresco adorning one wall of the Stanza in the Apostolic Palace in the Vatican (see Plate 5). Raphael's work on the Stanza was sponsored by Pope Julius II, but we don't know whether the actual design of either the Stanza or this particular fresco is due to Raphael or the Pope. Using vanishing point perspective, Raphael painted a vast architectural space within which he placed all of the central Greek philosophers, with Plato and Aristotle as the central pair. This fresco is significant because it depcits all of the great Greek philosophers in a single scene, and doing this in an artistically satisfactory manner is no mean achievement. *School of Athens* also presents these philosophers in action, as they enter into dialogue, read, write, lecture, argue, question, and even, in the case of Euclid, attempt to construct a proof.[2]

The tondo above the painting contains the phrase, "Causarum Cognitio," knowledge of causes. This is an allusion to Aristotle, who emphasized the importance of discovering the causes of things. The

---

[2] Glenn W. Most (1996) suggests that Raphael might have based the fresco's design on a verbal description of Protagoras with his followers assembled around him from Plato's *Protagoras* (314E–316A).

## PAINTINGS THAT ILLUSTRATE PHILOSOPHY    103

painting illustrates the enormous vitality of Greek philosophy by portraying so many individual philosophers, most of whom are engaged in philosophical pursuits of some sort. Philosophy was a vital activity in Ancient Greece, and its liveliness is certainly illustrated here. However, since the philosophers in the painting were not alive simultaneously, showing them together is clearly the product of Raphael's artistic imagination rather than a record of an actual occurrence, and shows the influence of the norm of felicity. As I mentioned earlier, it depicts both Plato and Aristotle in stances consonant with their philosophical positions.

## Rembrandt: *Aristotle Contemplating a Bust of Homer* (1653)

Rembrandt Hermenszoom van Rijn's *Aristotle Contemplating a Bust of Homer* provides more of a commentary on philosophy as an activity (see Plate 6). The painting shows the great Greek philosopher looking at a bust of the poet. They are located in front of a curtain that has been partially drawn to reveal a set of books, presumably representing the philosopher's library. Although the background is quite dark, a bright light illuminates both the philosopher and the bust he is gazing at. His left hand holds a chain draped across his breast and resting on his hip made of shiny, precious metal. His right hand rests lightly atop the bust of the poet, as the elderly philosopher gazes intently at him.

In interpreting this painting, it is significant that Aristotle thought poetry was allied with philosophy in its search for truth; he makes this clear in his *Poetics*, where he classifies poetry as more philosophical than history (9.1451b5–7). While it is difficult to attribute to Aristotle a specific attitude toward Homer in Rembrandt's depiction of him, it does not seem unreasonable to say that, in the painting, Homer is shown as both an inspiration

104 THOUGHTFUL IMAGES

for Aristotle and an object of Aristotle's admiration as he gazes at the poet's bust.

A prominent feature of the painting is the gold chain that Aristotle wears across his chest and that he is fingering with his left hand. Julius Held (1969) suggested the chain was a present to Aristotle from his student Alexander the Great, although there does not appear to be any historical evidence to support this claim. For Held, the painting shows Aristotle caught between his contemplation of Homer and his awareness of Alexander's significance, as if weighing the relative importance of poetry versus secular power and thus history.

Margaret Deutsch Carroll (1984) criticizes Held, asserting that the chain is a visual representation of the Golden Chain of Homer. The idea of such a chain derives from Zeus's boast in the *Iliad* that, given a long enough chain, he could pull all the other gods up to heaven, though they could not pull him down to earth. She believes that the chain's proximity to the bust of Homer would have suggested this association to contemporary viewers.

Carroll also points out that Aristotle is contemplating a work of art, viz., a bust. For Aristotle, contemplation is the quintessential human activity, the one that brings us closest to God's nature. That a work of art is a suitable subject for such contemplative activity is a view she thinks Rembrandt intends the work to illustrate.

On such an analysis, *Aristotle Contemplating a Bust of Homer* conveys the philosopher's attitude toward the arts. It suggests that he takes philosophy and the arts to be allied as two ways of ascertaining truth, from which we might conclude that Rembrandt himself had a positive attitude toward philosophy. His painting of Aristotle presents the philosopher as a deep thinker who had a reverence for his poetic predecessor. As in Raphael's painting, the scene is a pure invention of the painter, for there is no textual record of such an event. As a result, we can classify it as a concept-based illustration.

## PAINTINGS THAT ILLUSTRATE PHILOSOPHY 105

### David: *The Death of Socrates* (1787)

Jacques-Louis David's *The Death of Socrates* is a very different painting from the other two (see Plate 7). Painted in a Neoclassical style, it features a tableau of well-lighted philosophers in the foreground with a dark, receding architectural space on its left side and the wall of the room in a large building on the right. Unlike the previous two paintings, this one is not the product of the artist's imagination but is a text-based illustration.

The scene depicted in the painting is, as its title indicates, that of Socrates's death, and that event was recorded by Plato in his dialogue *Phaedo*. In that dialogue, Plato tells the story of Socrates's last moments during which he refused to stop teaching, even on the brink of his own demise. Socrates also refuses to flee Athens to save his life and uses his refusal to impart a lesson on the nature of the state to his followers.

In the painting, Socrates, the central figure, is seated on a bed gesticulating with his left hand as he reaches with his right for the cup of hemlock that will kill him. He is surrounded by his followers, all of whom are consumed with grief. The painting's vivid colors, bright central lighting, and dramatic portrayal of Socrates's disciples as they react to his impending death all contribute to the emotional impact the painting has on its viewers.

Although the painting is generally a faithful image of the scene as presented in the *Phaedo*, it includes some historical inaccuracies. For example, Plato, who is depicted at the foot of Socrates's bed, would have been a young man, not the old one we see in the painting. In addition, some of the individuals whom Plato describes as at the scene are missing. What we can say is that David made these alterations in accordance with the norm of felicity in order to create a compelling dramatic painting.

The painting presents its audience with the image of an imperturbable Socrates, continuing to teach his followers despite the immanence of his own death. Even as his followers exhibit their sorrow

through dramatic gestures, Socrates remains true to his mission as a teacher, shown by his being depicted with his left arm raised. As in the Platonic dialogue that the painting illustrates, Socrates lives true to his vocation until the end.

Given its basis in the *Phaedo*, David's painting is a masterful illustration of the scene described by Plato. Despite its inaccuracies, it remains a mostly faithful visual depiction of Plato's text. What is more, it illustrates Socrates's character, his refusal to allow his own impending death to affect his behavior or demeanor. The painting gives us a sense of the majesty of a philosopher who can truly face his own death unperturbed.

*The Death of Socrates* was painted shortly before the beginning of the French Revolution. David was a supporter of the Revolution, and this painting shows the importance of resisting unjust authority, be it Athenian or Parisian. At the same time that the painting illustrates Plato's text, it also has an allegorical meaning addressed to David's contemporaries about the need for them to rebel against injustice as Socrates did in his own way.

## Theory-based Illustrations

As I said at the beginning of this chapter, I will discuss three illustrations that were not intended to be illustrations by their creators. They must be considered illustrations, however, because they illustrate important ideas and concepts. These are what I call "theory-based illustrations." It is the existence of interpretations derived from specific theories that explains why these works are illustrations, although they were not so intended by their creators. I focus on three examples in which well-known philosophers turn to artistic masterpieces to illustrate their theories.

## Nietzsche and *Transfiguration* (Raphael, 1516-1520)

The first example of a theory-based illustration comes from the work of the nineteenth-century German philosopher Friedrich Nietzsche. A conceptual distinction central to the theory of history and culture Nietzsche develops in his first mature work, *The Birth of Tragedy* (1872), is the contrast between the Apolline and the Dionysiac. Nietzsche uses the names of two Greek gods to characterize the two distinct cultural tendencies he sees as fundamental to the historical development of Western civilization. Since this theory is intended as a criticism of Hegel's dialectical conception of history, it is crucial that Nietzsche provide a description of this fundamental dichotomy that will allow readers to assess its validity.

According to Nietzsche, the more ancient and fundamental term is the Dionysiac. One way that he gets at its significance is through a story conveying what he terms "the wisdom of Silenus."[3] Silenus was one of Dionysos's companions who had a reputation for being wise. King Midas hunted him down in order to ask him a question that consumed him: "What is the best and most excellent thing for human beings." According to Nietzsche, Silenus replies:

> Wretched, ephemeral race, children of chance and tribulation, why do you force me to tell you the very thing which it would be most profitable for you *not* to hear. The very best thing is utterly beyond your reach not to have been born, not to *be*, to be *nothing*. However, the second best thing for you is: to die soon. (Nietzsche, p. 23)

Silenus's supposed wisdom is quite depressing. No one wants to believe that the best things for them would be *not to exist*. The reason

---

[3] The source of the myth of Silenus is Plutarch, who attributes it to a lost work of Aristotle. See Plutarch, 28, p. 2.

108  THOUGHTFUL IMAGES

that not existing is preferable to existing, according to Silenus, is that human life is nothing but suffering. This is Nietzsche's way of incorporating a philosophical perspective that had a huge impact on his thought: Arthur Schopenhauer's pessimistic philosophy.

In *The World as Will and Representation*, Schopenhauer argued that all satisfaction of our desires is temporary and, as a result, ultimately futile. He counsels that the appropriate way for humans to live in the face of this metaphysical truth is simply to give up the project of satisfying their desires. Instead, they should take aesthetic satisfaction from observing the drama of human life from afar.

Nietzsche disagreed. To understand why, consider someone who accepts Silenus's claims about human life. How could they go on living? After all, Silenus has said that the best thing for human beings is not to have been born, and the second best is to die young. Doesn't this entail that suicide is the best course of action for one who has understood Silenus's message?

Nietzsche demurs. And here, he is not just thinking of an individual's response to Silenus's terrifying message; he is more centrally focused on Greek society and how it managed to find a way to thrive in the face of the import of Silenus's claim. Nietzsche claims that the Greeks invented the entire realm of Olympian gods to have a positive response to Silenus's supposed wisdom.

> In order to be able to live, the Greeks were obliged, by the most profound compulsion, to create these gods [i.e., the Olympians]....
> How else could that people have borne existence, given their extreme sensitivity, their stormy desires, their unique gift for *suffering*, if that same existence had not been shown to them in their gods, suffused with a higher glory? (Nietzsche, pp. 23–24)

This begins Nietzsche's attempt to explain the nature of the Apolline which involves the introduction of the notion of individuality. The world as seen through Apolline eyes, according to Nietzsche, is one in which order reigns supreme. For that to be true, everything

## PAINTINGS THAT ILLUSTRATE PHILOSOPHY    109

that exists must be a distinct entity, different from every other existing thing. Harking back to Schopenhauer once more, Nietzsche talks about the *principium individuationis* [principle of individuation] lying at the base of the Apolline worldview. According to this idea, every single existing thing is unique and different from everything else.

To contrast the Dionysiac worldview with the Apolline one, Nietzsche talks of a "breakdown" of the *principium individuationis*, that is, a recognition that individuality is only the appearance of a very different reality. According to the Dionysiac worldview, individuals are surface expressions of an eternal life force that seeks to push itself into existence. The Apolline recognizes only this surface reality, taking it to be the nature of reality itself. In so doing, the Apolline worldview valorizes order, beauty, and moderation.

How does the Apolline cope with Silenus's gloomy prognosis? Although Nietzsche's account is not without its ambiguities, his most consistent answer is: by denial. The idealized world that the Apolline takes to be real lacks the terror and horror that Silenus's wisdom generates. Its dream image is an idealization.

Using the distinction between the Dionysiac and the Apolline, Nietzsche constructs an entire history of Western civilization. He takes archaic Greek society to have been one in which the Dionysiac was dominant, with orgies and festivals that celebrated the essential unity of everything that exists. On this base, the later Greeks constructed a society in which the Apolline was able to temper the excesses of a Dionysiac culture. Greek architecture, for example, with its huge temples, was a manifestation of the Apolline desire for order and clarity, its rejection of change and confusion.[4]

Nietzsche does not take the rise of the Apolline in ancient Greece to have resulted in a complete destruction of the Dionysiac. Rather, he sees Greek society as developing a unique synthesis of these

---

[4] Martin Heidegger, the next philosopher I discuss, emphasizes the significance of the Greek temple as a work of art, taking his cue from Nietzsche.

## 110   THOUGHTFUL IMAGES

two cultural forces. This is most evident in the rise of Attic tragedy, an artform, Nietzsche argues, that subjects the Dionysiac insight into the terrors of existence to the rigor of an Apolline structure. Although the myths at the heart of Attic tragedy, such as Oedipus's self-mutilation at the realization of his crimes, are essentially Dionysiac in their recognition of the horror of existence, the form of Attic tragedy itself puts an Apolline spin onto the Dionysiac myth.

In Nietzsche's view, the next two thousand plus years of Western history show the increasing domination of the Apolline. Our scientific and rational culture, according to Nietzsche, has its roots in the triumph of "Socratism." According to Nietzsche, when Socrates confronted his fellow Athenians with his demand that they provide rational explanations for their actions, he precipitated the demise of the strong Aristocratic culture that had been dominant in Athens. For Nietzsche, the rest of Western history—up until his own time—showed the progressive triumph of the Apolline over all the Dionysiac aspects of society and human life.

When he surveys the cultural landscape of his contemporary world, Nietzsche has mostly only contempt, for there is no cultural form that has arisen analogous to Attic tragedy. Only in nineteenth-century Germany is there even a hint that such a cultural form might arise. He ends *The Birth* with an homage to Wagnerian opera as potentially heralding the first successful synthesis of Dionysiac and Apolline since Attic tragedy.[5]

To support his claims about the Apolline-Dionysiac distinction, Nietzsche turns to a painting. His idea is that his readers will see the painting as supporting the ideas he has just articulated. If there are grounds to see the painting as independently presenting the distinction between the truth of the inevitability of suffering and the illusory optimism of human rationality, it will serve to support Nietzsche's claims.

---

[5] Karol Berger (2017) provides a careful investigation of the very complicated Nietzsche-Wagner relationship.

## PAINTINGS THAT ILLUSTRATE PHILOSOPHY    111

The painting that Nietzsche invokes is *Transfiguration* (1516–1520) by Raphael (see Plate 8). This remarkable painting synthesizes two different biblical scenes of the miraculous into a unified vision.

The top half of the painting depicts the miracle from which the painting's title is taken: Jesus' Transfiguration. The Transfiguration is a story told in the *Gospels*—for example, in Matthew 17:1–8. In the story, Jesus goes to a mountain accompanied by three of his apostles, Peter, James, and John. On the mountain, Jesus shines with bright rays of light and his garments become shockingly white. He speaks to the prophets Moses and Elijah, who have appeared next to him in the sky. God's voice speaks to him from the sky, calling Jesus "son."

All the significant features in the top half of Raphael's painting are faithfully derived from statements made in the Bible. Jesus is shown clothed in white with a circle of puffy clouds behind him. Moses and Elijah, each holding a book, are shown in the sky next to Jesus. The three apostles are on a grassy knoll below and all take poses that show them to be overwhelmed by this vision. On the left, two other characters look on. Raphael has created an illustration of the Bible story governed by the norm of fidelity.

The lower half of the work, painted with a very different palette, represents a very different miracle. This one is found in Matthew 17 directly after the Transfiguration story itself. Whereas the white light illuminating Jesus from behind is the most striking feature of the top half of the painting, the bottom half, against a black background, portrays an array of brightly attired people many of whom are gesticulating wildly. This assembly actually consists of two groups of people joined by a central female character. The group on the left are the other apostles, with Matthew located at the bottom holding a book and reaching out to the viewer with his left arm. On the right, there is the family of a boy who has just recovered from demonic possession through the miraculous intercession of Jesus. The boy appears to be looking at the transfigured Jesus, but his family members look toward the Apostles. Linking the two

## 112 THOUGHTFUL IMAGES

groups is a female figure dressed in a luminous pink dress with a bright blue robe draped over her right shoulder. As she looks toward the Apostles, her left arm points toward the boy, as if to direct the apostles' attention to the miracle Jesus has just performed. This portion of the painting is another faithful illustration of a biblical story.

On Nietzsche's interpretation, the obvious Christian content of this painting is not its primary significance, for he takes Raphael's work to represent both the fundamental dichotomy of Nietzsche's own philosophy and the way the two terms in it are related. He claims that the lower half of the painting represents "a reflection of the eternal, primal pain, the only ground of the world" (Nietzsche, p. 26). That is, the lower portion presents the Dionysiac view of the world, based as it is on the necessity of pain and suffering.

But, of course, this portion of the painting is clearly linked to the upper portion, most centrally through the gestures of the characters and the gaze of the young boy. As a result, from the dark, somewhat chaotic world pictured in the lower half, there arises, according to Nietzsche, the vision of "a luminous hovering in purest bliss and in wide-eyed contemplation, free of all pain" (Nietzsche, p. 26). The upper portion of the painting is thus a vision of an Apolline world from which all suffering and pain have been removed, as indicated by the bright white light surrounding Jesus and the calm visages of the two prophets floating above the mountain on either side of him.

Nietzsche comments at length about the painting:

Here, in the highest symbolism of art, we see before us that Apolline world of beauty and the ground on which it rests, that terrible wisdom of Silenus, and we grasp, intuitively, the reciprocal necessity of these two things. At the same time, however, we encounter Apollo as the deification of the *principium individuationis* in which alone the eternally attained goal of the

PAINTINGS THAT ILLUSTRATE PHILOSOPHY     113

primordial unity, its release and redemption through semblance, comes about; with sublime gestures he shows us that the whole world of agony is needed in order to compel the individual to generate the releasing and redemptive vision and then, lost in contemplation of that vision, to sit calmly in his rocking boat in the midst of the sea. (Nietzsche, p. 26)

Nietzsche interprets Raphael's painting as doing more than simply representing the fundamental dichotomy he develops in *The Birth*; it also shows the relationship between the two terms and how the Apolline requires the existence of the Dionysiac in order to come into being.

My interest in Nietzsche's use of this painting is not in whether his interpretation of it is valid or whether it captures all the features of the work. Rather, I am interested in Nietzsche's using an artwork that antedated his own philosophy by around three hundred fifty years to *illustrate* and *to clarify* a number of basic theses that he wishes to defend in *The Birth of Tragedy*. For him, the painting shows the contrasting natures of the Dionysiac and the Apolline, and even illustrates their relationship.

It is remarkable that he doesn't bother to even mention the work's Christian iconography. As I have said, the painting does faithfully illustrate two distinct biblical tales in such a manner as to unify them. The biblical origins of the painting conceal its deeper metaphysical significance, Nietzsche believes, one that places it in harmony with his own theory of Western culture and history. Christianity, on his view, is just one manifestation of the Apolline, so that the significance of the painting transcends its Christian imagery.

Is there any way to justify Nietzsche's use of the painting in this manner? I would presume that art historians would bristle at Nietzsche's ahistorical interpretation that ignores the actual origin of the work, although his interpretation does explain the juxtaposition of the two different biblical stories. More significant for

## 114 THOUGHTFUL IMAGES

our purposes is Nietzsche's use of this work to assist his readers in understanding the theory he was putting forward in *The Birth of Tragedy*. Since Nietzsche believes that the Apolline-Dionysiac dichotomy was a real factor in the development of Western culture, he has justification for finding its presence in Raphael's painting. Giving his audience a graphic visual depiction of the contrast between these two "worlds" serves a number of functions. First, it helps the audience understand the contrast Nietzsche develops by attaching a visual image to each term in the dichotomy. But the visual images also are crystallizations of the ideas Nietzsche writes about and, as such, get lodged in people's minds better than the lengthy verbal descriptions the philosopher provides. The visual representation of the dichotomy of the Apolline and the Dionysiac has an immediacy and memorability that his extended verbal discussion lacks, and these are features whose presence I have repeatedly emphasized in previous illustrations of philosophy.

Nietzsche's use of a painting as an illustration of a philosophical thesis is, to my knowledge, unprecedented in the history of philosophy.[6] Although I will discuss two subsequent philosophers who make similar interpretive moves, Nietzsche's use of a work of art marks a high point in what we might term "philosophical art criticism." The painting functions not only as an illustration of Nietzsche's claims about the forces that determine European history and culture, but it is also, as a product of that history and culture, part of his evidence for the validity of those claims. Because Nietzsche takes Raphael to have been inspired by an insight similar to his own into the origins of Western civilization, he takes the painting to support the validity of his account of the significance of the Apolline-Dionysiac distinction.

---

[6] G. W. F. Hegel referred to artworks as support for his own theories, but he favored literary works, such as Sophocles's plays. While he wrote extensively about painting, I do not believe he used paintings as a means of illustrating the validity of his own philosophy.

## PAINTINGS THAT ILLUSTRATE PHILOSOPHY    115

### Heidegger and *Shoes* (Van Gogh, 1886)

The second philosopher who turns to a work of art to illustrate their metaphysical view is the twentieth-century German Martin Heidegger. In his long and deceptively titled essay, "The Origin of the Work of Art," Heidegger uses a number of different works to help illuminate his view of art. The one work I will focus on is Van Gogh's 1886 painting *Shoes*, a work that Heidegger discusses at length (see Plate 9).[7]

Heidegger's most systematic presentation of his philosophy of art occurs in the aforementioned essay. Concealed in the title, as well as in the question it raises about the work of art's origin, is a philosophic pun, for the phrase "*work* of art" is subtly ambiguous. The obvious meaning is the art object, what the artist produces, their *work*. But *work* can also mean *effect*, and Heidegger relies on this meaning as well when he seeks to explain the specific effect of art, what it *does* that distinguishes it from other cultural practices. The issue that his essay focuses on has to do with our response to works of art, how they affect *us*, how they, as we might put it, *work*.

Awareness of this subtle word play helps set the context for interpreting one of Heidegger's most fundamental claims about art: that art is *the setting-into-work of truth*. To understand this claim, we will have to investigate what Heidegger means by truth and setting-into-work.

The idea of truth is central to Heidegger's philosophy. Following his overall strategy, Heidegger argues that our usual philosophic understanding of truth as correspondence—say, of an idea or assertion and the object to which it refers—is derivative, for there is a more basic conception of truth that underlies the standard one and makes it possible. The problem, according to Heidegger, is that this more basic meaning of truth has been obscured by the predominance of the former, so that it is a philosophic task of the utmost

---

[7] A more complete examination of this essay can be found in Wartenberg (2005).

## 116 THOUGHTFUL IMAGES

importance to retrieve this basic meaning of truth. Relying for support on the supposed etymology of the Greek word for truth, *aletheia*, Heidegger argues that the fundamental sense of truth is *unconcealedness* or, more idiomatically, *disclosure*. To see a being in its truth is not to see its correspondence to an idea of it that we have in our minds but to see it for the very thing that it is, to disclose its being.

Heidegger's account of art's ability to disclose truth takes an unexpected turn in his essay. Rather than claiming that art discloses the nature of specific entities, Heidegger asserts that art is one of the few cultural forms that is uniquely positioned to disclose the nature of being itself. Heidegger believed that Western philosophy had failed to pay sufficient attention to *being*, passing over it in favor of *beings*. Heidegger's attempts to restore our awareness of being itself and one way to do so, he thought, was to show that works of art revealed its presence and presencing.

What precisely does this being-beings distinction mean? *A being* is, for Heidegger, anything that exists, what we call an "entity." Anything, from the smallest pebble to the grandest star, is a being, an entity, some-*thing* that exists. Heidegger uses the term "being" explicitly to avoid others—like "thing"—that carry along with them implicit but unthematized conceptions of what a being (an entity) is like, its basic structure, in other words, its *being*. If one were, for example, to take "thing" as the most basic means of conceptualizing beings, an implicit understanding of being would already be involved, for things—or, at any rate, *mere* things—are different from, say, works of art or persons, so one would already, albeit unconsciously, have invoked a specific conception of the being (nature) of such entities.

In my explanation of what "beings" means, I used the term "being." For Heidegger, "being" refers to the fundamental character of what exists. When we say that there are different types of things in the world, we are saying, for Heidegger, that *being* differentiates itself into different types of *beings*. It is of the utmost importance, he

PAINTINGS THAT ILLUSTRATE PHILOSOPHY  117

thinks, not to skip over the nature of being itself in order to focus exclusively on beings.

This is because, for Heidegger, being always reveals itself to humans in a specific socio-historical context. As we shall see, this is an important claim that affects Heidegger's understanding of art and its "work." For the moment, though, all that need concern us is the idea that the nature of existence always appears to us in a specific guise, one in which the being (nature) of beings (entities) is already determined.

Given the complexity of Heidegger's account of art, it is not surprising that he turns to actual works of art to give concrete illustrations of his view of art's *work*. Because he sees the human world as determined historically, Heidegger uses a number of examples from different time periods including a Greek temple. The one that is most relevant to our purposes is van Gogh's painting, *Shoes* (1886) (See Plate 9). There is some controversy about which of Van Gogh's paintings of shoes Heidegger is referencing. Although the artist made a number of paintings of shoes, it is generally agreed that Heidegger is discussing the 1886 one pictured in Plate 9.[8]

Heidegger identifies the shoes not as belonging to Van Gogh, but as those of a peasant woman who has taken them off at the end of a long day of work. Here is a portion of Heidegger's description of the painting:

From out of the dark opening of the well-worn insides of the shoes the toil of the worker's tread stares forth. . . . The shoes vibrate with the silent call of the earth, its silent gift of the ripening grain, its unexplained self-refusal in the wintry field. . . . This equipment [Heidegger's term for entities that fulfill our needs,

---

[8] Van Gogh painted shoes a number of times. The painting that Heidegger is referring to is presumably the one now in the college of the Van Gogh Museum in Amsterdam, https://www.vangoghmuseum.nl/en/collection/s0011V1962?v=1. Heidegger's interpretation was challenged by Meyer Schapiro in a series of articles. See Schapiro (1968) for an example.

118 THOUGHTFUL IMAGES

> such as shoes] belongs *to the earth* and finds protection in the *world* of the peasant woman. . . . In virtue of this *reliability* the peasant woman is admitted into the silent call of the earth; in virtue of the reliability of the equipment she is certain of her world. (Heidegger, 2002, p. 14)

The central fact about the painting, according to Heidegger, is not that it accurately depicts a pair of worn shoes but that it conveys an understanding of the life of the woman who wore the shoes, her *world*, another term Heidegger uses idiosyncratically.

Here is my understanding of how Heidegger reaches that conclusion. When we look at the shoes in Van Gogh's painting, we don't identify them simply as shoes; we realize that they are work shoes that have been heavily used by their owner. Heidegger infers that they belong to a peasant woman, a claim that the art historian Meyer Schapiro (1968) famously disputes.[9] In any case, once we make this identification, we are led, Heidegger claims, to an awareness of what the life of the peasant woman is like: how she must walk along rows of plants with the earth caking her shoes; how she becomes aware of the weather and how it will impact her life; and so on. Throughout her life, the peasant woman is able to rely on her shoes, for they make it possible for her to do the things she has to do without injuring her feet.

Heidegger uses his interpretation of Van Gogh's painting as an illustration of his theory of the significance that works of art have for our understanding the nature of human life in general. A first aspect to the effect (or *work*) of this (art)work is its revelation of what Heidegger calls the world of the peasant woman to whom the shoes belong. At first blush, we can say Heidegger uses the word "world" not to refer to a specific object existing alongside other objects, but more analogously to our use of it in speaking of the

---

[9] The disagreement between Schapiro and Heidegger is taken up by Jacques Derrida (1987, pp. 257–382).

# PAINTINGS THAT ILLUSTRATE PHILOSOPHY 119

*world* of the fashion model or the *world* of the student, in which it refers to the basic features of the lives of those engaging in these occupations.

Van Gogh's painting gives us a clear visual image of some of Heidegger's central ideas about humans inhabiting a world. As I have said, while the painting's manifest content is simply the two shoes, Heidegger suggests that there is a much richer latent content to the painting, for the two shoes reveal the existence of an entire network of objects and attitudes that make up the world of the peasant woman. Some things the worn shoes reveal, according to Heidegger, are the effort the peasant woman has to make going to and from the fields where she labors all day wearing those shoes, and her concern for having enough to eat.

The world of the peasant woman, as Heidegger sees it revealed in Van Gogh's painting, is one in which she has many cares and concerns, projects and plans. For example, she has to plant and harvest seeds so that she can feed herself and her family. To do this successfully, she *relies on* the shoes we see in the painting, for they enable her to do what she needs to do without any concerns about their functioning.

But this means that Van Gogh's painting does not just reveal the world of the peasant woman, as we might ordinarily use that term to refer to her environment. In addition, it reveals the basic character that beings or entities have in her world, what Heidegger refers to as *equipmentality (das Zeug)*. Here, Heidegger is relying on his analysis, first articulated in *Being and Time*, of the fundamental structure of beings in the modernity. He claims that the things we employ in our daily lives have the character of being objects of use—what he characterizes as the "ready-to-hand" rather than the "present-at-hand"—so that we think of them in terms of their functions rather than their structures. A chair, from this point of view, is not most basically conceived as a piece of furniture with four legs but rather as a thing-for-sitting, for, after all, that's how we use chairs, for sitting.

# 120 THOUGHTFUL IMAGES

Van Gogh's painting thus allows its viewers to grasp the fundamental structure of the world in which they as well as the peasant woman exist. The general category of "equipment" characterizes the way entities within that world are encountered. What this means is that we take the world to consist of a set of reliable tools for realizing our purposes.

We are still not done with Heidegger's interpretation, for *Shoes* does not just reveal the world of the peasant woman, according to Heidegger; it also shows that world as emerging from the *earth*. Once again, we need to be careful in interpreting what this claim means, for Heidegger does not intend us to think of the ground or even the planet we call "the Earth." Speaking a bit loosely, we can call the earth that from which the peasant's world is built—the literal earth she sows with seeds, and also the weather to which she must pay attention and upon which she depends, the leather from which her shoes are made, etc. Every *world* must take up what is available to it, namely, *the earth*, and give it shape and form.

But the earth is not simply passive, allowing itself to be easily shaped into a world. In Heidegger's view, world and earth exist in a tension that he dubs *strife*, using a term whose significance he traces back to the pre-Socratics. This indicates that just as a world needs to shape the earth in the manner that it requires—say, by turning all entities into equipment—so too does the earth resist such incorporation. Earth and world thus exist in an eternal conflict that Heiddger calls "strife."

This conflict between earth and world is important, for it explains an important aspect of Heidegger's view. He is a historicist in that he sees different historical epochs as having fundamentally different worlds that succeed one another. Our basic understanding of the world, one that we share with the peasant woman and that Heidegger characterizes as *equipmentality* at this point in his thinking, is one that distinguishes modern Western culture from other cultures and historical epochs. For Heidegger, the succession of such worlds is accounted for by the fact that the earth resists the

## PAINTINGS THAT ILLUSTRATE PHILOSOPHY    121

attempts by a world to hold it steady, to incorporate it into a static structure, and thus gives rise to different historical epochs.

All the elements are now in place for an elucidation of the formula, art is the *setting-into-work of truth*. After our detailed unpacking of Heidegger's essay, its meaning seems almost obvious. What this phrase means is that the social practice of art involves the creation of a work—that which is *set up*—that reveals the truth about human life. The truth that is revealed is the basic "world-in-strife-with-earth" unity that constitutes an historical epoch. Although our lives are unconsciously structured by the unity that makes up our age, it is only through such things as works of art that we become aware of this basic feature of our lives.

Van Gogh's painting plays an important role in Heidegger's argument about the origin of the work of art. Although he articulates the basic elements of his claim purely discursively, he relies on Van Gogh's painting to help his audience understand various aspects of his theory and to give it some plausibility. Without reliance on an illustration like this, Heidegger's account would remain abstract and even more difficult for readers to comprehend than it is.

Heidegger uses Van Gogh's painting to illustrate his claims about the "work" of art. He sees Van Gogh as providing a visual analogue to his own claims about how truth can be "set-into" a work, how a painting can reveal fundamental facts about our understanding of being. As was the case in Nietzsche's reliance on *Transfiguration*, Heidegger uses *Shoes* for a variety of reasons. A first is simply to explain the various elements in his theory of art's "work." Another is to give his readers an image that, as I put it, "crystallizes" his theory in a memorable manner. Heidegger's interpretation of *Shoes* is intended not only to show the validity of his account of what he terms "the origin of the work of art" but also to give his audience an easily recalled image that brings to mind the key claims of his theory.

In so doing, Heidegger employs *Shoes* as a visual illustration of his theory. As was the case with Nietzsche, a philosopher uses an artwork that predated his own theorizing to illustrate it. I have

## 122  THOUGHTFUL IMAGES

employed the category of theory-based illustration to explain such an innovative use of a work of visual art to illustrate a theory that is developed linguistically.

### Foucault and *Las Meninas* (Velasquez, 1656)

The final philosopher I consider in this chapter is Michel Foucault. Foucault was very interested in the arts and wrote a good deal about them. For example, he devoted an entire book, *This Is Not a Pipe* (1991), to the work of the surrealist painter René Magritte.[10] However, for the purposes of this book, I shall discuss only his interpretation of Velázquez's *Las Meninas* (1656) in his *The Order of Things* (1970), for Foucault begins the book by using the painting to illustrate some of the fundamental themes of that book.

In *The Order of Things*, Foucault presents an account of the development of differing assumptions about the nature of knowledge in the three different eras of Western history, from the Renaissance onward. In so doing, he puts some content into Heidegger's assertion that being reveals itself differently to people at different times in history. But Foucault eschews talk of being. In its place, he introduces the notion of an *episteme*, by which he means the fundamental assumptions about knowledge that are dominant in a particular epoch.

To justify his claim that there have been two fundamental transformations in the Western *episteme* since the Renaissance, Foucault traces differences in how "labor, life, and language" have been conceptualized in the different eras. Using the fruits of his extensive research in archives, Foucault charts the changes in the assumptions we have about these three fundamental areas of human life.

---

[10] Magritte saw himself more as a thinker than as a painter. This makes him an artist whose works are related to ones I discuss in this book.

## PAINTINGS THAT ILLUSTRATE PHILOSOPHY    123

One of Foucault's most controversial but also important claims is that "man" [*sic*] is a figure that arises only in the modern era. Before that, he claims, there was no such unified entity as that referred to by the term "man." His purpose in so doing is, at least in part, to show that there is a possibility of transcending this problematic being. Man and the disciplines based upon that concept—the human sciences of biology (life), economics (labor), and philology (language) (Foucault, p. 345)—are possible only within the Modern *episteme*; its breakdown heralds, in Foucault's famous phrase, "the disappearance of man" (Foucault, p. 386). Here again, Heidegger's influence on him is palpable. If man is a recent invention, then his existence may soon be transcended and, along with him, all of the scientific means by which he is known and controlled.

Central to Foucault's argument is the notion of *episteme*, an era's fundamental understanding of the nature of knowledge. He holds that all of the specific disciplines of a given age implicitly employ the same understanding of knowledge, the same *episteme*. Through history, one *episteme* gets replaced by another, and it is Foucault's project to trace this evolution.

The first era that Foucault documents is the Renaissance. Here, the central idea is *resemblance*. Something counts as an item of knowledge when it resembles the object that it attempts to know. As Foucault puts it:

> The nature of things, their coexistence, the way in which they are linked together and communicate is nothing other than their resemblance. And that resemblance is visible only in the network of signs that crosses the world from one end to the other. (Foucault, p. 29)

Since the objects in the world are signs, knowledge consists in deciphering the signs and thereby understanding, among other things, God's purposes. For example, because walnuts resemble the human brain in appearance, one might think that eating them

124 THOUGHTFUL IMAGES

would make one smarter, a mistaken belief based on treating the world as containing signs.[11]

In the Classical Age—roughly from 1600 to 1800—the second of the three eras Foucault describes, *representation* takes center stage. No longer does knowledge have to resemble the object known; instead, the relationship between them is conventional, one in which the knowledge refers to objects without having to share any common features with them. It is a time in which scientific rationality became dominant, in part through the efforts of philosophers from Descartes to Kant. Common to the efforts of these philosophers was the idea that scientific observation could unpack the nature of reality and provide access to a true, non-subjective view of the world.

Finally, there is Modernity and the dominance of the *organic*. An organism is an entity all of whose parts are internally related to one another. A foot is a foot in virtue of its relationship to other body parts and its ability to support the body, for example. Foucault argues that this organicist understanding of things gives rise to history as a crucial element of knowledge:

> History, as we know, is certainly the most erudite, the most aware, the most conscious, and possibly the most cluttered area of our memory; but it is equally the depths from which all beings emerge into their precarious, glittering existence. Since it is the mode of being of all that is given in experience, History has become the unavoidable element in our thought. (Foucault, p. 219)

Foucault here argues that we believe that anything that exists must come into existence through a historical process. Darwin's theory of evolution provides a paradigmatic example of how entities conceived of as organisms take their place in a historical order that explains their existence, the nature of their properties.

[11] This example was suggested by Robert Wicks.

PAINTINGS THAT ILLUSTRATE PHILOSOPHY 125

We don't have to concern ourselves with the details of either Foucault's account of these three distinct *epistemes* or of his claims about how they succeed one another in a contingent manner. We can also bypass Foucault's controversial claim that man has a place only in the Modern *episteme*, for we are interested only in understanding his use of a painting to illustrate some of the ideas he develops in *The Order of Things*.

Given my brief account of that book, you may be surprised to learn that its first chapter consists of a very detailed interpretation of Diego Velázquez's masterpiece, *Las Meninas* (1656) (Plate 10). Given the scope of Foucault's study, it is unexpected to find him begin by interpreting a painting. He does so, however, because he takes the painting to illustrate the nature of the Classical *episteme*. Let's see what he says about that work.

Foucault gives an extended description and interpretation of *Las Meninas* that pays attention to many of the details in the painting. I don't attempt to replicate it here—only to highlight certain features of it. The most important one is Foucault's emphasis on *representation* as the subject of the painting.

As Svetlana Alpers (1983) has emphasized, one of the remarkable features of the painting is that it portrays a number of its central characters as staring out of the canvas directly at the space occupied by the viewer. This gives rise to a sense of uncanniness, for we know that they can't be looking at *us*, for we are separated from the painting by a number of centuries. In addition, the place that we occupy as we look at the painting is the place that might have been occupied by the invisible subject that the represented painter is painting. It is also the position that Velasquez himself must have occupied while he was painting *Las Meninas*. That is, the fiction of the painting is that its central personages—from the depicted painter to the young Princess—are looking at the very place occupied by the person(s) that the depicted painter is fictionally painting. Of course, Velázquez actually painted the picture we are looking at, but his painting portrays him as the artist

## 126 THOUGHTFUL IMAGES

in the painting, painting a different painting whose subject we are barred from seeing.[12]

This is a painting about representation; this should be clear, as Velázquez has painted himself painting a canvas of which we can see only part of its reverse side.[13] As the king and his wife are captured in the mirror at the rear of the room, we might be tempted to infer that they are the subject of the painting, the models whom we cannot see but who are occupying the space we are actually standing in.[14] And while there is something to this suggestion, we don't know whether they really do have this role, for their image is so truncated that we can't infer with certainty what their role in the scene really is or the physical place they must occupy.

Foucault thinks that this painting provides a clear visual illustration of representation:

> Perhaps there exists, in this painting by Velázquez, the representation as it were, of Classical representation, and the definition of the space it opens up to us. And, indeed, representation undertakes to represent itself here in all its elements. . . . This very subject . . . has been elided. And representation, freed finally from the relation that was impeding it, can offer itself as representation in its pure form. (Foucault, pp. 17–18)

Foucault has a somewhat Hegelian view of history insofar as he maintains that any socio-historical stage contains an inconsistency that it cannot resolve. So, at the heart of representation, which the Classical Age takes to be the fundamental epistemic relation, lies

---

[12] The apparent paradoxical nature of this painting anticipates the issue of self-referentiality that I discuss in relation to *Logicomix* and *Fun Home* in chapter 9.

[13] For an illuminating discussion of the painting that explores its self-referential nature, see Stoichita, pp. 247–255.

[14] Stoichita (1997, pp. 251–255) suggests that the mirror is reflecting a portion of the depicted canvas that is not visible to us.

# PAINTINGS THAT ILLUSTRATE PHILOSOPHY    127

an inability to adequately characterize the subject of representation itself.

So, Foucault sees this painting *illustrating* a general truth about the nature of representation, a truth that he attempts to defend in the section of *The Order of Things* devoted to the Classical *episteme*: that there is an ineluctable aspect of representation that cannot itself be represented. As he puts it:

> It may be that, in this picture, as in all the representations of which it is, as it were, the manifest essence, the profound invisibility of what one sees is inseparable from the invisibility of the person seeing—despite all the mirrors, reflections, imitations, and portraits. Around the scene are arranged all the signs and successive forms of representation; but the double relation of the representation to its model and to its sovereign, to its author as well as to the person to whom it is being offered, this relation is necessarily interrupted. (Foucault, p. 16)

Foucault here points out the diverse modes of representation contained in *Las Meninas*: mirrors, reflections, imitations, and portraits. But despite this multiplicity, the absence of the subject of the depicted painting shows, according to Foucault, the impossibility of representing the one doing the representing and the one being represented within the Classical Age. Or, as he summarizes his conclusion, "It is not possible for the pure felicity of the image ever to present in full light both the master who is representing and the sovereign who is being represented" (Foucault, p. 16).

Robert Wicks asserts that Foucault takes the painting to demonstrate that Classical representation defies the very limits it sets for itself. Because the painting points toward a point outside of itself in which the viewer is located and the actual painter had to have been, it visualizes the impossibility of the scheme of Classical representation to find a place for the act of representation itself (Wicks, 2010, p. 623). Wicks points out that Foucault thinks an essential

## 128 THOUGHTFUL IMAGES

feature of the painting is that the viewer occupies a position outside of the painting itself. This is also the place where Velázquez must have stood as he executed the painting, as I have said. At the same time, as we have also seen, this is where the painting's subjects (those being painted) must have stood, given the aligned glances of the painting's various personages. But since it lies outside the painting itself, it points to a limitation of Classical representation, its inability to account for the act of representation itself.[15]

Foucault's target here is philosophically significant, for all the early modern philosophers from Descartes through Hume took representation to be the essence of the human mind, the means whereby the mind was able to move beyond itself and grasp extramental reality. Foucault's claim is that this view of our fundamental relationship to the world is deeply flawed because it cannot account for the act of representation itself, as he puts it, the "subject" that does the representing.

Foucault uses Velázquez's painting and its elision of the subject of the represented painting to illustrate his claims about the Classical *episteme*. The painting is self-referential insofar as it is a painting about painting and the nature of representation. Its uniqueness is that very elision of its own subject.[16] Foucault believes that this demonstrates the lacuna in the system of representation that dooms it to being replaced by a new "order of things."

Foucault's use of *Las Meninas* is my third and final example of a philosopher who uses a painting to illustrate philosophical claims he advocates. He uses it differently from the other philosophers we have discussed in this chapter because he introduces his discussion of the Classical *episteme* with a discussion of the painting, rather than introducing it subsequent to his presentation of his theory. Nonetheless, he takes the painting to show us something

---

[15] Wicks (2010) is very critical of both Foucault's interpretation of Velázquez's painting and the subsequent discussion that interpretation generated.

[16] For an interpretation of *Las Meninas* that contradicts Foucault's, see Svetlana Alpers (1983).

## PAINTINGS THAT ILLUSTRATE PHILOSOPHY   129

that he will attempt to justify more discursively, namely, the inevitable absence that haunts the very idea of representation. Independently of whether you think Foucault is correct about the problem he attributes to representation, it is clear that he thinks that his ideas can best be conveyed using a painting, for this work of art, despite having been created around 350 years prior to *The Order of Things*, illustrates some of the central ideas he seeks to defend in that book.

Like Nietzsche and Heidegger, Foucault employs a painting as a means of making some of his theoretical claims more accessible and memorable to his readers. This raises the question of what it is about paintings that prompted these philosophers to use them as theory-based illustrations of their theories.

In discussing the broadsides in chapter 3, I made reference to empirical research that showed that people remember information better if a verbal description is supplemented by visual images (Levie and Lentz, 1982). Words together with images allow people to remember an idea better than words alone; and because they can be taken in at a glance, visual images crystallize a theory that has to be described at length using words.

So, if a philosopher is interested in making sure that his readers understand his theory correctly and also retain that understanding, it makes sense to employ a visual image in addition to a verbal description of it. This may account for these three philosophers' use of well-known paintings to illustrate their theories. In addition to these psychological aspects of the use of images, the philosophers may also have thought that having a well-known painting identified with their theories would provide additional support for their theories, as I have argued earlier in this chapter.

The psychological research about the differences between verbal and visual media in terms of the speed at which they are processed and also how people are able to retain the information presented in them is a crucial one as we consider what the significance is of illustrations of philosophy. I have already mentioned these factors

130   THOUGHTFUL IMAGES

and will continue to do so in the rest of the book. It is important to remember the scientific basis for such claims.

## Intention and Illustration

A significant issue is raised by the use of these three paintings as illustrations of philosophical theories: Does it make sense to see a painting as illustrating a philosophical theory when it was not intended to do so by its creator?

It's easiest to justify this claim in the case of *Las Meninas*. Although Velázquez could not have intended to illustrate what Foucault calls the Classical *episteme*, there is no reason to deny that he did intend to depict the manner in which paintings are able to represent things and the limitations of what can be represented in this manner. That is, it is perfectly reasonable to claim that the subject matter of Velázquez's painting is the nature of pictorial representation. After all, he was a painter, and there is a tradition of painters painting paintings about the nature of painting. In fact, two of the paintings Velázquez painted on the back wall of *Las Meninas* are "allegories of artistic creativity in competition with divine creation" (Stoichita, 1997, p. 249), Peter Paul Rubens's *Athene and Arachne* (1636–1637) and Jacob Jordaens's *Apollo and Marsyas* (1625). Foucault's use of the painting is legitimated by Velasquez's placing it within a context of artworks about the nature of art.

In addition, the very subject matter of *Les Meninas* is clearly the act of painting itself. Velázquez has painted himself painting a picture, although the represented artist has paused in his work to glance at his painting from slightly behind the position he would normally take while painting. The manner in which the canvas on which the represented artist is working is barred from our sight also pushes us to consider what the subject matter of *that* painting is. If we attempt to use the mirror to reveal the subject of the painting,

PAINTINGS THAT ILLUSTRATE PHILOSOPHY 131

our efforts are frustrated because the mirror is not clearly reflecting those subjects. All in all, *Les Meninas* compels the viewer, as Stoichita (1997, p. 255) says, "to meditate on the paradox of representation."

A different rationale has to be used to justify Nietzsche's claim that *Transfiguration* illustrates the relationship between the Dionysiac and the Apolline. Since Nietzsche's theory claims that these two cultural tendencies have been present throughout history, it is legitimate for Nietzsche to hold that Raphael created a painting in which the two are present. After all, Christianity is one of the forms that the Apolline takes, so Raphael could be indicating the idealized nature of the Christian worldview even though he could not specifically conceptualize it in Nietzschean terms. By juxtaposing two biblical stories, Raphael likely intended to show how Jesus was able to transform human life, curing a young boy from demonic possession. While he abstracts from the painting's religious content, Nietzsche also sees the painting as showing the emergence of one mode of being from another one.

Van Gogh's *Shoes* presents a more complex problem. Heidegger's claims about the work of art are normative in that they posit an essential characteristic, or actually several essential characteristics, of artworks. Most fundamentally, Heidegger claims that works of art reveal the context in which one or more objects exist. This aspect of an object is normally not available to us while we use it in its customary manner. But art opens up or discloses the normally hidden aspect of an object to us, according to Heidegger.

From Heidegger's point of view, any successful work of art will disclose an object's context, the world in which it has a place, in his terminology. A perspicuous representation of an object in a work of art will necessarily involve revealing the world in which it is, in the case of *Shoes* the world of the peasant woman whose shoes Heidegger thinks they are. This doesn't mean that Van Gogh would have to consciously seek to reveal that world through his painting of the woman's shoes; rather, because Van Gogh seeks to make a

132  THOUGHTFUL IMAGES

genuine work of art, he depicts the shoes in such a way as to reveal facts about their wearer that Heidegger terms her world.

From a theoretical point of view, the importance of these three philosophers' use of paintings as illustrations of their theories is that it points to the existence of a type of illustration that I have not previously discussed: a *theory-based illustration*. As I have said, I call this type of illustration "theory-based" because it is the use of a theory, in these instances the philosopher's own theory, that justifies the claim that the painting is an illustration. Without the presence of such a theory, we could not see the works as illustrations. What the theory does is to guide an *interpretation* of the painting that posits it as an illustration of that very theory.[17] All three philosophers use their theories to interpret the paintings they view as illustrations of their own theories. What the theory does, by means of an interpretation, is to highlight aspects of the paintings that we might not have seen as significant. Once the significance of these features becomes evident, it makes sense to see the paintings as illustrating the theory in question.

It is worth pointing out that theory-based illustrations appear in places other than the works of philosophers. Art historians often point to a work of an artist claiming that it illustrates a future development in art history.[18] Consider, for example, Cezanne's *Still Life with Apples and a Pot of Primroses* (c. 1890). Even a cursory glance reveals that the table on which the apples and pot rest is not depicted from a single point of view but rather from two disparate points of view simultaneously. This is an example of what the art historian Katharine Kuh calls "break-up," claiming it to be the core of modern art (Kuh, 1965). It makes sense to say that *Still Life with Apples and a Pot of Primroses* not only *illustrates* breakup, but portends how that notion, central to modern art, gets its start

---

[17] It is equally plausible to call this type of illustration "interpretation-based," since the theories in question guide interpretations.

[18] I owe this point to Jeffrey Strayer.

in Cezanne. This is not an anachronist claim about what Cezanne intended to illustrate but rather a theory-based claim about what the work illustrates. As in the interpretations made by the three philosophers we have considered, this interpretation highlights features of the work—the presence of two different points of view—that might have escaped our attention without it, but are clearly significant once they are made prominent by the interpretation. And it is a theoretical claim about the role of Cezanne's art in the development of Cubism that grounds the interpretation.

## Conclusion

This chapter has pursued an interesting development in the illustration of philosophy: the use of paintings to present philosophical ideas and themes. All of these paintings are realistic to the extent that the "action" of the painting takes place in a single, coherent space. This marks a departure from previous representational techniques used to illustrate philosophy.

The first three paintings we looked at were all designed by their creators to illustrate some aspect of philosophy. All three of them feature famous philosophers, although they do so in different ways. Raphael creates a vast tableau in which all the famous Greek philosophers have a place and surround the two giants of philosophy, Plato and Aristotle. Rembrandt focuses only on Aristotle, but he allows us to gain access to his attitude toward Homer. The painting emphasizes the reverence Aristotle feels for his great predecessor and thereby asserts the commonality between philosophy and the arts. David, using bright colors, provides a model for his fellow citizens by depicting the imperturbable Socrates facing his own death with more than equanimity, making good his claim that philosophy is a preparation for death.

The second set of three paintings features works that were not designed by their creators to illustrate a philosophical theory.

134  THOUGHTFUL IMAGES

Nonetheless, three philosophers use them to illustrate some of their own theoretical positions. Nietzsche uses *Transfiguration* to support his account of the role that the Apolline-Dionysiac dichotomy plays in Western society and history; Heidegger shows us that *Shoes* exhibits more than what he takes to be a peasant's footwear, demonstrating how it illuminates the world of the peasant to us; Foucault uses *Las Meninas* to both illustrate the nature of representation as conceived by the Classical Age and also to show the defect that will cause its transcendence. These are three examples of theory-based illustrations.

Behind the writings of all three philosophers lies the idea that paintings themselves have philosophical content that a sensitive interpreter can bring out. As they each look at a painting made prior to their articulating the philosophical theories present in their writing, they find an artist aware of the ideas they wish to validate. Although their use of these ideas goes beyond anything the artists who painted them might have intended, it supports the claim that art provides an important resource for the illustration and elucidation of philosophical ideas and theories.

I juxtaposed three paintings used by philosophers as illustrations of their own ideas with the three paintings with which I began the chapter and which were consciously used by their creators to illustrate philosophical ideas. My purpose was to highlight two distinct ways in which great paintings in the Western tradition have illustrated philosophical texts, ideas, and theories. Despite the fact that Raphael, Van Gogh, and Velasquez could not have been aware of the theories their works are supposed to illustrate, Nietzsche, Heidegger, and Foucault treat their paintings as doing just that. I have not attempted to endorse the interpretations put forward by these philosophers, only to use them to point out the existence of a type of illustration that we had not yet discussed, viz., theory-based illustrations.

With Heidegger's use of *Shoes*, we move away from the realist style I claimed was present in Western painting from the Renaissance

until the late nineteenth century. That transitional work does not employ vanishing point perspective but a new sense of painting that will become dominant in the Modernist movement. This new conception of painting will bring it into alliance with philosophy, as we shall see in chapter 6.

# 6
# Modernist Art as Philosophy

In 1969, Barnett Newman cast a retrospective glance at the reasons he and his fellow Abstract Expressionists adopted a new and revolutionary style of painting. That school of painting had its heyday in 1950s New York. Newman is reflecting on the events in the first half of the twentieth century that he felt explained these artists' desire to radically break from the norms of traditional painting.

> You must realize that twenty years ago we felt the moral crisis of a world in shambles, a world devastated by a great depression and a fierce world war, and it was impossible at that time to paint the kind of paintings that we were doing—flowers, reclining nudes, and people playing the cello. At the same time, we could not move into the situation of a pure world of unorganized shapes and forms, or color relations, a world of sensation. And I would say that for some of us, this was our moral crisis in relation to what to paint. So, that we actually began, so to speak, from scratch, as if painting were not only dead but had never existed. (Quoted in Wicks, 2020, p. 162)

Newman focuses on two major historical events as part of his explanation for the development of the painting style of Abstract Expressionism. First, the Great Depression. After the 1929 stock market crash, millions of people were thrown out of work with little prospect for being able to meet their basic needs. Shortly thereafter, Hitler came to power in Germany and that eventually led to the Second World War. It was not just the war itself but the industrialized killing of millions of Jews, political activists,

*Thoughtful Images.* Thomas E. Wartenberg, Oxford University Press. © Oxford University Press 2023.
DOI: 10.1093/oso/9780197650547.003.0006

MODERNIST ART AS PHILOSOPHY 137

homosexuals, and gypsies in Death Camps that affected not just the Abstract Expressionists but also millions of people living at that time. The mood prevalent after the war can be seen in the oft-cited statement of T. W. Adorno about the impossibility of writing poetry after Auschwitz (Adorno, 1983, p. 34).

The question that Newman's remark presses on us is how the painting style of Abstract Expressionism addresses the issue of making art, specifically painting, after the Depression and the Holocaust. What he suggests is that he and his fellow artists embarked on reinventing painting from the ground up, that is, starting from scratch and not making any assumptions about what paintings should be or depict.

The traditional subject matter of paintings would have to be eschewed, as Newman remarked, because it seemed inadequate in the current context. But if a painting in this new, more radical mode could not employ any of the typical genres that paintings had previously employed—no portraits, still lifes, landscapes, or nudes, for example—then what could a painting be about?

The art critic and theorist Clement Greenberg suggested that the Abstract Expressionists were left only with painting itself as the subject matter for their paintings. In this chapter, I will explore Greenberg's suggestion and how it links the Abstract Expressionists to philosophy, for what these artists did was to create theory-based works that extended the range of visual illustrations of philosophy.

Greenberg's theory and the art it champions have been criticized in the decades since their ascendancy. I will look at the artist and philosopher Adrian Piper's critique of Greenberg and Abstract Expressionism. Piper asserts that it is a mistake to abandon the customary aims of art, so the works of the Abstract Expressionists failed to adhere to important aspects of traditional art. She views her own art as more firmly connected to the tradition of Western art, so that it is able to embody the critical social perspective she takes to be one of the hallmarks of Western art. She does so by rejecting the Abstract Expressionist elimination of "foreign" content from their

138   THOUGHTFUL IMAGES

work. I shall argue that despite its embracing of content, Piper's work also has a legitimate claim to be doing philosophy.

## Abstract Expressionism

The term "Abstract Expressionism" is used to characterize the artistic style of a group of artists who were active in New York during the 1950s. The members of this group include the painters Jackson Pollock, Lee Krasner, Mark Rothko, Grace Hartigan, Barnett Newman, Joan Mitchell, Robert Motherwell, Helen Frankenthaler, Norman Lewis, Clyfford Still, Ad Reinhardt, Willem de Kooning, and Elaine de Kooning—although the role of female and African American artists in the creation of this group has often been neglected.[1] In addition, a number of sculptors, David Smith and Louise Nevelson among others, are also included as practitioners of this style of art. Here, I will focus exclusively on the painters.

Stylistically, there are significant differences among the works of these artists. Pollock is known for his drip paintings. These were created by literally allowing paint to fall from a brush or stick that he moved across a canvas that was placed on the floor of his studio. One of the results of this radical departure from the norms of traditional easel painting is that every inch of the canvas became equally significant. Unlike most paintings since the Renaissance, Pollock's works have no central focus; each part of the canvas is as important as any other.[2]

Helen Frankenthaler, by way of contrast, created canvases in which there are large fields of color formed by diluted paint soaked into the canvas. Like Pollock, she painted large canvases and often placed them on the floor of her studio. However, her technique,

---

[1] *Ninth Street Women* by Mary Gabriel (2019) corrects this neglect by focusing on the women artists who were essential to this artistic movement.

[2] Pollock was not the inventor of the drip technique. Janet Sobel was. She made such paintings during the 1940's.

# MODERNIST ART AS PHILOSOPHY 139

while as radical as his, retained the traditional emphasis on the center of the canvas. One difference is that her paintings, and those of other artists with whom she shared this basic technique, is that the paintings are more static than Pollock's, less concerned to show the activity of painting rather than its result.

Despite such differences, there are a number of features that unite the Abstract Expressionists. They generally painted large canvases, not the small canvases favored by many more traditional painters. They eschewed representational subject matter for the most part, though Willem de Kooning is known for his paintings of women. And, as we shall see, there was a shared concern to make paintings that addressed the issue of the nature of painting.

## Modernist Painting as Philosophy

The theorist who first linked Modernist paintings to philosophy was, as I mentioned, Clement Greenberg. He maintained that as painting developed in the nineteenth and twentieth centuries, painters attempted to delineate the essential features of the artform, thereby initiating a philosophical dialogue about the nature of painting in their works.On his account, this trajectory led to the work of the Abstract Expressionists who he believed created paintings that showed the essential feature of painting.

In his essay "Modernist Painting," Greenberg focuses on the work of these painters, for he believes they share a common concern and practice, one that he labels "Modernist." He characterizes Modernism as follows: "The essence of Modernism lies, as I see it, in the use of characteristic methods of a discipline to *criticize* the discipline itself, not in order to subvert it but in order to entrench it more firmly in its area of competence" (Greenberg, 1982, p. 5, emphasis added). Greenberg is here applying Kant's characterization of his own philosophical method as *critical* to the works of these painters.

140    THOUGHTFUL IMAGES

As is well known, Kant's *Critique of Pure Reason* is a ground-breaking work. To establish the uniqueness of his enterprise, Kant characterizes his own philosophy as critical. From Kant's perspective, previous philosophers (he characterizes them as "metaphysicians" to highlight the centrality of metaphysics to philosophy as he conceived it) had failed to question the very possibility of metaphysical knowledge, that is, knowledge of reality as it actually is. They simply assumed that such knowledge could be attained through either reason (the Rationalists) or experience (the Empiricists). This led metaphysicians from both schools to make illicit philosophical claims whose inadequacy Kant seeks to demonstrate in the second half of the *Critique of Pure Reason*. Using a characteristic systematic structure, Kant diagnoses the origin of all the attempts made by his predecessors to secure metaphysical knowledge independently of experience. In every case, Kant argues, the claims made by his predecessors were illegitimate.

To focus on just one example, in the "Antinomies" chapter of the first *Critique*, Kant criticizes both the Rationalists and the Empiricists for trying to determine the spatial and temporal extent of the world simply on the basis of pure reason alone. Kant chastises them for failing to ask whether the world can actually be an object of a "possible experience," that is, whether we could actually have empirical acquaintance with such an "object." The world is, of course, too large for us to perceive it in its entirety. But that did not stop traditional metaphysicians from attempting to gain knowledge of it.

By failing to ask whether metaphysics was actually possible, Kant's predecessors failed to see that the objects of traditional metaphysics—the self, the world, and God—cannot be experienced in the same way that ordinary objects such as tables and chairs are. As a result, these metaphysicians tried to extend the principles that work well in regard to empirical objects to these three special "objects." The result, according to Kant, was their making claims

MODERNIST ART AS PHILOSOPHY   141

to have knowledge that were unjustified, resulting in paralogisms, antinomies, and other logical errors.

But even though Kant was critical of previous attempts to produce metaphysical knowledge, he did not reject the attempt to provide knowledge independently of experience. He insisted that such knowledge was of *appearances* only, not of *reality in-itself*. To produce such knowledge, he developed a radically new method which he termed "transcendental." As part of his program, he introduced what he called "a Copernican Revolution" into metaphysics, thereby characterizing his own method as one that paralleled the most important scientific advance of his time, the replacement of the Ptolemaic, geocentric universe with a Copernican, heliocentric one. Just as Copernicus had solved the problem of planetary motion by this shift of perspective, Kant claims to have transformed the theoretical perspective of metaphysics from one in which the fundamental question was "What do things have to be like in order to exist?" to one that asks "What must things be like in order for us to experience them?" The result of this methodological shift is the production of a set of truths that form the framework for our empirical knowledge of appearances. Kant believes that these principles are established on a secure foundation in his Critical Philosophy, one that cannot be subjected to the sort of critique he lodges against his predecessors.

From Greenberg's point of view, two features of Kant's project are central. First, there is the self-critical aspect. Kant doesn't just try to produce theoretical truths about the empirical world; he emphasizes the importance of first demonstrating that it is possible to have such knowledge. This adds a self-critical layer to the traditional metaphysical project of gaining knowledge of reality and explains why he emphasizes the importance of his own, transcendental methodology.

Second, in presenting this criticism of traditional metaphysics, Kant is not attempting to destroy it, as some of his initial critics like Moses Mendelssohn had thought.[3] He is, in Greenberg's

---

[3] In the preface to *Morning Hours*, Mendelssohn refers to the "all-destroying Kant."

142 THOUGHTFUL IMAGES

terminology, using a metaphysical method to establish on a more secure foundation his own metaphysics of the world of appearances.

Greenberg uses his understanding of this Kantian project to conceptualize what he thinks is unique about Modernist painting. Earlier in the nineteenth century, artists like Gustav Courbet and Rosa Bonheur had worked in a *realist* mode. In her groundbreaking book, *Realism*, Linda Nochlin states that the aim of realism "was to give a truthful, objective and impartial representation of the real world, based on meticulous observation of contemporary life" (Nochlin, 1971a, p. 13). For example, in works like *Plowing in the Nivernais: The Dressing of the Vines* (1849), Bonheur depicted cows plowing a field under the guidance of some farmers. The painting is based on meticulous study of rural life, so that viewers might feel that they are seeing the scene as if it were really there before their eyes and not just the subject of a painting.

The assumption that the goal of painting was to create such transparent views of reality dominated theoretical accounts of art going all the way back to Plato's banning of poetry from his ideal Republic (Plato, *Republic*, Book X). Modernist painters, to the contrary, rejected this assumption. For them, painting had to eschew all content that was given externally, that is, that related a painting to objects in the external world. Instead, painting had to focus on the nature of painting itself without importing any "alien" content. So, the project of Modernist painting—especially as realized in the work of the Abstract Expressionists—was to create works that had no content other than painting itself. It was this shared project that united all the Modernists and that distinguished them from more traditional painters.

Of course, Modernist painting did not come from nowhere. Beginning with the canvases of Édouard Manet in the mid-nineteenth century and proceeding through the Impressionists and Expressionists, Modernist painters deemphasized the

MODERNIST ART AS PHILOSOPHY **143**

representational character of their works.[4] For example, Claude Monet's late *Water Lilies* paintings are less about what water lilies actual look like in a pond than they are about the swirling colors and effects of light Monet perceived in his pond in Giverny.

It's appropriate to ask whether Modernist artists' reflections on the nature of painting resulted in a single answer to the question of painting's nature or in a variety of different ones, depending on what the artist took to be painting's essential feature(s). Could different artists answer this question differently and produce radically different types of work?

Greenberg answers with a resounding "No!" He posits that there was a single answer given by the Modernist painters to their self-critical reflection on painting. In developing this argument, Greenberg relies on Gotthold Lessing's contention in *Laocoön* (1767) that each artform is different from every other one in virtue of their respective mediums. To justify this claim, Lessing focuses on a single, exemplary case, viz., the difference between poetry and sculpture in regard to their temporality. Poetry, he argues, in necessarily sequential because that is the nature of language. A thought can only be expressed linguistically by a sequence of words, and these must be apprehended by a reader or listener one after the other to yield a coherent sentence. The sentence, "Socrates is a man," is made up of four words in a specific order, and they must be apprehended in that order at distinct temporal moments by a reader for the sentence to make sense.

Sculpture, Lessing argues, has a different relation to temporality. He believes that all of a sculpture's elements can be apprehended in a single moment. Consider, for example, Barbara Hepworth's 1934 abstract sculpture *Mother and Child*. A viewer situated at an appropriate distance from the work can take in all of its central

---

[4] Greenberg does not mention the work of J. M. W. Turner. But he could be regarded as the first Modernist painter because of his blurring of the distinction between figure and ground, as Jeffrey Stayer suggested to me.

## 144   THOUGHTFUL IMAGES

elements—the mother, the child she holds in her lap, the relationship between them—in a single glance. Vision presents a multiplicity of spatial items that can be apprehended simultaneously.[5]

Basing his claim on the putative difference between the temporality of these two artforms, Lessing argues that they must represent the same action differently. While the poet must aim to provide a complete description of a course of action, the sculptor should focus on a single moment, specifically the one just before the climax of the action.

Although Lessing developed his theory through his observations of the two artforms, cognitive psychologists have recently shown that there is strong empirical evidence to support his claims. As a result of experimentation, they determined that the brain is able to process entire images in as little as 13 milliseconds (Potter *et al.*). Apprehending linguistic descriptions takes much longer since a reader must absorb a linguistic text sequentially, decoding the words one after the other. This difference between the speed and manner in which visual and linguistic information is processed was noted by Lessing, and his insights are now confirmed empirically.

Lessing himself justifies his theoretical claim through an examination of the ancient sculpture whose creator is not known, *Laocoön and His Sons*, housed in the Vatican Museums. This sculpture shows the unfortunate priest and his two sons being strangled by two huge serpents.[6] The mythological story the sculpture illustrates is about Laocoön, a Trojan priest, who angered Minerva by trying to convince his fellow Trojans not to bring the giant wooden horse left by the Greeks into the city of Troy. In revenge,

---

[5] Particularly in the case of sculpture, where the rear of the work may be as important as the front and needs to be seen in a separate act of attention, this claim seems inapplicable. Still, there is a difference in how visual images and language are "taken in" by audiences, a difference that has now been studied by scientists, as I reported in chapter 5.

[6] Art historians disagree about whether this is an original work or a copy, and thus who the creators of it were. For one opinion, see Kenneth Clark, 1960, pp. 219–221. There are a variety of different classical sources for this story that disagree about some of the details.

## MODERNIST ART AS PHILOSOPHY    145

she sent two huge serpents to kill him and his two sons, as Virgil reported in the *Aeneid* (lines 201ff). Unable to represent this entire temporal process, the sculptor portrayed a moment just prior to the deaths of the three individuals. This is particularly appropriate, according to Lessing, for we can anticipate the fate awaiting the three and witness their struggle to avoid it, albeit frozen in time. Tellingly, the horrific conclusion is not depicted. (It is worth noting that this sculpture is a text-based illustration.)

Lessing focuses on the difference between Virgil's literary description of the event and the depiction of it by the sculpture. His point is that successful works in these two different mediums have to adhere to the essential features of their artform and not incorporate aspects that are appropriate only in the other form. Space is the defining feature of sculpture, whereas poetry involves action and hence time.

Greenberg takes from Lessing the idea that successful works of art in a particular artform have to be made with an awareness of the nature of that artform's distinctive medium. Unlike Lessing, Greenberg does not focus on space and time as elements of works of art. He pursues the more radical idea that each artform should attempt to express the essential features of its medium by rejecting all other content as extraneous. In so doing, the artforms will purify themselves by excluding all content not essential to their individual mediums.

> Each art, it turned out, had to perform this demonstration [of the value and uniqueness afforded by that art] on its own account. What had to be exhibited was not only that which was unique and irreducible in art in general, but also that which was unique and irreducible in each particular art. . . . The task of self-criticism became to eliminate from the specific effects of each art any and every effect that might conceivably be borrowed from or by the medium of any other art. Thus would each art be rendered "pure." (Greenberg, 1982, pp. 5–6)

146 THOUGHTFUL IMAGES

Greenberg here derives the specific character of Modernist painting from his account of the general nature of Modernism. All of the arts, he claims, face the same Modernist challenge: to purify themselves by eliminating the presence of anything that might be shared with another artform. It is this drive for *purity* that is distinctive of Modernism for Greenberg.

Greenberg's famous claim is that there is only one feature of painting that can be the legitimate focus for a Modernist painter because there is only one feature of a painting that it shares with no other artform: the *flatness* of the painted surface. Importing any other content into a painting undermines its purity and must be avoided by the Modernist artist, he states.

It's important to realize a potential ambiguity in the term *flatness*. For a painting literally to be flat, it could not stand out from the wall at all as do paintings that involve canvases. It was only in the late 1960s that artists made works that were flat in this radical sense by literally painting them on the wall. Two examples of works made directly on the wall of a gallery or museum are Andy Warhol's *Cow Wallpaper* (1966) and Sol Lewitt's *Wall Drawings* (1968–2007). But that sense of flatness is not what Greenberg has in mind, since all the Abstract Expressionists painted on canvas. For him, "flatness" refers to the absence of a representational structure that creates the illusion that one is looking into a three-dimensional space. In place of that, Modernist painters created canvases whose focus was on the surface of the canvas to the exclusion of everything else.[7]

It's not clear what Greenberg's justification is for rejecting other elements of painting that might also be unique to it as an artform as suitable content. For example, even if we only consider formal properties, there is the geometrical shape of the traditional canvas

---

[7] There is some question about whether the paint-soaked canvases of some of the Abstract Expressionists, color-field painters like Helen Frankenthaler and Mark Rothko, are limited to the surface of the canvas. In addition, Frankenthaler often gave titles to her paintings like *Mountains and Sea* (1952) that suggest they do have representational content.

MODERNIST ART AS PHILOSOPHY  147

(most are rectangular although tondos are circular) or the use of colored pigments (though we now know the Greeks painted their sculptures). Either or both of these could perhaps be taken to be essential features that painting does not share with other arts. But it is the flatness of a painting that Greenberg takes to be the only essential property of painting.

Greenberg's focus on flatness as the metaphysical feature of painting that is unique to it as an artform allows him to construct an historical narrative about Modernist painters developing a style of painting that privileges this feature. According to Greenberg, Édouard Manet is the first Modernist painter precisely because he is the first to reject the illusionistic space that had been essential to Western painting since the Renaissance. Greenberg takes the use of vanishing point perspective to violate Lessing's stricture because it employs in a painting a feature—the three-dimensionality of space—more properly belonging to sculpture. In works like *Olympia* (1863), while retaining a representational structure, Manet eschews the creation of a deep, receding space in favor of a shallow space that is nearly identical with the plane of the canvas. The central reclining figure in *Olympia* confronts the viewer with her direct gaze, a radical departure from the tradition of presenting naked women for the pleasure of the presumed male viewer (cf. *The Rape of Europa*, Plate 2). For Greenberg, however, the crucial feature of the painting is a *formal* one, viz., its rejection of a receding spatial perspective in favor of a completely flat one. By creating paintings that emphasized this unique feature of painting as an artform, Manet made a significant contribution to the philosophical understanding of painting.

In Greenberg's historical story, Manet's attempt to create paintings that do not employ an illusionistic spatial aspect is followed by a sequence of artists and styles that progressively make the flatness of the canvas more and more prominent. But the art movement that completed the rejection of illusionistic space was Abstract Expressionism. The achievement of Jackson Pollock, for

148 THOUGHTFUL IMAGES

example, was to create something recognizable as a painting that eschewed all the elements of painting that were not essential to it. Although Abstract artists like Wassily Kandinsky had rejected illusionistic space and a representational style, they still retained elements from traditional painting, such as the focus on a central region of the canvas. Even Piet Mondrian, whose spare, geometrical works appear to be the epitome of flatness, incorporated some of the principles of perspective into his works, as Meyer Schapiro has convincingly demonstrated (1995).

Jackson Pollock, along with other Abstract Expressionists— the other two whom Greenberg mentions are Mark Rothko and Clyfford Still—created paintings that met Greenberg's criterion of privileging the flatness of the canvas as the essential feature of painting. Pollock's "drip paintings," such as *White Light* (1954) (see Plate 11), are remarkable for eschewing all representational subject matter while also refusing to privilege any area of the canvas as more important than any other. For this reason, they are often called "all-over" paintings, a term that was first applied to the work of Janet Sobel. The surfaces of Pollock's canvases are completely filled with paint, with no space demarcated as marginal, less essential than any other. In a painting such as *Las Meninas* (Plate 10) that employs traditional perspective, our focus is directed to a single point, in this case the man in the doorway, the so-called vanishing point. Pollock's eschewal of perspective results in each element of the canvas being equally prominent. This contributes to the sense that his works emphasize the flat canvas surface that bears the paint.

Greenberg's discussion of Abstract Expressionism reflects the male bias that Linda Nochlin identified in 1971 as endemic in art history (Nochlin, 1971b). Although Greenberg identifies a number of different painters as part of the Abstract Expressionist movement, he neglects to mention Janet Sobel, Lee Krasner, Elaine de Kooning, Grace Harlingen, Joan Mitchell, or Helen Frankenthaler, all important artists whose work can be seen as focused on the importance

of the picture plane. Greenberg also ignores the work of African American artists who also contributed to Abstract Expressionism. (See Sheets, 2014, for a discussion of their role.) This, despite the fact that the African American artist Norman Lewis was part of the exclusive circle of artists organized by Willem de Kooning and Franz Kline (Kenney, 2019). Both women and black artists were crucial to the movement, and Greenberg's account simply erases their presence. If we pay attention to their contributions, a richer historical story than the one Greenberg tells emerges.

This erasure is only one of the problems with Greenberg's account. It could be argued, for example, that calling attention to the nature of paint is as important to the flatness Greenberg saw as essential to painting. However, the feature of his account of Modernist Painting that has come in for the most sustained criticism is its formalism.[8] Greenberg's account of the Modernist painters' works leaves out other aspects of them such as their content. His failure to include the content of a painting as essential to its nature neglects an important aspect of traditional painting, a claim we shall see Piper adderssing shortly. In addition, he doesn't discuss such important artistic movements as Surrealism since they don't fit into his narrative. But Surrealism is an artform that reflected on the nature of painting and also contributed important works that illustrate philosophy, as many of René Magritte's canvases do. (See Foucault [1991] for a discussion of the significance of Magritte's canvases.) In addition, Greenberg's account of Abstract Expressionism is not the only viable one. There are other insightful accounts of the development of the types of paintings Greenberg discusses, such as that presented by Harold Rosenberg through the concept of "action painting" (Rosenberg, 1959). Pollock's work are good examples of works that illustrate that term.

---

[8] See, for example, T. J. Clark (1982) for a criticism of Greenberg for neglecting the role of negation in modernist art. Greenberg's approach has also had its defenders. For one, see Michael Fried (1964) who argues for the necessity of formal criticism of modernist art.

# 150 THOUGHTFUL IMAGES

These problems are also significant from the point of view of my account of illustrations of philosophy. In considering works that illustrate philosophy, I am paying attention to the content of Modernist paintings, something Greenberg did not do. In addition, as I have said, the Surrealists made important contributions to illustrations of philosophy, so paying attention to them is crucial.

But rather than dwelling on the shortcomings of Greenberg's account, I want to pursue a different issue: Does Greenberg's account of Modernist painting provide a rationale for claiming that artists working in this tradition were actually doing philosophy by means of creating paintings?

Greenberg denies that artists themselves were consciously attempting to create paintings that embodied flatness: "No one artist was, or is yet, consciously aware of this tendency [toward flatness], nor could any artist work successfully in conscious awareness of it" (Greenberg, 1982, p. 9). Greenberg made this claim partly because he felt that *he* was the first to have identified flatness as the essential aspect of Modernist Painting. If this is the case, then the painters themselves would have, of necessity, been unable to conceptualize their work as attempting to embody it. This is, of course, a self-serving reason, so we need to ask whether Greenberg's claim about what artists were doing is defensible on its own merits.

Although Greenberg denied that the Abstract Expressionists were consciously attempting to create paintings that displayed the flatness of the canvas, he does suggest that these artists did actually make a contribution to the philosophy of art.

I repeat that Modernist art does not offer theoretical demonstrations. It could be said, rather, that it converts all theoretical possibilities into empirical ones, and in so doing tests, inadvertently, all theories about art for their relevance to the actual practice and experience of art. Modernism is subversive in this respect alone. Ever so many factors thought to be essential to the making and experiencing of art have been shown not to be

**Plate 1** Tom Phillips, "The Schismatics" from *Dante's Inferno*, 1983. © 2022 Artists Rights Society (ARS), New York/DACS, London.

**Plate 2** Titian, *The Rape of Europa* (c.1560–1562). Isabella Stewart Gardner Museum, Boston

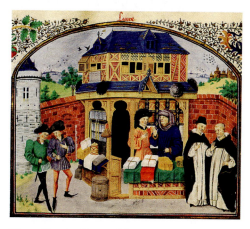

**Plate 3** The Three Types of Friendship in Aristotle's *Nicomachean Ethics* (fifteenth century). NPL-DeA Picture Library/M. Seemulle/Bridgeman Images.

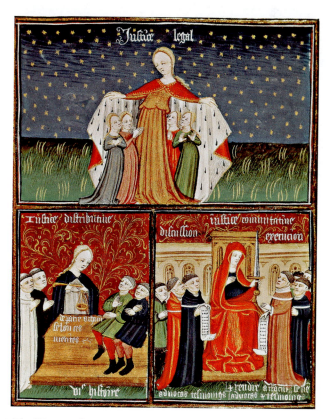

**Plate 4** The Nature of Justice in Aristotle's *Politics* (fifteenth century). Musée Conde, Chantilly, France© Iberfoto/Bridgeman Images.

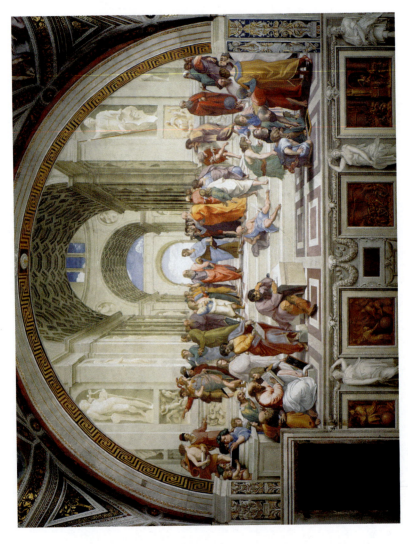

**Plate 5** Raphael Sanzio, *School of Athens* (1509–1511).

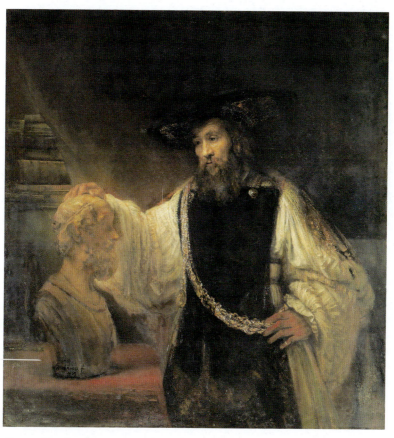

**Plate 6** Rembrandt van Rijn, *Aristotle Contemplating a Bust of Homer* (1653). Metropolitan Museum of Art.

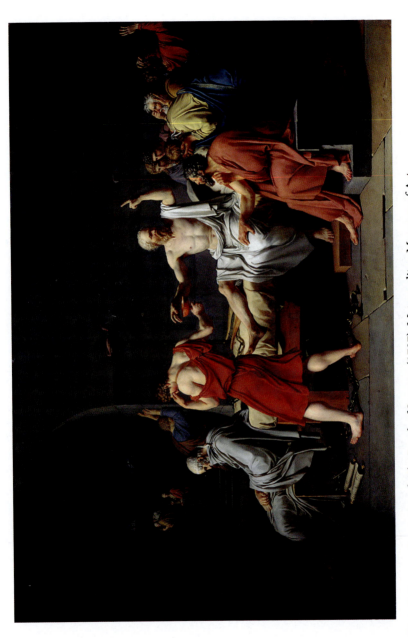

**Plate 7** Jacques-Louis David, *The Death of Socrates* (1787). Metropolitan Museum of Art.

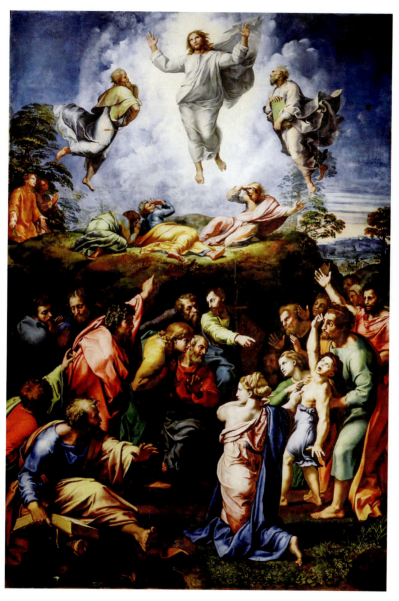

**Plate 8** Raphael Sanzio, *Transfiguration* (1516–1520). incamerastock/Alamy Stock Photo.

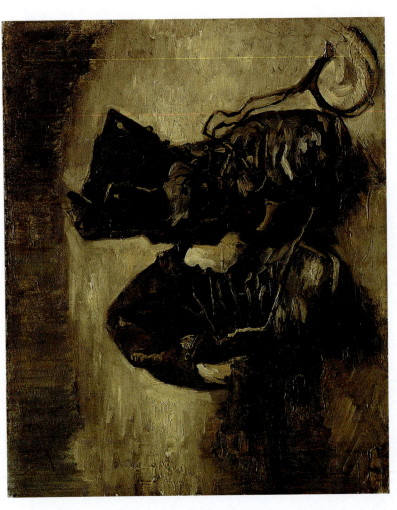

**Plate 9** Vincent Van Gogh, *Shoes* (1886). Van Gogh Museum, Amsterdam, The Netherlands. Photo © Fine Art Images/Bridgeman Images.

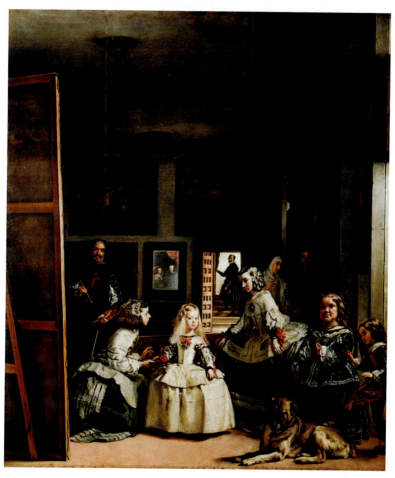

**Plate 10** Diego Velasquez, *Las Meninas* (1656). incamerastock/Alamy Stock Photo.

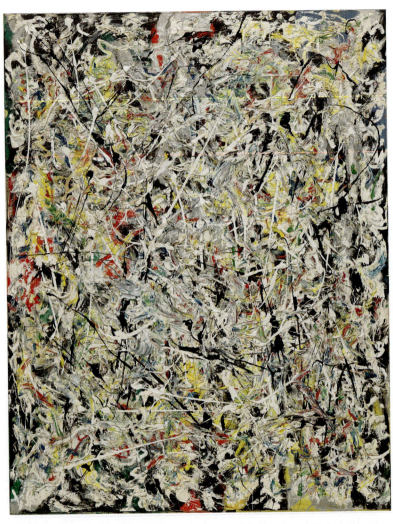

**Plate 11** Jackson Pollock, *White Light*. 1954. Oil, enamel, and aluminum paint on canvas, 48 1/4" x 38 1/4" (122.4 x 96.9 cm). The Sidney and Harriet Janis Collection. Digital Image © Museum of Modern Art/Licensed by SCALA / Art Resource, NY.

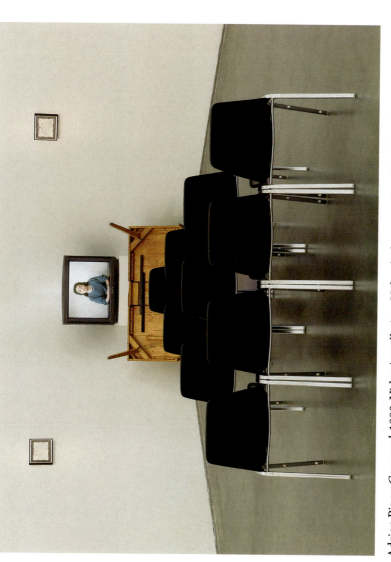

**Plate 12** Adrian Piper, *Cornered*, 1988. Video installation. Video (color, sound); with tablem chairs, monitor, two framed birth certificates for Adrian Piper's father Daniel R. Piper, and lighting. Dimensions variable. Photo creid: Nathan Keay. Collection of the Museum of Contemporary Art Chicago. ©Adrian Piper Research Archive (APRA) Foundation Berlin.

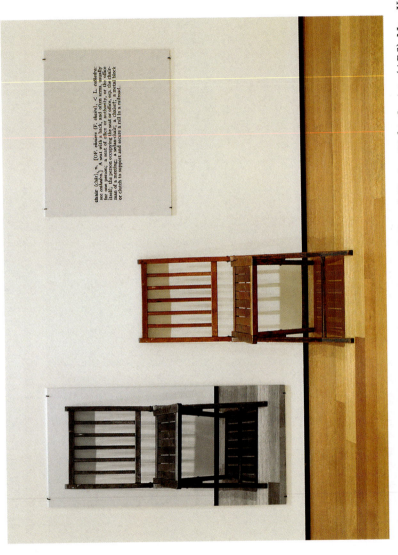

**Plate 13** Joseph Kosuth, *One and Three Chairs*, 1965. © 2022 Joseph Kosuth/Artists Rights Society (ARS), New York.

**Plate 14** Joseph Kosuth, 276. *On Color Blue*, 1990. Neon tubing, transformer, and electrical wires, 30 x 162 in. (76.2 x 411.48 cm). Brooklyn Museum, Mary Smith Dorward Fund, 1992.215. © 2022 Joseph Kosuth/Artists Rights Society (ARS), New York.

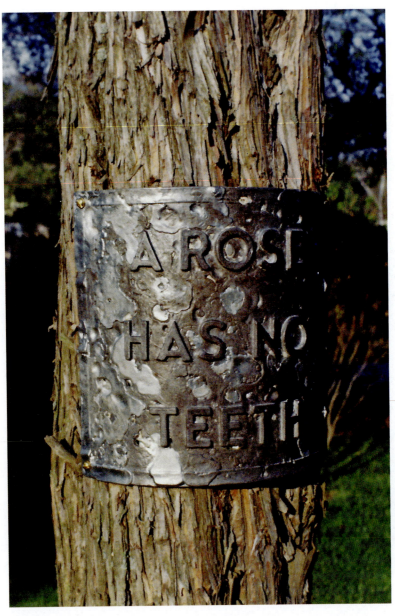

**Plate 15** Bruce Nauman, *A Rose Has No Teeth* (Lead Tree Plaque), 1966.

**Plate 16**  Mel Bochner, *If the Colour Changes #1* (1987).

**Plate 17** Jasper Johns, *Seasons ("Spring")* (1987). © 2022 Jasper Johns / Licensed by VAGA at Artists Rights Society (ARS), NY.

**Plate 18** Maria Bußmann, *Drawing to Wittgenstein's "Tractatus"* (1996–1999).

**Plate 19** Maria Bußmann, *Tractatus 3.324* (1996–1999).

**Plate 20** Eduardo Paolozzi, *He Must, So to Speak …* from *As Is When*, 1965. © The Paolozzi Foundation, Licensed by DACS / ARS 2022.

**Plate 21** Eduardo Paolozzi, *Parrot* from *As Is When*, 1965. © The Paolozzi Foundation, Licensed by DACS / ARS 2022.

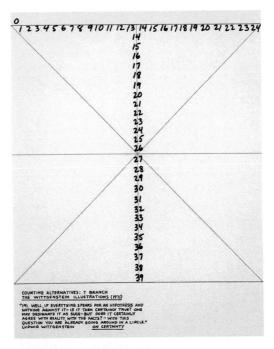

**Plate 22** Mel Bochner, *"T" Branch* (1971).

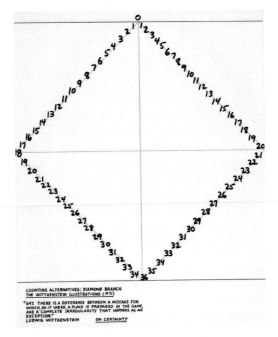

**Plate 23** Mel Bochner, *Diamond Branch* (1971).

**Plate 24** Mel Bochner, *Fourth Range* (1973).

**Plate 25** Mel Bochner, *Range* (1979).

**Plate 26** "Hist! Look There!," Classics Illustrated No. 4, *Last of the Mohicans*, Illustrated by John P. Severin, Leonard P. Cole, Stephen L. Addeo,© 2012 First Classics, Inc., classicsillustratedbooks.com.

**Plate 27** *WHAMM!, Deconstructing Roy Lichtenstein*™ © 2000, David Barsalou MFA, https://www.flickr.com/photos/deconstructing-roy-lichtenstein/.

MODERNIST ART AS PHILOSOPHY 151

so by the fact that Modernist art has been able to dispense with them and yet continue to provide the experience of art in all its essentials. (Greenberg, 1982, p. 9)

Previously, philosophers and art theorists had posited various features as the essence of art. Imitation (Aristotle), the communication of emotion (Leo Tolstoy), significant form (Clive Bell), the expression of emotion (Suzanne Langer), and the unconcealing of truth (Martin Heidegger) are examples of the types of properties that had been considered essential to art and, hence, painting.[9] Modernist painters painted paintings that, at least on Greenberg's account, lacked all of those features and yet were not just recognizable as paintings but were also acknowledged to be great works of art. The only feature of traditional painting that the Modernists did not eliminate, on Greenberg's view, was the flat surface upon which they placed their paint.[10]

This account gives the Modernist painter an important role. The Modernist painter does not do the sort of conceptual work that Greenberg did in "Modernist Painting." The Modernist painter, by the very fact of making paintings that are both flat and artistically significant, demonstrates that previous conceptions of the nature of art are inadequate. Speaking philosophically, we can say that, through their works, Modernist painters have demonstrated the falsity of received theories about the nature of art and shown that flatness is painting's only truly essential property. Their works function as counterexamples to traditional conceptions of painting and suggest the significance of the flat surface provided by the stretched canvas.[11]

---

[9] I discuss all of these theories in my edited 2011 collection, *The Nature of Art*.

[10] Greenberg is a formalist and, as such, is not interested in the content of the works he champions. Yet many of the works do appear to express emotions and thus to embody a traditional feature of painting not acknowledged by Greenberg.

[11] The philosopher who most explicitly theorized artists' contributions to philosophy is Arthur Danto. See, especially, his 1981 *The Transfiguration of the Commonplace*. He sees Andy Warhol as making an important contribution to philosophy.

## 152   THOUGHTFUL IMAGES

It is important to recognize that the Abstract Expressionists made their philosophical point by creating concept-based illustrations. The concept that these painters illustrated was, not surprisingly, flatness. In creating their revolutionary paintings, the Abstract Expressionists not only undermined traditional assumptions about the nature of painting, but they did so by illustrating their understanding of what the essence of painting was and, in so doing, philosophized in paint.

When we look back at Greenberg's argument seventy years or so later, we realize that the attempt to provide a definition of painting that would lay bare its essential nature was a mistake. While Kant may have been justified in claiming that causality was part of the innate structure of the human mind, the category "painting" no longer seems as immutable as it did to Greenberg. The objects that are displayed on the wall of a museum now take a variety of forms, including the three-dimensionality traditionally taken to be definitive of sculpture. Such departures were encouraged by the Modernist painters' insistence that paintings had to be flat, a claim that, once made, became the target for subsequent generations of painters and sculptors to subvert.

### Adrian Piper's Confrontational Art

Adrian Piper is a contemporary artist whose works have generated a great deal of controversy. Her 2018 exhibition at the Museum of Modern Art in New York, *A Synthesis of Intuitions, 1965–2016*, was the largest exhibition of a living artist ever shown there. In addition, Piper has a PhD in philosophy from Harvard University and has written extensively on Kant as well as on art. This makes her a unique presence in the artworld, since she is a formidable Kant scholar as well as a skilled and important artist.

Piper's art is a far cry from the work of the Abstract Expressionists, however. Unlike them, she thinks it is important for art to address

## MODERNIST ART AS PHILOSOPHY    153

social issues, so it is a serious mistake to reject all "external content" from works of art, as the Abstract Expressionists were said to have done (Piper, 1996, 209). Her own art is a clear example of philosophically informed art that rejects the assumptions made by Greenberg and the Abstract Expressionists.

In "The Logic of Modernism," Piper is extremely critical of Greenberg's formalism and the art that he champions for its very emphasis on formal features. To support her criticism, she provides a very different account of art than that developed by Greenberg. She characterizes what she calls "Euroethnic art"—a term I take to refer to those Europeans who were not viewed as white, viz., Eastern Europeans, Southern Europeans, and European Jews—as having four characteristics: appropriation, formalism, self-awareness, and social content.

*Appropriation* is a well-known feature of Western art. Extending all the way back to the influence of Byzantine art on Duccio and Cimabue, Western artists have developed their own artistic styles through the incorporation of ideas from non-Western art. To justify this claim, Piper cites the influence of Japanese art on Van Gogh, the impact of African art on Picasso, and the use of tropes from African American graffiti by Keith Haring (Piper, 1996, p. 209). Piper conceives of such appropriation as an important feature of Western art that a theorist like Greenberg simply misses.

Piper traces the *formalism* of Western art—a feature we have seen emphasized in Greenberg's account of the Modernist tradition—to this appropriation of art from other cultures. Because Western artists were working in very different social circumstances from those of non-Western artists, their works had to abstract from those conditions. As a result, they borrowed only formal techniques from these other artists, ignoring the social function the art might have had. According to Piper, the formalism of Western art is derived from its appropriative nature (Piper, 1996, p. 210).

The formalism of Western appropriative art also results in its *self-awareness*. To appropriate the formal techniques of non-Western

**154 THOUGHTFUL IMAGES**

art, Western artists had to be aware that non-Western artists were using techniques that were not available in the canon of Western art. This led these artists to become conscious that their own style was a choice of one among many, leading to a self-conscious awareness about the nature of their own work.

Finally, Piper argues that Western art has generally attempted to have a social impact, so that art has traditionally had a *social content*. One only has to think of Pablo Picasso's *Guernica* (1937), Francisco Goya's *The Disasters of War* (1810–1820), or Édouard Manet's *Dejeuner sur l'herbe* (1862–1863)—these are Piper's examples—to see that Western art has used formalist devices to render specific content in a manner that promotes social action (Piper, 1996, p. 210–211). *Guernica*, for example, was painted by Picasso in response to the dictator Francisco Franco's bombing of the town of Guernica in the Spanish Civil War. Picasso used the Cubist style he had recently developed (along with Georges Braque and Juan Gris) to create a work that had a tremendous impact on its viewers precisely because its radical stylistic innovation allowed it to express Picasso's indignation in a way that could not be in works done in more traditional styles. The stylistic innovations of such important artists were in the service of their social vision.

Given this perspective on Western art in general, it is no surprise that Piper sees Greenbergian formalism as "an aberration" (Piper, 1996, p. 210). In particular, she is critical of his treatment of social content as *impure*, as sullying the appropriate character of art. If an interest in social issues marks an impurity in art, then art is left with no subject matter other than its own nature, exactly as Greenberg claimed. However, from Piper's point of view, Greenberg's endorsing of abstraction is a misunderstanding of the nature of Western art that ignores much that is responsible for its value and impact.

Piper characterizes the artistic movements subsequent to Abstract Expressionism as efforts to restore art to its traditional mission. She mentions Sol LeWitt as reintroducing content into art

MODERNIST ART AS PHILOSOPHY 155

through his claim that the idea is more important than its realization, an idea we will discuss when investigating Conceptual art in chapter 7. She also discusses artists including Joseph Kosuth and Hans Haacke who have adopted strategies related to her own in an attempt to create contemporary art with significant social content and meaning (Piper, 1996, p. 213214).

Given her critique of formalism, it is not surprising to discover that Piper's own art has a significant socio-political agenda. Piper is a light-skinned African American woman, although she now resists that designation preferring to be called, "The Artist Formerly Known as African American" (http://www.adrianpiper.com/news_sep_2012.shtml). Much of her art is an attempt, as Michael Brenson puts it, "to expose and challenge assumptions about race that make it difficult for some people to see those with a different skin color in a fully human manner" (Brenson).

To explain this focus of her art, Piper describes her own art-making practice as stemming from her own identity as a woman of color and how those characteristics have affected her experience. She says that her own art moved "from my body as a conceptually and spatiotemporally immediate art object to my person as a gendered and ethnically stereotyped art commodity" (Piper, 1996, 213–214). It's clear that Piper uses her own identity to give her art social content.

In focusing on her own identity, Piper is employing an avowedly Kantian artistic strategy. In the first *Critique*, Kant used a theory of the self and its activities as the basis for his critique of traditional metaphysics. His theory of synthesis is an account of how the self processes the information it receives from the senses into a coherent view of the world. It is instructive to consider how Kant's notion of self-activity might have been used by Piper to develop a unique artistic style.

It is this application of a Kantian perspective that indicates Piper's commitment to producing art that is philosophically significant. But there is another reason that her art has philosophical

156 THOUGHTFUL IMAGES

content. Unlike the Abstract Expressionists, who excluded all content other than what is necessary for something to be a painting, Piper creates art that has a political and social content. But rather than keeping her art from doing philosophy, as Greenberg's view implies, this approach results in work that does philosophy because of the impact it has on its viewers. Her art is confrontational in that it directly addresses her audience members, asking them to reflect on racialized aspects of their identity. And it is their reflections that mark her art as philosophical, albeit in a distinctive manner.

It is important to acknowledge that the landscape of philosophy has changed a great deal since the time of the Abstract Expressionists. Political philosophy, which had been pretty much ignored by analytic philosophers, became a vital area of research and discussion after the publication in 1971 of John Rawls's *A Theory of Justice*. As a result, the philosophy of race also was acknowledged as a valid subject area in philosophy. There has been vigorous debate, for example, about whether "race" refers to a biological reality or is something that is constituted by how people are treated differently because of characteristics like the color of their skin.[12]

Piper's work raises issues of race in a philosophical manner. In particular, the work pushes white audience members to think more deeply about their unacknowledged racial attitudes. These days, it is generally acknowledged that whites need to become more aware of the ways in which they participate, perhaps unconsciously, in the racism of American society. Piper's art does this through the use of her own body and what was at the time her chosen self-identification as black.[13]

Piper had been using herself as the subject of her work since the 1970s. In 1981, she created *Self-Portrait Exaggerating My*

[12] For one insightful account of the nature of race, see Appiah, *In My Father's House* (1993).

[13] As I mentioned above, Piper no longer identifies this way. On this, in addition to the previous citation, see http://www.adrianpiper.com/dear_editor.shtml.

MODERNIST ART AS PHILOSOPHY 157

*Negroid Features*. This work is one that explores her own racial identity artistically but also philosophically. This piece poses questions about how we visually identify a person as being of a specific race. It problematizes assumptions that people make about racial identity. Because she does not have stereotypical Negroid facial features, Piper was assumed by many people to be Caucasian. This work counters that assumption by challenging viewers to accept her self-identification at that time as black or African American.

Piper's 1988 work *Cornered* (see Plate 12) continues to explore racial identity both artistically and philosophically, albeit in a more confrontational manner. In this work, a TV monitor is placed in the corner of a gallery with a large table overturned against it. Ten chairs are arranged in a triangle facing the monitor. Piper addresses the audience in a quiet and casual voice as they look at her face. Here, too, Piper plays on her ambiguous racial identity, the result of her light skin and conservative style of dress. But she moves beyond her earlier work by presenting a carefully worded argument that deconstructs not just her own apparent racial identity but also that of her audience.

In the work, Piper addresses its viewers, telling them that according to genetic statistics and the normal conventions of racial classification, they are likely black. This claim is meant to be confrontational, with white viewers being forced to reflect on their own racial identity. She presents them with a number of alternatives. She asks the audience:

> Are you going to research your family ancestry, to find out whether you are among the white "elite"? Or whether perhaps a mistake has been made, and you and your family are, after all, among the black majority?
> And what are you going to do if a mistake has been made? Are you going to tell your friends, your colleagues, your employer that you are in fact black, not white, as everyone had supposed?

158    THOUGHTFUL IMAGES

Or will you try to discredit the researchers who made this esti-
mate in the first place? (Quoted by Rinder, p. 1)

Viewers of *Cornered* are made to reflect on their own racial
identities in ways they likely had not done prior to encountering the
installation. For example, viewers may not have been aware that if
they are white American, they likely had at least one black ancestor,
making them black on at least some official ways that have been
used to determine a person's race. According to the "one drop" rule,
anyone with one drop of African American blood counts as African
American. This rule was used in some southern states to enforce
segregation and, in particular, to prohibit interracial marriage.[14]

The ignorance of many white people about the specific practices
used to enforce racism in the United States provides the context for
understanding *Cornered*. By asserting her own blackness, Piper
confronts viewers with their failure to reflect seriously on their
assumed identity as white, to ask whether their assumption about
their racial identity is true to their genetics and history.

Viewers of *Cornered* who are made uncomfortable will likely
begin thinking about their own identity in new ways. For this
reason, I characterize the work as philosophical as it causes viewers
to reflect about their own identities in ways they had not done
previously.

To see why I believe that Piper's work is philosophical, consider
the practice of Socrates in one of Plato's early dialogues, *Euthyphro*
(Plato, 2002). Socrates encounters Euthyphro as he is headed into
court for his own trial. Euthyphro is there to prosecute his own
father for impiety. In his characteristic manner, Socrates asks
Euthyphro to explain to him what piety is. As Euthyphro attempts
to present a coherent answer to Socrates's question, Socrates keeps
showing him the problems with his proposed answers. Eventually,

[14] For more information on the one-drop rule, see Dworkin and Lerum, "Race,
Sexuality, and the 'One Drop Rule'" (2009).

## MODERNIST ART AS PHILOSOPHY    159

the frustrated Euthyphro breaks off the conversation saying he has business to conduct.

The feature of Socrates's practice that I want to emphasize is the attempt to get someone to see the need to reflect on basic features of their world and experience that they had taken to be unproblematic. For Euthyphro, this meant thinking about the meaning of piety.

Piper's work operates similarly. The audience members of *Cornered* are to critically consider their own racial identities and attitudes. Disquieting as this may be, questioning one's previously unquestioned assumptions can function as the beginning of philosophical engagement.

So, like Socrates, Piper's work gets her audience to engage in philosophical reflection stimulated by her work. Lawrence Rinder acknowledges this aspect of Piper's work when he concludes, "As in *Cornered*, Piper's art leaves us less certain of who we are, but more engaged in determining who we might be" (Rinder, 1989). This effect—the beginning of a more serious reflection on one's racial and gender identity—is precisely what constitutes the philosophical impact of some of the most effective works by this philosopher-artist.

## Conclusion

In this chapter, we have seen a new way in which works of art can illustrate philosophy. Through an examination of claims about the Abstract Expressionist made by Clement Greenberg, I argued that artists such as Jackson Pollock created concept-based paintings that illustrated what Greenberg claimed to be painting's essential nature, flatness. The significance of this is that it extends my argument that great paintings can also be illustrations. Indeed, seeing works like *White Light* as concept-based illustrations assists us in understanding their appeal.

## 160 THOUGHTFUL IMAGES

After a critical assessment of Greenberg's claim, I examined the work of Adrian Piper, an artist and philosopher who rejects Greenberg's view of painting in favor of a more socially engaged form of art making. Despite her rejection of Greenberg's view and her criticism of Abstract Expressionism itself, I have attempted to show why I think that Piper's own art can legitimately be said to be doing philosophy.

In chapter 7, I will, to an extent, continue this line of enquiry by focusing on works of art influenced by the philosopher Ludwig Wittgenstein. While some of the works I will discuss stick to the more traditional approach by illustrating his ideas, others will develop the idea that art can do philosophy through continuing the deconstruction of the "illustration-doing philosophy" dichotomy that I began in chapter 2.

# 7

# Art Inspired by Wittgenstein

In this chapter, I return to a consideration of art made to illustrate the ideas and theories of a philosopher. Unlike the illustrations of Aristotle's ideas that I discussed earlier, the ones I focus on in this chapter do not have a primarily pedagogical function. They are full-fledged works of art that take their inspiration from the work of one of the most important twentieth-century philosophers, Ludwig Wittgenstein (1889–1951). Although Wittgenstein did not write extensively about the nature of art, his views about language, which form the core of his philosophical writings, inspired many artists to develop works that illustrate some of the ideas and theories he put forward.[1] Many of these artists, though not all, belong to the school of Conceptual art.

One of the interesting features of these works is that many of them introduce a new form of visual illustration of philosophy by using Wittgenstein's actual words in them. Earlier, we saw how, with the rise of Realism, text became excluded from works of art. Works in the Realist tradition employed a visual space that was exclusively imagistic, even when it eliminated representational elements. With the advent of Cubism and its use of collage, words once again invaded the purely pictorial space of Western art. A number of the artists who I discuss in this chapter integrated Wittgenstein's words into their works, creating a distinctive type of visual illustration. They did so by transferring the philosopher's words from the printed page into visually arresting artistic mediums. In addition,

---

[1] Wittgenstein's discussion of issues in aesthetics are published in his (1967) *Lectures and Conversations*.

*Thoughtful Images.* Thomas E. Wartenberg, Oxford University Press. © Oxford University Press 2023.
DOI: 10.1093/oso/9780197650547.003.0007

## 162 THOUGHTFUL IMAGES

I will also explore a unique means of illustrating philosophy, viz., using a visual image in a work of art that is transposed from a work of philosophy.

After a brief examination of Wittgenstein's philosophy and the nature of Conceptual art, I will explore the works of a number of twentieth-century artists who created artworks employing Wittgenstein's text: Joseph Kosuth, Bruce Nauman, Mel Bochner, and Jasper Johns. Johns is a transitional figure. In some of his works, the element of Wittgenstein's texts that appears is a visual image, thereby creating a novel type of illustration of philosophy. He also uses a more standard form of illustrating Wittgenstein's ideas by finding a visual correlate for one of his significant theories. A similar strategy animates Maria Bußmann's illustrations of Wittgenstein's *Tractatus*. The chapter ends with a consideration of Eduardo Paolozzi who attempted the most comprehensive illustration of Wittgenstein's works and life.

In exploring these Wittgenstein-inspired works of art, my emphasis will be on explicating the manner in which Wittgenstein's ideas are illustrated by them. Although all of the artists I discuss garnered inspiration from the great philosopher, their works exhibit a wide variety of ways of visually expressing his ideas.

## Ludwig Wittgenstein

Wittgenstein is one of the most important philosophers of the twentieth century. He published only one philosophy book during his lifetime, the *Tractatus Logico-Philosophicus* in 1922, although typescripts of his lectures were later circulated among his students and colleagues at Cambridge University where he taught. The most important of these were later published as *The Blue and Brown Books* (1958). His second major work, *The Philosophical Investigations* was published posthumously in 1953 and contains his mature thought in which he repudiated many of his earlier ideas. Many other works

ART INSPIRED BY WITTGENSTEIN 163

by Wittgenstein have appeared subsequently, mostly consisting of notes he had been working on at the time of his death but was not ready to publish. Among the most significant is *On Certainty* (1959), a book I will discuss in detail in the next chapter in relation to Bochner's illustrations of it.

Wittgenstein's ideas evolved significantly during his lifetime. Nonetheless, his central focus remained constant throughout his life: He was interested in investigating the nature of language and how it structures our understanding of the world. As a young man, Wittgenstein had encountered the philosophical works of the German logician and philosopher Gottlob Frege and the British philosopher Bertrand Russell. Both of these philosophers were also concerned with understanding how language functions and had developed revolutionary philosophical accounts of its working. Russell in particular thought that our ordinary ways of talking are not sufficiently clear and that it was necessary to employ the resources of modern logic, recently developed by Frege, to construct an adequate theory of language. (I will discuss this more fully in chapter 9 in relation to *Logicomix*.) One of Russell's fundamental ideas was that one could reveal the true meaning of sentences whose grammatical structure misleads us by using the techniques of logic.

In the *Tractatus*, Wittgenstein followed Russell's lead. He also believed that logic provided the key for understanding the nature and structure of language. An important element of his account is "the picture theory of language." The basic claim of this theory is that language pictures the world or, as Wittgenstein puts it, "$2.12 A picture is a model of reality" (Wittgenstein, 1961). When I say "Fred is standing next to Mary," the words "Fred," "standing next to," and "Mary" provide a type of picture of Fred standing next to Mary, although the grammar of the sentence obscures this fact. The three elements of the sentence reflect reality. Ordinary language, with its complex grammatical structure, makes it difficult to discern the pictorial aspect of language, but an ideally perspicuous language

# 164 THOUGHTFUL IMAGES

would reveal the picturing structure of words, Wittgenstein thought.

It's clear that many of the things we say don't fit this model of language. When I say, "It's wrong to steal!," for example, there is no entity in the world or relationship among entities that are pictured by the word "wrong." Wittgenstein was aware of this and argued that only sentences that pictured facts could be true or false. Other uses of language did not reflect the structure of the world. This explains Wittgenstein's famous conclusion to the *Tractatus*: "§7 What we cannot speak about we must pass over in silence" (Wittgenstein, 1961).

One of the features of Wittgenstein's philosophical method that makes it attractive to artists is his reliance on aphorisms. The first statement of the *Tractatus*, "§1 The world is all that is the case" (Wittgenstein, 1961), seems obvious and yet its meaning is not clear. The entire book is, in a sense, an explanation of the implications of this apparent truism. This aphoristic style persists throughout Wittgenstein's oeuvre, making its way even into the late works.

Not one to exhibit false modesty, Wittgenstein believed that he had solved all of the major problems of philosophy in the *Tractatus*. As a result, after the book's publication he gave up philosophy for a number of years. But he found that he could not completely abandon his philosophical reflections. In part, this was because he became increasingly dissatisfied with the Tractarian account of language. His later philosophy, presented most fully in the posthumous *Philosophical Investigations*, develops an account of language that has very different emphases from that of his earlier work.

The central idea of Wittgenstein's later philosophy is that language is something that people *use* in the course of their lives. As he says, "§43. For a *large* class of cases of the employment of the word 'meaning'—though not for *all*—this word can be explained in this way: the meaning of a word is its use in language" (Wittgenstein, 2009). Language is not, as he earlier maintained, an abstract structure that we use to develop a pictorial map of reality but a tool

# ART INSPIRED BY WITTGENSTEIN    165

that we use to navigate our world. Instead of focusing on the relationship between language and the world, Wittgenstein now emphasizes the importance of how language is *used*. When a waitress in a restaurant yells, "Coffee!," she is not trying to accurately describe or "picture" something present in the restaurant, say a pot of coffee, Wittgenstein now maintains, but trying to get something done, perhaps seeking to get a coworker's assistance in refilling a customer's cup.

To convey this radically new view of language, Wittgenstein develops the notion of a *language-game*. He talks about "one of those games by means of which children learn their native language. I will call these games '*language-games*' and will sometimes speak of a primitive language as a language-game" (Wittgenstein, 2009, §7). Human beings play many games. Chess is an example of a game that can help illustrate Wittgenstein's idea. There are various pieces, often made of wood, that are necessary for playing chess. When someone plays chess, they need to move these wooden pieces on a playing board in accordance with the rules of chess. Someone who didn't understand the rules of chess would be puzzled by what two people were doing, sitting in front of a checkered wooden slab, moving small pieces of wood in what appeared to be arbitrary ways. But their behavior makes perfect sense in the context of the game of chess and the rules that specify how it is played.

Wittgenstein uses this analogy to clarify how language functions. Language, he argues, is like a game, with seemingly arbitrary rules that make it possible for people to do things together with each other. Consider making a promise by saying, "I promise." This use of language accomplishes something. It doesn't picture a preexistent fact about the world but makes a commitment to behaving in certain ways. On this view, language is an inherently social enterprise through which human beings coordinate their activities with their fellows.

Wittgenstein also rejects the view of language as a monolithic structure whose essence he had tried to describe in the *Tractatus*.

## 166 THOUGHTFUL IMAGES

Instead, he sees natural languages such as English and German as patchworks consisting of many different language-games, each of which has its own specific uses. There is, for example, a language-game for the use of color words and another one for measuring distances. Wittgenstein came to believe that we need to pay attention to the specific ways in which words are used in determinate contexts rather than to seek the general theory of language he had earlier attempted to develop.

Another important aspect of Wittgenstein's later thought is his belief that philosophical problems are the result of the misuse of language. Our goal as philosophers should not be, he claimed, to solve all the traditional problems of philosophy but rather to diagnose how such problems arise through a failure to pay attention to the ways in which language is actually used in concrete situations. Descartes's revolutionary skeptical methodology, for example, was diagnosed by Wittgenstein in *On Certainty* as arising from a misuse of the concept of doubt, a topic I will investigate in more detail in chapter 8.

As a result of the posthumous publication of the *Investigations*, Wittgenstein's thought had a huge impact on Anglo-American philosophy. (His views initially had less of an impact on Continental philosophy.) It was clear to Analytic philosophers that Wittgenstein had developed a new and revolutionary way of thinking about philosophical problems. Wittgenstein's ideas were influential in creating the school of philosophy known as "ordinary language philosophy."

Although Wittgenstein's thought was genuinely revolutionary, his impact on the philosophical world also came about because of his personal example. Wittgenstein lived a life dedicated to reflecting persistently on the most fundamental philosophical questions, a task he pursued with single-minded passion. Norman Malcolm, who had studied with him at Cambridge and later invited him to Cornell where Malcolm was a professor, wrote a memoir that brought out Wittgenstein's intense personal engagement with

philosophy as well as his deep dissatisfaction with his own efforts to solve philosophical problems (Malcolm, 1958). Malcolm showed people the determined intensity with which Wittgenstein pursued his reflections on philosophical problems and helped disseminate the image of Wittgenstein as a latter-day Socrates.

Wittgenstein also developed a unique method for writing philosophy during this period. Instead of relying on the strict deductive argumentation that many philosophers at least aspire to, Wittgenstein employed a type of dialogue within his writing in which he first articulated the view of someone he disagreed with and then responded to it. Because these different voices are not clearly marked in the text, readers have to track for themselves the thought process that Wittgenstein had himself followed in developing his view.

Both the uniqueness of Wittgenstein's ideas about language and his intense personal style made him an attractive figure for artists. As a result, a number of them attempted to provide visual illustrations of both his life and thought. But these facts do not fully explain the intensity of preoccupation that these artists had in regard to Wittgenstein.

The final factor I can point to as accounting for Wittgenstein's attractiveness to artists is his aphoristic style. My guess is that few visual artists have taken the time and expended the effort to work their way through, say, the difficult prose of Heidegger's *The Origin of the Work of Art*, a work I discussed in chapter 5. Although Wittgenstein is a writer whose own style makes his reflections difficult to fully comprehend, their aphoristic nature likely appealed to artists. Without reading the entire *Philosophical Investigations*, they could focus on a short, numbered section and find a relatively complete thought that they would dwell on in order to mull over its implications. In addition, Conceptual artists might feel commonality with a philosopher whose prose did not just proceed linearly and therefore required careful and sustained attention and observation. Works of art in the Conceptual mode make similar demands on their audiences, and this is another factor that could account for the attraction Wittgenstein exerted on artists.

# 168 THOUGHTFUL IMAGES

## Conceptual Art

Although not all of the artists who illustrated Wittgenstein were Conceptual artists, many were. I turn now to a brief description of this type of artistic production to clarify its unique nature.

In 1967, Sol LeWitt published what is widely regarded as the first definition of Conceptual art.[2] He stated:

> In conceptual art the idea or concept is the most important aspect of the work. When an artist uses a conceptual form of art, it means that all of the planning and decisions are made beforehand and the execution is a perfunctory affair. The idea becomes a machine that makes the art. (LeWitt, 1967)

LeWitt's provocative claim is that in Conceptual art, the *idea* and not its physical embodiment is the central aspect of the work.[3] Once the idea has been developed by an artist like himself, LeWitt claims, the production of the perceptual object derived from the idea does not require any creativity, for this perceptual object is "executed" purely mechanically.

LeWitt's claim might appear applicable to his own wall drawings. The wall drawings were a type of artwork that LeWitt began creating in 1968. Over the course of his career, he created 1,259 wall drawings or, better, the instructions for executing wall drawings. Although he executed the first wall drawings himself, he eventually created only the instructions for the drawings, leaving their actual execution to others, often under the supervision of his team of trained experts.[4]

---

[2] In fact, however, Henry Flynt wrote an essay about what he called "Concept art" in 1961. LeWitt's formulation was the most influential, however.

[3] There is a tension between LeWitt's initial claim that the idea is the most important component of the work and the claim in the final sentence that the idea produces the art, which erroneously suggests that the work is limited to its perceptual component.

[4] Kirk Pillow (2003) raises the interesting question as to whether Goodman's distinction between autographic and allographic works of art survives the wall drawings since the instructions are allographic but the execution is autographic. Thanks to Jeffrey Strayer for this reference.

# ART INSPIRED BY WITTGENSTEIN 169

Many features of the wall drawings are innovative. I earlier mentioned that they were one of the first artworks that actually instantiated flatness. For our purposes here, however, their crucial feature is the set of instructions LeWitt provided for each drawing. For example, his 1971 work, *Wall Drawing 118* consists of the following instructions:

> On a wall surface, any continuous stretch of wall, using a hard pencil, place fifty points at random. The points should be evenly distributed over the area of the wall. All of the points should be connected by straight lines.

From LeWitt's perspective, these instructions are the creative portion of the work. As we saw, he thought of its realization as a perfunctory affair (see figure 7.1),

**Figure 7.1** Sol LeWitt, *Wall Drawing 118*. © 2021 The LeWitt Estate/Artists Rights Society (ARS), New York.

## 170 THOUGHTFUL IMAGES

The instructions for *Wall Drawing 118* leave open much of what will happen when the actual drawing is, to use the term he preferred, realized. To see this, I encourage the reader-viewer to go to https://mc560.wordpress.com/tag/wall-drawing-118/. As you scroll down the column on the left, you will find a small, changing image. These are different executions of *Wall Drawing 118*, each of which was made in accordance with LeWitt's instructions. Although one can see a certain similarity among all the drawings, given their common origin in LeWitt's instructions, I find it quite remarkable to see the range of different realizations of this single work of LeWitt. They demonstrate the radicalism of LeWitt's notion of a wall drawing.

When one looks at the range of highly distinctive works that have been created in accordance with the instruction for *Wall Drawing 118*, one realizes that installing such a drawing by following the instructions is not quite the mechanical process LeWitt claims it to be. Skilled artists are used to create the wall drawing, and the resulting images vary despite all being executed in accordance with LeWitt's instructions.

Although LeWitt may be correct in maintaining that the essential part of one of his wall drawings is the instruction for creating it, the actual realization cannot be ignored or treated as if it were produced completely mechanically. It is true that realizing the drawing requires the installer to follow LeWitt's instructions carefully and not to deviate from what it tells them to do. Still, it is the interplay between the instructions and any of its realizations that is the focus of our appreciation of his work. Even if the idea is primary in a work of Conceptual art like *Wall Drawing 118*, its realization has aesthetic and artistic properties of which viewers are aware as they perceive it.

From the point of view of our developing theory of illustration, LeWitt has created an interesting technique for generating

concept-based illustrations. His instructions constitute the work's concept, the idea that is to be illustrated. Those who take up the project—his workers—are the illustrators. They follow the rules and in so doing produce an illustration of the concept or idea. The incompleteness of LeWitt's instructions give the workers freedom to illustrate it in different ways. From my point of view, LeWitt's wall drawings are a paradigmatic instance of a concept-based illustration. Or better said, the instructions for the wall drawings allow other artists to produce multiple illustrations of the concept embodied in the directions.

Many works of Conceptual art also prioritize the idea over its artistic realization, but only the realization of the idea brings with it a new object for artistic appreciation. So, it is best to treat LeWitt's claim about the lack of importance of the perceptual object as a provocation that does not adequately characterize the nature of works of Conceptual art. Conceptual though they may be, they are also works of art whose realizations have aesthetic and artistic properties that are one focus of our appreciation. They are also, and crucially, illustrations of the concept they embody.

The work that many cite as a precursor to Conceptual art is Marcel Duchamp's (1887—1968) *Fountain* (1917). Duchamp submitted this work to the initial exhibition of the Society of Independent Artists. It consists of a urinal placed on its back on a pedestal and labeled with what appears to be the artist's signature and the year of the work's creation, "R. Mutt 1917." The work was rejected by the exhibition's curators and a furor ensued.

Although there is disagreement about the significance of *Fountain*, since the object that was to be displayed was a standard urinal manufactured by the J. L. Mott Ironworks Company, the object itself is not the complete artwork. In appreciating

172 THOUGHTFUL IMAGES

the work, some viewers focus on the aesthetic qualities of the urinal, an everyday object, treating it as something worthy of contemplation likely for the first time in their lives. However, most philosophers of art think that this is not the proper way to appreciate the work. They propose that it was Duchamp's idea of submitting this work to the exhibition that constitutes the most important feature of the work. If we accept this claim, then *Fountain* is an early Conceptual artwork, similar in conception to Duchamp's earlier works *Bicycle Wheel* (1913), which consisted of a bicycle wheel attached to an ordinary wooden kitchen stool, and *Bottle Rack* (1913), which simply consisted of a bottle rack that Duchamp exhibited without altering it in the least. But it was the controversy surrounding the rejection of Duchamp's work from the inaugural exhibition of the Society of Independent Artists in 1917 that caused *Fountain* to become an icon of twentieth-century art.

We can see that there is more to *Fountain* than the physical object, a urinal, that forms its perceptual component. Not every urinal in every men's room is a work of art, but only the one that Duchamp submitted to the exhibition.[5] By submitting the urinal to an exhibition, Duchamp, in Arthur Danto's words, "transfigured" an "ordinary thing" into a work of art by giving the "mere thing" a meaning. It is the presence of such a meaning that distinguishes artworks from mere things on Danto's account (see Danto, 1981) and that allows its physical component to be characterized as an illustration.

Although the Conceptual Art Movement proper flourished only between 1966 and 1972 (Goldie and Schellekens, 2007, p. xi), many other works produced both before and after that time period are generally characterized as examples of Conceptual art.

---

[5] Although the original was lost, Duchamp created multiple instantiations of the work. There are also others derivative of it, such as Maurizio Catalan's *America* (2011), whose physical component is a golden toilet.

So long as the works emphasize the ideas that generated their perceptual components, they can be considered instances of Conceptual art.

## Joseph Kosuth

It will be useful to begin our survey of Wittgenstein-influenced works by looking at one Conceptual artwork that clearly has a philosophical agenda. This will help establish the philosophical credentials of Conceptual art.

Joseph Kosuth (1945–), one of the first Conceptual artists, has a significant interest in philosophy. It is therefore not surprising to find him creating a work that has a clear philosophical reference. *One and Three Chairs* (1965) is an installation that consists of three "chairs" (see Plate 13): The first is a wooden folding chair of the kind that could be purchased at a department store; the second is a life-size black-and-white photograph taken of the first chair in its location in the gallery that is displayed on the wall to the left and slightly above the first chair; finally, to the right of the first chair, a large print of a dictionary definition of "chair" is hung on the wall.

A viewer looking at this work is likely to wonder about the relationship of the different "chairs" to one another. In so doing, they are entering into philosophical territory that was first explored by Plato.[6] Many people would say that the "real" chair is the wooden one; the photograph is only a representation or picture of the chair, and it wouldn't exist if there were no physical chair in the first place; and as to the dictionary definition, it doesn't seem to be a chair at all, but only a collection of words. However, Plato maintained

---

[6] Curiously, Carolyn Wilde (2007) fails to see the relevance of Plato's metaphysics to this work. She claims that Van Gogh's paintings of his own chair as well as that of Gaugin's chair are precedents for this work.

174 THOUGHTFUL IMAGES

that, without the idea or concept of a chair—what the definition provides—it would not be possible for the wooden chair to have been created in the first place or for us to recognize it as one. The artisan who designed the folding chair had to have had the idea of the chair in mind in order to create it (or design its production). And don't we, in identifying an object as a chair, make reference to a definition that provides the criteria for an object's being a chair? So, which is the real chair?

*One and Three Chairs* is an example of a Conceptual work of art that demonstrates the ability of works in this genre to provide concept-based illustrations of a philosophical theory, in this case Plato's theory of Forms. It illustrates the theory that ideas (called "Forms" by Plato) are the basis of the physical world and works of art—the photograph being the example within the work—stand at two removes from reality itself, being a copy of the physical object that is identifiable only through its idea or definition. Although it is not based on a specific text of Plato's, it is a faithful portrayal in visual form—a concept-based illustration—of the metaphysics of the great philosopher.

One of the important features of concept-based illustrations is that they can actually make philosophical claims. We can see that *One and Three Chairs* does this, for the work is a critique of Plato's denigration of art, a view he presents in *The Republic* and is supported by his metaphysics. For Plato, as we have seen, paintings present viewers with "appearances of appearances" and are thus twice removed from reality itself. *One and Three Chairs* boldly asserts that art—it is an installation, not a painting—has the capacity to represent the three orders of reality Plato accepts in his metaphysics, so that Plato's denigration of art is based on a false view of art's capacities. Art has the ability to discern truths that is at least equal to that which philosophy claims for itself, as evidenced by this work. Kosuth's installation illustrates the three categories of Plato's metaphysics and, in so doing, undermines Plato's denigration of art.

ART INSPIRED BY WITTGENSTEIN     175

Kosuth is the first artist to employ one of the revolutionary means of illustrating philosophy we find in illustrations of Wittgenstein's ideas: creating artworks featuring the words to the philosopher himself. Kosuth was deeply interested in Wittgenstein's philosophy. In 1989, he curated an art exhibition called *The Play of the Unsayable: An Exhibition of the Vienna Secession after a Concept by Joseph Kosuth.* Kosuth also wrote a catalogue essay, "The Play of the Unsayable: A Preface and Ten Remarks on Art and Wittgenstein." In that essay, Kosuth attributes to the *Tractatus* the insight that traditional philosophy was not able to speak about many important things, such as "value, ethics, and the *meaning of life*" (Kosuth, Huys, and Köb, 1989, p. 17, italics in original). According to Kosuth, art is now able to take up that task as a "*post-philosophical activity*" (Kosuth, Huys, and Köb, 1989, p. 18, italics in original). He appears to have thought that art would take over the role that he believed philosophy had abdicated. "The twentieth century," he tells us, "brought in a time that could be called 'the end of philosophy and the beginning of art'" (Kosuth, 1973, p. 73). Given the positivists' rejection of many traditional areas of philosophical inquiry, there is some rationale for Kosuth's position even if, at the present time, it seems bizarre to think of philosophy as having ceded ground to art on these matters.

Considering the importance that Kosuth attributes to Wittgenstein, it's not surprising that he created art derived from Wittgenstein's texts. Using a technique he developed in 1965 in which his artworks consisted of words formed in illuminated neon tubing, Kosuth created a series of works using phrases from Wittgenstein's texts. The series reached its apogee in 1990 with *276. On Color Blue* (Plate 14).[7] This work consists of neon tubing that emits blue light and is formed into the following quotation from the *Philosophical Investigations*: "'But don't we at least *mean* something quite definite when we look at a color and name our color

---

[7] Different instances of the work have different dates; 1990 is the earliest and 1993 the latest I could find.

## 176  THOUGHTFUL IMAGES

impression?' It is virtually as if we detached the color *impression* from the object like a membrane. (This ought to arouse our suspicions)" (Wittgenstein, 2009, §276).[8]

In the previous paragraph of the *Investigations*, Wittgenstein had been criticizing the philosophical temptation to treat color words like "blue" as referring to our private "inner sensations." His undermining of this suggestion is part of what is often dubbed the "private language argument" in which he is said to contest the idea that there could be such a thing as a language that was limited to one speaker, or that the primary referent of linguistic terms like "blue" is our private inner experience of the color. He describes a certain thought experiment:

> Look at the blue of the sky and say to yourself, "How blue the sky is!"—When you do it spontaneously—without philosophical purposes—the idea never crosses your mind that this impression of color belongs only to *you*. And you have no qualms about exclaiming thus to another. And if you point at anything as you say the words, it is at the sky. (Wittgenstein, 2009, §275)

Our normal way of thinking about the color of the sky is that it is something that everyone can experience. It is not something that, in some sense, is my private possession but is something that is publicly available for everyone to see and experience.

The paragraph from which the quotation in Kosuth's work is taken is a good example of the style Wittgenstein employs in the *Investigations*. It begins with the interlocuter responding to Wittgenstein's earlier claim. The interlocuter still maintains, albeit quite vaguely, that there must be something to the idea of color sensations, that is, private internal episodes of color. Wittgenstein

---

[8] I have inserted the quotation marks that are in the German text but were omitted from the English translation. The original German reads: "'Aber *meinen* wir den nicht wenigstens etwas ganz Bestimmtes, wenn wir auf eine Farbe hinschauen und den Fabeindruck benennen?' Es ist doch förmlich, als lösten wir den Farb*eindruck*, wie ein Häutchen, von dem geshenen Gegenstand ab. (Dies sollte unsern Verdacht erregen.)"

then responds in his own voice, saying this does not make sense. It treats colors as having two modes of existence, one objective and one subjective, with the subjective mode determining the meaning of the term. The problem with such a view is that it makes learning to use color words impossible while also obscuring how communication using them can take place. In addition, the two modes in which colors' existence is posited lack any coordination, making the entire notion of colors philosophically problematic.

The question that presents itself when we return to Kosuth's neon sculpture is, "What do we see when we look at Kosuth's work?" I have to caution the reader that, unlike most of the other works I discuss in this book, I have not seen the actual work but only photographs of it. Anything I say about the work is based on this secondhand experience.

Looking at *276. (On The Color Blue)*, we see three sentences from the *Investigations* executed in neon tubing. The tubes give off a blue light. The blue forms a sort of penumbra that surrounds the quotation and exemplifies the topic of the quotation, namely, the nature of color. The light also casts a shadow on the wall in which most of the words from the quotation are legible.

The first thing to note about this work is that since the sentences that make it up are an accurate reproduction of the English translation of Wittgenstein's text, this work adheres to the norm of fidelity. However, that is not the most interesting feature of the work, even considered from the point of view of its illustration of Wittgenstein's ideas. The most striking feature of the color we see surrounding the tubing is that it does not appear to exist primarily on the surface of any object, but rather to envelop the neon tubes that are the material element of the work. A viewer of the work is therefore confronted with the presence of a color that she cannot locate on the surface of an object. In this respect, the color in the artwork exactly parallels the blue of the sky.[9]

---

[9] The one "object" that appears to be blue is the shadow cast on the wall. I don't think this contradicts the claims I make about the location of blue in the work since it is not the primary locus of the color.

178 THOUGHTFUL IMAGES

*276. (On Color Blue)* presents us with a version of the experience that Wittgenstein alludes to in his thought experiment about looking at the sky and thus can be seen as an attempt to support Wittgenstein's perplexity about the nature of color. While he rejects the idea that color words refer to internal sensations that we have, Wittgenstein is not satisfied with his interlocuter's alternative suggestions about the "location" of colors. Kosuth's neon sculpture problematizes viewers' understanding of colors by providing them with the experience of seeing a color that is not identifiable as existing on the surface of any object.

Kosuth has created an artwork that undermines viewers' received understanding of the notion of color in a manner analogous to that which Wittgenstein achieves in the passage displayed in the work. It does so by displaying a color that is clearly visible but not as an aspect of an object's surface.

Kosuth here develops a new way of illustrating a philosopher's ideas: by recreating the philosopher's words in an artistic medium that replicates the very assertion made by the philosopher. The viewer of *276. On the Color Blue* will find the whole notion of their experience of seeing blue as one in which they name an inner sensation of blue as deeply problematic, as Wittgenstein claims it to be in paragraph 276 of the *Investigations*. Kosuth's work provides the viewer with an experience of seeing blue that requires them to reflect on the claim made by Wittgenstein that constitutes the perceptual aspect of the work. In so doing, he aims to get viewers to reflect on Wittgenstein's enigmatic remark.

The text-image relationship in this work differs from those we have seen previously. Kosuth has created a work in which the text being illustrated is transferred from one medium (the printed word) into another (neon tubing). Of course, all illustration involves a transposition of the printed word into a visual form. What's novel about this work is that the very text being illustrated is presented in a novel medium. This is a new way for an artist to

ART INSPIRED BY WITTGENSTEIN    179

illustrate a philosophical text: by actually presenting the text in a visual medium, here neon tubing.[10]

Is this work a text-based or a concept-based illustration? Text-based works generally take a piece of text and render it visually. What they don't do is reproduce the text in a visual medium, as Kosuth does here. On the other hand, a concept-based illustration is not based on a specific piece of text as *276. (On the Color Blue)* is. It would make sense to classify this as a concept-based illustration insofar as it seeks to provide its reader-viewers with an experience that supports the idea Wittgenstein articulates in the text.

Given the difficulties of classifying this work. I will introduce into our categorization the new category of illustrations of philosophy that feature quotations transposed into an artistic medium. *Quotation-based* illustrations of philosophy share characteristics of both text- and idea-based illustrations, but they are a distinct type of illustration that we will see other artists create.

It is worth noting that Kosuth presented quotations from Plato in this new form of illustration. His *Intellect to Opinion* (2017) features a quotation from the Divided Line section of *The Republic* (534a). This work of art, made for the 2018 exhibition at the Getty Villa *Plato in L.A.*, employs the same technique as *276. (The Color Blue)*; that is, it takes a quotation from a work of philosophy and displays it in neon tubing against a dark background. This time, Kosuth renders the quotation in stark, white neon tubing:

As being is to becoming, so is pure intellect to opinion

And as intellect is to opinion, so is science to belief, and understanding to the perception of shadows. But let us defer the further

---

[10] Unfortunately, I only discovered a set of illustrations of Wittgenstein's work while this book was already in press. In 2000, Archetype Press published a set of illustrations of Wittgenstein's *Remarks on Colour* (Studley, 2000). The remarkable images in that book were created by students at the ArtCenter College of Design and all use typography to illustrate Wittgenstein's ideas. It contains interesting examples of quotation-based illustrations of philosophy.

180 THOUGHTFUL IMAGES

correlation and subdivision of the subjects of opinion and intellect, for it will be a long inquiry, many times longer than this has been. (*Republic*, 534 a–b)

This passage comes from a prominent illustration that Plato uses to explain his ideas, the Divided Line. Plato uses this image to explain the metaphysics that Kosuth illustrated so critically in *One and Three Chairs*. Though similar to *276. (On the Color Blue)*, and Kosuth's other works employing Wittgenstein's texts in being quotation-based, this work lacks the profundity of *276. (On the Color Blue)*. While it does provide its viewers with a perceptual experience of the distinction between an object—in this case, a neon tubing version of Plato's text—and its shadow cast on the wall where the work is exhibited, I don't see it as shedding light on or criticizing the metaphysical view Plato illustrates in the displayed passage.

## Bruce Nauman

The next work of art I discuss packs a great deal of philosophical punch and, like *276. (The Color Blue)*, embodies a statement from the *Investigations*. Because of his own interest in language, the influential artist Bruce Nauman was intrigued by the ideas in Wittgenstein's *Philosophical Investigations*. In 1966, he took a sentence from that book, "A rose has no teeth," and rendered it as an embossed lead plaque that was intended to be attached to a tree so that "after a few years the tree would grow over it, and it would be gone" (Tomkins, 2009) (see Plate 15).[11]

---

[11] Although there are pictures of the plaque attached to a tree, such as the one in plate 15, Nauman's wishes were not followed by the owners of the piece. Still, many writers treat the piece as if it were attached to a tree. See, for example, Robert C. Morgan, (2002), p. 9. There are also replicas of the original made in polyester resin. Whether these should

ART INSPIRED BY WITTGENSTEIN    181

To understand why Wittgenstein uses the sentence "A rose has no teeth," it will be useful to consider Bertrand Russell's theory of definite descriptions, a centerpiece of early twentieth-century Analytic philosophy of language (Russell, 1905). Russell was concerned with terms that referred to non-existent entities, like the mythical horse Pegasus. Previous metaphysicians—he mentions the Austrian philosopher Alexius Meinong—had been driven to admit that even non-existent entities had to have some type of existence, since it was possible to refer to them in sentences, even if only to deny their existence.

To Russell, such metaphysics violated Ockham's Razor, the heuristic that entities not be multiplied needlessly. His solution was to provide an analysis of the denoting phrase that eliminates any reference to non-existent entities. Consider the statement, S: "The present king of France is bald." This sentence seems to refer to a non-existent being, the present king of France. However, this reference is only apparent once one realizes the appropriate logical analysis of the sentence. According to Russell, here is the correct analysis of S which asserts their conjunction:

1. There is something that is now king of France.
2. Anything that is king of France is identical with that something.
3. Anything that is king of France is bald.[12]

The important feature of Russell's analysis is that it removes reference to the non-existent present king of France. Instead, the first clause in the logical analysis of S is clearly false, for presently there

---

be considered to be copies of the work or alternative instantiations of it is an issue I leave open here.

[12] These three statements can be put into logical form:
(Ex)Fx; Fa
$(x)(Fx \rightarrow x = a)$
$(x)(Fx \rightarrow Bx)$

182 THOUGHTFUL IMAGES

is no king of France. This makes the sentence S itself false. Instead of creating a bizarre ontological realm to accommodate non-existent entities, Russell's analysis only has a false existential statement. The impetus for granting a weird type of existence to non-existent entities vanishes.

By the time of the *Investigations*, Wittgenstein rejected the attempt to clarify the nature of natural language by the application of logic such as Russell did via his theory of definite descriptions. Instead, he focuses on the circumstances in which a sentence is actually used, as we have seen. His idea is that a sentence makes sense only if we can specify the circumstances in which its use is intelligible.

It is in this context that Wittgenstein introduces the sentence, "A rose has no teeth." The passage that contains this sentence occurs in the second half of the *Philosophical Investigations*:

> §314. "A newborn child has no teeth."—"A goose has no teeth."—"A rose has no teeth."—This last at any rate—one would like to say—is obviously true! It is even surer than that a goose has none.—And yet it is far from clear. For where should a rose's teeth have been? The goose has none in its jaw. And neither, of course, has it any in its wings; but no one means that when he says it has no teeth.—Why, suppose one were to say: the cow chews its food and then dungs the rose with it, so the rose has teeth in the mouth of an animal. This would not be absurd, because one has no notion in advance where to look for teeth in a rose. (Wittgenstein, 2009)

While Wittgenstein's interlocuter maintains that "A rose has no teeth" is obviously true, Wittgenstein demurs. He suggests that the sentence is not making a determinate assertion. As he points out, we do not have a definite idea of where a rose's teeth would be if it had any. This is different from the situation with a goose, for its jaw is the obvious place where its teeth would have been if it had any. This is why Wittgenstein doesn't simply brush off the

suggestion that we could say that a rose has its teeth in the cow that provides it with nourishment. After all, teeth help animals digest food and receive nourishment from it. So, the bizarre suggestion about the cow being a rose's teeth can't simply be dismissed as absurd, Wittgenstein says, since we simply don't know where to look for a rose's teeth.

The broader context for this paragraph is a series of reflections concerning G. E. Moore's attempt to refute skepticism, a topic that I will explore more fully in chapter 8. Wittgenstein is reflecting on the concept of knowledge and what it makes sense for us to claim to know. In the previous paragraph, Wittgenstein had said that the sentence, "The earth has existed for millions of years," makes more sense than the sentence, "The earth has existed for the last five minutes," for there does not seem to be a clear observational context to determine the truth of the latter sentence.

The two statements about things lacking teeth—one about a newborn child and one about a goose—set up a context for understanding the claim about a rose. But in the former two cases, we have a clear idea of how to confirm the truth of the statements, i.e., by looking in the mouth of a newborn or a goose. That is what Wittgenstein says we don't have in regard to a rose, which is why he says we have no idea where a rose's teeth would have been.

Does our analysis of this passage help us understand why Nauman chose to make a lead sculpture of it? In one sense, the work is clearly ironic. The metal plaque has the appearance of something permanent, a work that time will not be able to mar. Being made of lead, a metal likely chosen because of its malleability, the piece can maintain its structure even when exposed to harsh weather conditions outside. To create a metallic sculpture of, say, an important person is to emphasize their significance by means of the permanence of the statue.

Rendering a statement in lead to give it permanence also makes a claim for its significance. But "A rose has no teeth" is not a significant sentence, nor does it qualify as one of Wittgenstein's

184    THOUGHTFUL IMAGES

brilliant aphorisms. Rather, it borders on nonsense, since it is not, as Wittgenstein points out, the sort of sentence that we can imagine someone actually asserting. The contrast between the vapid sentence and the permanence of the material makes Nauman's gesture of rendering the sentence ironic. Nauman has created a work that embodies a sentence from a philosophical text and that highlights the difference that the medium makes, i.e., that a metallic plaque featuring a sentence from a book means something other than what it means in the book.

Of course, Nauman is not, as Wittgenstein was, interested only in making a point about the nature of language. More centrally, like many of the artists in the Modernist tradition (see chapter 6), his work poses questions about the nature of art.

This becomes clearer when we realize that Nauman's *A Rose Has No Teeth* was intended to be attached to a tree as it is in Plate 15. The idea was that the work would be covered over by the natural process of the tree growing. Since the sculpture itself is made of a material that emphasizes its permanence, the entire work—plaque plus the tree—highlights a contrast between the pretensions of art and the character of natural processes to which even the plaque is subject. While we might think of works of art as eternal and unchanging, much like Platonic Forms, Nauman's work suggests that they are subject to change and decay. Nauman's work makes evident the error of segregating art as categorially different from the natural world.

*A Rose Has No Teeth* is a fascinating and deep work of art inspired by Nauman's reading of Wittgenstein. It exhibits the impact that the *Investigations* had on philosophers during the 1960's. In a literal sense, it displays Wittgenstein's remark by making a metal casting of it. *A Rose Has No Teeth* is an interesting work illustrating a profound idea, even if it does so by casting a vapid sentence in lead.

But does it actually help us understand Wittgenstein's claim about the meaning of the statement that Nauman rendered in the work? Remember Wittgenstein's claim that it is not absurd to say

that the teeth of a rose reside in the cow that chews the food that provides the rose's sustenance. Would it be absurd, I ask in a similar vein, to see the tree as a stand-in for the rose and its absorption by the tree over time as metaphorically eating it, as if it had teeth? The poor rose may lack teeth; perhaps the tree has them at least metaphorically when it "gobbles up" Nauman's plaque.

Nauman's work follows the path first developed by Kosuth in being quotation-based. Like Kosuth, he actually transposes Wittgenstein's words from the printed page into a different medium—lead in this case. This transfer transforms the meaning of the words, as I have explained. In so doing, Nauman, like Kosuth, produces a work of philosophical significance, one that uses Wittgenstein's text to make an original point about art.

## Mel Bochner's *If the Colour Changes*

In chapter 8, I will examine Mel Bochner's (1940–) suite of *Wittgenstein Illustrations*. Here, I focus on another series he made that picks up an important idea of Wittgenstein's: *If the Colour Changes*. Beginning in 1997, Bochner made a series of works— some prints, some paintings—that featured a quotation from Wittgenstein's *Remarks on Colour* (1977), a set of reflections about the nature of color that Wittgenstein made during the last year and a half of his life.

The works in this series all feature a quotation from §326 of *Remarks* in the original German overlaid with its English translation. Here is the original German followed by its translation:

Beobachten ist nicht das Gleiche wie Betracten oder Anblicken. "Betracte diese Farbe und sag, woran sie dich erinnert." Andert sich die Farbe, so betrachtest du nicht mehr die, welche ich meinte. Man beobachtet, um zu sehen, was man nicht sähe, wenn man nicht beobachtet(e).

186 THOUGHTFUL IMAGES

> To observe is not the same thing as to look at or to glance at. "Look at this color and say what it reminds you of." If the color changes, you are no longer looking at the one I meant. One observes in order to see what one would not see if one did not observe. [Translation modified]

One feature of Wittgenstein's philosophical method that I will discuss more fully in relation to Paolozzi's work *Parrot* is its getting philosophers to recognize the many uses of terms that they had generally ignored. Here, we see this method in operation as Wittgenstein criticizes the tendency of philosophers to focus on only one meaning of "see" in their accounts of perception. Using three supposed synonyms for "seeing," Wittgenstein claims that each has its own unique meaning.

When you merely look or glance at something (*Betracten* or *Anblicken*), you have only a momentary view of it. This is very different from observing it (*Beobacten*), which here means looking at it carefully and really inspecting it. If you are looking at a color and it changes, Wittgenstein says, you need to *observe* what has taken place. If you don't take a more careful and extended look at the color, you will not see important features of it.

This difference between glancing at something and really observing it is the key to understanding Bochner's series, all of whose works include the German text of §326 and its standard English translation with the two texts superimposed on one another. In the first of his illustrations of Wittgenstein's remark, *If the Colour Changes #1* (Plate 16), the German quotation begins in bright red but slowly changes until the final line is nearly black. Slightly below but superimposed on it, the English translation begins in a royal blue but it also slowly transforms until the final line is written in a much paler blue. Clearly, Bochner is illustrating Wittgenstein's notion of a color changing. But he is also playing with the idea of translation.

## ART INSPIRED BY WITTGENSTEIN 187

Later works in the series are more complex, with more factors competing for our attention and obscuring the quotation. For example, in *If the Colour Changes #4*, each of the letters in the two overlayered quotations varies in color, so the letters in the word "beobachten," for example, shift from yellow to blue, brown, aqua, red, maroon, beige, black, yellow, and then black again. All the variations in color make deciphering the text in this painting more difficult than in *If the Colour Changes #1*.

In *If the Colour Changes #6* from 1998, the two quotations remain, though now in a single, unchanging color: the German is in bright blue and the English translation in pale green. However, the two quotations are placed on a field of multi-colored circles of varying dimensions, much like a color-blindness test. The presence of this complex background makes reading the two texts much more difficult, even if the words form a type of figure on a multicolored ground.

A first thing to note about Bochner's works in this series is that they employ the same strategy used in the works I have discussed by Kosuth and Nauman: The work consists of reproducing Wittgenstein's words in a different medium. In this case, the words are still rendered in print but now the print is in various different colors, all in capital letters, within quotation marks, with the German and English superimposed. So, let us turn to interpreting the meaning of works in the series.

It's pretty clear that these works are concerned with translation. Bochner is explicit about this: "One of the underlying themes of these paintings is the question of translation, not only from one language into another, but from the textual to the visual" (Bochner, 2014, pp. 119). Although the works do not, as Bochner claims, eliminate the text in favor of the visual, they do emphasize the visual aspect of a text. What's more, while we think of a translation as providing non-speakers of a language with access to a work, the superimposition of the translation of Wittgenstein's original German on

## 188 THOUGHTFUL IMAGES

its English translation actually obscures both of them and makes both texts difficult if not impossible to decipher. The quotation is removed from its original context in Wittgenstein's reflections, even though it acquires colors and a background in Bochner's paintings.

In this context, it is worth recalling that translation provided the model for my initial account of text-based illustration. Could Bochner be thinking about the nature of illustration since his work is another type of illustration of Wittgenstein's ideas and he had, as we shall discuss in the next chapter, created a series of illustrations of Wittgenstein's text, *On Certainty*?

The later works in the series do something else, according to Bochner:

> By later paintings in the series, the words often dissolve into little more than a fog of color, diverting the text from any duty of meaning. In addition, the optical antagonism makes it a struggle to decipher the text, reenacting the very situation described in the quotation. (Bochner, 2014, pp. 119–120)

Of particular interest to us in the context of other works based on Wittgenstein's ideas is Bochner's claim that the later works in this series actually "reenact" the situation described by the text that they include. I have said something similar about Kosuth's *276. (On the Color Blue)*. Here, I take Bochner to mean that the works in this series require that the viewer do more than glance at them, though I would argue that this is true of *all* the works in this series and not just the later ones. A mere glance cannot resolve the difficulties introduced by placing the German and English texts over one another, thereby rendering them difficult to read. It is only by careful observation—and with the later works in the series even this may not be sufficient—that one is able to disentangle the two overlapping statements and actually see what Bochner has quoted in these works.

# ART INSPIRED BY WITTGENSTEIN    189

In this series, Bochner has actually found a way to render visually the distinction that Wittgenstein draws between different ways of seeing an object. Although the works have stunning colors, and this contributes to their aesthetic impact, their philosophical significance is their ability to demonstrate to the viewer the validity of the distinction Wittgenstein draws between two different senses of "see": to glance at and to observe. Of course, the colors make the overlay of the quotation in two languages possible to notice but also difficult to decipher. The rendering of the quotation in various colors is essential to its success at engaging its audience in reflecting on the truth of the distinction Wittgenstein makes.

There is no doubt that this is a significant use of visual art to illustrate and, indeed, support a philosophical thesis, namely, that the word "see" needs to be disambiguated. For Wittgenstein, a great deal of philosophical importance is attached to the difference between glancing at something and really observing it. Bochner's works emphasize this difference. In so doing, it uses a quotation-based illustration to "reenact" what Wittgenstein is pointing towards in the quotation.

And, finally, Bochner has taken Wittgenstein's distinction between different types of seeing and shown that works of art cannot just be "glanced at"; they need to be "observed." Only a careful scrutiny of the works in the *If the Colour Changes* series allows a viewer to see what happens in them. They cannot be understood or even really be experienced as the works that they are without being carefully observed—and that means taking more than the fifteen to thirty seconds the *New York Times* of October 12, 2014, says viewers typically spend in front of a work. The difficulty of understanding the visual images Bochner has created requires that one observe them with the attitude Wittgenstein describes in the quote displayed on the works. The series is a significant artistic achievement that both illustrates and also expands the realm in which Wittgenstein's distinction has application.

190  THOUGHTFUL IMAGES

Like Kosuth and Nauman, Bochner has used Wittgenstein's own words to create quotation-based illustrations. These three artists have created a novel use of text in illustrations that is unlike anything else we have or will encounter.

Perhaps even more significant from the point of view of our evolving understanding of illustrations of philosophy is how Kosuth and Bochner create works that, to use Bochner's term, *reenact* "the very situation described in the quotation" (Bochner, 2014, p. 120). These artists' discovery of a novel way for art to illustrate philosophy marks their works as especially important for our study.

## Jasper Johns

Jasper Johns is another artist on whom Wittgenstein had an important impact that is registered in his works. Like the other artists I have discussed in this chapter, he had an abiding interest in Wittgenstein's philosophy.[13] He also created works that featured elements of Wittgenstein's text, but what is unique about them is that Johns incorporated a visual image from Wittgenstein's text into his own paintings and prints.

The image that Johns employed in his works is that of the duck-rabbit that we looked at in the first chapter (see figure 1.2). This image is one that Wittgenstein uses as part of his discussion of what he terms "noticing an aspect" (Wittgenstein, 2009, II, §113). Wittgenstein is arguing that certain visual images—of the duck-rabbit in this case—can be seen differently at different times, that is, now *as this* and now *as that*. The same visual image can be viewed differently, but this requires us to interpret it and this influences

[13] Johns began to read Wittgenstein in 1961 as a result of hearing of an incident in Malcolm's *Memoir*. Various art historians have discussed Wittgenstein's impact on Johns. Peter Higginson (1974) offers the most complete discussion of Wittgenstein's influence on Johns.

## ART INSPIRED BY WITTGENSTEIN 191

what we see: "But we can also *see* the illustration now as one thing now as another.—So we interpret it, and *see* it as we *interpret* it" (1953, II, xi, p. 193).

The duck-rabbit is an image first made famous by the psychologist Joseph Jastrow in his 1900 book, *Fact and Fable in Psychology*. Jastrow actually took the image from the humor magazine *Fliegende Blätter* that published it in 1892. This image can be seen in two different ways, i.e., as an image of a duck facing to the left or as an image of a rabbit facing to the right, but cannot be seen as both of these at the same time. Wittgenstein uses this instance of an ambiguous image to develop an account of what he calls "aspect seeing" or "seeing-as." The same image exhibits a perspectival shift enabling it to be seen as representing different types of entities. Wittgenstein suggests thinking of the image placed in the context of numerous ducks and then numerous rabbits, to encourage us to agree that we can see the same drawing differently depending on its context.

The idea of *seeing an aspect* is an important one for, among other areas, the philosophy of art. Consider a painting. In one sense, we can see a painting as simply consisting of areas of paint on a canvas backing, especially when we stand close to it. In another sense, of course, when we are looking at a traditional representational painting from a greater distance, we see it as depicting a three-dimensional scene, such as that in Titian's *The Rape of Europa* (Plate 2). Viewing representational works of art in the manner in which they were intended requires us to see a two-dimensional object— the flat canvas—as representing a three-dimensional scene.

The idea that art involves a type of "doubleness" has been influential in the philosophy of art. Both Ernest Gombrich (1962) and Richard Wollheim (1987) developed theories of representational art in which experiencing artworks required an awareness of both the surface of the painting and also its represented subject. Both these theories were themselves deeply influenced by Wittgenstein's notion of aspect seeing.

## 192 THOUGHTFUL IMAGES

Wittgenstein's analysis of seeing has broader implications than this, however. The suggestion is that all perception requires a context that determines how we see the things that we do. We see what we do because the context determines what we *see* things *as* being.

If we return to my discussion of Titian's *Rape of Europa* in the second chapter, we can see that Wittgenstein's idea helps nail down the point I made there. Of course, Titian's work is a great painting, its problematic subject matter notwithstanding. When we are making that judgment, we are considering the manner in which Titian has rendered his subject, e.g., his use of color and shading. But we can also see the painting differently, treating it as a text-based illustration of Ovid's retelling of the myth. When we do so, we are not primarily focused on the artistic qualities of the painting but rather on how the details of the painting reflect features of Ovid's version of the myth. We can see the same work in two different ways.

Given the importance of Wittgenstein's notion of "seeing-as" for understanding art, it's not exactly a surprise to discover that Johns made a number of artworks that present this idea visually. What *is* surprising is that he actually incorporated Wittgenstein's drawing of the duck-rabbit into his works.

Placing a visual image from a philosophical text into a work of art creates a new type of quotation-based illustration of philosophy, for what is quoted are not words but a visual image. Johns is the first, and I think only artist to place a visual image from a philosopher's text directly into their art. Of course, this is due in part to the near total absence of visual images in philosophers' texts.

The work in which the duck-rabbit first appears is Johns's etching and aquatint *Seasons (Spring)* (1987) (Plate 17), one in the series of four works that includes *Summer, Fall,* and *Winter,* all in a similar format. Johns created the series as he was moving studios, so that the entire series is not just about the seasons that compose a year but also about the stages of a person's life. In addition, *Seasons (Spring)* is also about art and its "double" nature as discussed by Wittgenstein. This becomes clear when we

realize that the work contains a number of ambiguous images including the duck-rabbit that "can be seen one way or another," as Wittgenstein puts it.[14]

One familiar ambiguous image present in the work aside from the duck-rabbit is "Rubin's Vase," an image created around 1915 by the psychologist Edgar Rubin.[15] The image consists of a white irregular space surrounded by two identical but reversed black spaces on either side. If a viewer takes the white center space to be a figure on the ground of the black spaces, they see a cup; however, if they take the white space to be the ground for the two black figures, they see two people looking at one another. As in the duck-rabbit, viewers are usually able to see both versions of the image but never at the same time. On the right third of the page, Johns's print contains multiple images of "Rubin's Vase." They are tilted and appear to be panes of a window or some other object with a ladder placed horizontally above them with a rope extending downward. There is another portion of a (the?) ladder on the top left half of the painting with a corner of the same window-like "object" with Rubin's vase on it.

The presence of a ladder that is not in the usual upright position calls to mind Wittgenstein's admonition that someone who had understood his work would realize that he no longer needs what he had read and he could dispense with it. He puts the point in an unforgettable aphorism: "He must, so to speak, throw away the ladder after he has climbed up it" (Wittgenstein, 1961, p. 151). I will discuss this passage more fully when I consider the work of Eduardo Paolozzi. But what we see in *Seasons (Spring)* might be remnants of the ladder that a reader of Wittgenstein had discarded, suggesting that Johns believes he has understood Wittgenstein's message and no longer needs the ladder.

---

[14] These images are often referred to as paradoxes. The Metropolitan Museum of Art refers to these images as "optical illusions" (http://metmuseum.org/art/collections/search/491256). This is to misunderstand and to mischaracterize their nature.

[15] A lithograph from 1973 also features this image.

194 THOUGHTFUL IMAGES

There is a third ambiguous image in this wor called "My Wife and Mother-in-Law."[16] This image was first created by an anonymous German illustrator and eventually became a postcard in 1888. The British cartoonist William Ely Hill recreated the postcard. When the image was published in the American magazine *Puck*, it became widely known. In Johns's version, it consists of a figure rendered in purple that can be seen as either a young woman looking back over her right shoulder or an older woman looking down and to the left. As with all such ambiguous images, both aspects of the image can be seen by a viewer although both cannot be seen simultaneously. (Johns also imposes a portion of "Rubin's Vase" over "My Wife and Mother-in-Law" to suggest similarities between them.)

*Seasons (Spring)* contains various features that recur in the other three works in the series including the ladder. Another is a blue silhouette of a human body standing next to and in front of a tree. This shadow is derived from Johns's own shadow, and Johns paints it in front of a vertical brownish board. The figure is cut off below the waist by a whitish piece of paper on which is painted another shadowy silhouette. Over the figure, Johns has painted a number of figures in black: two circles, two diamonds, and two triangles. This doubling of shadows suggests that Johns is thinking about the ambiguous images we have just discussed and is seeking another way to represent such ambiguity in his work.

Other elements in the painting are a black circle with an arrow along the bottom of its circumference that points at the white rectangle. On the circle there is also a hand and arm print stretched out vertically. This image is one that Johns used in many of his paintings around that time and is a symbol of a clock hand and hence the passing of time. The print also has a small rectangle made up of areas of red, white, and blue stripes that looks like one of Johns's

---

[16] Johns seems to have been particularly fascinated with this ambiguous image. It makes its appearance in his work beginning with a number of untitled paintings in 1984 and continues at least until 1987 when it was featured in another untitled work.

ART INSPIRED BY WITTGENSTEIN 195

works (such as *Usuyuki* [1982]). Additionally, the print contains, on either side of the larger silhouette, a star-lit blue sky that Johns took from Picasso's *Minotaur Moving His House* (1936) that Bernstein claims is an inspiration for the entire series (Bernstein, 1991, p. 10). Throughout the print, there are diagonal black and white stripes that slightly obscure the images. Since the print is about the spring, these stripes can be seen to represent rain, a symbol of that season.

The only portions of the work not so striated are the lower, gray figure and the duck-rabbit. The duck-rabbit is on the left midway up the work. It is on a polka dotted ground located between the black circle, the smaller "Rubin's Vase," and the striped "painting."

I can't provide a full explanation of this visually striking but intellectually puzzling work. What I can say is that it indicates Johns's interest in exploring the ambiguity of images like the duck-rabbit and the other two ambiguous images contained in the work, perhaps positing the alternation in our seeing of them as a way of thinking about art. As I've mentioned, aspect seeing can be taken to be essential to our perception of art and Johns appears fascinated with this phenomenon which to my knowledge had not previously been included in works of high art. Bernstein says that these features demonstrate "Johns' fascination with the process of perception and how habits of the eye and mind are formed and broken" (Bernstein, 1991, p. 11). We have to take Bernstein's suggestion further, for Johns here shows his fascination with the specific phenomenon that ambiguous images show, that which Wittgenstein called "seeing an aspect."

The fact that Johns has included in the print two well-known ambiguous images in addition to the duck-rabbit makes it evident that he is reflecting on the way in which art can be illuminated by taking it to be a type of double image. As of yet, however, he has not focused on the duck-rabbit.

This happens in 1990 with his making an untitled print to benefit the campaign of Harvey Gantt who was running for the US Senate against Jesse Helms (Johns, 1994, no. 252). Prior to making that

## 196  THOUGHTFUL IMAGES

print, Johns had used the duck-rabbit in a number of other prints, two entitled *The Seasons*, one in 1989 and one in 1990 (Johns, 1994, nos. 247 and 249) and two entitled *Spring* both from 1989 (Johns, 1994, nos. S61 and S66). In those prints, many of the elements of the 1987 work *Seasons: Spring* recur, with the duck-rabbit being clearly visible in all of them.[17]

In the Harvey Gantt print, the only recognizable image is that of the duck-rabbit. The background of the print is unusual for Johns, consisting of organic forms in blue and white that appear liquid-like. A melon-colored cloth is depicted as nailed onto this background. On the cloth, the duck-rabbit is drawn with its eye the white of the paper. Johns had used a similar conceit in which an object appears to be nailed to a background in *Montez Singing* (1989).

As in *Seasons (Spring)*, Johns takes a visual image from a philosophical text, the duck-rabbit, and uses it in a work of art without any commentary. The reference to Wittgenstein is obvious. As in the work of Kosuth, Nauman, and Bochner, a portion of Wittgenstein's text is reproduced, only this time it is a visual image rather than a sequence of words.

By including Wittgenstein's drawing in these works of art, Johns suggests that what Wittgenstein called "aspect seeing" is part and parcel of how we view art. When we look at the cloth with the duck-rabbit on it, we try to see the cloth as an object represented by Johns, but the attempt keeps collapsing as we see the background as a flat abstract work. Johns has thus produced a work that reproduces the experience of aspect-seeing while also including Wittgenstein's example of it. The difference is that, in these works, the work itself becomes an ambiguous image as we shift our perception. For Johns, as for Wittgenstein, art involves aspect-seeing and he has managed to reenact this using one of the central visual images from

---

[17] It is worth noting that Johns also continued to use some of the other ambiguous images in his work, especially "My Wife and Mother." See, for example, Johns, 1994, number 243 (1988).

the *Investigations*. This work uses Wittgenstein's image of the duck-rabbit to create a quotation-based illustration of Wittgenstein's thesis about seeing an aspect.

The final work of Johns that I will discuss is an early one, his 1962 piece *Fool's House*, created a year after he had begun studying the *Investigations* and then recreated as a lithograph a decade later. In this work, Johns employs a more traditional means of illustrating philosophy, viz., creating a visual analogue of a philosophical theory. However, as we shall see, this work illustrates philosophy in a significant manner.

On a mottled grey, blue, and white surface that is painted in a manner reminiscent of the Abstract Expressionists, Johns has placed on the canvas four real objects that would often be found in an artist's studio. Along the bottom edge of the canvas he has incorporated a towel and a stretcher, while a cup hangs from the bottom of the canvas. In the middle of the canvas, he has attached a real broom partially covered in the paint we see behind it on the canvas. Johns even includes a double headed arrow as if to provide instructions on how the broom is to be used in sweeping, and its having "swept the canvas" is registered in the brush strokes visible on either side of it. Johns also includes in hand-painted script the names of each of the objects along with an arrow pointing from the name to the object. At the top of the canvas, Johns has stenciled its title, though the word "house" is split. The title begins to the right of the broom but the letter *O* is split and the remainder of it and the *U*, *S*, and *E* are on the left edge of the canvas.

It's clear that Johns is reflecting on the relationship between objects and their names in this piece. Art historians have suggested, that the splitting of the word "House" between the right and left edges of the paper, with the word "use" visible on the left, is a nod to Wittgenstein's idea, central to the *Investigations*, that the meaning of most terms is their use. Since most of the painting seems to be more clearly related to the *Tractatus*, perhaps Johns is criticizing the view the rest of the work embodies.

## 198  THOUGHTFUL IMAGES

It's hard not to see Johns here as presenting a visual illustration of the picture theory of meaning, one of the central theories Wittgenstein developed in the *Tractatus*. This theory posits *picturing* as the connection between words and objects in the world. An essential element of that theory is that nouns function as the names of objects, and this is what we see illustrated in *Fool's House*. It could be suggested that the obviousness of the painted words' connections to the objects they are connected to by an arrow is a laconic parody of the theory and an endorsement of Wittgenstein's later theory of language often captured by phrase "meaning is use," the word appearing at the left top of the painting. But even if that seems a bit far-fetched, there is no doubt that Johns has shown that a painting is able to present a philosophical theory visually, qualifying this stunning work as a concept-based illustration of the picture theory of language. It even suggests that art can rival philosophy as a means of representing the truth, as we saw earlier exhibited by Kosuth's *One and Three Chairs*.

In both *Seasons (Spring)* and the Harvey Gantt print, a central part of Johns's work of art is a visual image from a philosophical text, Wittgenstein's duck-rabbit. In producing works of art that include a visual element from Wittgenstein's text, Johns does something new: he imports into his visual art a visual image from a philosophical text. This is a completely unprecedented way of illustrating philosophy, one that has rarely if ever been followed.[18] *Fool's House*, while not including a visual image from Wittgenstein's text, is a profound work that visualizes and perhaps even critiques one of the philosopher's central theories about the nature of language.

---

[18] Roy Lichtenstein's painting, *Portrait of Madame Cézanne* (1962), is based on Earle Loran's diagram of Cézanne's 1887 portrait of his wife and is related to illustrations of philosophy.

## Maria Bußmann

I now turn to a consideration of the work of the only woman artist I know of who published illustrations of Wittgenstein's philosophy. Maria Bußmann is an artist who received her PhD in "art-philosophy" from the University of Vienna. She has produced a large number of drawings that illustrate and comment on philosophy. Among the philosophers whose works and claims she has illustrated are Baruch Spinoza, Martin Heidegger, Maurice Merleau-Ponty, and Hannah Arendt.

From 1996 to 1999 Bußmann produced a series of ninety-two drawings that are illustrations of Wittgenstein's *Tractatus Logico-Philosophicus*. All of these works are in pencil and each has the number of the proposition that is illustrated by it written on the left. Since most of the other artists who have illustrated Wittgenstein have focused on his later philosophy, it is intriguing to find Bußmann illustrating the earlier text.

On her website, mariabussman.org, Bußmann includes one of her works illustrating Wittgenstein's ideas, providing her own translation of the passage from the *Tractatus* that it illustrates. Here is the German and Bußmann's own translation of it.

§6.421 Es ist klar, daß sich die Ethik nicht aussprechen läßt.
Die Ethik ist transcendental.
(Ethik und Ästhetik sind Eins.)
§6.421 It´s clear that Ethics is not expressable [*sic*].
Ethics is transcendental.
Ethics and Aesthetics are one in the same [*sic*].

You can see Bußmann's picture, *Drawing to Wittgenstein's "Tractatus,"* in Plate 18.

## 200  THOUGHTFUL IMAGES

From her work based on *Tractatus* §6.4,[19] we know that the object depicted in Plate 18 is a type of pen, here suspended hanging from a nail that allows it to swing.[20] The setup is familiar from versions of Foucault's Pendulum, in which a pen is allowed to trace its rotating circular motions onto a piece of paper. Here, however, although there are some lines on the left side of the page that suggest the movement of the object, the object itself does not appear to move; it is, however, reproduced in a more abstract manner on the right side of the page. One of these objects refers to ethics and one to aesthetics, which Wittgenstein's passage states are identical. At the top right of the page, straddling a nearly vertical line that separates a darker background from the rest of the sketch, there is a small equilateral triangle that is the one constant presence in all of Bußmann's Wittgenstein drawings. There is also a schematic version of the sketch's large image high up on the left, at the top of which is either an arrow or a person.

How does Bußmann's drawing illustrate Wittgenstein's claim about the relationship between ethics and aesthetics? It seems evident that the object on the left, rendered in more detail than the one on the right, stands for aesthetics which, in comparison with ethics, presents objects in a more expansive manner. The right-hand object is much more schematic, reflecting the tendency toward abstraction in ethics. Since the two objects are recognizable as versions of the same thing, this suggests that aesthetics and ethics are the same in that they deal with the same objects, the very claim Wittgenstein makes in §6.421.

One feature that appears consistently in all of Bußmann's *Tractatus* drawings is the nearly vertical line on the right side of

---

[19] Wollenbecker (2013) includes a copy of this image, which is not on Bußmann's website.

[20] The nature of this object is ambiguous. It could also be an incense censer. In his essay in Bußmann (2018, p. 130), Thomas Micchelli identifies it as such. In personal correspondence, Bußmann has stated that it can be both, that is, a pen that is shaped like a censer but that is also studded in a manner to be recognizable as a world. (Received 8/31/2020)

the page that separates the main body of the work from its right-hand portion. Genevieve Wollenbecker (2013) comments that "the line acts as the separation between understanding and what we do not know, 'what we must pass over in silence,'" referring to the famous ending of the *Tractatus* (Wittgenstein, 1961, §7) that we will discuss in a moment in relation to one of Paolozzi's screenprints (see Plate 20).[21] Wittgenstein asserts in this passage that there are areas of human practice whose linguistic expressions are not meaningful, including ironically the very statements that constitute the *Tractatus* itself as well as those of ethics. It is for this reason that Wittgenstein states in §6.421 that ethics is transcendental, borrowing that term from Immanuel Kant who used it to characterize the knowledge developed in the *Critique of Pure Reason*.

Earlier, I mentioned that Wittgenstein's philosophy was focused on the nature of language. His views are the subject of Bußmann's drawing of *Tractatus 3.324* (see Plate 19). *Tractatus* §3.324 and §3.325 discuss one of the origins of the confusions that Wittgenstein sees as endemic to philosophy that we have seen him try to address through his method of philosophizing. He specifies the problem in §3.323, namely, that the same word in everyday language can have more than one meaning. The example he uses is the word "is" which "figures as the copula [in, for example, 'grass *is* green'], as a sign for identity [in 'Venus *is* the morning star'], and as an expression for existence [in 'there *is* no solution to the problem']" (Wittgenstein, 1961, §3.323). In §3.324, Wittgenstein states that the failure to attend to such ambiguity is the "way the most fundamental confusions are easily produced (the whole of philosophy is full of them)." In the next paragraph, Wittgenstein says that this can be avoided by using different signs (words) to stand for different objects. The idea is to create a "sign-language that is governed by *logical grammar*."

---

[21] Michelli (Bußmann, 2018, p. 130) also interprets the horizontal line in this manner.

202 THOUGHTFUL IMAGES

It is this conception of an ideal sign-language governed by logic for which Bußmann provides a text-based illustration.[22] The drawing shows us the relationship between a rectangular sort of tray that is filled with different objects floating high above an abstract landscape on which there are objects that are represented as projectiles from the field on which they are located, each one set in a circle. All the objects in the tray are different from one another, though the things on the field are similar to one another. There are thin pencil lines that link each object on the tray to one of the projectiles on the plane. These lines represent the idealized manner in which linguistic signs are "attached" to the objects in the world that they represent, for each sign is connected to only one object by a line. The tray also has two perpendicular, directed line segments (i.e., each has an arrow at the end), in a manner reminiscent of a two-dimensional graph, highlighting the tray as a product of human activity.

Bußmann has created a work that gives a clear visual representation of Wittgenstein's argument about the source of philosophical confusion and the need for a more perspicuous language if such confusions are to be avoided. The tray in the upper portion of the drawing represents such a regimented language, for the objects in it are "attached" to objects in the world by a single, unique line. Bußmann's work shows that this disambiguation of signs results in greater clarity, for each sign now stands for only a single object. This illustration is a text-based analogical illustration of Wittgenstein's claims.

I have discussed only two of the ninety-two drawings that Bußmann has made to illustrate the *Tractatus*. Her 2018 book, *Allerdings* (a word with a variety of meanings including "though," "certainly," "admittedly," and "mind you"), contains eight images, although not the second one I examined. All of them are difficult

---

[22] This drawing can be found at https://www.villa-wittgenstein.net/node/19.html. Accessed on August 9, 2020.

to interpret as illustrations of Wittgenstein's text despite the fact that each indicates the particular proposition in the *Tractatus* that is its source. David Carrier, one of the few philosophers to discuss her work, says, "Her art is not a depiction of the ideas of these philosophers, but rather a commentary, or as she puts it, an 'addendum' to their work" (p. 3). I have tried to show that, for at least some of her enigmatic drawings, this is not the case; they can be seen to illustrate Wittgenstein's ideas.

We can only hope for a more comprehensive examination of Bußmann's various series of artworks inspired by major philosophers. Bußmann's project of illustrating philosophy is unique and deserves to receive more attention than it has.

## Eduardo Paolozzi

Eduardo Paolozzi (1924–2005), was a Scottish artist often associated with Pop Art because of his colorful prints. Paolozzi's work is the most comprehensive attempt to present illustrations of both Wittgenstein's philosophical ideas and also his personal example. Paolozzi's fascinating works are definitely inspired by Wittgenstein though it's not clear how they function as illustrations of Wittgenstein's ideas. The works that illustrate aspects of the philosopher's life are more easily interpreted as text-based illustrations.

During 1964 and 1965, Paolozzi made a series of 12 screenprints[23] entitled *As Is When: A series of screen prints based on the life and writings of Ludwig Wittgenstein*. Each of the screenprints has a separate title, often referring to Wittgenstein, and they each have either a quotation from Wittgenstein's writings,

---

[23] The term "screenprint" is now somewhat confusing because of the prevalence of computers. A screenprint of the sort Paolozzi made is a stencil-based print-making technique, not a print made of the content of a computer screen.

204 THOUGHTFUL IMAGES

from Norman Malcolm's memoir of Wittgenstein, or from a re-view of that memoir by James R. Newman. The quotations are usu-ally placed around the edges of the image. Four of the prints are about aspects of Wittgenstein's life; the rest are related to his phi-losophy, as presented in either the *Tractatus* or the *Investigations*.

The presence of the quotations is very important, for without them it would be virtually impossible to determine what aspect of Wittgenstein's life and thought is illustrated by each print. The abstractness of the images—some do have recognizable figures—precludes any obvious interpretation in the absence of the guid-ance provided by the quotations. Once again, we are confronted with works that blend text and images, though the text is kept sepa-rate from the colorful images in these prints. The presence of these texts suggests that the images are text-based illustrations though, as I said, it is not easy to see the manner in which they illuminate the texts.

It is hard to describe Paolozzi's screenprints and to convey their visual impact. On the whole, the prints consist of geomet-rical shapes—circles, squares, curves, etc.—that are often colored with stripes of bright, uniform, primary colors. These shapes are arranged in intricate patterns, frequently with colorful grids sur-rounding and enveloping them. Their titles are *Artificial Sun*; *Tortured Life*; *Experience*; *Reality*; *Wittgenstein the Soldier*; *Wittgenstein in New York*; *Parrot*; *Futurism at Lenabo*; *Assembling Reminders for a Particular Purpose*; *The Spirit of the Snake*; *He Must, So To Speak, Throw Away the Ladder*; and *Wittgenstein at the Cinema Admires Betty Grable*. In addition, there is another print serving as the cover of the *As Is When* series, making for a total of thirteen screenprints.

As these titles indicate, some of the prints refer to ideas from Wittgenstein's writing while others refer to events or periods in Wittgenstein's life or even features of his personality. An example of a work that refers to Wittgenstein's writings is *He Must, so to Speak, Throw Away the Ladder* (February 1965) (Plate 20). The title is taken

## ART INSPIRED BY WITTGENSTEIN    205

from *Tractatus Logico-Philosophicus*. The quotation from that book is given in English on the left edge of the print and in German on the right, in a manner reminiscent of the standard facing page editions of Wittgenstein's works. In English, it reads as follows, though the paragraph numbers are not reproduced in the print:

§6.54 My propositions serve as elucidations in the following way: anyone who understands me eventually recognizes them as nonsensical, when he has used them—as steps—to climb up beyond them. (He must, so to speak, throw away the ladder after he has climbed up it.)

He must transcend these propositions, and then he will see the world aright.

§7 What we cannot speak about we must pass over in silence. (Wittgenstein, 1961, p. 151)

This passage, which concludes the *Tractatus*, is among the most famous in Wittgenstein's oeuvre. However, the images in Paolozzi's silkscreen only obliquely refer to this passage. On a maroon background, there are seven multicolored irregular shapes that are reminiscent of a jigsaw puzzle. They are colored with bands of green, red, blue, purple, and orange, and seem almost like waves. Perhaps the idea is that the various propositions of the *Tractatus* are elements in a jigsaw puzzle that the reader needs to assemble, and when this is done, the original propositions or shapes will merge into a single cohesive whole. Alternatively, the shapes might be taken to resemble a disgarded ladder like the one visible in Johns's *Seasons (Spring)*.

On such an interpretation, we can see the relationship between Wittgenstein's text and Paolozzi's silkscreen. Yet, the silkscreen does not provide any rationale for or explanation of Wittgenstein's claim. This is not to say that Paolozzi was not deeply influenced by his reading of Wittgenstein, only that his silkscreen does not make an independent contribution to the question Wittgenstein

206    THOUGHTFUL IMAGES

raises in the final passage of his book concerning the status of the propositions of the *Tractatus*.

Can we interpret this work as a text-based illustration of Wittgenstein's claims in §6.54 and §7 of the *Tractatus*? I find it hard to make a convincing case for doing so. After all, illustrations are supposed to shed light on a text or idea, illuminate it. But Paolozzi's work is at least as puzzling as Wittgenstein's remarks. Of course, that could be what Paolozzi is trying to do, to make a work of art derived from Wittgenstein's text that mimics the perplexities engendered by it.

The silkscreen that comes closer to embodying an analogue to Wittgenstein's remark quoted in it is *Parrot* (#7) dated November 1964 (Plate 21). The background of the print is formed by a grid composed of small boxes made by white lines on a dark beige surface. On the grid, toward the top of the print, are two, slightly tilted triangles that have striped surfaces. Seemingly generated by the triangles are a series of random geometrical shapes that have long curving lines coming out of them, some of which culminate in semi-circles with different colors making them up. There are also two almost staircase-looking objects that form a background for these shapes.[24]

The quotation from Wittgenstein on this print comes from Malcolm's memoir and concerns Wittgenstein's philosophical method. Malcolm quotes Wittgenstein as saying that his method consists in finding possibilities for the use of a phrase or term that are not generally recognized, a claim I have already explored. While an expression normally has one or two uses at most, Malcolm reports that Wittgenstein says his aim is to show that there are others and he takes this to result in a freeing up one's "mental cramp" so that one will be able to find other uses for the expression.

---

[24] It is worth pointing out that Paolozzi often changed the colors of his prints. I refer to the one in the Tate collection. *Parrot* is also a sculpture that shares many of the shapes on the print.

ART INSPIRED BY WITTGENSTEIN 207

If we take the two triangles at the top of the image to represent the two standard uses an expression has, then the rest of the print can be seen as presenting an analogue of Wittgenstein's search for other uses of the expression. The harsh, clear lines composing the triangles stand in marked contrast to the flowing curves that form most of the rest of the images in the print. The print can be taken to represent the process of searching for new uses of an expression that Wittgenstein reports to be central to his own philosophical practice, a practice that results in freeing one from the constraints imposed by thinking of two uses of the expression as the only valid ones. Perhaps, we can treat Paolozzi's print as an artistic analogue to Wittgenstein's philosophical method, one that illustrates the unique nature of his way of doing philosophy.

An example of a silkscreen print that is biographical rather than philosophical is *Wittgenstein at the Cinema Admires Betty Grable*. This work is based on Malcolm's report that, after a seminar, Wittgenstein would go to the movies in order to put to rest his anxiety at having taught poorly. He would sit in the first row of the theater, so there was nothing between him and the screen, which would take up his entire visual field, and munch on some food he had bought on the way. The reference to Betty Grable is likely Paolozzi's mistake, since Malcolm states in his memoir that Wittgenstein liked the actor Betty Hutton (along with Carmen Miranda) and jokingly asked Malcolm to introduce him to her when he visited New York.

The print itself, while having a structure and feel similar to the other prints, has some easily discernible elements. On a white field, there is a grid of small gray diamonds that functions as the background to the colorful images that make up the print. There is a large humanoid form presented in profile that is filled with stripes of different colors. Other images are also discernible: a plane in the upper right-hand corner; an umbrella that is held in a horizontal position by the central figure; what might be a cartoon character (perhaps Mickey Mouse) holding a gun; etc. I can't see an element

## 208   THOUGHTFUL IMAGES

of the print that corresponds to Betty Grable, nor do I see much evidence (other than Mickey Mouse) that this is an image of someone in a movie theater, although the presence of the gun could signal Wittgenstein's interest in American films. The text of Malcolm's memoir that the print illustrates is at the bottom of the print.

Paolozzi here provides a visual representation of Malcolm's account of Wittgenstein going to the movies as well as some other stories about Wittgenstein. He saw Wittgenstein as a person as dedicated to his work as Paolozzi was to his own. And while there are some interesting connections between the prints and Wittgenstein's life and writings, I don't see them as specifically philosophical, a fact confirmed by Paolozzi's characterization of them as autobiographical.

## Conclusion

In this chapter, I have surveyed a number of artists who created works inspired by Wittgenstein's ideas. This has demonstrated the enormous impact that Wittgenstein's theories have had on artists in the second half of the twentieth century and beyond. No other philosopher has had anything like Wittgenstein's impact on post–World War II Anglo-American art.

It may have occurred to readers that there is another philosopher who has crept into this chapter almost against my conscious intention: Plato. Two of Kosuth's works I discuss are about Plato's metaphysics. As I mention in the introduction, Plato's Cave is also something that has been illustrated by philosophers over the years. The fact that the literary form in which Plato expressed himself—dialogues mostly featuring Socrates—makes his metaphysics more approachable than, say, Aristotle's links him to Wittgenstein whose aphoristic style must have appealed to artists.

A unique feature of some of the Wittgenstein-inspired works of art that I have discussed in this chapter is that they generally

# ART INSPIRED BY WITTGENSTEIN 209

feature quotations from Wittgenstein's philosophical writings. In this respect, they differ from the illustrations of philosophy we have previously considered. Take, for example, the famous frontispiece to Hobbes's *Leviathan*. That work renders some of the fundamental ideas in Hobbes's treatise visually, as when we see the visual image of the Sovereign literally composed out of the bodies of his subjects. This idea, so central to Hobbes's political philosophy, is one of the ideas that the frontispiece illustrates. And an analogous point can be made about the works I have studied in previous chapters and even some included in this chapter.

With Wittgenstein, however, it is generally the *language* of his works that becomes the primary vehicle for illustrating philosophy. Most of the works I have discussed in this chapter involve specific quotations from Wittgenstein's writings. (The exception is Johns's *Seasons [Spring]* which involves an image taken from Wittgenstein's text and his *Fool's House*, which illustrates a theory visually.) The words that Wittgenstein wrote are now the object the artists employ in their works, using those words to convey a philosophical idea or claim that is the subject of their work. It is the very materiality of language—the fact that a meaning has to be given a physical form in order for it to be expressed linguistically—that artists have been drawn to. So, when Kosuth renders paragraph §276 of the *Investigation* in neon, he is, in effect, transposing a sentence (which actually appears in German as well as in English translation in the published book) from its written form in the translation of Wittgenstein's text into a visual artwork in which the words are reproduced in neon tubing.

This shift in how works of art illustrate philosophy can be related to the emphasis that philosophers placed on language in the twentieth century. Prior to that, philosophers had generally treated language as transparent, as a diaphanous medium through which we could communicate our ideas to others. Beginning with the work of Gottlob Frege, however, language itself became, at least for a while, the primary focus of philosophical inquiry.

## 210 THOUGHTFUL IMAGES

The Conceptual artists we have been discussing also emphasized the importance of language. But they did so by creating artworks that included language as an important element. Whereas language had mostly been excluded from paintings from the time of the Renaissance, under the dominance of the idea of a painting as a window onto the world, the Conceptual works we have examined have generally rejected that exclusion. One of the revolutionary features of Conceptual art was its inclusion of words in a manner that emphasized the visual or physical aspects of language, opening up a new terrain for painting.

As a result, the basic material by means of which philosophy was illustrated underwent a fundamental change as language, not just the ideas expressed by it, became the primary means for illustrating philosophy. As we turn to more of Bochner's works in chapter 8, we will see that trend continue albeit with a subtle change, for Bochner uses numeric sequences as the fundamental means of illustrating philosophy.

# 8

# Mel Bochner Illustrates *On Certainty*

In 1971, the Conceptual artist Mel Bochner exhibited a set of ten drawings entitled *Counting Alternatives: The Wittgenstein Illustrations*. These drawings were made in response to the publication in 1969 of Ludwig Wittgenstein's book, *On Certainty*, in the now standard bilingual format for Wittgenstein's works, with the English translation on the right-hand page facing the German original. In 1973, at the request of a collector, Bochner recreated the drawings, although two departed from the original ten.[1] In total, Bochner made twelve distinct illustrations of Wittgenstein's text.[2]

Many of the drawings are now dispersed, and others are in poor condition. Fortunately, in 1991 Bochner executed a series of twelve prints modeled after his original drawings for an illustrated version of *On Certainty* published by Arion Press (Wittgenstein and Bochner, 1991). Although the print versions Bochner created in 1991 are smaller than the original drawings—the prints measure 15" x 20" whereas the original drawings are 22 3/8" x 30"—they replicate all the features of the drawings quite accurately. For example, each of the 1971 drawings has a hand-lettered quotation from *On Certainty* at the bottom, and the print versions include the quotations from that book.

[1] These drawings were included in the exhibition, *Mel Bochner Drawings: A Retrospective*, at the Art Institute of Chicago, where I was able to see them for the first time on April 22, 2022. While the structure of the drawings is the same as the ones I discuss, they are larger, and all the quotations are from *Zettel* rather than *On Certainty*. In conversation, the artist said that he didn't want to repeat himself, but offered no further clarification for the change.

[2] My earlier discussions of *The Wittgenstein Illustrations* (Wartenberg, 2015a and 2015b) did not distinguish clearly enough between different stages of Bochner's work that I here describe.

*Thoughtful Images.* Thomas E. Wartenberg, Oxford University Press. © Oxford University Press 2023.
DOI: 10.1093/oso/9780197650547.003.0008

## 212 THOUGHTFUL IMAGES

The Arion Press edition of *On Certainty* also contains smaller, slightly altered versions of the original drawings interspersed in the text.[3] The identical quotations from *On Certainty* are typeset and printed in blue ink on the left page opposite the book's versions of the drawings. In addition, Bochner created for the book two new *Range Drawings*—this is a series he began in 1973 whose images also illustrate Wittgenstein's ideas—that were "printed as end papers to the inside front and back covers" (Wittgenstein and Bochner, 1991, p. 7.) In addition to the two end papers, I have seen one of the original *Range* drawings, *Fourth Range* (1973), as well as a silk screen entitled *Range* executed in 1979.[4]

In this chapter, I present a detailed analysis of all of these works. I do so because these are, I believe, among the most successful attempts by an artist to render Wittgenstein's ideas visually. However, as in his *If the Colour Changes* series, Bochner's works make significant demands on the viewer who cannot approach them passively hoping to be drawn in by, for instance, their beauty. In this respect, as Arthur Danto noted in his introduction to the Arion Press edition of *On Certainty*, they resemble Wittgenstein's philosophizing, which also places demands on its readers (Danto, 1981). Sustained study and attention are required to work out the significance of the works of both the philosopher and the artist, as well as to determine whether and how the artist succeeded in illustrating the philosopher's ideas.

A partial explanation for the difficulty viewers have in understanding Bochner's illustrations is their abstractness: The works consist of little more than sequences of natural numbers arranged in various different patterns. Because the significance of these

---

[3] In a letter to the publisher Andrew Hoyem of February 10, 1991, Bochner complains about the design proposed for the drawings in the book: "The drawing and text are unable to conform to the square format. Because of this, the text is being forced to become an element of the overall typographic design, instead of remaining an integral element of the drawing, which it is."

[4] These works were included in the exhibition I curated at the Mount Holyoke Art Museum in 2015 and can be seen in Wartenberg, 2015b.

MEL BOCHNER ILLUSTRATES *ON CERTAINTY*   213

numbers is not immediately apparent, a viewer seeking to appreciate these works must attempt to understand the rationale for the sequences taking the form they do. The focused attention this requires is analogous to the interpretive process required to understand Wittgenstein's text.

I shall argue that Bochner's works succeed in transposing some of the philosopher's central ideas about knowledge and language from written texts into visual images.[5] More specifically, Bochner's use of sequences of natural numbers allows him to provide a visual analogue of Wittgenstein's central argument against the skeptical claim that all of our beliefs about the world might be radically mistaken. For this reason, I take him to have created works of art that are successful concept-based analogical illustrations of Wittgenstein's ideas.[6]

## On Certainty

*On Certainty* was assembled from reflections in Wittgenstein's notebooks written during the year and a half before his death in 1951. Their subject is the attempt of his Cambridge University

[5] Bochner denies that the drawings are literally illustrations. "Of course, the *Wittgenstein Illustrations* are not literally illustrations. My intention was to construct in abstract visual terms a mental state parallel to that evoked by Wittgenstein's meditations." (Letter to Alice Young, September 1, 1986.) While I don't believe that Bochner's drawings qualify as *pictorial* illustrations of Wittgenstein's text, I do claim that they are concept-based *analogical* illustrations, as I explain below.

[6] While the presence of these quotations might indicate that the drawings are text-based illustrations, I do not believe this to be the case, for it's hard to see the quotations illuminating the drawing on which they are placed. Bochner did contemplate changing some of the quotations. For example, the quotation below *Double Square Branch* is described in a letter to Arthur Danto on May 7, 1991, as "471. It is so difficult to find the *beginning*. Or, better, it is difficult to begin at the beginning. And not try to go further back." But this is not the quotation used in any of the versions of *Double Square Branch*. In addition, the series executed in 1991 has quotations from *Zettel*. In general, although the quotations may help reader-viewers get a sense of which ideas from *On Certainty* Bochner was illustrating, I don't think their placement is significant for understanding the works on which they figure.

214  THOUGHTFUL IMAGES

colleague G. E. Moore to refute radical *skepticism* about the truth of our beliefs or, as Moore termed it, *idealism*. Moore published papers in 1903, 1925, and 1939 that present his anti-idealist/skeptical views. Whereas the idealist asserts that we are not justified in claiming that material objects in the external world exist independently of minds, Moore defends what he termed a "common sense" view of the world against the idealist denigration of it. He did this by citing a number of propositions that he knows for certain, such as that he has two hands.

While one might find the term "skepticism" more appropriate as a way to characterize Moore's opponent, Moore's terminology derives from Immanuel Kant. Kant uses the term "idealism" in the second edition of the *Critique of Pure Reason* to refer to a theory that asserts that our knowledge of the external world is less certain than our knowledge of our own mental states (Kant, 1998, B 275 ff.). Idealism is further characterized by Kant as either "problematic," that is, used strategically in an argument as René Descartes does in his *Meditations on First Philosophy*, or "dogmatic," that is, a doctrine that is endorsed as in George Berkeley's position in *The Principles of Human Knowledge* that nothing corresponds to our idea of material substance.

Kant claims it is a scandal to philosophy that the reality of objects external to us had not been proven, a task he attempts to accomplish in the *Critique of Pure Reason*. Although his argument is fundamentally different from Kant's, Moore attempts the same thing in his papers, i.e., a refutation of idealism/skepticism.

Wittgenstein pursues a different path. Rather than following Kant and Moore by trying to prove the skeptic wrong by showing that we do have the knowledge the skeptic denies we possess, Wittgenstein attempts to diagnose the underlying epistemic confusion that motivates idealism/skepticism. If he can find an accurate diagnosis of this confusion, then the temptation to believe its claims will be undercut. At the same time, he is critical of Moore's assumption that knowledge and certainty are equivalent.

MEL BOCHNER ILLUSTRATES *ON CERTAINTY* 215

So, although Wittgenstein is interested in exposing the flaws of the idealist/skeptical position, he doesn't believe that this can be done by citing a series of propositions that one knows with certainty, as Moore does. Among the propositions Moore says that he knows for certain are the following:

> There exists at present a living human body, which is my body. This body was born at a certain time in the past, and has existed continuously ever since. . . . Ever since it was born, it has been either in contact with or not far from the surface of the earth; and, at every moment since it was born, there have also existed many other things, having shape and size in three dimensions (in the same familiar sense in which it has), from which it has been at various distances. . . . Among the things which have, in this sense, formed part of its environment (i.e., have been either in contact with it, or at some distance from it, however great) there have, at every moment since its birth, been large numbers of other living human bodies, each of which has, like it, (a) at some time been born, (b) continued to exist from some time after birth, (c) been, at every moment of its life after birth, either in contact with or not far from the surface of the earth; and many of these bodies have already died and ceased to exist. But the earth had existed also for many years before my body was born. (Moore, 1925, p. 107)

Moore claims that all of these propositions are truisms. But, in fact, one of them—that there have been other human bodies all of which have been in continuous contact with or not far from the surface of the earth—is false. After all astronauts and now others have flown high above the earth's surface. Nonetheless, most of Moore's statements qualify as truisms.

To begin his critique of Moore's claims, Wittgenstein argues that asserting any of these propositions in the context of an actual conversation would be met with puzzlement. Consider a person who asserts that she knew that the earth had existed for a long time

216 THOUGHTFUL IMAGES

before she was born. Here are some questions that show the oddity of her making the assertion: Is there any context in which such an assertion could meaningfully be made? What could possibly prompt her to say so? Would you think that her saying so shows she had gone mad?

Wittgenstein's insight is that the oddity of Moore's truisms is not that they are false, for with the aforementioned exception they clearly are not, but rather, while one might be subjectively *certain* of them, one cannot objectively *know* them. His reason is that there is no proposition more certain than these that could serve as their justification. In addition, he points out that there is no situation in which their *use* would make sense, no circumstances in which one might reasonably utter them. Although these propositions are all meaningful, using them in any imaginable situation would be puzzling. So, these propositions belong to an odd class of propositions, namely, true propositions for which no appropriate occasions exist for their use.

Although Wittgenstein engages a number of different lines of inquiry concerning these odd propositions and their relation to skepticism/idealism, I here focus on a single line of reasoning interspersed throughout *On Certainty* because of its relation to Bochner's prints. I will draw a great deal from a single sequence of Wittgenstein's remarks in *On Certainty*, §§231–256, but will also reference others when they help support my argument.

Wittgenstein begins by considering how he might respond if someone told him that they doubted that the earth had existed for a long time before their birth, one of Moore's truisms (Wittgenstein, 1969, §231). Wittgenstein says that he wouldn't know how to respond precisely because it is not clear what such a person would count as evidence for or against their claim. This is because the proposition his interlocuter claims to doubt is so fundamental to our understanding of the world that it is not possible to find evidence that would support or undermine it. It is a proposition that we presuppose as part of our framework for justifying other

propositions, but is not itself capable of justification. One must be certain of propositions such as these in order to know anything at all, according to Wittgenstein.

We can grasp Wittgenstein's point by noting that he is here developing an account of Moore's truisms that distinguishes them from what I term "standard empirical propositions." With a standard empirical proposition, such as that Sue is twenty years old, we know how to respond if someone doubted its truth, say, by saying she is not that old. That's because we understand what would count as evidence in favor of or against the person's doubt. One might respond to the assertion that Sue is younger than twenty by saying, "I know she looks young, but I saw her driver's license and it says she was born in 2003 and it's now 2023." Here, the date of birth on Sue's driver's license counts as evidence in favor of the proposition that she is twenty years old and undermines the grounds for skepticism about her age.

But in the case of someone doubting that the earth existed for a long time before they were born, Wittgenstein asserts, we are nonplussed because we don't know what evidence might be adduced either to support or refute that claim. Part of the problem is that this proposition is related to many other propositions all of which, as Wittgenstein puts it, *stand fast* for us (Wittgenstein, 1969, §234).

What does Wittgenstein mean when he says that certain propositions stand fast? This phrase is meant to capture the truth concealed behind Moore's mistaken claim to know certain propositions with certainty. Although Wittgenstein agrees with Moore's contention that we don't doubt these claims, he doesn't think this entails that we know them. To show this, he reflects on what it means to say one knows something. He states that when one claims to know something, one must be prepared to give compelling grounds for one's belief, strong evidence to support it. But the propositions singled out by Moore are not ones for which such grounds can be found. This is not because these propositions are uncertain but is due rather to the role that they play within

218 THOUGHTFUL IMAGES

our knowledge. In relation to another of Moore's truisms—that he knows with certainty that he has two hands—Wittgenstein remarks the proposition itself "is, in normal circumstances, as certain as anything that I could produce in evidence for it" (Wittgenstein, 1969, §250). Because claiming to know a proposition entails being able to provide evidence to support it, it is highly peculiar to claim to know the propositions Moore singles out. They are so basic to our system of beliefs that nothing can serve to support their truth.

The propositions that stand fast for Wittgenstein, then, are not ones that he claims to know, but ones that form "the rock bottom of [our] convictions" (Wittgenstein, 1969, §248). In place of the traditional metaphor of knowledge having a foundation, Wittgenstein proposes an alternative more in keeping with his view: "These foundation-walls [those propositions that stand fast for him] are carried by the whole house" (Wittgenstein, 1969, §248). His suggestion is that we hold fast propositions like Moore's because they are supported by so many other beliefs that we do not have any idea what it would be to deny their truth.

Wittgenstein also uses another analogy, comparing these propositions to the hinges that hold doors in place: "That is to say, the *questions* that we raise and our *doubts* depend on the fact that some propositions [such as Moore's truisms] are exempt from doubt, are as it were like hinges on which those [questions and doubts] turn" (Wittgenstein, 1969, §341, emphasis in original). We can raise doubts about various empirical propositions only because these *hinge propositions* are immune from doubt.

Hinge propositions are empirical, but unlike standard empirical propositions they are not capable of being doubted.[7] That is not because we know them with certainty; rather, it is due to the role they

---

[7] Andy Hamilton (2014, p. 6) does not consider these propositions empirical ones. I prefer to think of them as a special class of empirical propositions to distinguish Wittgenstein's views from traditional conceptions of the *a priori*.

play within our system of beliefs as what Hamilton (2014, p. 6) calls "framework propositions." We don't know them, for they are part of our framework for justifying other propositions, the ones we can claim to know. But this does not mean that we are not certain about them.

Wittgenstein holds that, despite the fact that the hinge propositions are immune from doubt, the set of hinge propositions can change. This is because "a language-game changes with time" (Wittgenstein, 1969, §256). As the language-game changes, so too will the class of propositions that form the framework for empirical investigation. He uses another metaphor when he states that "the river-bed of thoughts may shift" (Wittgenstein, 1969, §97), although we can't say when or how.

The distinction between ordinary empirical and hinge propositions is one that had not been drawn prior to *On Certainty*. Although philosophers at least as far back as David Hume distinguished relations among our ideas (or truths of reason) from empirical matters of fact (see Hume, 1748, §4), this is not the distinction Wittgenstein draws to our attention. His distinction is one *among* empirical propositions (matters of fact). He claims that the hinge propositions, while empirical, play such a crucial role in our thought that they are immune from doubt. As he puts it, "It belongs to the logic of our scholarly [*wissentschaftlichen*] investigations that certain things are *in point of fact* [*in der Tat*] not doubted" (Wittgenstein, 1969, §341, translation modified). These "certain things" are the hinge propositions, the ones that form the framework for empirical investigations.

Wittgenstein's examination of Moore's claims to have certain knowledge led him to develop a novel understanding of what types of propositions cannot be doubted and what this entails about them. This brings him to consider the nature of doubt itself, an investigation that results in a claim that undermines the validity of Descartes's skeptical program: "A doubt that doubted everything would not be a doubt" (Wittgenstein, 1969, §450). Wittgenstein's

# 220 THOUGHTFUL IMAGES

target here is the *hyperbolic doubt* with which Descartes begins his skeptical argument in his first *Meditation*.

Descartes introduces hyperbolic doubt in the following manner. He begins with the fact that we sometimes have reason to doubt sensory reports that posit the existence of an external object. He then asserts that such unreliability requires that we reject all sensory reports and, along with them, our belief in the existence of the external world which they ground. Here is Descartes' brief argument for this conclusion:

> Whatever I have accepted until now as most true has come to me through my senses. But occasionally I have found that they have deceived me, and it is unwise to trust completely those [faculties] who have deceived us even once. (Descartes, 1641, p. 1)

The coherence of Descartes's rejection of our knowledge of the existence of the external world is based on his earlier proposal to reject sources of knowledge if even one of their reports can be shown to be doubtful, let alone false. The senses sometimes do deceive us, so we need to reject all beliefs based on them, he asserts.

Wittgenstein's response to such skeptical argumentation is that the notion of deception or doubt, as he prefers to term it, is being used improperly: "One gives oneself a false picture of doubt," he says (Wittgenstein, 1969, §249). The move from doubting a specific perceptual report—that the person across the quad is Laverne, for example—to doubting the senses as a whole—we have no reason to believe in the existence of an external world—is simply illegitimate on Wittgenstein's view.

Wittgenstein develops his view using the notion of a language-game that he first articulated in the *Philosophical Investigations*, pointing out that the idealist/skeptic fails to understand that "a doubt about existence only works in a language-game." This means that for an expression of doubt to be legitimate, meaningful, we need to determine how it would actually be employed by someone

MEL BOCHNER ILLUSTRATES *ON CERTAINTY* 221

in an actual situation as part of a language-game. But this is just what we can't seem to do: "We should first have to ask: what would such a doubt be like?, and [we] don't understand this straight off" (Wittgenstein, 1969, §24). Wittgenstein's point is that we have to understand the language-game in which someone could meaning-fully assert that they doubt that physical objects exist. "Doesn't one need grounds for doubting?" (Wittgenstein, 1969, §122), he asks rhetorically.

To pin down the point, Wittgenstein's next move is to assert that doubting makes sense only in a context in which there is the pos-sibility of making a mistake. If I can't conceive of making a mis-take about something, then I will never have grounds for doubting it. "What we call 'a mistake' plays a quite special part in our lan-guage games," he remarks (Wittgenstein, 1969, §196). Something is a mistake only when an applicable rule has been followed incor-rectly. There must be some criterion to use to assess whether or not something actually is a mistake, and the rules of the language-game provide it.

In the case of doubting the existence of the external world of physical objects, it is precisely such a rule that is lacking. With a particular matter of fact, I may be mistaken because I misinter-pret what the senses have shown me, say, by misidentifying the person I see in the distance. The perceptual rule might take the following form, "*This* is how Laverne looks when seen from a dis-tance." I misjudge my sensory input when I think I see Laverne, but it's really Shirley.

Nothing similar applies to our belief in the reality of the physical world. There is no perceptual rule that I can misapply, no mistake I can make about the existence of physical objects in general. As a result, the skeptical doubts developed by the idealist/skeptic are misguided.

One can ask whether Wittgenstein has here developed a suc-cessful critique of idealism/skepticism. For example, one might claim that there can be reasonable grounds for doubt even in the

## 222  THOUGHTFUL IMAGES

absence of a rule. I'm not trying to defend Wittgenstein nor can I give an adequate account of the rationale for his view, though I do think there are persuasive elements to it. All that is necessary for my purposes is an account of Wittgenstein's position that is sufficient to allow us to see how Bochner's drawings can illustrate it.

It's important to note that Wittgenstein here displays no skepticism about rules. Especially in light of Kripke's interpretation of §201 of the *Investigations* (Kripke, 1982), many people attribute to Wittgenstein a skeptical view about rule following. Whatever the truth about §201 might be, in *On Certainty* Wittgenstein shows no awareness of rule following as problematic.

To sum up, my very partial account of *On Certainty* shows that Wittgenstein develops a putative refutation of idealism/skepticism that has a very different character from Moore's. Rather than citing a set of certain knowledge that he possesses, Wittgenstein attempts to show that the idealist/skeptic employs the concept of doubt and mistake (error) in an illicit manner, one that extends the justified use of those concepts beyond the sphere in which they can be meaningfully applied. Moore had, in a sense, already discovered this when he claimed to know a certain set of propositions with certainty. But Moore misunderstood the grounds for his own claims, taking them to lie in his own certain knowledge rather than the way in which language as a social practice is constituted. By designating Moore's propositions "hinge propositions," Wittgenstein provides an alternative explanation for why these propositions cannot be doubted.

Wittgenstein sees both the skeptic and Moore as misunderstanding the relationship between doubt and certainty. Whereas the skeptic generalizes the possibility of doubt beyond any context in which it might legitimately arise, Moore treats certainty as residing in a set of specific propositions rather than the structure of knowledge as such. Rather than trying to settle the conflict between the skeptic and Moore, Wittgenstein presents an innovative picture of knowledge in which one can raise a doubt only when a

## MEL BOCHNER ILLUSTRATES *ON CERTAINTY* 223

significant range of propositions "stand fast," that is, are treated as secure and indubitable, at least for the moment. And, much like the American pragmatists whom he acknowledges (Wittgenstein, 1969, §422), Wittgenstein argues that doubts arise only in specific contexts, namely, those in which a rule in our language-game has been violated.

Although Wittgenstein did not live to prepare *On Certainty* for publication, he clearly thought of his reflections as suitable for others to read:

> I believe it might interest a philosopher, one who can think for himself, to read my notes. For even if I have hit the mark only rarely, he would recognize what targets I had been ceaselessly aiming at. (Wittgenstein, 1969, §387)

Perhaps this explains the improvisatory quality of the book, with Wittgenstein returning repeatedly to questions about certainty and doubt, as he tries to develop an adequate assessment of Moore's error. It is also why we find Wittgenstein recording his own doubts about his view in a moment of candid self-assessment: "Haven't I gone wrong and isn't Moore perfectly right?" (Wittgenstein, 1969, §397).

## Counting Alternatives: The Wittgenstein Illustrations

The appearance of the English translation of *On Certainty* in 1969 came at an apposite time in Bochner's career.[8] At the time, his work

---

[8] Brenda Richardson points out that Bochner had been investigating the nature of numbers as a subject for art: "It was only when the artist understood and accepted the numbers (or the 'diagrams') as the substantive form and content of his art that the broader possibility of number asserted itself. Number (and, later, shape generated by number) could convey meaning or content through form without the impediment of referential or expressionistic imagery." (Richardson, 1976, p. 28)

224 THOUGHTFUL IMAGES

had moved away from the more traditional creation of physical art objects to an art consisting of the visual representation of ideas and thoughts. For example, an entire exhibit from this period, recreated at Dia:Beacon and shown from November 9, 2019 to April 4, 2021, consisted of measurements of the dimensions of a gallery, with those distances marked on the gallery wall between arrows (see https://www.diaart.org/exhibition/exhibitions-projects/mel-boch ner-exhibition).

Another of Bochner's concerns was the relationship between thought and language. Generally, language has been considered the vehicle for thought. Bochner's idea was that, to the contrary, language played a more substantive role in the transmission of thoughts, a subject presented by his well-known work, *Language Is Not Transparent* (1970). Wittgenstein's reflections on knowledge and language found fertile ground in an artist who shared some of his fundamental concerns.

How, then, do Bochner's twelve *Wittgenstein Illustrations* illustrate ideas presented in *On Certainty*? There are two features of the drawings that are the key to answering this question.[9] The first is the presence in each drawing of the same *matrix*, that is, a square formed by the two horizontal red lines, the left and right borders in each of the drawings, and the four crisscrossing blue lines. This matrix is present in all but the last drawing. (I will discuss the special status of that drawing presently, for its matrix varies slightly from that of the others.) The second is the distinct patterns formed by the sequences of black ascending natural numbers that are written next to and on the lines and edges of the matrix. In each drawing, these numerical sequences when viewed from a distance form a different geometrical shape, such as a square or a star. These shapes give each

---

[9] I will refer to these works as drawings since that is how they were initially created, even though our access to them is generally via prints. In my description of the drawings, the terms appearing in italics are drawn from Bochner's description of them in his Artist Statement.

of the drawings its title, such as "Counting Alternatives: T Branch" (see Plate 22).

Using these two features, Bochner creates what I will refer to a "numbers-game" in which certain of Wittgenstein's ideas in *On Certainty* apply. I use the term "numbers-game" to indicate the analogy between this feature of Bochner's drawings and language-games. Because the placing of the numerical sequences in the drawings occurs in a manner analogous to that with which our language-games operate, the drawings help us understand the validity of Wittgenstein's claims by modeling his claims about language using numbers.

The first element in the numbers-game, the matrix, represents the set of statements that Wittgenstein claims we "hold fast," that is, presuppose in our empirical investigations. The matrix represents these statements because it is the element in the drawings that is the same from one drawing to the next (with the exception of the final one). As such, this is the element of the drawings that is constant and unalterable, and that creates the context for the numerical sequences that are drawn on them.

The manner in which the sequences of linearly increasing black natural numbers ($1, 2, 3, 4 \ldots$) are placed on the matrix allows Bochner to illustrate a number of other aspects of Wittgenstein's view. Each of the sequences begins with a $0$ placed slightly above the top horizontal red line. It then follows one of the red or blue lines until an *intersection* of the lines is reached. At this point, Bochner tells us "decisions (hence doubt) must be made" ("Artist's Statement" in Wittgenstein and Bochner [1991], and Wartenberg [2015b]), providing the illustration of another of Wittgenstein's ideas.

To understand how the intersections can represent doubt, we need to recognize that the numerical sequences in these drawings exhibit a rule-like structure that allows them to model a language-game. These rules form the "grammar" of the drawings, a feature Wittgenstein also attributes to language. Some of the rules are

## 226 THOUGHTFUL IMAGES

specific to the drawings.[10] The first such rule specifies that a *0* must be written above the top horizontal line at an intersection. The second rule specifies that the sequence of natural numbers must begin directly below the *0* and proceed along one of the matrix's lines until an intersection is reached. The third rule specifies that when an intersection has been reached, the numerical sequence can continue along the same line uninterrupted, change direction and proceed along a different line, or stop. Which direction the sequence takes at this point is not specified by the rules of the number-game but is at the discretion of the artist, who must make a decision at each intersection of the matrix. The only constraint on the artist's decision-making, in addition to the requirement that the sequence proceed along one of the lines of the matrix, is that once all the decisions have been made, the pattern formed by the numerical sequences must be a recognizable one, such as a square or an *8*.

The sequences of black numerals also follow a rule that is not specific to these works: The numerals are always written in the sequential order that the natural numbers themselves have (*1, 2, 3, 4* . . .). Although there are intersections where a sequence "splits" and more than one sequence continues from that intersection, the numbers in these sequences all follow the order of the natural numbers themselves.

Having elucidated the aspects of *The Wittgenstein Illustrations* that model claims Wittgenstein makes about language, we are now in a position to ask how this allows the drawings to illuminate the anti-skeptical argument Wittgenstein makes.

The place to begin is with the intersections, the decision points where the artist must decide which of the matrix's lines the sequence will follow. The artist might wonder, for example, "Should the sequence continue in a straight line? Or should it make a 90 degree turn to the right? Perhaps I should just end it here." The

---

[10] I have abstracted these rules from the drawings themselves.

intersections provide the analogue to a moment of doubt in which a person wonders whether a belief they have is justified. Nowhere else along the matrix is it possible for the artist to decide to have the sequence diverge from its linear direction. The rules of this numbers-game do not allow this.

This feature of the drawings directly models Wittgenstein's claim that the skeptic has misunderstood the nature of doubt. The skeptic's problem is that he has transformed a doubt that occurs in a specific context into a generalized doubt about the truth of all beliefs. Wittgenstein agrees that it is possible to doubt, as we have seen, whether the person I saw over there really was Laverne and not Shirley. But this does not legitimate the idea that all of my beliefs can be doubted. Similarly, while an intersection provides the context for the artist to doubt in which direction the numerical sequence should proceed, no such doubts can be raised anywhere else on the matrix. In this respect, *The Wittgenstein Illustrations* embody a corrective to the skeptical problem that Wittgenstein diagnoses in an aphorism that Bochner inscribes on the bottom of "Line Branch," "One gives oneself a false picture of doubt" (Wittgenstein, 1969, §249).

In assessing the success of Bochner's works as illustrations of *On Certainty*, we need to remember that illustrations are generally governed by what I have called the fidelity norm: They need to accurately represent ideas presented in the text being illustrated. It is important to realize that Bochner's drawings are not text-based illustrations of the specific passages from *On Certainty* written on each of them. Instead, they are concept-based illustrations that illuminate the fundamental argument of the book.

Still, with a complex philosophical text like *On Certainty*, it is not easy to determine what claim the illustrations illustrate. Especially since there may be conflicting interpretations, what is required is only that there is a plausible interpretation of the text that the images illustrate. So, let's consider whether Bochner's illustrations satisfy this requirement.

228  THOUGHTFUL IMAGES

We have already seen that he has provided a visual analogue to Wittgenstein's claims about doubt and hence his critique of skepticism. But we also need to assess other aspects of the illustrations— for example, his use of the matrix as a representation of the idea that Moore's propositions are held fast, i.e., not doubted. The blue lines in the drawing are, indeed, "held fast" from one drawing to the next (again, with the exception of the last one). Because the numerical sequences are written on them, it is easy to see the analogy between the matrix and the set of hinge propositions that form a framework for empirical knowledge.

Wittgenstein explicitly says that we should not regard the hinge propositions as a foundation for empirical propositions; instead, we should see them as themselves supported by standard empirical propositions. The use of the matrix as a background onto which the numerical sequences are written could be seen to encourage a mistaken view of the hinge propositions, one that treats them as foundational. But one need not make this assumption and they do illustrate Wittgenstein's claim that he can't make sense of the idea of doubting them: Were the matrix to be removed, we would have no idea how to proceed in placing the numerical sequences on the drawing. "Doubting" the matrix can no more be made sense of than doubting the hinge propositions. Both of these are part of the grammar of their respective "games."

But what about the final drawing in the suite, in which the matrix is different from the matrix in all the other drawings? *Diamond Branch*'s (Plate 23) matrix differs from that of the other drawings in that the four internal blue lines form a diamond alongside which the numeric sequences are written. Aside from this difference, "Diamond Branch" resembles the other eleven drawings. Previously, I pointed out Wittgenstein's assertion that the hinge propositions could change: "The river-bed of thoughts may shift" (Wittgenstein, 1969, §97). It is this possibility that *Diamond Branch* models, namely, a change in the hinge propositions. What Bochner

has illustrated is that even when the hinge propositions change, our language-game can accommodate that.

Works of art are often enhanced by the presence of multiple meanings. Bochner is clear that the multiple branches of *The Wittgenstein Illustrations* are meant to represent "the narrative development, the constant circling and doubling-back of Wittgenstein's approach to philosophy" ("Artist's Statement" in Wittgenstein and Bochner [1971] and Wartenberg [2015b]). In *On Certainty*, Wittgenstein returns over and over to the same questions, and each time his reflections follow a different path, just as each of the different "Branches" of Bochner's drawings has a different shape formed by the sequences of numerals. In addition, those branches which have multiple lines proceeding from a single vertex, such as *Asterisk Branch*, model this feature of Wittgenstein's philosophizing in a single image.

In my analysis of Bochner's *Wittgenstein Illustrations*, I have posited that Bochner's numbers-game models Wittgenstein's notion of a language-game. Because of this, we should view Bochner's illustrations as *analogical*. They embody a system of rules modeling that inherent in language, and this allows a viewer to reach a more adequate understanding of Wittgenstein's claims about propositions that are immune to doubt and the contextual nature of doubt. In this respect, they resemble, for example, the early modern broadsides of Aristotle's metaphysics I discussed in Chapter 3. A person who has deciphered Bochner's drawings learns something important about *On Certainty*, even though the drawings are not pictorial illustrations of the book's central claims. Through the process of interpreting the drawings, the reader-viewer becomes aware of the rationale for Wittgenstein's ideas precisely because Bochner has provided a visual system in which those ideas and the rationales for them have explicit analogues.

230 THOUGHTFUL IMAGES

## The *Range* Works

The Arion Press edition of *On Certainty* contains, in addition to *The Wittgenstein Illustrations* interspersed in the text, prints of two *Range* drawings as endpapers. These prints are additions to a series of drawings Bochner began in 1973. The only one of the 1973 drawings I was able to see is *Fourth Range*, a much larger drawing than those in the book. Bochner also created a silkscreen version, *Range* (1979), because he was worried that all the drawings were fading, a problem that the silkscreen would eliminate. I proceed to discuss these four works in order to show how they also are concept-based illustrations of Wittgenstein's anti-skeptical arguments.

All of the *Range* works are composed of patterns of numbers in red and black, and one's initial impression is that they have great complexity. However, after a bit of careful and somewhat pains-taking examination, it emerges that, as with *The Wittgenstein Illustrations*, each *Range* drawing conforms to a fairly simple set of rules that determine the numbers-games Bochner has created in these works. Indeed, the works are generated using specifications of the following rules that Bochner mentions in his description of how the *Range* works were created:

> The "rules" of these drawings were simple. The integers 0, 1, 2, 3, 4, 5, 6, 7, 8, 9, were written in vertical rows in alternating sets of red and black. I found that depending on which number I ended the column with and whether the next column began at the top and counted down, or at the bottom and counted up, or if I alternated the up/down procedure and changed color when starting a new column, I would arrive at a surprising, unpremed-itated *horizontal* pattern. (Bochner, 2008, p. 118)

The rules that Bochner mentions here apply to all the works in the series. Each particular work is generated by a further specification of the rules, one that determines what will be done in the move

MEL BOCHNER ILLUSTRATES *ON CERTAINTY*    231

from column to column, i.e., where the next column will start—top or bottom—and what color the first numeral will be—red or black.

Bochner's remarks suggest that a good way to begin interpreting his *Range* works is to determine what specific rules were used to constitute the particular variation in each drawing. Before I do so, I want to mention something else that is important about the *Range* works as works of art. The red and black numerals on the page constitute interesting patterns of color when looked at from a distance. Bochner himself mentions that the drawings can be looked at in two different ways.

> The *Ranges* were entirely unexpected in their binary complexity. But most unanticipated was that the drawings had two "focal lengths." Up close one read the integers and could distinguish the counting phases, but from six to ten feet away the individual integers submerged into their respective colors and one saw a pattern of broad colored bands develop, which had all the odd "naturalness" of wood-grain veneer." (Bochner, 2008, p. 118)

In this respect, the *Range* drawings exhibit the "doubleness" discussed in relation to Johns's *Seasons (Spring)* in chapter 7. However, although this aspect of the drawings is important in assessing their impact as works of visual art, it does not bear on how these works illustrate *On Certainty*.[11]

The artist whose works seem closest to Bochner's is Sol LeWitt. His *Wall Drawings* (see figure 7.1) include instructions that those who execute the actual drawings have to follow.[12] Viewers of the

---

[11] Bochner also emphasizes the fact that all the horizontal rows of numerals generated by following the rules in the *Range* works contain non-sequential patterns of the ten numerals. While this is fascinating mathematically, and depends on the choice of the height and width of the drawing, I don't see it as playing any more of a role in illustrating *On Certainty* than do the visual patterns that emerge.

[12] Adrian Piper has a discussion of LeWitt that is helpful in understanding the revolutionary nature of his art. See "The Logic of Modernism" in Piper, 1996 (Volume 2, esp. p. 213).

232 THOUGHTFUL IMAGES

*Range* works are faced with a puzzle that is similar to the one facing those looking at LeWitt's *Wall Drawings*, i.e., figuring out the rules by which the works were generated. The difference is that unlike LeWitt, Bochner does not provide the specific rules he used to make his works, although he does provide general guidance that is useful in figuring them out, as we saw earlier. In a sense, then, the viewer of the *Range* works has to determine what specific rules Bochner followed to create each work, since the rules vary from work to work and even within each one, as we shall see.

To explain the structure of the *Range* series, I will begin with the silkscreen *Range* (Plate 25). Like the other works in the series, this silkscreen exhibits a clear, if somewhat complex, structure that is determined by a set of simple rules and a number of decisions left open for the artist to make. What I call *the basic sequence* for these works is composed of the natural numbers 0, 1, 2, 3, 4, 5, 6, 7, 8, 9. Each basic sequence is written in either red or black, with subsequent sequences alternating between red and black (with some exceptions to the alternation to be discussed in relation to *Fourth Range*).

The sequences are written in vertical columns initially beginning at the top left of the sheet of paper and ending at a seemingly arbitrary point, in *Range* after 46 numerals. The initial numeral of a new column (which is just the next one in the basic sequence) can be either at the top of the next column (a *jump* in my terminology) or at the bottom of it (a *lateral* move). The color of that numeral can either switch from that of the last numeral or remain the same.

The more complex units formed by the basic sequences are *blocks*. A block is constituted by the occurrence of a 9 at the top or bottom of a column, depending on the direction in which the sequence is written. This constitutes *closure*, since the end of a basic sequence coincides with the end of a column. As in *Counting Alternatives*, there are a number of significant decisions that the artist is free to make and that vary from one block to another. Of course, the decisions are not completely arbitrary: They determine

MEL BOCHNER ILLUSTRATES *ON CERTAINTY*    233

how the rules will be applied for the duration of a block, that is, a set of ten columns in this and other works in the series, although *Fourth Range* varies the width of its blocks.

*Range* is composed of seven blocks. At the bottom of the silkscreen, there are letters to designate the blocks. The seven blocks are labeled: *A, A, B, C, D, E,* and $B_R$ (*R* for reversed). With each new block, there are other decisions for the artist to make. Although each block begins with a *0*, that numeral can be placed in the top or bottom-left position of the first column of the new block. In addition, the initial color of the first numeral can either be the same as or different from that of the last sequence in the previous column. Again, once decisions about this and other features have been made for a new block, they determine the rule-governed structure that is continued until the end of the block.

These rules specify both the structure of the work and the decisions that must be made at specific locations in the work. The first five blocks have somewhat different rules for how to proceed at the end of a column, although they all require the sequence to change colors at the end of a column. *A, A,* and *D* begin at the top and continue with a jump to the top of the next column and alternate the color of the numerals. This determines the sequencing rule for the block, and these rules never vary in any of the blocks once they have been fixed at the second column. *B* begins at the top of the first column, and the second column begins with a lateral move and a color shift. *C* begins at the bottom, and the second column continues with a jump to the bottom and a switch of colors. Although the rules for the first five columns of *Range* change, this does not alter the pattern effect when the work is viewed from a distance. When viewed this way, the regularity of the nice, orderly V's or W's conceals the fact that the rules for constructing the blocks have changed.

Things are different in blocks 6 and 7. Viewed from a distance, the broad patterns of the first five blocks are now compressed and seem slightly chaotic. Although one might assume that there have been

234  THOUGHTFUL IMAGES

radical changes in the rules for these blocks, this is not the case. The only difference between these rules and the earlier ones is that the color of the numerals does not change at the end of a column. The microstructural rules for *E* are identical with those for *A*, except for the one specifying that the color initiating the new column remains the same; *F* has the same relation to *B*. Nonetheless, the resulting visual pattern is very different. Aesthetically, varying the rules creates a striking difference in the image when viewed from what Bochner calls a longer "focal length."

Having now examined the ways in which the *Range* series constitutes a new numbers-game, we are ready to turn to the large and more complex drawing, *Fourth Range* (Plate 24). This work represents a continuation and deepening of Bochner's reflections on Wittgenstein and, in particular, the idea of doubt. *Fourth Range* is a near rectangle of 67x100 numerals arranged in columns. I say "near" because there are a few deviations from this structure, unlike the other *Range* works whose sequences of numerals form perfect rectangles.

Although the blocks composing the two *Range* prints in the published book and the silkscreen are uniform in height and width, *Fourth Range* begins with 3 anomalous blocks. Although all of these blocks exhibit closure, they do so at widths that are less than ten columns, being 2, 5 and 5 columns wide. The fourth block is also anomalous in that, while it has a length of 67, its width is 7 columns.

An alert reader/viewer will realize that the fourth block raises a question. If the blocks of standard width (10 columns) reach closure at the end of the tenth column, how can the fourth column reach closure at the end of only seven? Mathematically, this is not possible, assuming the rules of the numbers-game have been followed consistently.

Just as in the *Range* prints that form the endpapers of the Arion edition of *On Certainty*, the answer is that there is a *mistake* concealed in *Fourth Range*. In the fifth column of the fourth block, the black sequence above the red one at the bottom of the column ends

with an 8, not a 9. Since the numbers-game requires the entire sequence of numerals from 0 to 9 appear in order, the jump from an 8 to a 0 violates this rule. Hence, it is a *mistake*, a failure to follow the rule. The consequence of this failure is that closure is reached three columns more quickly than in the following blocks.

The twelfth block, labeled *M*, is also anomalous as it is only two columns wide and ends without reaching closure. It is an example of an *exception* to the rule that a column must attain closure for a new block to begin. The next block, *E*, simply begins without *M* having attained closure.

These anomalies provide a visual illustration of one of Wittgenstein's most important claims in *On Certainty*, one inscribed on "Diamond Branch": "There is a difference between a mistake for which, as it were, a place is prepared in the [language] game, and a complete irregularity that happens as an exception" (Wittgenstein, 1969, §647). *M* ended without closure, and this is an irregularity that has no explanation. But to skip the 9 in *A2* is a mistake. The rules of the numbers-game very clearly require a basic sequence to be completed before a new sequence begins.

The philosophical significance of these anomalies is that they provide an illustration of the problem with the skeptic's claim that all of our empirical belief could be mistaken. They do this by demonstrating the appropriate context required to recognize the presence of a mistake. In *Fourth Range*, we can see that Bochner made a "mistake" by ending a sequence with an 8 only because we have understood that the work's rules require sequences to end always with a 9. Without the context provided by these rules, there is no way to understand the complete 0-8 sequence as an error.

Wittgenstein claimed that the philosophical skeptic operates with a concept of error that has become unmoored from the context of its appropriate use. The skeptic asserts that we can be wrong about all our empirical beliefs. But as Bochner, following Wittgenstein, has shown in *Fourth Range*, only in the context of a rule does it make sense to say that a mistake has been made and,

## 236 THOUGHTFUL IMAGES

hence, that there is a ground for a doubt about the veracity of a belief. The skeptic's radical doubt ignores the fact that a doubt is only cogent when it occurs within a context of beliefs that stand fast.[13]

It's important to my appreciation of Bochner's *Range* works that they are *concept-based illustrations* of Wittgenstein's claim. Wittgenstein makes a conceptual claim in *On Certainty* about the nature of doubt and its relation to the possibility of error. And he does try, to use one of his oft-quoted distinctions, to *show* us rather than *tell* us why this is so. Still, it is a difficult claim to justify and one of the virtues of the *Range* works is that they really do *show* that a mistake can occur only in the context of a rule, one that can be followed either correctly and incorrectly. This claim is shown to us with clarity and vividness in Bochner's works, whose illustrations illuminate the rationale for Wittgenstein's claim.

Let me briefly respond to a possible objection to my line of thought. Someone might suggest that Bochner might simply have made the two mistakes, so that the weight I am putting on them as key aspects to the works serving as illustrations of Wittgenstein's position is unjustified.

It is irrelevant to my claim whether Bochner intended the mistakes or not. If he intended them as illustrations of Wittgenstein's claim, then this confirms my claims about it. If he simply made two mistakes as he executed his artworks, this does not affect my argument, for he had to decide to leave them there. After all, he does change the color of the sequence in the next numeral, so he must have become aware of the mistake even if it was a genuine mistake. And the decision to leave it allows it to function as an illustration of Wittgenstein's claim. The presence of just one mistake in each drawing suggests to me that Bochner intended them as illustrations

---

[13] The two *Range* prints included as endpapers in the Arion Press edition of *On Certainty* each has an error in it, just like the one in *Fourth Range*. Their analysis does not add anything substantive to the claims I made in regard to *Fourth Range*, but an interested reader should consult my article, "Illustrating Philosophy" (2015a) for an account of these "errors."

of *On Certainty.* But what really matters is that the *Range* works themselves function as illustrations of Wittgenstein's claims regardless of Bochner's intentions.

## Conclusion

The "Conceptual artist" Mel Bochner's illustrations of *On Certainty* achieve a philosophical depth in their attempt to present viewers with visual works whose interpretation reveals insights similar to those developed by Wittgenstein in *On Certainty.* The most profound idea in both the drawings and the philosophical text is that errors, and hence doubts, make sense only in the context of unquestioned beliefs. It is this claim that is used by Wittgenstein to undermine the skeptical/idealist program of hyperbolic doubt.

Let me end my analysis of Bochner's illustrations of *On Certainty* with a comment on their aesthetics. Although many viewers' first reaction to the drawings is a sense of confusion and uncertainty— Dare I say a skeptical doubt?—as they wonder what the drawings mean and how they could possibly illustrate Wittgenstein's ideas, the drawings have an austere beauty that emerges as their meaning becomes clearer. Although Bochner is often labeled a Conceptual artist, *The Wittgenstein Illustrations* and *Range* series demonstrate that he is more than that. Although his art is always engaged with ideas and philosophical concerns, the drawings and prints we have been discussing have a precise beauty that emerges as one studies them in detail and becomes aware of their structure.

# 9

# Graphic Philosophy

Recent years have seen the emergence of a new artform that is generally called the "graphic novel." Evolving out of the comic book, the graphic novel is normally published in book form and contains a sequence of panels in which pictorial images are conjoined with text. This artform has become immensely popular, at least since the publication of Art Spiegelman's Pulitzer Prize–winning *Maus* (1991), arguably the first masterpiece in this evolving artistic genre.[1]

Like *Maus*, many of the works in this genre are memoirs; Spiegelman's was focused on his relationship with his father, a survivor of the death camps during the Holocaust. This makes the term "graphic novel" inappropriate as a means of referring to the genre. Some author-artists working in this genre, such as Scott McCloud (1993), prefer to retain the term "comic," treating graphic novels as a specific form that comics can take. I will accept this usage, treating "comic" as the general term for works in the artform that includes graphic literature, traditional comic books, and even the comic strips found in daily newspapers. But by treating graphic literature as a species of comic, I will retain the more current emphasis on graphic works being a unique artform.

The more specific mode of comics that forms the focus of this chapter is what I call *graphic philosophy*. The works I discuss in this chapter present philosophical ideas in the form of a comic. As we

---

[1] *Maus*, like most early graphic novels, was originally serialized. Some argue that Will Eisner's *A Contract with God, and Other Tenement Stories* (1978) was the first graphic novel.

*Thoughtful Images.* Thomas E. Wartenberg, Oxford University Press. © Oxford University Press 2023.
DOI: 10.1093/oso/9780197650547.003.0009

GRAPHIC PHILOSOPHY    239

shall see, not all of these works actually make a philosophical argument, but some do, and that is a remarkable development, one that weds words and pictures into a unique mode of philosophical writing and drawing.

Before turning to these works, I need to address another issue. Given the topic of this book—works of art that illustrate philosophy—it might seem that graphic philosophy comics would be the quintessential example of illustrated works of philosophy. However, I make the controversial claim that most comics do not contain illustrations, although they obviously are made up of (mostly) pictorial images. I begin with a defense of that claim.

## Why Comics Do Not Have Illustrations

The comic book artist/author Scott McCloud offers this definition of comics: "juxtaposed pictorial and other images in deliberate sequence, intended to convey information and/or produce an aesthetic response in the viewer" (McCloud, 1993, p. 9). A number of features of this proposed definition of comics call for comment.[2] Perhaps the most evident is that McCloud's definition denies that cartoons—the word I shall use for "one-panel comics" such as *Dennis the Menace* (Hank Ketcham) and *The Far Side* (Gary Larson)—are comics at all, since, according to the definition, a comic must include a *juxtaposition* of images and so cannot consist of simply a single one.[3] This is arbitrary. After all, anyone reading

[2] Both Hayman and Pratt (2005) and Meskin (2007) give more systematic criticisms of McCloud's proffered definition of comics.

[3] One-panel comics are sometimes also called "cartoons," as in *The Complete Cartoons of the New Yorker* (Mankoff et al., 2006). Such usage is derived from the art historical use of the term to refer to the full-size drawings some artists made for their oil paintings. However, this terminology is confusing since the term "cartoon" is also used for short animated films. In addition, I see no systematic reason for denying that one-panel comics are, in fact, comics.

240 THOUGHTFUL IMAGES

the *comics* page(s) of their favorite daily newspaper is accustomed to the presence of cartoons or single-panel comics alongside the "strips" or multiple-panel ones. Furthermore, *The Yellow Kid* is generally taken to be the first "newspaper comic strip," and it is a single-panel comic.[4] This suggests that unless some independent grounds are found to exclude one-panel comics, an adequate definition of comics ought to include both single- and multiple-panel comics within a single framework.

A second controversial feature of McCloud's proposed definition is that it privileges the *images* in comics over the *text*. McCloud is quite clear that he views images, but not text, as an essential element of comics. In *Understanding Comics*, McCloud pictures his cartoon self giving a lecture, and in response to a question from a member of his depicted audience—"What about **words**?"— McCloud's comic alter ego (I'll refer to him as "Scott" to distinguish him from the actual author of the comic) responds, "Oh, it doesn't have to contain words to be comics" (McCloud, 1993, p. 8). In fact, McCloud specifies that the *images* contained in a comic must be *pictorial* to rule out treating the presence in a panel of written text alone, which is, after all, a visual image of words, as fulfilling this condition for being a comic.

McCloud is right in claiming that the presence of words or, as I think is more accurate, text is not a necessary feature of a comic. In fact, wordless comics are a specific genre of comics. *Biozoics* by Gerry Swanson is an example of a textless comic, one in which there are no words but merely the juxtaposed pictorial images that McCloud takes to be a necessary feature of comics.[5] *Biozoics* is certainly a comic, albeit a web-based one, and it shows that a comic need not have any text at all. I encourage skeptics to consult a list of

---

[4] http://xroads.virginia.edu/~MA04/wood/ykid/illustrated.htm, retrieved December 12, 2009. *Wikipedia* makes a similar claim.

[5] *Biozoic* can be accessed at http://www.webcomicsnation.com/gerry/biozoic/series.php.

textless comics—http://comics.lib.msu.edu/rhode/wordless.htm (accessed 12/11/2019)—that demonstrates that textless comics are an important genre of this artform.[6]

McCloud is also right that a purely textual comic is not possible, although for a reason other than the one he gives. The pictorial space defined by a panel is one that attributes significance to the visual form of anything that appears within it, so that words, when they appear in a comic panel, are visual objects as well as visual correlates of concepts or ideas. We'll see an example of a word used this way in figure 9.2.

Despite the primacy of the visual in a comic, as any reader of the comics page of a daily newspaper knows, comics *generally* are characterized by the presence of both visual images and written text. In what follows, I propose to examine this widespread feature of many comics, for it raises an interesting question: How are we to understand the structure of a comic that is marked by the co-presence of images—especially pictorial images—and text? After all, as we have seen, words and images signify in very different ways. Not any assemblage of images and text counts as a comic; our goal will be to develop a theoretical account of the unique complex of text and image that characterizes the vast majority of comics.

To develop an account of the structure of comics, it will be useful to consider two other image-text complexes that are similar to, but different from, that typically found in comics. Although many theorists, including McCloud, reference film as an artform that includes words and images and therefore needs to be distinguished from comics, I think there are other artforms that are more appropriate to compare with comics. Because films generally do not include (written) text but rely on sound as the

---

[6] Parity considerations would lead us to expect the possibility of imageless comics. In fact, I only know of pictureless comics, that is, comics in which the images consist solely of text. See for example, Kenneth Koch (2004).

## 242  THOUGHTFUL IMAGES

medium through which words are presented, they are not the artform closest to comics, ontologically speaking. Films do use written language, of course, but in limited contexts. Generally, in addition to the film's title, the names of the people involved in the production of the film are shown on screen at the end of the film. And often films will have written comments after the end of the narrative, especially when a film is based on real events. These comments tell us what happened to the actual people depicted in the film after the end of the narrative. But these are marginal presences, for the majority of the film is constituted by the audio and visual tracks, neither of which contains written language.[7]

Illustrated books are the first visual artform involving both (written) text and (visual) images that present a contrast to comics. I have in mind illustrated books in which the images and the text are printed from the same plate. Wood engraving, a technique invented by Thomas Berwick in 1775, was the first technology for producing illustrated books of this type. Because wood engravings are made by cutting away the material you do not want to appear in the print, thus leaving the raised material that will print the image, it became possible to print images together with copper plates of text. Wood engravings are also quite durable, allowing many copies to be printed from a single engraving. This was the dominant mode for printing books until photoengraving emerged in the 1820s. At that point, it became possible to use a copper plate to print both an image and accompanying text. This could not be done with early illustrated books, as I mentioned in chapter 4.

A fine example of a contemporary illustrated book is Barry Moser's handsome illustrated edition of *The Holy Bible: King*

---

[7] Silent films did employ written text in their intertitles which performed important narrative functions. But this structure is rarely used today, and that's why I do not discuss it here. I do realize that one could see flips books, which are essentially comics rearranged, as the predecessor to films. Nonetheless, I will not use films as an entry point into my discussion of comics.

# GRAPHIC PHILOSOPHY 243

*James Version/The Pennyroyal Caxton* (1999). This edition of the Bible includes 232 highly detailed black and white relief engravings made by Moser that are presented alongside the text of the King James translation of the Bible. While Moser's edition is certainly a work of art, there is a clear asymmetry between the text and the images contained in it.[8] This is because the images are text-based illustrations and not autonomous images or pictures.

A good example is the first illustration in Moser's edition of *The Holy Bible*. It bears the title "Adam and Eve in the Garden of Eden" (Moser, 1999, p. 3). (figure 9.1). The image contains a naked man and woman in the left upper corner of a bucolic scene of lush vegetation with a stream in the center of the page that ends in a waterfall at the bottom of the page.

This engraving would be an impressive work, even if it stood alone. It illustrates a scene from the story of Adam and Eve, specifically the one described in Chapter 3 of Genesis. The story concerns God's creation of the Garden of Eden and contains a number of details about the landscape into which God placed the first two human beings. Here is a portion of that story:

> And the Lord God planted a garden eastward in Eden; and there he put the man whom he had formed. And out of the ground made the Lord God to grow every tree that is pleasant to the sight, and good for food; the tree of life also in the midst of the garden, and the tree of knowledge of good and evil. And a river went out of Eden to water the garden; and from thence it was parted, and became into four heads. (Moser, 1999, p. 2)

This text specifies many features that an image of the Garden of Eden needs for it to satisfy the norm of fidelity that we have seen is

---

[8] The entire book counts as a work of art because of its design, the paper, the fonts used, etc. I do not discuss these here.

**Figure 9.1** Barry Moser, *Adam and Eve in the Garden of Eden* from *The Holy Bible*: King James Version/The Pennyroyal Caxton Bible (1999).

central to text-based illustrations. As that norm specifies, the picture includes many features of the scene mentioned in the text. In this case, such features include, for example, trees that are pleasant to look at, a man represented as inhabiting the place, and a river flowing through the garden. If the illustration lacked most or all of these features, even if such a difference made it artistically superior to the actual engraving, it would fail to be a faithful illustration of the place described by the text, though some omissions can be justified by the norm of felicity, as we have seen.[9]

This example supports the claim that there is an asymmetry between text and image in illustrated books, with *the text being ontologically primary*. In this case, the text has a description of a location that the images must picture in order to exhibit fidelity to the text.[10] Even when an illustrated book is a genuine work of art, as is the case with the illustrations in Moser's *The Holy Bible*, the images remain subordinate to the text from an ontological point of view, for they are illustrations of the scene described by the text, no matter how deeply moving and beautiful they may be.

It is worth noting that nothing prevents the illustrations in illustrated books from becoming independent works of art. Especially when a book and its illustrations are hand printed, the illustrations may be separated from the book in which they are found and exhibited as independent works of art. Such is the case, for example, with Pablo Picasso's illustrations of Aristophanes's *Lysistrata* (1934) or Marc Chagall's suite of illustrations of Longus's *Daphnis and Chloé* (1961). Nonetheless, the point still remains that the images

---

[9] Can there be illustrations that are not faithful to the text they illustrate? This is an interesting question for a theory of illustration that would have to take into account the possibility of what might be called "creative illustrations" of texts that are intentionally unfaithful to the texts they illustrate. We have also seen that in the case of *The Rape of Europa*, there are artistic choices that entail a violation of the fidelity condition.

[10] I ignore the visual aspects of the text here. Many illustrated books are works of art in part because of the manner in which the book was made, with the font itself being carefully chosen and displayed.

in such illustrations are ontologically dependent on the text they illustrate.[11]

Moser's engraving shows another important feature of illustrations: Adam and Eve are depicted as Caucasian. This racial feature of the first humans contradicts the actual evidence about the race of the first humans. They probably came from Africa and hence were likely not Caucasian. Moser follows a tradition in Western art by depicting them as Caucasian. This is not a feature of the biblical description of Adam and Eve but represents a cultural tradition that Moser employed in his engraving. Any illustration of this scene has to include humans of some, even if indeterminate, race as the supplementation norm requires. Most illustrations will have similar features that incorporate cultural assumptions that may be erroneous.

Just as illustrated books form an artistic genre that is distinct from comics, so do children's picture books, the second, related artform employing words and images. Early examples include Lewis Carroll's *Alice's Adventures in Wonderland* (1865) and A. A. Milne's *Winnie the Pooh* (1926). Even though the images in such books are text-based illustrations of the story whose text they accompany, and thus are bound by the fidelity constraint, they have a different status from those in books such as Moser's *The Holy Bible*.[12]

We can begin to see the difference by looking at John Tenniel's illustrations of *Alice's Adventures in Wonderland* (see figure 2.1). In earlier work, I characterized these as *canonical*.[13] They are so

[11] Not all books that include images count as illustrated books. There are, for example, illuminated manuscripts in which the first letter of each chapter is rendered as a beautiful design. These images do not count as illustrations in the sense I am using that term.

[12] I mentioned earlier that *Where the Wild Things Are* includes spreads with no accompanying text. This shows the possibility of wordless picture books. For such books and images, there is no text to which the images can be faithful.

[13] In another context, I called this second type of word-image complex one in which the images are "iconic" (Wartenberg, 2007, pp. 40–41). I used that term to indicate that we needed to view such images as more than simply illustrations of the story specified by their text, though they are that as well.

GRAPHIC PHILOSOPHY    247

closely tied to Alice's story that it is plausible to say that when we refer to the work, *Alice's Adventures in Wonderland*, we are referring not just to Carroll's text but also to Tenniel's drawings.[14] In support of this contention one can point out that readers take Tenniel's drawings, derived from Carroll's own original drawings, to represent what the characters in the book actually looked like. That is, they take Alice to be a girl who looks and dresses like the girl in Tenniel's illustrations, just as centrally as they take her to have undergone the adventures described in Carroll's text.

This means that the text and the illustrations *codetermine* the nature of Wonderland. Even though the images in this case are illustrations and thus are ontologically dependent on the text and must adhere to the standard of fidelity, they have a more foundational role than the illustrations in illustrated books like Moser's *The Holy Bible*.[15] They, together with the text, determine the nature and structure of the work's story.[16]

Is it possible to specify why some illustrations in books count as canonical while others do not? One might think that an illustration will count as canonical only if it was present in the original edition of the work. But this turns out not to be true. Most people believe that Mark Twain's *The Adventures of Huckleberry Finn* (1884) is a purely textual work, indeed, one of the classics of nineteenth-century American literature. They do not realize that the original edition of the book, published by Webster and

---

[14] There are other illustrations of Carroll's story, for example, Barry Moser's beautiful 1982 version. Nonetheless, I think that Carroll's remain canonical.

[15] Nothing prohibits illustrations like Moser's from becoming canonical. At this point in time, however, it is clear that they are not.

[16] John Holbo has questioned whether Tenniel's drawings are really canonical for *Alice in Wonderland* (Holbo, 2012, pp. 3–30). It certainly is true that they might turn out not to be if alternative sets of drawings came to predominate. Perhaps, we should relativize the notion of canonicity to a particular time, place, and/or social context. On the other hand, if Tweedledum and Tweedledee are presented as siblings in all other sets of illustrations of *Alice*, that will show that Tenniel's drawings are canonical in that features of the story-world are derived from the drawings rather than Carroll's text.

248　THOUGHTFUL IMAGES

Company in 1884, included 174 illustrations. The written text of *Huckleberry Finn* is ontologically primary, despite the fact that the first edition contained a large number of drawings illustrating Huck's story.[17] Because they are not typically associated with the world of the novel, these illustrations are not canonical.

On the other hand, illustrations can be canonical even if they did not appear in the original edition of the book. We associate *Winnie-the-Pooh* (Milne, 1926) with E. H. Shepherd's wonderful illustrations, even though they were not the ones with which the Pooh story first appeared. When the first Pooh story was published in the *London Evening News* on December 24, 1925, it was accompanied by illustrations made by J. H. Dowd, and not those of Shepherd.

Shepherd's illustrations have become canonical since, despite their recent Disneyfication, they are taken to specify how Pooh and his friends look. Of course, the first edition of the book version of *Winnie-the-Pooh*, did have Shepherd's illustrations, but those illustrations were not the first to accompany a Pooh story.

In light of these facts, I don't think it is possible to give a complete account of what makes an image a canonical illustration. Even though Arthur Conan Doyle never states in his Sherlock Holmes stories and novels that Holmes wore a deerstalker, once the illustrator Sydney Paget placed one on his head, imagining Holmes without one became nearly impossible.[18] Clearly, this canonical illustration (or feature of a set of them) determines how we imagine Sherlock Holmes. Even in recent films that depart from Doyle's actual stories, Holmes himself is still usually pictured in ways derived from Paget's illustrations.

---

[17] Richard West suggested to me in conversation that the reason for this is that Twain's book was originally published as a work of children's literature, a genre that requires the presence of illustrations. Now, however, since we regard the book as one of the great works of American literature, the illustrations are no longer treated as part of the work. This explanation may not be valid, however, since many nineteenth-century books intended for adult readers had illustrations in them.

[18] I owe this point to Richard West.

GRAPHIC PHILOSOPHY    249

Perhaps all we can say in general is that an illustration that seems uniquely suited to a story, that somehow captures the essence or feel of that story and its characters, is likely to become canonical. If this conjecture is true, then we can say that, in addition to the norm of fidelity, canonical illustrations will conform to a norm of *appropriateness.*

How does the image-text complex in comics differ from those we have just investigated? One might think that there is a quick and easy answer to the problem of distinguishing comics from the other types of illustrated texts we have been discussing. After all, unlike them, the images in comics are not illustrations of a preexisting story specified by a written text. As a result, the images of comics cannot be subject to the fidelity constraint that governs text-based illustrations. The *simple theory* states that comic book images are not illustrations of a preexisting text.

Attractive as the simple theory is, it won't do as it stands. Take the *Classics Illustrated* comic book series that was published between 1941 and 1971. Each comic book was an illustrated version of a classic literary text, such as James Fenimore Cooper's *Last of the Mohicans* (1919). In 1942, a *Classics Illustrated* version of Cooper's novel was published with images that are, in some sense, illustrations of the story presented in the original book. Given this fact, the simple theory cannot be correct.

But we should not be too quick to reject the simple theory or, at least, the insight on which it rests. The panel from the *Last of the Mohicans* comic reproduced in Plate 26 was chosen more or less arbitrarily. At first blush, we might think that the picture of the man pointing at the figures in the river is simply an illustration of the text that is present in the panel—"Hist! Look there! The risky devils have swum across to our island." Because the text says "Look there!" and the man is pointing at something, it's natural to assume that the image illustrates what the text describes.

This is not the case, however. For one thing, the text of this panel is itself derived from Cooper's novel. The passage in the

250 THOUGHTFUL IMAGES

novel runs as follows: "Hist! Look into the water above, just where it breaks over the rocks. I am no mortal, if the risky devils haven't swam down upon the very pitch, and, as bad luck would have it, they have hit the head of the island" (Cooper, 1919, p. 65). Because the comic's text is itself derived from the novel, it does not have ontological priority over the image: Both are derived from the novel.

In addition, there are many features of the image that are clearly derived from the novel but are not mentioned at all in the text of the comic. Take a look, for example, at this passage from Fenimore Cooper's novel:

> With no other guide than the ripple of the stream where it met the head of the island, a party of their insatiable foes had ventured into the current, and swam down upon this point, knowing the ready access it would give, if successful to their intended victims. As Hawkeye ceased speaking, four human heads could be seen peering above a few logs of driftwood that had lodged on these naked rocks, and which had probably suggested the idea of the practicability of the hazardous undertaking. (Cooper, 1919, pp. 65–66)

Although some details in the novel's description of the scene are omitted from the illustration, most clearly the driftwood logs (remember the importance of the felicity norm and the size of a comic frame), the general description of the location, and the characters are definitely represented in the picture. So, if the image illustrates anything, it is not the story derived from the text that appears with it but rather the story as originally specified by the text of the novel. In this respect the comic's image is no different from its text. Both the image *and* the text together refer to one (part of an) episode in Cooper's novel.

The text and images of the *Classics Illustrated* version of *Last of the Mohicans*, both derived from Cooper's original text, but

only together do they present a version of the novel's story. As a result, even though the simple theory is not correct as it stands, a slight revision allows it to handle the case of *Classics Illustrated* comics: The distinctive feature of the (pictorial) images in comics is that they are not illustrations of a story determined by *the text with which they appear*.

At this point, it will be useful to introduce some terminology for describing the word-image structure that is characteristic of comics. I have already used the term "panel" to refer to the basic unit of a comic. Like the panel in Plate 26, panels are generally rectangular in form and constitute the first element of a comic. Comics can be composed of just one panel or a number of panels, but the panel is always the basic unit of a comic. When panels are juxtaposed, they constitute a "sequence," usually a temporal one in the depicted world of the comic. The juxtaposition of panels creates a *necessary* sequence, for the panels are to be read in a specific order that parallels the flow of time in the story.[19]

As in films, the sequence of images in a comic does not have to correspond to a linear temporal sequence. Flashbacks are used in both artforms and indicate a break in the ongoing temporal flow and a jump to a previous time. This does not invalidate my general point.

A panel is usually composed of an image or picture, mostly but not always a drawing, together with a written text. We will investigate what the text can signify in a moment. For now, we need only note that in the types of comics we are interested in, there is usually a text composed of one or more words. We have already noted that there are cases in which there are no words in a panel; we now have to add that although it happens more rarely, there are instances in which the panel appears not to contain any image at all. Nonetheless, at a basic level, comics are composed of panels,

---

[19] This feature of comics is reminiscent of Kant's claim (1998) that causality involves the necessity of a temporal sequence.

## 252  THOUGHTFUL IMAGES

and panels generally involve a complex of (pictorial) images and (written) text.

Seeing comics as composed of panels clarifies some of the ontological issues associated with them as well as providing the unified treatment of one- and multiple-panel comics I earlier claimed was needed. By taking the basic unit of a comic to be the panel, both one-panel comics and multiple-panel sequences can be seen to be two species of comics.

A second term that will be important for our analysis is "frame." Generally speaking, each panel of a comic contains a frame, that is, a drawn box or other plane figure that designates the panel's representational space and also identifies the unity that constitutes a single panel. The line-drawn plane figure resembles the physical frames within which oil paintings are traditionally displayed or the edges of a sheet of paper on which a picture is drawn. These establish the extent of the physical space on which the representational image(s) is (are) placed and indicate that there is a representation at all; the frame in a comic functions similarly. In Plate 26, you can see the presence of such a frame.

Two quick comments are in order. First, sometimes the frame will be merely implicit, suggested, for example, by the drawn frames on contiguous panels. Generally, though, comics include actually drawn frames that help individuate the different panels or establish the limits of a single panel comic. Second, the frame can be identical with a panel or a proper subset of it. That is, although the frame often establishes the boundaries of a panel, both the imagistic and textual features of a panel can extend beyond the frame. Most single-panel comics, for example, include text that is placed outside the frame. But the text in a strip can also transgress a frame's boundary.

Another feature of the pictorial space created by the frame is that it need not be "pure" in that it can also contain text, often indicating words that are uttered by the comic's characters. However, some comics do have pure pictorial spaces, so that nothing is placed

GRAPHIC PHILOSOPHY    253

within the frame except for visual elements with a depictive function.[20] *Dennis the Menace* (Hank Ketchum) is an example of such a comic. Its daily comic is a one-panel one in which the frame contains no non-depictive linguistic elements (other than the copyright by North American Syndicate that we can simply ignore). Below the frame there are usually a couple of lines in quotation marks, often representing a comment that Dennis makes about the scene represented within the frame. Such a rigid separation of image and text occurs mostly in one-panel comics (aka cartoons). Multipanel comics tend to integrate image and text within each frame, although, as I have mentioned, the text sometimes transgresses the limits established by the frame.

The central point I have established here is that a distinctive feature of comics is that the images and text both contribute at an equally basic level to their story. Neither the text nor the images have a more fundamental role than the other; both work together to create the comic's story. Before exploring precisely how these two elements work together with one another in the creation of a story, we need to look separately at each of these two features of a comic.

As we have seen, McCloud characterizes comics as having "pictorial images." I take this to mean that he sees the frame as characterizing a perceptual space within which images have a pictorial or depictive function. The frame marks a space on the page that allows for images that partially characterize the story of a comic. Saying that these images are *pictorial* means that they present visual depictions of what things in the story look like.

The pictorial space determined by the frame is not always *purely* pictorial. That is, it can also accommodate text within it without confusing viewer-readers. Generally speaking, the text present

---

[20] We should note that words can be present in what I am calling a purely pictorial space when the words are features of the depicted sign, as when the image includes a stop sign with the word "STOP" in it. For convenience, I refer to such words as *depictive*.

## 254 THOUGHTFUL IMAGES

within the frame of a comic functions to specify the speech or thought of a character, but there are other uses of text as well.

There are other non-pictorial visual markers used in a comic to characterize elements of the story. For example, consider speed lines. "Speed lines" are lines emanating from an object or person that indicate that the object or person is moving quickly. (In a moment, we will examine an example in Roy Lichtenstein's *WHAMM!* and its comic counterpart.) Clearly, speed lines are features of the image, but they are not pictorial; they are *symbolic*, indicating, a feature of the story, namely, the speed with which objects move. So, even though the frame indicates a pictorial space within a panel, not every feature of the image within that frame must have a pictorial function.

Turning now to the other element of a comic—the presence of words or text—there are at least four different ways in which text functions: as the representation of the thought or speech of a character; as narration; as a pictorial element; or as the representation of sonic events. I explore each of these in turn.

The first use of text is what David Carrier, the first philosopher to write a book about the philosophy of comics, mistakenly takes to be one of the essential features of a comic: the "text-balloon."[21] A text-balloon is a symbol that occurs within the pictorial space created by the frame of a comic that indicates the presence of a (more or less) enclosed space, generally within the frame of a comic, that is not part of the pictorial representation in that panel. Instead, it creates a linguistic space, and its linguistic element can be understood in at least two ways. In both of its basic uses, a text-balloon is attached to a particular character, indicating that the words inside the balloon are either (i) thought or (ii) said by that character. Text-balloons attribute the words written within them to a specific character as

---

[21] Carrier refers to "speech-balloons." Since the words need not be speech and there need be no closed plane figure such as a balloon, I prefer the term "text-balloon." See Carrier, 2000, chapter 2.

GRAPHIC PHILOSOPHY 255

either the person's thoughts or speech, although multiple stems can indicate that these words are uttered or thought simultaneously by more than one character.

As the example of *Dennis the Menace* demonstrated, comics do not have to render characters' speech via text-balloons. Words indicating Dennis's speech and that of other characters, such as the eternally frustrated Mr. Wilson, are always placed *outside* and *beneath* the frame of this comic's panel, thereby indicating that that space should not be understood pictorially. Speech rendered in this way is less common than the presence of text within the frame of a comic, at least in multi-panel comics.

There is no need for the presence of an actual text-balloon to indicate that the words within the frame are to be attributed to a character's thought or speech. Given audiences' understanding that comics have an ontological structure in which text is often employed to represent the speech and thoughts of the characters depicted in the image, some comic artists use minimal means to indicate that this is how the text should be interpreted. Although Gary Trudeau often uses text balloons in *Doonesbury*, he frequently just connects a section of text to its speaker with a single line with no plane figure enclosing it. In doing so, he relies on the more explicit rendering of the text-balloon to determine this specific use of text within the frame of a comic.

A second, and quite prominent use of text in comics is for narration or commentary. For example, the *Mark Trail* strip for November 16, 2009, contains two yellow boxes with words in them (one of which is superimposed over the two frames of the comic) that explain what is happening in the strip, namely, that the man depicted running in the right-hand panel has escaped from the poachers shown shooting in the background of the left-hand panel. The running man is trying to rescue the little dog that is being threatened by an alligator in both panels. The text in these boxes provides the narrative needed to explain what is happening in the two panels. The text in the first box reads: "One of

## 256 THOUGHTFUL IMAGES

the poachers fires at the big alligator as it comes out of the water to get the pet dog."

Such extensive use of text as a narrating tool is quite rare in comics. Perhaps this is because the presence of extensive text tends to subordinate the pictures and thus threaten to render them illustrations of the story constituted by the text alone. Still, many comics do use narrative text, albeit in a more restricted manner. Comic readers are familiar with small text boxes in the first frame of a daily strip that say things like "Meanwhile . . ." and thereby indicate how one is to understand that day's strip in relation to previous ones.

A third use of text in comics is pictorial. An example of a pictorial use of a word is the use of the word "STOP" within the image of a stop sign. What characterizes such a use of text is that it depicts a feature of the story. When, in the *Peanuts* strip from November 26, 1951, we see the word "Beethoven" under the drawing of a bust of the famous composer, that is because there the fictional bust depicted in the strip actually has the word "Beethoven" inscribed on it.

The final use of text that I shall discuss is neither purely linguistic nor simply pictorial. It is rather a transformation of (usually) auditory features of the depicted (fictional) world of the comic into visual form. Consider figure 9.2. It displays the word "POW!" written in all caps and surrounded by a large star. In this case, the text is used representationally, but not *visually* or *pictorially*. Rather, it represents sonic elements of the scene that could also be represented pictorially by the images in the other frames in a strip, such as a man winding up to punch another.

The pop artist Roy Lichtenstein established that this use of text is one of the distinctive features of comics through his paintings of comics such as *Whaam!* (1963). That painting is derived from a large panel in DC Comics' *All American Men of War* (Grandenetti, 1962). Plate 27 is a deconstruction of Lichtenstein's work by David Barsalou that shows it in front of the original DC

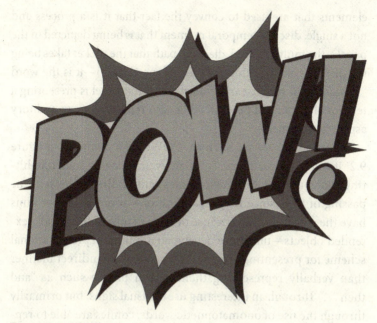

Figure 9.2 POW!

Comics version. The use of text to represent auditory events originated in comics, although it has subsequently been employed occasionally by television (as in the Batman TV series) and films.[22]

This use of text moves beyond a simple representation of a sonic element of the pictured scene. The word "Whaam" does not simply provide an onomatopoetic representation of the sound caused by the rocket's striking the plane, the event that is pictured in the panel. Instead, it provides a means for the static image to indicate the dynamic process that the panel represents, namely, the shooting down of one plane by another. Although there are pictorial

---

[22] The first use of onomatopoeia I could discover was the first *Popeye* cartoon on June 11, 1929. A gun fires and the word "Bang" appears over the smoke track of the bullet. There may be previous uses, but I am not aware of them.

## 258 THOUGHTFUL IMAGES

elements that are used to convey the fact that it is a process and not a single, discrete temporal moment that is being depicted in the panel—the multi-colored, diagonal path that the rocket takes being the primary one (including its use of speed lines)—it is the word "Whaam" that most clearly indicates that the panel is presenting a temporally extended process, while also representing an auditory aspect of the process.

When we see a word such as "POW!" in a comic as in figure 9.2, it indicates the presence of an event, such as someone hitting someone else. Although comics cannot directly present the passing of time since they lack duration—something that films have the capacity to do because of their nature as temporally extended objects—they have developed a unique representational scheme for presenting temporal events in a less indirect manner than verbally representing them with a phrase such as "and then . . .". Through an interesting use of visual signs, but primarily through the use of onomatopoetic words, comics are able to represent temporally extended processes or events in a way that traditional visual mediums such as painting standardly do not, since they generally eschew such symbolic means of representation.[23]

In general, it is impossible to describe a comic's story without referring to both its text and images. Unlike the case of illustrated books, in which the text is ontologically primary, a comic's images and text have equal ontological status in determining the story the comic tells and in providing reader-viewers with the enjoyment they get from the comic.

Although we have encountered a variety of text-image relationships in our study of illustrations of philosophy, comics generally involve a unique interplay between text and image. The two work together to create the comic's story. For this reason, the

---

[23] Text-balloons also represent the temporally extended processes of thinking and speaking. I am here only concerned with the relation of text and image.

images present in comics are best not considered illustrations in the sense I have used the term, paradoxical as this may sound and even though comics are clearly illustrated texts.

Since I have just argued that the images in comics are not standardly illustrations, it might seem peculiar for me to claim now that there are comics that illustrate philosophy. This is not the case, however, for the comics I discuss as illustrating philosophy do so not simply by means of their images but by the complex of image and text that is distinctive of this unique artform.

## Graphic Philosophy

Having analyzed the nature of comics as an artform, I am now ready to proceed to the main topic of this chapter, graphic philosophy. I will look at four comics that I consider to be works of graphic philosophy, a category I use to include comics that are published in book form that have philosophy as their subject matter. My aim is to investigate the different ways in which the text and images in these books illustrate philosophical ideas and theories.[24]

I use the term "graphic philosophy" to refer to a new genre of philosophical writing that emerged in the past thirty years or so. Until around 1990, very few philosophy texts, even introductory ones, had many pictures in them. But with the rise of graphic novels and the concomitant receptivity to illustrated books among the broad reading public (and, very importantly, students), publishers were interested in illustrated introductory textbooks. Thus was born the genre "graphic philosophy."

[24] Meskin and Cook (2019) address many of the issues I raise. They employ the concept of metacomic to characterize the unique style employed by many works of graphic philosophy including *Logicomix* and *Understanding Comics*.

260   THOUGHTFUL IMAGES

An early example of an introductory philosophy text that has many pictures is Donald Palmer's *Looking at Philosophy: The Unbearable Heaviness of Philosophy Made Lighter*. First published in 1988, *Looking at Philosophy* is an historical introduction to philosophy beginning with the pre-Socratics and ending with Poststructuralism. Virtually every page of the book has a picture on it, often illustrating a philosophical idea such as Plato's Cave. However, the book is not structured like a comic. Although its text is printed in a font that suggests informality, the pictures are placed within the text more or less like they are in illustrated books rather than in comics.

Subsequently, book series arose that featured even more pictures. Volumes in one series are all of the form "X for Beginners," where you substitute for X the name of a famous philosopher; in another series, the titles are "Introducing Y," where Y could be the name of a philosopher or a philosophical movement such as Existentialism; finally, there is the "For Beginners" series that covers similar territory as the others. These books generally have many more illustrations than *Looking at Philosophy* does, but in all of them the text does the majority of the philosophical work with the illustrations providing the entertainment.

A book recently published by a philosopher who is also an artist, Helen De Cruz, has a similar structure. *Philosophy Illustrated* (2021) consists of forty-two thought experiments, each of them accompanied by an illustration by De Cruz. De Cruz's text-based illustrations do an excellent job of presenting visual images of the thought experiments described in the text.

Eventually, the use of images in philosophy texts spawned the new genre of graphic philosophy. To qualify as a work of graphic philosophy, it is not enough for a philosophy book to have images in it. Graphic philosophy forms a genre of comics, one in which the subject matter of the comic is philosophical. Comics, as we have just seen, have a very specific structure and this structure is maintained in works of graphic philosophy.

## Graphic Philosophy 1: *Logicomix*

The first example of a work of graphic philosophy I will discuss is *Logicomix: An Epic Search for Truth* (2009). Because *Logicomix* employs the form of a comic, it is an example of graphic philosophy.

*Logicomix* was written by Apostolos Doxiadis and Christos H. Papdimitriou and illustrated by Alecos Papadatos and Annie Di Donna. The subject of the work is the development of modern logic and its use to ground mathematics. It turns out to be a very dramatic story, one that the graphic work explicitly compares to the tragic story of Aeschylus's *Oresteia*.

One of the interesting features of *Logicomix* is that the authors and illustrators of the book are represented in it. Early on, for example, Apostolos is depicted telling Christos his reason for writing a comic book about logic: "The form is *perfect* for stories of *heroes* in search of *great goals!*" (Doxiadis and Papadimitriou, 2009, p. 22, emphasis in original). The hero of the story is Bertrand Russell, the primary narrator of the comic. The comic alternates between simply telling the story of logic's development and depicting its creators discussing the process of creating the comic.

Although the creators of this book call it a comic, one episode depicts them characterizing the work as a graphic novel to explain how it deviates from the truth. "Yet, despite the fact that its characters are real persons, our book is definitely not—nor does it want to be—a work of history. It is—*and* wants to be—a graphic novel" (Doxiadis and Papadimitriou, 2009, p. 12). The authors and illustrators— depicted within the comic as characters—claim that they have departed from the truth only to make the story more coherent, and that these departures do not alter the fundamentals of the story they are telling. This is a clear instance in which a work of graphic philosophy adheres to the felicity norm in telling its story.

Even more significant from our point of view is the presence of the comic's authors and illustrators as characters in their own comic. As the book demonstrates, such self-referentiality is what

## 262  THOUGHTFUL IMAGES

dooms Russell's logicist program, thereby connecting the form of this comic with the story it tells.

*Logicomix*'s main story begins with Russell's concern that mathematics appears arbitrary because it appeals to axioms and postulates, basic principles that are not themselves subject to proof within mathematics itself. Russell took this to show that mathematics did not have the sort of certainty required by its subject matter and that philosophers, at least since Descartes, had been seeking. His great quest was to use logic—a field that had just been revolutionized by the work of the German philosopher and mathematician Gottlob Frege whom we encountered in chapter 7—as the basis for deriving mathematical truths. This would give mathematics the certainty Russell sought. This philosophical project is characterized as *logicism*.

What makes the story tragic is that Russell's logicist program ends in failure.[25] Two important events are presented by the book as contributing to this failure. The first we have already discussed: the publication of Ludwig Wittgenstein's *Tractatus Logico-Philosophicus* (1921) in which Wittgenstein argued that there are many important statements that are neither true nor false, such as the statements of ethics. The second was the publication of Kurt Gödel's two incompleteness theorems. In 1931, Gödel proved that there were true statements in any mathematical system that includes arithmetic that can neither be proven nor disproven. Driving a wedge between truth and provability resulted in the failure of Russell's dream of using logic to secure the certainty of mathematical truths, since Gödel demonstrated that there were mathematical statements whose truth was indeterminate.

I classify *Logicomix* as a work of graphic philosophy because it takes a specific philosophical topic as its subject, namely, the attempt to find a secure basis for mathematics. From the point of view

---

[25] It is not clear that logicism has actually failed. There continue to be attempts to resuscitate it. See Tennant (2017) for an excellent summary of logicism and its defenders.

GRAPHIC PHILOSOPHY    263

of our interest in art that illustrates philosophy, however, we need to ask what role the images play in creating the work's narrative and whether they contribute to the philosophical content of the work.

Before answering that question, I want to acknowledge that *Logicomix* is a real achievement. It takes a difficult and abstract topic—the rise and fall of logicism—and presents it as a tragic story, complete with Russell as its tragic hero. Many of its topics are depicted with wit and grace, acquainting readers who are not specialists in logic or the philosophy of mathematics with one of the great intellectual adventure stories of the twentieth century.

One example of the comic's presentation of a difficult topic so that non-specialist readers understand both it and its significance is its depiction of Russell's Paradox. Russell discovered this paradox in the spring of 1901, and it appeared to doom the effort to use set theory to ground mathematics. Georg Cantor had recently developed set theory and had treated numbers as sets. This kindled the hope that this theory could provide the sound basis for mathematics Russell and others had sought.

Russell discovered an inconsistency in set theory having to do with self-reference that appeared to bar set theory from playing the foundational role he had hoped it would. Theoretically, a set can be defined by any property. For example, we can create a set of all the natural numbers greater than 10. The numbers 11, 12, 13, etc., are all members of this set; 9 is not because it doesn't satisfy the definition that generates it.

Russell discovered that set theory was beset by a paradox of self-reference. Consider a set consisting of all the sets that are not members of themselves. For example, the set of all dogs is not itself a dog, so it would be one of the sets in this set. Let's call this new set "the Russell set." The problem arises by asking whether the Russell set is a member of itself. If it is, then it shouldn't be, because only sets who are *not* themselves members of their sets can be included in the Russell set. On the other hand, if it is not, then it should be, because it is stipulated *not* to be a member of itself and thus satisfies

## 264 THOUGHTFUL IMAGES

the requirement for membership in the Russell set. This is Russell's paradox and it seems to render set theory inconsistent.

This very abstract discussion can be hard for non-mathematicians to follow. There is a standard way that Russell's paradox has been made more intuitive, although, as we shall see, it doesn't represent the paradox with complete accuracy. To illustrate the nature of Russell's paradox, we are asked to consider a barber who shaves all and only those men who don't shave themselves. The question is: Does the barber shave himself? If he does, then he is shaving someone who shaves himself and this contradicts his characterization. But if he doesn't, then he should, since he is characterized as shaving all those men who don't shave themselves. This barber seems to land us in the terrain of the Russell paradox.

*Logicomix* does a very nice job of presenting this interpretation of Russell's paradox using visual images. To make the subject matter of these panels—Russell's paradox—more intuitive, the authors present in a cartoon-like style what we can call "the Barber Paradox" that I have just described. The people in the images have only circles for eyes and very abstract black shapes that represent their hair and clothes. The book here employs illustrations made in the style of comics to tell its story.

The use of such typical comic book imagery is one way that the creators of *Logicomix* make it fun to follow the book's narrative and argument. Nonetheless, the images do not contribute to the philosophical content of the book. That is established by the purely linguistic narrative presented in the panels. In this sense, it is more like an illustrated book than a comic despite the style of its drawings.

Contrary to what *Logicomix* maintains, the supposed Barber Paradox is not, strictly speaking, a paradox. All that it shows is that there can be no barber who has the property of shaving all and only those men who don't shave themselves. The supposed paradox arises only if it is assumed that there must be such a barber, for then it seems like there can't be. Rather than being puzzled, the appropriate response to this apparent paradox is simply to deny the possibility of such a barber existing.

The root of the problem in both the so-called Barber Paradox and the actual Russell Paradox is self-referentiality. That is, the paradox arises only when a set can be a member of itself. Russell attempted to resolve the actual set-theoretic paradox by developing a theory of types that explicitly prohibited the creation of such self-referential sets.[26] Although Russell's solution seems arbitrary—the theory of types was developed simply to block the paradox—logicians have continued attempting to resolve the paradox in order to provide the grounding of mathematics that Russell sought.

As I have mentioned, *Logicomix* itself exhibits the self-referential structure that generated Russell's Paradox. The comic does not simply present the story of Russell's failed attempt to ground mathematics in logic. It also shows the four creators of the comic as characters in the comic discussing how to make it. From the beginning, we see Apostolos ruminating over how to tell his story. When Christos joins him, we see images of the four authors and illustrators as they discuss the story that they will be telling. Interspersed with the developing story of Russell's quest are many of the creators reflections about the comic they are creating.

There are works of art that exhibit a similar sort of paradoxical self-referentiality. Probably the most famous examples are prints made by M. C. Escher. Many of the images that he created show us objects that puzzle us, for they seem possible when their parts are considered, but impossible when viewed as a whole. There is a famous print of four hands in a circle, with each hand holding a pencil drawing the next one. The paradoxical feature of this drawing is a result of the same type of self-reflexivity that generated the Russell Paradox.[27]

Earlier in this chapter, I argued that in the normal case, the images in comics are not illustrations. This is not generally true of

---

[26] The theory of types is developed by Russell and Alfred North Whitehead in *Principia Mathematica*.

[27] Chris Mortensen et al. (2013) discuss Escher's prints, arguing that only four of them are actually paradoxical.

## 266 THOUGHTFUL IMAGES

the images in *Logicomix*. Like the *Mark Trail* comic I mentioned earlier, the text in *Logicomix* establishes the narrative of Russell's quest for a secure foundation for mathematics, and the images function as text-based illustrations of that story. In this respect, this comic departs from the relationship between text and images that is standard in comics.

*Logicomix* is both a comic that presents an important part of the history of Analytic philosophy in the twentieth century and also, self-referentially, a comic about the making of a comic. Like other such works, its self-referentiality makes it difficult to differentiate the actual creators of the comic from their represented selves within the comic. Who, we might ask, makes its claims: the actual creators or their represented selves?

The presence of these two intertwined elements of the comic qualify it as a distinctive work of graphic philosophy. I think the (represented) creators make a mistake in calling it a graphic novel. It clearly takes liberty with the truth, but this is done under the cover of the norm of felicity.

It is worth noting that *Logicomix* may be the first in an evolving genre of comics about the history of philosophy. *Heretics!* by Steven and Ben Nadler is an illustrated history of seventeenth-century philosophy and another example of a work in this genre. It gives very accurate descriptions of the ideas of philosophers from Descartes to Newton (who counts as a "natural" philosopher). Interesting as this work is, it is quite traditional in presenting only pictorial illustrations of the text, and it is the text that contains all of the philosophically interesting material.

### Graphic Philosophy 2: Unflattening

Nick Sousanis' 2015 book *Unflattening* is a graphic work that presents an argument or, at least, a philosophical position in which the images are tightly linked to the verbal text. In this sense, it is a

work of graphic philosophy in a more substantive sense than that exhibited by *Logicomix*.

The book's first chapter develops a critique of the conformity of contemporary society derived from Herbert Marcuse's *One-Dimensional Man*. Using inventive and powerful images of humanoid creatures who are manufactured in a standardized manner, *Unflattening* literally draws a picture of Modernity in which people have become uniform, unthinking pods in a great system. Marcuse's one-dimensional society receives a graphic illustration in this chapter with its creative depiction of how humans are dehumanized by a system designed to enforce standardization and conformity, and to stifle independent thought. On this count alone, the book qualifies as an exemplary illustration of philosophy.

After a brief digression that explores ideas from Edwin A. Abbott's classic 1884 novel *Flatland* to suggest the possibility that there are more dimensions than the standard three, *Unflattening* investigates how it might be possible to undermine the conformity it abhors. Its solution, based on the idea that gives the book its title, is *unflattening*, which it defines as "a simultaneous engagement of multiple vantage points from which to engender new ways of seeing" (Sousanis, 2015, p. 32). Sousanis derives the idea of unflattening from the concept of parallax, how our mind creates three-dimensional space visually through the superposition of the two different views of reality contributed by our eyes. The book contains pictures that demonstrate how each of our eyes presents us with a slightly different view of the objects in front of us, and how parallax transforms those two two-dimensional, "flat" views into a single three-dimensional, "unflattened" one.

Sousanis claims that just as two distinct views are necessary to unflatten the two-dimensional view of reality received by each eye individually, employing multiple frames or points of view will allow us to unflatten our lives. This claim is supported by considering Copernicus and how his changing the point of view

## 268 THOUGHTFUL IMAGES

from which to observe stellar motion resulted in a transformation in the understanding of planetary motion. With the sun moved from its peripheral position to the center of the universe, a simple, more unified account of planetary and stellar motion was achieved.

Sousanis argues that the dull conformity that he has depicted dominating the lives of so many people in our society can be overcome by using a similar employment of multiple perspectives. For example, he tells us:

> Let us forgo thinking of argument as war . . with opposing sides . . . winners and losers. Following Lakoff and Johnson imagine argument reframed as dance. Dueling parties become collaborative partners. This doesn't mean erasing or ignoring differences. Instead, it's a complex dynamic, what Simeon Dreyfuss calls "holding different ways of knowing in relationship." In recognizing that our solitary standpoint is limited, we come to embrace another's viewpoint as essential to our own (Sousanis, p. 38).[28]

This text is accompanied by a series of images that are visible in figure 9.3. The point is that we need to move beyond a single perspective if we are interested in understanding the nature of reality and also living more fulfilling, less constrained lives.

The nature of the argument Sousanis presents illuminates the nature of his book. He is definitely making an argument, but he does not do so purely with words. Unlike *Logicomix*, the images in *Unflattening* are not illustrations of a text that tells an essentially complete story without them; rather, the text and images in *Unflattening* work together symbiotically to constitute the book's

---

[28] The reference to Lakoff and Johnson is to their book, *Metaphors We Live By*. The phrase "holding different ways of knowing in relationship" comes from Simeon Dreyfuss (2011, pp. 74 ff.).

**Figure 9.3** *Unflattening*, p. 38, by Nick Sousanis, Cambridge, MA: Harvard University Press, Copyright © 2015 by Nick Sousanis. Used by permission. All rights reserved.

## 270 THOUGHTFUL IMAGES

argument. The text without any images would lack conviction; but the images without the text are, to use Sousanis's word, "unanchored," for the images on their own do not supply the appropriate context to be understood. The context for understanding them is supplied by the accompanying text.

Sousanis's images are drawn with great ingenuity and are an essential element in his attempt to persuade the reader-viewer of the correctness of his assertions. If we focus on figure 9.3, we notice that the bottom of the page is structured with a receding spatial perspective. In the pattern of black and white triangles, the spatial recession is truncated, and the two eyes on which the small figures stand are presented completely face on. The single drawing entitled "Multiple Perspectives" graphically represents the theme Sousanis is presenting by means of it and the language it contains.

Sousanis, or more accurately the comic's narrator, argues that the integration of words and images in a comic make it the ideal medium for presenting the case that our lives will be enriched by unflattening. Discussing the nature of the book, Sousanis says, "We've been conducting this discussion amphibiously—breathing in the world of image and text—seeing from both sides. Text immersed in image. Pictures anchored by words" (Sousanis, 2015, p. 53).

"Amphibious" generally refers to creatures that can survive both in water and on land. Sousanis adapts this term to characterize his explicit use of multiple perspectives to characterize both his method and the nature of comics. Because comics employ words and images, and since, as we have seen, both are equally basic to the nature of a comic, Sousanis believes that comics are able to move beyond the standard "one-dimensional" nature of a philosophical text. His example of such a text is Descartes's *Meditations on First Philosophy*, although he could have chosen many others. What Sousanis has in mind is Descartes's skeptical claim denigrating mental images for not necessarily resulting in true beliefs. Descartes's rejection of visual images results, in Sousanis's view, in a flattened view of reality.

GRAPHIC PHILOSOPHY    271

Sousanis points out that a written text, because of its dependence on the nature of language, is always linear, proceeding step by step, with only one item entering our awareness at any time. Images are different, as we have already discussed on more than one occasion. All of the aspects of an image are said to present themselves to consciousness simultaneously or, at least, without the rigid ordering of elements necessary for linguistic expression.

Comics, according to Sousanis, are an artform that is particularly useful in overcoming one-dimensionality precisely because they embody two different ways of knowing, two distinct types of perception, one linear and one holistic. What began as cultural criticism has transformed itself into an analysis of the artform of the comic.

In building his case for this claim, Sousanis uses text and images equally. He is very clear that the images are as fundamental as the text for his argument. Using a very innovative and creative visual style, Sousanis argues for the importance of maintaining multiple perspectives as a way of accessing the truth.

*Unflattening* is a good example of a work of graphic philosophy. Using both words and images, the book presents an original philosophical thesis that is both critical and substantive. Although reader-viewers will not all agree with Sousanis's conclusions, they will hopefully all agree that it is a work that illustrates philosophical claims.

Rather than pursue Sousanis's thinking further, I want to turn now to the third example of a philosophical comic, for we will see that it involves an interplay between text and image in actually *doing* philosophy.

## Graphic Philosophy 3: *Understanding Comics*

The earliest example of graphic philosophy I know of is the comic artist Scott McCloud's extraordinary 1993 book *Understanding*

272 THOUGHTFUL IMAGES

*Comics*. In that book, McCloud presents a philosophy of comics in the form of a comic. The book consists of nine chapters each of which is composed of pages with comic panels on them.

*Understanding Comics* is a (mostly) serious work on the philosophy of comics that takes the form of a comic. Throughout, McCloud represents himself giving a lecture about the nature of comics, thereby partaking of the same self-reflexive form we saw in *Logicomix*. Since the book involves pictures of McCloud giving a lecture and McCloud is also the book's author, I continue my practice of referring to the figure we see drawn in the book as "Scott" and reserving "McCloud" for the book's actual author.

The nine chapters of the book are each composed of series of panels that are sequential. The panels form a sequence not because they tell a story; rather, the sequencing allows them to present a philosophical *argument*. In philosophy, it is logic rather than time that constitutes the principle of sequentiality.

This is evident in a set of four panels that occurs on page 24 of *Understanding Comics* (see figure 9.4). At this point, Scott wants his audience to become aware of an imprecision that talking of illustrations is likely to engender. He attempts to get his audience to realize that the "pipe" they are seeing is not a pipe; nor is it a painting of a pipe; it is not even a drawing of a painting of a pipe; it's actually a print of a drawing of a painting of a pipe. It does this by asking reader-viewers to look at a drawing of Magritte's well-known painting, *The Treachery of Images*, the one that gave Foucault the title for his 1991 book. Scott initially focuses on the French phrase written in precise script below the picture of the pipe in the painting: *Leci n'est pas une pipe* (This is not a pipe.) After translating the French for his audience, he points out that what it says is correct, for what we are looking at is a painting of a pipe. He quickly complicates things in a manner reminiscent of Wittgenstein by pointing out that it's really a drawing of a painting of a pipe and then refines that to being a printed

GRAPHIC PHILOSOPHY 273

**Figure 9.4** "This Is Not a Pipe!" p. 25, from *Understanding Comics*, by Scott McCloud. Copyright ©1993, 1994 by Scott McCloud. Used by permission of HarperCollins Publishers.

copy—or actually multiple printed copies—of the drawing of a painting of a pipe.

Scott (or is it McCloud?) makes these distinctions in service of developing an account of the visual style of comics. For our purposes at the moment, however, the important point is that the sequence of four panels is deployed as part of a *philosophical argument* about the nature of the images that constitute comics. McCloud is making an argument using verbal and visual means in a distinctive manner.

274  THOUGHTFUL IMAGES

At some points in the comic, Scott's argument proceeds purely verbally, as in his attempt to define comics. As we saw earlier in this chapter, he defines comics as "juxtaposed pictorial and other images in deliberate sequence, intended to convey information and/or to produce an aesthetic response in the viewer" (McCloud, 1993, p. 9). In proposing this definition, McCloud does not use panels with important visual information, for the bulk of the argument is made verbally in Scott's lecture.

The discussion of *icons* that begins with the four-panel sequence I have just discussed is a good example of McCloud's use of visual images as part of his argument. The panels occur in a specific order not because they represent a temporal process, as I have said, but rather because of logical relationships among them. Scott makes a claim in one panel and then corrects it in the next in order to make a significant distinction, one between a painting and a drawing of a painting, that the reader-viewer can assess by looking at the different images. The two panels bear a logical relationship to one another and it is that fact that makes them elements in an argument and allows us to characterize them as elements in a sequence.

There are definite moments in Scott's argument when he relies on images to make his point. While we couldn't understand what he is claiming without seeing Magritte's painting, I want to examine an even more substantive use of images in his philosophical argument.

Consider the complex panel in figure 9.5. At the bottom of the page Scott is represented asking what the secret of the comic icon is. His answer is presented visually at the top of the page in a sequence of five images of a human face. The first is drawn to look like a photograph, the most realistic image possible, that shows us the face of an individual human being. Each of the subsequent image is rendered more abstractly, with the shading and distinguishing facial features progressively eliminated until the final image of the

**Figure 9.5** "The Process of Abstraction," p. 29, from *Understanding Comics* by Scott McCloud. Copyright ©1993, 1994 by Scott McCloud. Used by permission of HarperCollins Publishers.

face remains: a circle with two dots for eyes and a line representing a mouth.

Scott uses this sequence of images as part of an argument for the claim that there is a unique visual style employed by comics. This visual style involves a process of *abstraction* that the sequence of faces breaks down for us. What the sequence of five faces allows us to see is how the usual form of comic image is derived by gradual abstraction from a photorealist picture of a human face.

McCloud emphasizes two different aspects of this visual style that he claims is distinctive of comics. The first is that abstracting from all the details in a realistic picture of a human face retains only the essential aspects of the image (McCloud, 1993, p. 31). The second is that this *style* of representation is universal in that it eliminates features that cannot be understood cross-culturally. Unlike words, which reader-viewers can understand only if they speak the language employed in the image, these iconic images are readily understood by reader-viewers across the globe, no matter what language they speak or read. Of course, there are likely to be some aspects of comics' images that are not readily understood by

## 276 THOUGHTFUL IMAGES

members of a different culture. But comics' abstractions keep those features to a minimum.

The question is not whether McCloud's claim about the genesis or universality of the style of cartoons is true. Rather, we need to acknowledge that McCloud has developed his argument using an interplay between the words in the panels of his graphic work and the images or pictures it presents reader-viewers. We could not be convinced of the validity of his claim that cartoons involve a distinctive visual style if we didn't see the pictures he uses in figure 9.5. Those images provide the evidence to support his claims that (1) there is a distinctive style of representation in comics, and (2) this style is achieved by a process of abstraction from a realistic image.

Despite employing mostly traditional graphic elements, *Understanding Comics* makes a distinctive use of images in developing its argument. Although large portions of the book rely on text to state claims and develop its argument, there are moments like the ones I have just discussed in which McCloud conjoins text and images in a unique manner.

McCloud's self-referential style has introduced some paradoxical features into my discussion, reminding us of the structure of *Logicomix* and Russell's Paradox. When presenting McCloud's argument, I have been unsure whether to attribute it to Scott or McCloud, as I have occasionally indicated. Indeed, I have self-consciously attributed a claim sometimes to Scott, the character within the narrative, and sometimes to McCloud, the book's creator who is responsible for all of its features. Within the comic, Scott is depicted as making the argument, but the argument that is made is really due to McCloud, the comic's creator.

Although such self-referentiality can lead to some confusing questions about who is maintaining what, it also opens up possibilities for a comic's creator. Most centrally, it allows the beliefs of the book's creator to diverge from the claims made by his eponymous character. While *Understanding Comics* has this possibility,

GRAPHIC PHILOSOPHY 277

I don't believe McCloud avails himself of it (nor did the creators of *Logicomix*).

Both Sousanis and McCloud have produced comics that make philosophical arguments. But there are many differences between their books. Sousanis employs a much more elaborate and innovative range of images that play a constitutive role in his argument. Although McCloud has created a more traditional-appearing comic, he uses images even more centrally in the development of his philosophical argument. What is unique in *Understanding Comics* is that McCloud makes very specific claims that rely on the images he uses as a necessary element in the argument. They are not ancillary to the text, but are an essential component of the book's argument.

## Graphic Philosophy 4: *Fun Home: A Family Tragicomic*

The final work of graphic philosophy I discuss in this chapter is Alison Bechdel's innovative memoir, *Fun Home: A Family Tragicomic*. Unlike the other books I have discussed in this chapter, the subject of Bechdel's memoir is not obviously philosophical. In the comic, Bechdel attempts to make sense of her father's death and the sexual orientations of both herself and her father. She does so in a series of chapters that reflect on the events of her life from the time she was six or so until her father's death in 1980, when she was twenty years old. The memoir is based on her memories, the extensive diaries she kept as a girl, and various documents that she is able to find about her family, such as letters and photographs.

Bechdel portrays herself as trying to discover evidence to justify her belief that her father, Bruce, committed suicide. He was hit by a truck as he was crossing a highway while getting rid of some brush from an area he was clearing. Since he did not leave a suicide note and did not appear to have been depressed, there is no compelling evidence to support the notion that he actually had intended to kill

## 278  THOUGHTFUL IMAGES

himself. It seems equally plausible that he was the victim of a tragic accident. Still, Bechdel believes that her father did commit suicide, and she structures her memoir as an investigation that attempts to determine whether there is sufficient evidence to justify her belief.

The second issue *Fun Home* addresses is sexuality. As the reader-viewer discovers in the course of the memoir as Bechdel reflects on her own sexuality, she is a lesbian. Her portrayal of her lesbianism is quite frank, including even an image of herself engaging in oral sex with her lover, Joan (Bechdel, 2006, p. 214). Her portrayal of her father's sexuality is more tentative since she didn't discover that he was bisexual until shortly before his death.

Soon after realizing what her sexual orientation is, Bechdel writes her parents, coming out to them as a lesbian. Her mother responds to Bechdel's announcement with a shocking revelation of her own: that Bruce has been having sex with young men for many years. Shortly before his death, Bruce confirms this in a letter to Bechdel. The result of his admission is a deepening doubt on Bechdel's part about her previous understanding of her family and its peculiarities. One reason she suspects her father committed suicide is that his death followed so closely on the heels of his admission that he had been leading a closeted life. She even thinks that her coming out to him may have caused him to kill himself, a belief that launches her into a discussion of causality, an important philosophical topic in its own right (Bechdel, p. 84).

While exploring the questions she has about her father's death, Bechdel makes reference to a number of other philosophical issues and ideas. For example, as she faces the question, "Who will embalm the undertaker when he dies?" (Bechdel, p. 51)—Bruce was the local undertaker as well as a high school English teacher—Bechdel refers to Russell's Paradox which we saw playing an important role in *Logicomix*. Unlike the authors of that book, Bechdel is aware that the standard example used to illustrate the Paradox is not a paradox at all. As we have seen, there cannot be a barber who shaves all and only those men who don't shave themselves.

GRAPHIC PHILOSOPHY 279

In contrast, referring to her father's body, Bechdel avers, "Yet somehow, there he is" (Bechdel, p. 51), that is, the undertaker who does not bury himself.

Bechdel's reference to Russell's Paradox is an example of how she uses ideas from recent philosophy to understand her own life. Although it turns out that the impossible barber and her dead father are not as closely related as Bechdel seems to have originally thought, her use of the philosophical trope reveals how she conceptualizes her own life through ideas derived from philosophy.

We can see this when Bechdel discovers that her father was reading the French philosopher and essayist Albert Camus's *The Myth of Sisyphus* shortly before his death. In that book, Camus boldly pronounces, "There is but one truly serious philosophical problem, and that is suicide" (Camus, 1991, p. 3). In the course of his book, Camus discusses whether suicide is the appropriate response to the realization of the absurdity of life. He characterizes life's absurdity as stemming from the conflict between the world's lack of rationality and our human need for a rationally-structured world. It might seem that suicide is a reasonable response to this situation, for by killing oneself, one defies the indifference of the world.[29]

Bechdel wonders whether Bruce used Camus's book to justify his own suicide. She comments that, if he did, he misunderstood Camus's argument. She notes correctly that Camus argues *against* suicide as an appropriate response to the realization of life's absurdity. On page 47, Bechdel counters Camus's claim with another: that "death is inherently absurd," explaining how absurd it is for someone to be there one moment and then, suddenly, no longer exist. That is a feature of our lives that cannot be accounted for in rational terms and, hence, it is, according to Bechdel, absurd, critically supplementing Camus's contention life is absurd.

---

[29] For a more extensive discussion of Camus's claims, see my 2008 book, *Existentialism: A Beginner's Guide.*

280 THOUGHTFUL IMAGES

Bechdel's use of *The Myth of Suicide* is more substantial than her invocation of Russell's Paradox. The fact that her father was reading this book shortly before his death indicates that the topic of suicide was on his mind. While this doesn't entail that he committed suicide—especially given Camus's own explicit intention to show that suicide is not the appropriate response to the realization of life's absurdity—it does mean that the topic was on Bruce's mind shortly before his death. And this makes it more likely that he did, in fact, kill himself.

These are two examples of Bechdel's use of philosophy as a means of understanding her father's death as well as her relationship with him. In each case, a philosophical thesis provides her with a way of understanding aspects of her complex relationship with her father. The references to philosophy also demonstrate that Bechdel herself uses philosophy as a means for interpreting events in her own life. It also presents Bechdel's understanding of the appropriate role of philosophy. For her, philosophy is not a discipline that presents abstract arguments about theoretical issues; it is a field that supplies all the materials necessary for reflecting on the nature of our lives.

Before exploring how *Fun Home* illustrates a philosophical thesis, I want to discuss the role that the book's images play in creating its narrative. I have argued that comics generally involve text and images working together in sequences of panels. In Bechdel's book, as in other works of graphic philosophy, the images, despite being imaginative and engaging, often do little more than render visually information provided linguistically by the text. Sometimes, however, the image presents information that cannot be found in the text, establishing the images as equal partners with the text in the creation of the comic's narrative.

There is one image in *Fun Home* that is exemplary in this regard. As a young girl, Bechdel is eating in a restaurant with her father when a "truck-driving bulldyke" (Bechdel, p. 119) enters the restaurant. Bechdel uses that term to characterize the woman who she earlier pictured in a panel that takes up three-quarters of the

GRAPHIC PHILOSOPHY   281

page. In that panel, we see a large, overweight woman with short hair wearing a plaid shirt with a keyring suspended from her belt ordering from a waiter as Bechdel and her father look at her from the booth in which they are seated. Bechdel inserts her commentary on the scene in two square text boxes. In the top one, she comments that she didn't know that there were women who dressed and had their hair cut like men. In the bottom one, she says, "But like a traveler in a foreign country who runs into someone from home—someone they've never spoken to but know by sight—I recognized her with a surge of joy" (Bechdel, p. 118). As her father notices the woman, he asks Bechdel whether *that's* what she wants to look like. Clearly, he is worried that his young daughter aspires to being butch, a desire that he has been shown to repeatedly attempt to quell by such stratagems as giving her a barrette to use in her hair (Bechdel, p. 97).

I mention this image because the visual information it includes is essential to our understanding of this incident in the book. The text itself does not give us enough information to understand what transpires in the restaurant, especially since the brief characterization of the woman's appearance happens *after* the interchange between Bruce and Alison. Bechdel here uses a picture to convey information quickly in a readily understood manner, something that could not be done as efficiently with words alone.

This series of panels demonstrates that at least some of the pictures in this graphic memoir are essential to understanding its narrative. Although the written words—both Bechdel's narration and commentary as well as the text-balloons that transmit the words of the characters in the narrative—have the primary role in structuring the narrative, the images Bechdel has drawn are not simply visual versions of statements that have been presented linguistically. Rather, at least at some points, the images or pictures provide important information that the linguistic statements do not. The words and images of this comic work together with one another to create a meaningful narrative.

## 282 THOUGHTFUL IMAGES

We are now ready to consider more fully how *Fun Home* illustrates philosophy. The crucial idea illustrated by the book is skepticism. Skepticism, as we saw in our discussion of *On Certainty*, is the philosophical position that denies the possibility of human beings having accurate, objective knowledge. It was introduced into modern European philosophy by Descartes who, although not himself a skeptic, presented a strong version of a skeptical argument to begin his *Meditations on First Philosophy*.

Bechdel's illustration of the philosophical position of skepticism begins when she discusses what she terms "an epistemological crisis" that she experienced as a ten-year-old (Bechdel, p. 141). At the time, she was in the throes of an obsessive-compulsive disorder (OCD). She counts obsessively, lines her shoes up precisely, and exhibits other forms of OCD behavior. She realizes that her OCD is motivated by a "dark fear of annihilation" (Bechdel, p. 139).

Reflecting on her youthful obsessions, Bechdel talks of her "own compulsive propensity to autobiography" as a way of explaining her interest as a young girl in keeping a diary (Bechdel, p. 140). In response, her father gives her a calendar in which to write down her thoughts, even initially writing three words to begin the diary. Although the diary begins well, with Bechdel writing down summaries of the events of her day, her skepticism soon sabotages her project. "How did I know," she asks, "that the things I was writing were absolutely, objectively true?" (Bechdel, p. 141). She loses faith in her ability to record what happened accurately: "My simple, declarative sentences began to strike me as hubristic at best, utter lies at worst" (Bechdel, p. 141).

Bechdel is here recording the onset of a skeptical crisis in her life. The statements that she writes down no longer have the authority they once appeared to have, for she questions whether the statements she writes down are objectively true and not just her own subjective version of what happened. This is parallel to Descartes's worry in the *Meditations* that he might be mistaken about everything he takes to be true.

GRAPHIC PHILOSOPHY    283

In an attempt to represent her skeptical doubt, Bechdel qualifies all the statements in her diary with the addition of "I think" to them in a sort of parody of Descartes's famous dictum, "I think, therefore I am." For example, after the simple statement of an apparent fact, "Dad ordered 10 reams of paper!," Bechdel appends a small "I think" (Bechdel, p. 141).

The "I think" is a crucial feature of Descartes's philosophy. For him, "I think" is able to counter his skeptical worry that none of his beliefs are justified because "I think" is itself a self-certifying idea, one that "must be true every time I think or assert it" (Descartes, 1641, p. 4). Bechdel uses the same phrase in her diary, but with a different purpose in mind. She uses "I think" as a qualifier that hedges on the truth of the statements it modifies. To say "I think that p" is to turn the objective assertion of p into a subjective claim about one's own beliefs rather than about how things objectively stand in the world. Bechdel has come to accept the skeptical claim that a person cannot be certain that their beliefs are true, so she amends her diary entries with a phrase that converts them from being about the world to being about her beliefs.

Bechdel here moves into paradoxical territory once again. G. E. Moore, whom we encountered in chapter 8, is also known for his recognition of a paradox that is involved in asserting a statement and, at the same time, denying that one believes it. The statement Moore discusses is the following apparently paradoxical claim: "I went to the pictures [i.e., movies] last Tuesday, but I don't believe that I did" (Moore, 1942, p. 543). The idea is that one cannot both assert a claim and then deny that one believes it. Although Bechdel doesn't actually make such paired claims, she is clear that she wants to "withhold assent" (Descartes's term) from the sentences she writes in her diary.

Eventually, Bechdel even invents a special symbol to stand for "I think." It is a stylized inverted "Y" and she includes it at the end of every sentence of her diary. This symbol, which begins as a small annotation after each entry, eventually gets written over entire entries, obscuring them and rendering the diary illegible.

284 THOUGHTFUL IMAGES

Bechdel's presentation of her own struggles with OCD provides a good illustration of skepticism and its corrosive nature, one that treats it not as an abstract philosophical topic but as a real human experience.[30] The skeptic is moved by the fact that there appears to be no sure means for ascertaining the truth of one's beliefs. Young Alison is vulnerable to this concern and alters her diary to register her worry that the statements she has written in it are not objectively true even though that is how they present themselves to her. Although Bechdel reports that she gradually got over her epistemological crisis, this is more the result of her mother writing her diary entries for her than of her coming to a philosophical resolution of her skepticism. Bechdel illustrates the devastating nature of skepticism by showing how it winds up destroying her ability to keep a journal.

In the main, though, the real innovations in *Fun Home* come from Bechdel's pursuit of the question of her father's suicide, which brings up the issue of whether it is possible to know what he intended to do. She eventually comes to see him as a deeply closeted man who is living a life that appears to conform to the homophobic standards that were dominant in mid-century Beech Creek, Pennsylvania. She is tempted to think of his life as embodying "a narrative of injustice, of sexual shame and fear, of life considered expendable," but finds that narrative inadequate because, among other things, it doesn't make room for her, the daughter of her father who is herself living out a different but related narrative (Bechdel, p. 196).

Once she recognizes that her father has been closeted, she realizes that everything she thought she knew about him was the result of a carefully cultivated image that he projected even to his closest family members, an image crafted to conceal the reality of

---

[30] Bechdel's understanding of skepticism is reminiscent of Stanley Cavell's, for he also treats skepticism as a feature of human life rather than as a purely theoretical issue. See, for example, Cavell (1979).

## GRAPHIC PHILOSOPHY 285

his sexual desires and activities. The book begins, for example, by focusing on her father's sustained efforts to remodel their Victorian house t, giving the reader-viewer a sense of how determined he was to create a veneer of aestheticism to conceal the closeted life he was living.

Since Bechdel had taken these carefully constructed appearances to reveal the truth about her father, her sudden realization that he was not the man he had seemed to be results in her undergoing another epistemological crisis: How can she determine who her father really was and whether he actually committed suicide? *Fun Home* is in part the result of her attempt to lay that skeptical specter to rest.

Bechdel's uncertainty is also reflected in the images Bechdel creates for her memoir. One of the most interesting is a two-page spread on pages 100–101. Most of the images in the book are drawn in Bechdel's characteristic cartoon style. But this image, although it includes her thumb rendered cartoonishly, is a drawing of a photograph of Roy, her father's yardwork assistant and the family's babysitter. Although Bechdel has included numerous text boxes around the photograph, it is drawn in the photo-realistic style we encountered in McCloud's illustration of comic images' abstraction, graphically illustrating the fact that is a photograph. Philosophers have argued that photographs show us their subjects transparently, with no distortion introduced by the medium (Walton. 1984). As such, it might seem that photographs are not subject to skeptical doubt. But Bechdel uses this photograph to support her doubts. After her father's death, she found it in an envelope of family photos. It is a picture of Roy lying on a bed naked except for a pair of briefs. Roy is lying in the position that many women do in pornography, as they display themselves for the voyeuristic interest of male viewers (cf. Europa's pose in Plate 2). Does this mean that the photograph, presumably taken by Bruce, records his sexual interest in Roy?

Bechdel goes on to wonder why her father included it in this collection of family photographs. Although it is an erotic photo,

286   THOUGHTFUL IMAGES

Bechdel is not sure that her father had a sexual relationship with Roy. (Later, her mother tells her that he had [Bechdel, p. 211].) Her father also tried to rub out the year in which it was taken, but not the month. As Bechdel comments, "It's a curiously ineffectual attempt at censorship. Why cross out the year and not the month? Why, for that matter, leave the photo in the envelope at all?" She concludes, "In an act of prestidigitation typical of the way my father juggled his public appearance and private reality, the evidence is simultaneously hidden and revealed" (Bechdel, p. 101). Even more significant, from our point of view, is Bechdel's inability to provide a definitive answer to the question of why her father left that image in the envelope of family pictures, for this reflects the uncertainty (or skeptical doubt) that surrounds nearly every aspect of his life for Bechdel.

Despite marshaling a great deal of evidence to support her belief that her father committed suicide, Bechdel continues to wonder whether her belief is true.

> I have suggested that my father killed himself, but it's just as accurate to say that he died gardening. He'd been clearing brush from the yard of an old farmhouse he was planning to restore . . . and had just crossed Route 150 to toss an armload over the bank. The truck driver described my father as jumping backward into the road "as if he saw a snake." And who knows, perhaps he did. (Bechdel, p. 89)

Bechdel goes on to describe an incident in which she discovers a large snake, as if to give more support to the hypothesis that her father was jumping to avoid a snake he had seen.

Bechdel here illustrates her quandary about her father's death. Even though the images she draws to accompany this text have no hint of ambiguity in them, the text makes it clear that more than one interpretation fits the evidence they provide. As a result, Bechdel is unable to acquire certain knowledge about her father's mental state before his death: Was he depressed? Did he intend to

GRAPHIC PHILOSOPHY    287

commit suicide? Was he just startled by a snake? There is no way for Bechdel to establish a reasonable assessment of her father's mental state prior to his death, thereby condemning herself to the skeptical position of uncertainty.

I have not yet commented on Bechdel's use of various well-known fictional characters as a way of conceptualizing her relationship to her father. In fact, she claims that her parents are more real to her when she thinks of them in fictional terms. Initially, she characterizes her father as Daedalus to her Icarus, although she mentions that it is he, rather than she, who will fly too close to the sun. Later on, she uses Leopold Bloom and Stephen Daedalus's relationship in James Joyce's *Ulysses* as a way to understand her relationship with her father. Her understanding of that book's theme—"that spiritual, not consubstantial, paternity is the important thing" (Bechdel, p. 231)—links that book to her own life and her attempt to understand her own relationship with her father as embodying a version of the Daedalus-Bloom relationship despite Bruce being her biological father.

Toward the end of her memoir, Bechdel reflects on her father's life and the price he had to pay for being closeted. "I suppose that a lifetime spent hiding one's erotic truth could have a cumulative renunciatory effect," she says. "Sexual shame," she continues, "is in itself a kind of death" (Bechdel, p. 228). Although she feels a strong connection to her father because of their parallel same-sex desires, Bechdel is able to avoid the shame that she sees as so important in her father's life because of the changed social circumstances in which she lives. As her father points out, "I'll admit that I have been somewhat envious of the 'new' freedom (?) that appears on campuses today. In the fifties [when he went to college] it was not even considered an option" (Bechdel, p. 212).

*Fun Home* explores homosexual desire in a manner that I do not believe had previously been done in a comic. All of the works she refers to as precedents are works of "high" literature, such as Collette's *Earthly Paradise*, a book her father gave her.

288 THOUGHTFUL IMAGES

Bechdel's exploration of both her own and her father's sexuality takes place through her philosophically inflected investigation into her father's death. Although she is not able to definitely determine whether he committed suicide, her inquiry does provide her with a more adequate picture of her father and the difficult, closeted life he chose for himself. At the same time, Bechdel shows her own struggle with sexuality, as she slowly comes to acknowledge her own lesbianism. Although Bechdel repeatedly points out the parallels between her life and Bruce's, we come to see that she is able to resolve her sexual issues in a way that he was not. In the course of presenting her narrative, Bechdel illustrates the relevance of philosophy to her life as a way of helping her come to terms with the complex issues she has had to face.

Bechdel's memoir is an illustration of philosophy in a different sense than I have been exploring in *Thoughtful Images*. The book illustrates that skepticism is more than a theoretical position articulated by philosophers in books and journal articles. She shows how she has been afflicted with skeptical doubts in the course of living her life. Her autobiographical memoir illustrates philosophy not so much through its visual images, but through her depiction of how the abstract positions discussed by philosophers acquire vivacity in the life of a thinking—and drawing—human being.

## Conclusion

This chapter has explored the manner in which comics employ visual images. I have argued that we should not regard the standard use of images in comics as illustrations because there is no preexisting text for them to illustrate. Instead, the images in comics are as essential as the text.

I have looked at four comics that I think are exemplary in their attempt to illustrate philosophy. Each of the books in its own marks a high point of the use of the comic form for philosophical purposes.

## GRAPHIC PHILOSOPHY   289

More and more works of graphic philosophy are being developed at the current time. The popularity of the so-called graphic novel explains this recent trend. But it is also important to realize that when presented graphically, philosophy's remote and forbidding nature gets tempered by the assumption that comics are fun to read and easy to understand. We will have to wait to see how new works in this artform bring philosophy into popular culture. But it seems likely that many more pedagogical works of philosophy will be produced in comic form.

From the point of view of my investigation of illustrating philosophy, comics represent a significant development. Because they embrace the presence of text along with visual images, comics are able to use visual images to make philosophical arguments in ways that had not previously been done. As such, they represent a new development in the relationship between text and images that we have traced over the course of more than two millenia.

# 10
# Conclusion

This book is an illustrated work of philosophy. There are others like it. For example, Jan Westerhoff's *Twelve Examples of Illusion* contains many illustrations as part of its discussion of Buddhist claims about illusion. But neither my book nor Westerhoff's is an example of the type of book I discuss in *Thoughtful Images*, which focuses on artists' illustrations of philosophical ideas, concepts, theses, and theories. *Thoughtful Images* contains many examples of such illustrations, which I discuss critically; but it is not itself a work of philosophy that has been illustrated by one or more artists. It is a philosophical study of the illustrations of *other* works of philosophy that have been created by visual artists.

In the previous chapters, I have examined an array of artistic works that are illustrations of philosophy. After an initial look at Greek and Roman works, the book examines early modern illuminated manuscripts. It proceeds through various different types of illustration, ending with works of graphic philosophy. It demonstrates that books and manuscripts have illustrated philosophy in a variety of different ways. The goal was to canvass these possibilities by examining illustrations of philosophy, both independent works of art and those published in books. Examples of the former are paintings such as Rembrandt's *Aristotle Contemplating a Bust of Homer* (plate 6) and broadsides illustrating Aristotle's metaphysics (figures 3.3 and 3.4); examples of the latter are the frontispieces to Hobbes's *Leviathan* (figure 4.1) and Rousseau's *Emile* (figure 4.2).

What all of these works have in common is that they are visual artworks that directly illustrate philosophical ideas, concepts,

*Thoughtful Images.* Thomas E. Wartenberg, Oxford University Press. © Oxford University Press 2023.
DOI: 10.1093/oso/9780197650547.003.0010

CONCLUSION 291

or theories. Works of art illustrating philosophy take a variety of different forms and employ a range of artistic mediums. Among the types of artworks that illustrate philosophy are illuminated manuscripts, printed broadsides and books, paintings, etchings, prints, and sculptures of different types. All of them transpose an idea or theory initially presented verbally into a visual artistic medium.

In this concluding chapter, it examine *Thoughtful Images* from the perspective of the theoretical understanding of illustrations of philosophy it employs. The most fundamental element of its theorization is a four-fold distinction between different types of illustrations. The first type of illustration is *text-based*. This word-image relationship is the dominant one in illustrations of stories. A passage of text is selected because of its significance and the image illustrates the ideas put forward in that portion of text. Barry Moser's illustration of the Garden of Eden from his edition of the Bible provided an example of this type of illustration (figure 9.1). His woodblock image of the Garden shows the central features of the biblical description in Genesis: among them the presence of a lone man and a lush garden with a stream flowing through it. This illustration is faithful to the text and *fidelity* is the first criterion for something being a text-based illustration. *Felicity* is the second major norm governing text-based illustrations and it specified that an artist could depart from fidelity in the interest of creating a successful work of art. The examination of Titian's *Rape of Europa* (plate 2) revealed the importance of this norm for understanding text-based illustrations.

A number of the illustrations of philosophy examined in this book work similarly. One of the earliest is the illustration of Aristotle's theory of three types of friendship published in a fourteenth-century French translation of Aristotle's *Nicomachean Ethics* (plate 3). Placed at the head of the chapter in which Aristotle presents his theory, this illustration is faithful to Aristotle's distinction between three types of friendship: friendships based on

## 292  THOUGHTFUL IMAGES

pleasure, those based on utility, and complete friendships. Each of the three pairs of friends in the illustration represents one of the types of friendship.

This illustration is also an example of a prominent strategy for illustrating philosophy, that of *personification*. One of the challenges for an artist attempting to illustrate philosophy is how to take the abstract claims made by a philosopher and render them visually. Personification is one way to do so. This strategy takes an abstract concept, such as friendship, and uses human figures to create a visual representation of it. The three pairs of friends in this illustration, from *bon vivants* to priests, personify the three types of friendship.

There are also contemporary examples of illustrations of philosophy that are text-based. Maria Bußmann's illustrations of Wittgenstein's *Tractatus* are tied to specific textual passages from that book (plates 18 and 19). In this case, the text is necessary to understand the significance of her illustrations of the *Tractatus* while her drawings reciprocally function as illuminations of the text they illustrate.

The second type of illustration of philosophy discussed is *concept-based*. Such illustrations illustrate an idea or concept that is important in a philosopher's work. The visual form assumed by the illustration provides a "crystallization" of a philosopher's theory. The huge figure of the sovereign in Bosse's frontispiece for *Leviathan* (figure 4.1) likely ensures that no one who has seen it will ever forget that the sovereign in Hobbes's work is constituted out of the people who make up the state's citizenry—literally in the frontispiece and theoretically in the book. In so doing, it provides an excellent example of a concept-based illustration.

A more contemporary example of a concept-based illustration of philosophy is Mel Bochner's *Fourth Range* (plate 24). I interpreted this work as containing what I termed a "numbers-game" that was analogous to what Wittgenstein called a "language-game." By working out the rules that Bochner followed in creating his work

CONCLUSION    293

and observing the places where he violated those rules, a reader-viewer will come to understand the basis for Wittgenstein's claim that mistakes require the presence of a rule, the basis for his undermining of skepticism.

Bochner's work is a good example of the second strategy for illustrating philosophy discussed in this book. *Analogical illustrations* are an important type of concept-based illustration that artists have used to illustrate abstract philosophical ideas. Beginning with the early modern broadsides produced by Gaultier and Meurisse as a mnemonic device for his students (figures 3.3 and 3.4), illustrations have used various analogies to render abstract philosophical ideas more concrete. Two trees producing a new fruit is a creative and memorable way to render the concept of a proposition in Aristotle, arguably even going further than Aristotle did in providing an account of how the terms in a proposition create a new entity. The analogy of a garden to represent all the elements of Aristotle's logic and metaphysics might strike one as impossible until one inspects Meurisse's amazing prints.

Bochner's use of numerical sequences in his illustrations of *On Certainty* are another example of the creative use of an analogy to illustrate a philosophical theory (plates 22 and 23). In these works, Bochner employs numerical sequences as visual analogues to Wittgenstein's claims about language and knowledge, and even to provide justification for them. Although all of these works have a basis in the philosophical texts that they illustrate, they are not linked to a specific passage and thus qualify as concept-based analogical illustrations.

When philosophers employed works of fine art to demonstrate their theories, they wound up highlighting the third type of illustration of philosophy: those that are *theory-based*. When Heidegger, for example, uses Van Gogh's painting *Shoes* to illustrate how art reveals truth (plate 9), that work functions as a theory-based illustration of Heidegger's complex claim about the "work" of art. His interpretation of the painting use it to

294  THOUGHTFUL IMAGES

provide analogues for a set of complex philosophical terms that he presents discursively in his essay, *The Origin of the Work of Art*, such as world, reliability, and earth.

Heidegger's use of Van Gogh's painting also illustrates one important function that illustrations have that many of the other works examined in *Thoughtful Images* exemplify: their being useful *pedagogically*. When used in this manner, illustrations assist people in understanding a difficult philosophical claim or text. There is no doubt that Heidegger's complex discussion of the work of art is difficult for readers to understand. Using a visual example such as *Shoes* allows Heidegger to give readers an easier way to understand his theoretical claims about the function of art.

Another example of a pedagogical use of an illustration is that of the three types of friendship we saw in the fourteenth century illuminated manuscript (plate 3). The illustration visually depicts the three forms of friendship in a manner that makes the distinctions Aristotle draws among them easier to remember than they would be solely on the basis of the text. Because images can make an impact on a person's consciousness that is more direct and memorable than a long section of text that requires concentration to be deciphered and understood, an important function of these illustrations of philosophy is pedagogical and heuristic: They help reader-viewers remember important theoretical concepts by creating images that are directly perceived and assist people in retaining the philosophical claims they illustrate.

Although this function of illustrations has been employed for many years, a contemporary work such as the so-called graphic novel *Logicomix* also employs its illustrations this way. This is particularly clear in the case of Russell's Paradox, for the comic depicts Russell's Barber in a clever way that ensured readers get the point of the paradox. The comic-style rendering of the barber is entertaining but also lodges the philosophical point in the consciousness of a reader-viewer.

CONCLUSION    295

Works of art can also illustrate philosophy for purposes that are not pedagogical. Rembrandt's *Aristotle Contemplating a Bust of Homer* (plate 6), to choose one example, is less concerned with helping anyone understand Aristotle than in showing Rembrandt's understanding of art and allying himself with Aristotle in this regard. This does not disqualify it from being an illustration of philosophy, for Rembrandt here presents art and philosophy as allied intellectual pursuits in the common view of both Aristotle and himself.

Artworks illustrate philosophy for a variety of different purposes. David appears to have used his portrait of Socrates as he was about to die to send a message to his contemporaries about the importance of resisting tyranny, but he also created a stunning work of art (plate 7). More recent illustrations of Wittgenstein's ideas and theories (chapters 7 and 8) are less concerned with pedagogy and more focused on creating innovative works of art that demonstrate the significance of the philosopher's ideas for art and artists.

The final type of artistic illustration of philosophy discussed in *Thoughtful Images* is *quotation-based*. This type of illustration only emerged when Conceptual artists used the words of philosophers to create works of art. The first one we examined was Kosuth's *276. (On Color Blue)* (plate 14). Kosuth transposed the words from paragraph 276 of the *Philosophical Investigations* by rendering them in blue neon tubing. This use of an author's words to illustrate their theory was a new development in how philosophy could be illustrated. It was followed by other artists in the Conceptual tradition including Nauman and Bochner. Despite the presence of an author's words in these works, they function differently from one another. We see this especially in Nauman's ironic casting of Wittgenstein's apparently nonsensical phrase (plate 15).

*Thoughtful Images* is structured historically. On reason for this is that its story of the development of illustrations of philosophy places them in the context of technological developments that

## 296 THOUGHTFUL IMAGES

made different types of artwork possible. For example, only when vellum was used for the production of manuscripts did it become possible to create visual works using it. Before that, it would have been difficult if not impossible to paint illuminations onto the surface of a text. This explains why the Greeks and Romans were limited to sculptures, vases, and mosaics as the means for illustrating philosophy. After it was possible to produce vellum manuscripts, illuminated manuscripts flourished, and along with them came illustrations of philosophy such as the ones we saw gracing the French translation of Aristotle's *Nicomachean Ethics* and *Politics* (plates 3 and 4). Once images were placed in close proximity to written or printed texts, complex illustrations of philosophy such as these could be created.

The introduction of paper (an export from China that greatly influenced the development of Western printing) was crucial for the development of illustrations of philosophy. Although I have not thematized the importance of China in the development of techniques for illustrating philosophy in the West, this is only because the focus of this book is on the illustrations and not the technologies by which they are produced.

When printing books on paper became possible—the introduction of movable type into Europe was crucial here—multiple copies of the same image could be produced. First, illustrations of philosophy were produced primarily for pedagogical purposes, as we have seen, although these works were also artistically stunning. The initial examples were the large broadsides of Aristotle's theories that were used as study guides in medieval France (figures 3.3 and 3.4). Later, the frontispieces of philosophy books presented the main theoretical claims in striking visual images, such as that adorning the first edition of Hobbes's *Leviathan* (figure 4.1). In both cases, difficult philosophical claims were given a more or less easily legible rendition that helped reader-viewers, be they students or professionals, understand them as well as remember them more easily.

CONCLUSION 297

Technology was not the only factor both limiting and encouraging illustrations of philosophy; ideology also played a role. One example is how the emergence of secular tendencies during the Renaissance allowed for the production of non-religious paintings. It was no surprise to find Raphael painting *School of Athens* around 1510 during the High Renaissance (plate 5), although he also painted religious works such as *Transfiguration* (plate 8). But the openness to non-religious images made it possible for artists to render philosophy visually and many later artists followed suit.

Similarly, a later cultural development made it possible for graphic philosophy to emerge. When comics first came into being, they were thought of as a form of low, popular culture. It was only when the so-called graphic novel came into being that comics became widely recognized as an artform that was significant in its own right. Works of graphic philosophy followed this transformation in the nature of comics, for soon the presence of comic-style images in a book was not taken to diminish the value of the work.

An ancillary trend can be seen to follow from changes in the nature of philosophy itself. During the twentieth century, philosophy began to focus on the nature of language. Previously, as mentioned in the text, philosophers viewed language as transparent, as simply a medium for the expression of ideas that did not affect the ideas expressed in a substantial manner. Twentieth-century philosophers recognized the importance of language in shaping the ideas expressed by means of it and the study of language soons became the dominant field in the discipline. Wittgenstein's continued interest in language and what could be expressed in it is evidence of this transformation in the field of philosophy.

This trend affected the content of artists' illustrations of philosophy. This is apparent in the illustrations of Wittgenstein's ideas, for most of them involved the use and display of language. It's also evident in the way in which words, which were previously banished from the representational space of Western art, reappeared in illustrations of philosophy. Of course, the resurgence of language

within art did not begin with illustrations of philosophy, but in the early twentieth century with the use of newspapers in collages by the Cubists. Nonetheless, the display of text in works of illustrations of philosophy takes on new significance in the mid-twentieth century and highlights a connection between the rise linguistic philosophy and its illustration.

This summary demonstrates the complexity of analyzing illustration as an artform. It is affected by many factors including technology, assumptions reigning in a discipline, and broader cultural trends. The book's examination illustrations of philosophy from various time periods involves a sustained attempt to contextualize them in order to demonstrate how all of these different factors played a role in their creation.

*Thoughtful Images* provides an historical and theoretical survey of a variety of different ways in which philosophy has been illustrated for over 2,500 years in Western society. Although the manner in which philosophical ideas and theories have been illustrated has undergone significant changes over the years, visual images of philosophy remain a persistent if marginal presence in philosophy.

Taking a step back, we can ask what this tradition tells us about both philosophy and visual images. One thing is evident: As a very abstract discipline, philosophy has generally been restricted to an elite group of scholars and theorists. One function of visual illustrations of philosophy is to create a wider audience for philosophical ideas. By assisting reader-viewers understand the difficult and abstract concepts presented in a philosophical text, illustrations of philosophy have expanded the reach of philosophical ideas, making them an important means for increasing the impact of philosophical theorizing on a broader public. Illustrating philosophy makes philosophy more accessible to more people.

One interesting example of this are the illustrations of Aristotle's *Nichomachean Ethics* and *Politics* (plates 3 and 4). The French translation of this work involved the creation of new terms for Aristotle's

CONCLUSION 299

philosophical jargon, for French itself lacked them. Since Charles V wanted his advisors to benefit from Aristotle's text, the abstruse vocabulary used in them had to be rendered more accessible. This is precisely what the pictures that grace Oresme's translations do. Using personification, they provide easily deciphered visual renderings of Aristotle's terminology that enabled Charles V's advisors a means to understand and recall them.

But it is only through the work of visual artists like Kosuth, Johns, Bochner, and Bussmann, discussed in chapters 8 and 9, that one of the most significant aspects of visual illustrations of philosophy emerge. Focusing on ideas put forward by Wittgenstein that are quite difficult to understand, these artists created works of art that can play a substantial role in one's attempt to comprehend the meaning and significance of Wittgenstein's claims. These works are not themselves easy to understand. But when they are interpreted in the light of the texts they embody, the works shed light on Wittgenstein's ideas in a way that might not happen when one limits oneself to simply reading the text. A visual rendering of a philosophical idea can show connections that are not apparent in the written text and thus enable a reader-viewer to grasp a work's significance more readily than they would simply by reading the text.

An important theme in this book is that some visual artworks can actually make a contribution to our understanding of a philosophical issue. Although we first saw this claim enunciated in regard to the broadsides of Aristotle's logic and metaphysics (figures 3.3 and 3.4), it emerges most clearly in relation to Modernist painting in chapter 6. A fundamental philosophical issue in relation to painting is, "What makes something a painting?" What the Modernists tried to establish, at least according to Greenberg, was that the essential feature of paintings was the flatness of the surface on which paint was applied. Although this answer has come in for both theoretical criticism and rejection as an artistic style by subsequent artists—after all, artists react to claims made by other artists

## 300 THOUGHTFUL IMAGES

in order to undermine them—it did present a view of painting that encompassed work that had been done in that medium up to that time.

All in all, then, we have surveyed a tradition of visual illustrations of philosophy whose existence may have come as a surprise to many readers. This tradition is a rich and diverse one, as this book has demonstrated. To my knowledge, *Thoughtful Images* is the first attempt to provide a broad historical and theoretical account of this tradition. In surveying it, it shows all that artists have been able to accomplish in their attempt to present philosophy in visual terms. A great deal more work needs to be done in probing into virtually every aspect of the story the book has told. Nonetheless, *Thoughtful Images* marks an important beginning, for it brings into the awareness of its reader-viewers the existence of a tradition that has largely been invisible to many people, among them philosophers and art theorists. It is a rich and diverse tradition that deserves more recognition than it has hitherto received. My hope is that *Thoughtful Images* will begin the process of recognizing the philosophical and artistic significance of visual illustrations of philosophy.

# Bibliography

Adorno, Theodor W. 1983. "Cultural Criticism and Society." In *Prisms*, 17–34. Cambridge, MA: MIT Press.

Alighieri, Dante. 1867. *The Inferno*. Henry Wadsworth Longfellow, trans. https://en.wikisource.org/wiki/Divine_Comedy_(Longfellow_1867)/Volume_1/Canto_28/. Accessed January 14, 2020.

Alpers, Svetlana. 1983. "Interpretation without Representation, or, the Viewing of Las Meninas." *Representations* 1 (February): 31–42.

Appiah, Kwame Anthony. 1993. *In My Father's House: Africa in the Philosophy of Culture*. Oxford: Oxford University Press.

Arion Press. 1971. *Prospectus for "On Certainty."* San Francisco: Arion Press.

Aristophanes. 1934. *Lysistrata*. Gilbert Seldes, trans. New York: Limited Editions Club.

Aristotle. 1938. *Categories. On Interpretation. Prior Analytics*. Harold Percy Cooke and Hugh Tredencik, trans. Cambridge, MA: Harvard University Press.

Aristotle. 1985. *Nicomachean Ethics*. Terence Irwin, trans. Indianapolis: Hackett.

Aristotle. 1987. *Poetics*. Richard Janko, trans. Indianapolis: Hackett.

Aristotle. 2017. *Politics: A New Translation*. C.D.C. Reeve, trans. Indianapolis: Hackett.

Bechdel, Alison. 2006. *Fun Home: A Family Tragicomic*. Boston: Houghton Mifflin.

Berger, Karol. 2017. *Beyond Reason: Wagner contra Nietzsche*. Oakland: University of California Press.

Berger, Susanna. 2017. *The Art of Philosophy*. Princeton, NJ: Princeton University Press.

Berger, Susanna. 2020. "Meaning and Understanding in Intellectual History." *Global Intellectual History* 5 (3): 329–354.

Berkeley, George. 1710. *Principles of Human Knowledge*. Jonathan Bennett, trans. www.earlymoderntexts.com. Accessed June 3, 2013.

Bernstein, Roberta. 1991. *Jasper Johns: The Seasons*. New York: Brooke Alexander Editions.

Black, Jeff J. S. 2013. "The Very Pictures of Education." https://www.academia.edu/3875573/The_Very_Pictures_of_Education_On_the_Illustrations_in_Rousseaus_Emile. Accessed April 1, 2016.

Bochner, Mel. 1986. Letter to Alice Young. Personal correspondence dated September 1, 1986.

## 302  BIBLIOGRAPHY

Bochner, Mel. 1991a. Letter to Andrew Hoyem. Personal correspondence dated February 10, 1991.

Bochner, Mel. 1991b. Letter to Arthur Danto. Personal correspondence dated March 7, 1991.

Bochner, Mel. *Solar System and Rest Rooms: Writings and Interviews, 1965–2007.* Cambridge, MA: MIT Press, 2008.

Bochner, Mel. 2014. "Some Thoughts on Color, Language, Painting, and *Blah, Blah, Blah*." In *Mel Bochner: Strong Language*, edited by Norman L. Kleeblatt, 119–126. New Haven, CT: Yale University Press.

Bredekamp, Horst. 2018. *Image Acts: A Systematic Account of Visual Agency.* Berlin: De Gruyter.

Brenson, Michael. 1990. "Adrian Piper's Head-On Confrontation of Racism." *New York Times*, October 26: C 36.

Brown, Keith. 1978. "The Artist of the *Leviathan* Title-Page." *British Library Journal* 4 (1): 24–36.

Brown, Margaret Wise. 2005. *Good Night, Moon.* New York: Harper Collins.

Bussmann, Maria. 2018. *Allerdings: Zeichnungen und Plastiken.* Vienna: Passagen Verlag.

Campbell, Stephen J. 2003. "Europa." In *Eye of the Beholder*, edited by Alan Chong et al., 103–107. Boston: ISGM.

Camus, Albert. 1959. *Reflections on the Guillotine.* Michigan City: Fridtjof-Karla Publications.

Camus, Albert. 1991. *The Myth of Sisyphus and Other Essays.* Justin O'Brien, trans. New York: Vintage International.

Carrier, David. 2000. *The Aesthetics of Comics.* University Park: Pennsylvania State University Press.

Carrier, David. 2020. "When Philosophy and Art Intersect." *Hyperallergetic.* May 2. https://hyperallergic.com/559392/when-philosophy-and-art-intersect/. Accessed August 10, 2020.

Carroll, Lewis (Charles Dodgson). 1865. *Alice in Wonderland.* London: Macmillan.

Carroll, Lewis (Charles Dodgson). 1982. *Alice in Wonderland*, Barry Moser, illus. Berkeley: University of California Press.

Carroll, Margaret Deutsch. 1984. "Rembrandt's 'Aristotle.'" *Artibus et Historiae* 5 (10): 35–56.

Carroll, Noël. 2006. "Philosophizing through the Moving Image: The Case of *Serene Velocity.*" In *Thinking through Cinema: Film as Philosophy*, edited by Murray Smith and Thomas E. Wartenberg, 173–186. Malden, MA: Blackwell.

Cavell, Stanley. 1979. *The Claim of Reason: Wittgenstein, Skepticism, Morality, and Tragedy.* Oxford: Oxford University Press.

Clark, Kenneth. 1960. *The Nude, A Study in Ideal Form.* New York: Penguin.

Clark, T. J. 1982. "Clement Greenberg's Theory of Art." *Critical Inquiry* 9 (1): 139–156.

## BIBLIOGRAPHY   303

Collingwood, R. G. 1947 *Principles of Art*. Oxford: Clarendon Press.

Cooper, James Fenimore. 1919. *The Last of the Mohicans*. New York: Charles Scribner's Sons.

Corbett, Margery, and Ronald Lighthown. 1979. *The Comely Frontispiece: The Emblematic Title-Page in England, 1550–1660*. London: Routledge and Kegan Paul.

Danto, Arthur. 1981. *The Transfiguration of the Commonplace: A Philosophy of Art*. Cambridge, MA: Harvard University Press.

Danto, Arthur. 1999. *Philosophizing Art: Selected Essays*. Berkeley: University of California Press.

Danto, Arthur. 2003. *The Abuse of Beauty: Aesthetics and the Concept of Art*. Chicago: Open Court.

De Cruz, Helen. 2021. *Philosophy Illustrated: Forty-two Thought Experiments to Broaden Your Mind*. New York: Oxford University Press.

Dean-Ruzicka, Rachel. 2010. "Mourning and Melancholia in Alison Bechdel's *Fun Home: A Family Tragicomic*." *ImageTexT: Interdisciplinary Comics Study* 7 (2). https://imagetextjournal.com/mourning-and-melancholia-in-alison-bechdels-fun-home-a-family-tragicomic/. Accessed August 4, 2020.

Derrida, Jacques. 1987. *The Truth in Painting*. Chicago: University of Chicago Press.

Descartes, René. 1641. *Meditations on First Philosophy*. Jonathan Bennett, trans. www.earlymoderntexts.com. Accessed June 3, 2013.

Doxiadis, Apostolos, and Christos H. Papadimitrious. 2009. *Logicomix*. New York: Bloomsbury.

Dreyfuss, Simeon. 2011. "Something Essential About Interdisciplinary Thinking." *Issues in Integrative Studies* 29: 67–83.

Dryden, John. 1685. "Preface to *Sylvae, or the Second Part of Poetical Miscellanies*." https://www.bartleby.com/204/180.html. Accessed December 7, 2021.

Dworkin, Shari, and Kari Lerum. 2009. "Race, Sexuality, and the 'One Drop Rule': More Thoughts about Interracial Couples and Marriage," *Sexuality and Society*. https://thesocietypages.org/sexuality/2009/10/18/race-sexuality-and-the-one-drop-rule-more-thoughts-about-interracial-couples-and-marriage/. Accessed August 29, 2020.

Eaton, A. W. 2003. "Where Ethics and Aesthetics Meet: Titian's Rape of Europa." *Hypatia* 18 (4): 159–188.

Evans, Michael W. 1980. "The Geometry of the Mind." *Architectural Association Quarterly* 12 (4): 32–55.

Flynt, Harry. 1995. "Concept Art." In *Theories and Documents of Contemporary Art: A Sourcebook of Artists' Writings*, edited by Kristine Stiles and Peter Selz, 820-822. Berkeley: University of California Press. http://www.henryfl ynt.org/aesthetics/conart.html. Accessed May 16, 2022.

Foucault, Michel. 1970. *The Order of Things: An Archaeology of the Human Sciences*. New York: Random House.

## 304 BIBLIOGRAPHY

Foucault, Michel. 1991. *This Is Not a Pipe*. Berkeley: University of California Press.

Freedberg, David. 1980. *Dutch Landscape Prints of the Seventeenth Century*. London: British Museum Publications.

Freedberg, David. 1989. *The Power of Images: Studies in the History and Theory of Response*. Chicago: University of Chicago Press.

Fried, Michael. 1964. "Modernist Painting and Formalist Criticism." *American Scholar* 33 (4): 642–648.

Gabriel, Mary. 2019. *Ninth Street Women: Lee Krasner, Elaine de Kooning, Grace Hartigan, Joan Mitchell, and Helen Frankenthaler: Five Painters and the Movement That Changed Modern Art*. New York: Little, Brown.

Goldie, Peter, and Elisabeth Schellekens. 2007. *Philosophy and Conceptual Art*. Oxford: Clarendon Press.

Gombrich, E. H. 1962. *Art and Illusion*. London: Phaidon.

Goodman, Nelson. 1976. *Languages of Art*. Indianapolis: Hackett.

Grandenetti, Jerry. 1962. *All American Men of War*. New York: DC Comics.

Grant, Edward. 1997. "Nicole Oresme, Aristotle's *On the Heavens*, and the Court of Charles V." In *Texts and Contexts in Ancient and Medieval Science*, edited by Edith Sylla and Michael R. McVaugh, 187–207. Leiden: Brill.

Grau, Donatien. 2018. *Plato in L.A.: Contemporary Artists' Visions*. Los Angeles: J. Paul Getty Museum.

Greenberg, Clement. 1982. "Modernist Painting." In *Modern Art and Modernism: A Critical Anthology*, edited by Francis Frascina and Charles Harrison, 5–10. New York: Harper and Row.

Grimal, Pierre. 1991. *The Penguin Dictionary of Classical Mythology*. London: Penguin Books.

Grootenboer, Hanneke. 2020. *The Pensive Image: Art as a Form of Thinking*. Chicago: University of Chicago Press.

Hamilton, Andy. 2014. *Routledge Guidebook to Wittgenstein and "On Certainty."* Abingdon, UK: Routledge.

Hayman, Greg, and Henry John Pratt. 2005. "What Are Comics?" In *A Reader in Philosophy of the Arts*, edited by David Goldblatt and Lee Brown, 419–424. Upper Saddle River, NJ, Pearson Education.

Hegel, G. W. F. 1977. *The Phenomenology of Spirit*. A.V. Miller, trans. Oxford: Oxford University Press.

Heidegger, Martin. 1962. *Being and Time*, John Macquarrie and Edward Robinson, trans. New York: Harper and Row.

Heidegger, Martin. 2002. "The Origin of the Work of Art." In *Off the Beaten Track*, edited by Julian Young and Kenneth Haynes, 1–56. Cambridge: Cambridge University Press.

Held, Julius. 1969. *Rembrandt's "Aristotle" and Other Studies*. Princeton, NJ: Princeton University Press.

BIBLIOGRAPHY 305

Hesse, Mary. 1965. "Aristotle's Logic of Analogy." *Philosophical Quarterly* 15 (61): 328–340.

Higginson, Peter. 1964. *Jasper Johns and the Influence of Ludwig Wittgenstein*. MA Thesis. https://open.library.ubc.ca/cIRcle/collections/ubctheses/831/items/1.0093801. Accessed April 15, 2021.

Hobbes, Thomas. 1994 (1651). *Leviathan*. Indianapolis: Hackett.

Holbo, John. 2012. "Redefining Comics." In *The Art of Comics: A Philosophical Approach*, edited by Aaron Meskin and Roy T. Cook, 3–30. Malden, MA: Wiley-Blackwell.

Homer. 1998. *The Iliad*. Rev. ed. Robert Fagles, trans. London: Penguin Classics.

Homer. 1999. *The Odyssey*, Robert Fagles, trans. London: Penguin Classics.

Hume, David. 1748. *Philosophical Essays Concerning Human Understanding*. London: A. Millar.

Jastrow, Joseph. 1900. *Fact and Fable in Psychology*. Boston: Houghton, Mifflin.

Johns, Jasper. 1994. *The Prints of Jasper Johns, 1960–1993: A Catalogue Raisonné*. West Islip, New York: Universal Limited Arts Editions.

Joplin, Katherine. 2011. "Plato's Circle in the Mosaic of Pompeii." *Electrum Magazine*. http://www.electrummagazine.com/2011/11/platos-circle-in-the-mosaic-of-pompeii/. Accessed June 2, 2022.

Kant, Immanuel. 1987. *The Critique of Judgment*. Werner S. Pluhar, trans. Indianapolis: Hackett.

Kant, Immanuel. 1998. *The Critique of Pure Reason*. Paul Guyer and Allen K. Wood, trans. Cambridge: Cambridge University Press.

Kanter, Albert Lewis. 1942. *Classics Illustrated Last of the Mohicans*. New York: Gilberton.

Kaufmann, Walter, ed. 1965. *Existentialism from Dostoyevsky to Sartre*. New York: Meridian Press.

Kenney, Nancy. 2019. "Whitney Acquires Abstract Expressionist Painting by Norman Lewis." *Art Newspaper*. February 7. https://www.theartnewspaper.com/news/whitney-acquires-abstract-expressionist-painting-by-norman-lewis-an-overlooked-african-american-artist. Accessed August 16, 2020.

Kenny, Anthony, ed. 1994. *The Oxford Illustrated History of Philosophy*. Oxford: Oxford University Press.

Koch, Kenneth. 2004. *The Art of the Possible: Comics Mainly without Pictures*. New York: Soft Skull Press.

Kosuth, Joseph. 1973. "Art after Philosophy I and II." In *Idea Art*, edited by Gregory Battcock. New York: E. P. Dutton.

Kosuth, Joseph, Marcel Huys, and Edelbert Köb. 1989. *Wittgenstein: The Play of the Unsayable*. Vienna, Austria: Wiener Secession.

Kripke, Saul. 1982. *Wittgenstein on Rules and Private Language*. Cambridge, MA: Harvard University Press.

# 306  BIBLIOGRAPHY

Kuh, Katharine. 1965. *Break-Up: The Core of Modern Art*. Greenwich, CT: New York Graphic Society.

Lessing, Gotthold Ephraim. 1962. *Laocoön: An Essay on the Limits of Painting and Poetry*. Baltimore: Johns Hopkins University Press.

Levie, J. Howard, and Richard Lentz. 1982. "Effects of Text Illustrations: A Review of Research." *Educational Communication and Technology* 30 (4): 195–232.

LeWitt, Sol. 1967. "Paragraphs on Conceptual Art." *Artforum*. https://www.artforum.com/print/196706/paragraphs-on-conceptual-art-36719/. Accessed January 14, 2020.

LeWitt, Sol. 1971. *Wall Drawing 118*. https://observer.com/2012/10/here-are-the-instructions-for-sol-lewitts-1971-wall-drawing-for-the-school-of-the-mfa-boston/. Accessed September 2, 2019.

Livingston, Paisley. 2006. "Theses on Film as Philosophy" in Murray Smith and Thomas E. Wartenberg, *Thinking Through Cinema: Film as Philosophy*, 11–18. Oxford, UK: Blackwell.

Livy. 2017. *Fabulae ab Urbe Condita*. Geoffrey Steadman, trans. https://geoffreysteadman.files.wordpress.com/2019/10/livy.aucbk1_.06oct19.pdf. Accessed June 2, 2022.

Lobel, Arnold. 1972. "Dragons and Giants." In *Frog and Toad Together*. New York, HarperCollins.

Lopes, Dominic McIver. 2005. *Sight and Sensibility: Evaluating Pictures*. Oxford: Oxford University Press.

MacRae, Ian. 2017. "Queering Epistemology and the Odyssey of Identity in Alison Bechdel's *Fun Home*." In *Graphic Novels as Philosophy*, edited by Jeff McLaughlin, 130–149. Jackson: University Press of Mississippi.

Malcolm, Norman. 1958. *Ludwig Wittgenstein: A Memoir*. London: Oxford University Press.

Mankoff, Robert, Adam Gopnik, and David Remnick. 2006. *The Complete Cartoons of the New Yorker*. New York: Black Dog and Leventhal Publishers

Mantoan, Diego, and Luigi Perissinotto. 2019. *Paolozzi and Wittgenstein: The Artist and the Philosopher*. Cham, Switzerland: Palgrave Macmillan.

Marcuse, Herbert. 1964. *One Dimensional Man: Studies in the Ideology of Advanced Industrial Society*. Boston: Beacon Press.

McCloud, Scott. 1993. *Understanding Comics: The Invisible Art*. Amherst, MA: Kitchen Sink Press.

McDaniel, Spencer. 2020. "The Amazing Origin of the Story of Achilles's Heel." https://talesoftimesforgotten.com/2020/06/04/the-amazing-origin-of-the-story-of-achilless-heel/. Accessed April 30, 2021.

McGrath, Elizabeth. 2009. "Platonic Myth in Renaissance Iconography." *Plato's Myths*, edited by Catalin Partenie, 206–238. Cambridge: Cambridge University Press.

## BIBLIOGRAPHY    307

McLaughlin, Jeff, ed. 2017. *Graphic Novels as Philosophy*. Jackson: University Press of Mississippi.

Mendelssohn, Moses. 2011. *Morning Hours: Lectures on God's Existence*. Daniel O. Dahlstrom and Corey Dyck, trans. Dordrecht: Springer.

Meskin, Aaron. 2007. "Defining Comics?" *Journal of Aesthetics and Art Criticism* 65 (4): 369–379.

Meskin, Aaron. 2019. "Comics and/as Philosophical Aesthetics." In *More Critical Approaches to Comics*, edited by Matthew J. Smith, Matthew Brown, and Randy Duncan, 160–174. London: Routledge.

Meskin, Aaron, and Roy T. Cook. 2012. *The Art of Comics: A Philosophical Approach*. Malden, MA: Wiley-Blackwell.

Milne, A. A. 1926. *Winnie-the-Pooh*. London: Methuen.

Miller, J. Hillis. 1992. *Illustration*. London: Reaktion Books.

Moore, G. E. 1903. "The Refutation of Idealism." *Mind* 12: 433–453.

Moore, G. E. 1925. "A Defense of Common Sense." In *Contemporary British Philosophy* (2nd Series), J.H. Muirhead, ed., 106–133. London: George Allen and Unwin.

Moore, G. E. 1939. "Proof of an External World." In *Philosophical Papers*, 126–148. New York: Collier Books.

Moore, G. E. 1942. "A Reply to My Critics." In *The Philosophy of G. E. Moore*, edited by P. A. Schilpp. Evanston, IL: Northwestern University.

Morgan, Robert C., ed. 2002. *Bruce Nauman*. Baltimore: Johns Hopkins University Press.

Mortensen, Chris, Steve Leishman, Peter Quigley, and. Theresa Helke. 2013. "How Many Impossible Images Did Escher Produce?" *British Journal of Aesthetics* 53 (4): 425–441.

Moser, Barry. 1983. *Lewis Carroll's "Alice's Adventures in Wonderland."* Berkeley: University of California Press.

Moser, Barry . 1999. *The Holy Bible: King James Version/The Pennyroyal Caxton*. New York: Viking.

Most, Glenn W. 1996. "'The School of Athens' and Its Pre-Text." *Critical Inquiry* 23 (1): 145–182.

Moyal-Sharrock, Daniele, and William H. Brenner, eds. 2007. *Readings of Wittgenstein's On Certainty*. Basingstoke, UK: Palgrave-Macmillan.

Mulhall, Stephen. 2002. *On Film*. London: Routledge.

Nehamas, Alexander. 2016. *On Friendship*. New York: Basic Books.

Newman, James R. 1959. "The Tortured Life of an Influential Modern Philosopher: The Late Ludwig Wittgenstein." *Scientific American* 21 (2): 149–158.

Nietzsche, Friedrich. 1999. *The Birth of Tragedy and Other Writings*. Raymond Geuss and Ronald Speirs, eds. Cambridge: Cambridge University Press.

Nochlin, Linda. 1971a. *Realism*. Baltimore: Penguin Books.

## 308 BIBLIOGRAPHY

Nochlin, Linda. 1971b. "Why Have There Been Great Women Artists?" In *Woman in Sexist Society: Studies in Power and Powerlessness*, edited by Vivian Gornick and Barbara Moran, 580–510. New York: Basic Books.

Nussbaum, Martha. 1992. *Love's Knowledge: Essays on Philosophy and Literature*. Rev. ed. Oxford: Oxford University Press.

Oresme, Maistre Nicole. 1940. *Le Livre de Ethiques D'Aristotle*. New York: G. E. Stechert.

Oresme, Maistre Nicole . 1957. *Le Livre de Yconomique D'Aristotle*. Albert Douglas Menut, trans. *Transactions of the American Philosophical Society*, 47 (5): 783–853.

Oresme, Maistre Nicole . 1970. *Le Livre de Politiques D'Aristote*. *Transactions of the American Philosophical Society* 60 (6): 1–392.

Ovid. 2003. *Metamorphosis*. David Hine, trans. *Poetry*. From *"Metamorphoses,"* Book II, 846-875 http://www.poetryfoundation.org/poetrymagazine/ poem/181311. Accessed October 23, 2015.

Pass, John Roger. 1996. "Inseparable Muses: German Baroque Poets as Graphic Artists." *Colloquia Germanica* 29 (1): 13–38.

Perry, Patrick. 2015. "Inside Job: Norman Rockwell's Unconventional Approach to Illustrating Fiction." *Saturday Evening Post*. https://www.satu rdayeveningpost.com/2015/09/inside-job/. Accessed August 19, 2020.

Phillips, Tom. 1985. *Dante's Inferno*. London: Thames and Hudson.

Pillow, Kirk. 2003. "Did Goodman's Distinction Survive LeWitt?" *Journal of Aesthetics and Art Criticism* 61 (4): 365–380.

Piper, Adrian. 1996. "The Logic of Modernism." In *Out of Order, Out of Sight, vol. 2: Selected Writings in Art Criticism, 1967–1992*, 209–214. Cambridge, MA: MIT Press.

Pippin, Robert B. 2014. *After the Beautiful: Hegel and the Philosophy of Pictorial Modernism*. Chicago: University of Chicago Press.

Pippin, Robert B. 2021. *Philosophy by Other Means: The Arts in Philosophy & Philosophy in the Arts*. Chicago: University of Chicago Press.

Plato. 1974. *Republic*. G.M.A. Grube, trans. Indianapolis: Hackett.

Plato. 1989. *Symposium*. Alexander Nehamas and Paul Woodruff, trans. Indianapolis: Hackett.

Plato. 1992. *Protagoras*. Stanley Lombardo and Karen Bell, trans. Indianapolis: Hackett

Plato. 2002. *Five Dialogues: Euthyphro, Apology, Crito, Meno, Phaedo*, G.M.A. Grube, trans. Indianapolis: Hackett.

Plato. 2010. *Memo and Phaedo*. Alex Long, trans. Cambridge: Cambridge University Press.

Plutarch. 1928. *Moralia*. Frank Cole Babbitt, trans. Cambridge, MA: Harvard University Press. http://data.perseus.org/citations/urn:cts:greekLit:tlg0007. tlg076.perseus-eng1:27. Accessed January 1, 2022.

## BIBLIOGRAPHY 309

Poochigian, Aaron. 2016. "Have We Lost the Lofty? Virgil's *Aeneid* and the History of English Poetry." *Words Without Borders* (January 11). https://www.wordswithoutborders.org/dispatches/article/have-we-lost-the-lofty-virgils-aeneid-and-the-history-of-english-poetry. Accessed December 7, 2021.

Potter, M.C., Wyble, B., Hagmann, C.E., *et al.* 2014. "Detecting Meaning in RSVP at 13 ms per picture." *Attention, Perception, Psychophysics* 76: 270–279. https://doi.org/10.3758/s13414-013-0605-z

Rawls, John. 1971. *A Theory of Justice*. Cambridge, MA: Harvard University Press.

Remmert, Volker R. 2005. *Widmung, Welterklärung und Wissenschaftslegitimierung: Titelbilder und ihre Funktionen in der Wissenschaflichen Revolution*. Wiesbaden: Harrassowitz Verlag.

Richardson, Brenda. 1976. *Mel Bochner: Number and Shape*. Baltimore: Baltimore Museum of Art.

Rinder, Lawrence. 1989. *Adrian Piper/Matrix 130*. Exhibition brochure. http://archive.bampfa.berkeley.edu/exhibition/130. Accessed August 13, 2020.

Roe, Cynthia. 2005. "Titian's *Rape of Europa*: The Posture of the Pose." *Comitatus: A Journal of Medieval and Renaissance Studies* 36: 93–113.

Roosevelt, Franklin Delano. 1941. "State of the Union Address: The Four Freedoms." https://voicesofdemocracy.umd.edu/fdr-the-four-freedoms-speech-text/. Accessed April 13, 2022.

Rozin, Paul, and Carol Nemeroff. 2002. "Sympathetic Magical Thinking: The Contagion and Similarity 'Heuristics.'" In *Heuristics and Biases: The Psychology of Intuitive Judgment*, edited by T. Gilovich, D. Griffin, and D. Kahneman, 201–216. New York: Cambridge University Press.

Rosenberg, Harold. 1959. *The Tradition of the New*. New York: Horizon Press.

Rousseau, Jean-Jacques. 1979. *Emile, or On Education*. Harold Bloom, trans. New York: Basic Books.

Russell, Bertrand. 1905. "On Denoting." *Mind* 14: 479–493.

Ryle, Gilbert. 1968. "Jane Austen and the Moralists." In *Critical Essays on Jane Austen*, edited by B. C. Southam, 106–122. London: Routledge and Kegan Paul.

Sartre, Jean Paul. 1995. "The Humanism of Existentialism." In *Existentialism Basic Writings: Kierkegaard, Nietzsche, Heidegger, Sartre*, edited by Charles Guignon and Derk Pereboom, 268–286. Indianapolis: Hackett.

Schapiro, Meyer. 1968. "The Still Life as a Personal Object—A Note on Heidegger and van Gogh," 203–9. In *The Reach of Mind*, edited by M. L. Simmel. Berlin: Springer.

Schapiro, Meyer. 1995. *Mondrian: On the Humanity of Abstract Painting*. New York: George Braziller.

## BIBLIOGRAPHY

Schjeldahl, Peter. 2013. "A Kind Word for Norman Rockwell." *New Yorker*, November 5. https://www.newyorker.com/books/page-turner/a-kind-word-for-norman-rockwell/. Accessed January 14, 2020.

Schmidt, Dennis J. 2005. *Lyrical and Ethical Subjects: Essays on the Periphery of the Word, Freedom, and History*. Albany: State University of New York Press.

Schmidt, Dennis J. 2013. *Between Word and Image: Heidegger, Klee, and Gadamer on Gesture and Genesis*. Albany: State University of New York Press.

Schopenhauer, Arthur. 1966. *The World as Will and Representation*, vol. 1. E.F.J. Payne, trans. New York: Dover.

Scott, John T. 2014. "The Illustrative Education of Rousseau's *Emile*." *American Political Science Review* 108 (3): 533–546.

Sendak, Maurice. 1963. *Where the Wild Things Are*. New York: Harper Collins.

Sheets, Hilarie M. 2014. "The Changing Complex Profile of Black Abstract Painters." *Art News*. https://www.artnews.com/art-news/news/changing-complex-profile-of-black-abstract-painters-2452/. Accessed August 16, 2020.

Sherman, Claire Richter. 1977. "Some Visual Definitions in the Illustrations of Aristotle's *Nicomachean Ethics* and *Politics* in the French Translations of Nicole Oresme." *Art Bulletin* 59 (3): 320–330.

Sherman, Claire Richter. 1995. *Imaging Aristotle: Verbal and Visual Representation in Fourteenth-Century France*. Berkeley: University of California Press.

Silver, Nathaniel. 2021. "Titian's 'Rape of Europa.'" In *Titian's 'Rape of Europa,'* edited by Nathaniel Silver, 36–47. London: Paul Holberton.

Skinner, Quentin. 2018. *From Humanism to Hobbes: Studies in Rhetoric and Politics*. Cambridge: Cambridge University Press.

Smith, Murray, and Thomas E. Wartenberg. 2006. *Thinking through Cinema: Film as Philosophy*. Malden, MA: Blackwell.

Solomon, Deborah. 2013. *American Mirror: The Life and Art of Norman Rockwell*. New York: Farrar, Straus and Giroux.

Sophocles. 1990. *Antigone*. Oxford: Oxford University Press.

Sousanis, Nick. 2015. *Unflattening*. Cambridge, MA: Harvard University Press.

Statius. 2015. *Achilleid*. Stanley Lombardo, trans. Indianapolis: Hackett.

Stoichita, Victor I. 1997. *The Self-Aware Image: An Insight into Early Modern Meta-Painting*. Cambridge: Cambridge University Press.

Strayer, Jeffrey. 2021. "Planarity, Pictorial Space, and Abstraction." In *The Palgrave Handbook of Image Studies*, edited by K. Purgar, 187–202. Basingstoke, UK: Palgrave Macmillan.

Studley, Vance, ed. 2000. *Ludwig Wittgenstein, "Remarks on Colour."* Pasadena, CA: Archetype Press.

Taylor, Paul. 2011. "Adriano Castellesi and the *School of Athens*," *Mantova e il Rinascimento Italiano: Studi in Onore di David S. Chambers*, edited by

## BIBLIOGRAPHY 311

Philippa Jackson and Guido Rebecchini, 179–189. Mantova: Editoriale Sometti.

Tennant, Neil. 2017. "Logicism and Neologicism." *The Stanford Online Encyclopedia of Philosophy*. November 3. https://plato.stanford.edu/entries/logicism/. Accessed March 10, 2020.

Thomson-Jones, Katherine. 2016. *Current Controversies in Philosophy of Film*. New York: Routledge.

Tomkins, Calvin. 2009. "Western Disturbances: Bruce Nauman's Singular Influence." *New Yorker*, June 1. https://www.newyorker.com/magazine/2009/06/01/western-disturbances. Accessed August 26, 2019.

Trafton, Anne. 2014. "In the Blink of an Eye: MIT Neuroscientists Find the Brain Can Identify Images Seen for as Little as 13 Milliseconds." https://news.mit.edu/2014/in-the-blink-of-an-eye-0116. Accessed May 11, 2021.

Twain, Mark. 1884. *The Adventures of Huckleberry Finn*. New York: Charles L. Webster.

Verene, Donald Philip. 2015. *Vico's "New Science": A Philosophical Commentary*. Ithaca, NY: Cornell University Press.

Vermeir, Koen. 2005. "The Magic of the Magic Lantern (1660–1700): On Analogical Demonstration and the Visualization of the Invisible." *British Journal of the History of Science* 38 (2): 127–159.

Vinken, P. J. 1960. "Spiegel's Antrum Platonicum: A Contribution to the Iconology of the Heart." *Oud Holland*, no. 75, 125–142.

Virgil. 2008, *The Aeneid*. Robert Fagles, trans. London: Penguin.

Walton, Kendell. 1984. "Transparent Pictures: On the Nature of Photographic Realism." *Critical Inquiry* 11: 246–277.

Warner, Marina. 2018. "The Politics of Translation." *London Review of Books* 40 (19): 21–24.

Wartenberg, Thomas E. 1979. "Order through Reason: Kant's Transcendental Justification of Science." *Kant-Studien*, no. 4, 409–424.

Wartenberg, Thomas E. 1991. "Reason and the Practice of Science." In *The Cambridge Companion to Kant*, edited by Paul Guyer, 228–248. Cambridge: Cambridge University Press.

Wartenberg, Thomas E. 2005. "Martin Heidegger." In *The Routledge Companion to Aesthetics*. 2nd ed., edited by Berys Gaut and Dominic Lopes, 147–158. London: Routledge.

Wartenberg, Thomas E. 2007. *Thinking on Screen: Film as Philosophy*. London: Routledge.

Wartenberg, Thomas E. 2011. *The Nature of Art*. 3rd ed. Boston: Cengage.

Wartenberg, Thomas E. 2015a. "Illustrating Philosophy: Mel Bochner's Wittgenstein Drawings." *Word and Image* 31 (3): 233–248.

Wartenberg, Thomas E. 2015b. *Mel Bochner: Illustrating Philosophy*. South Hadley, MA: Mount Holyoke College Museum of Art.

## 312  BIBLIOGRAPHY

Wartenberg, Thomas E. 2021. "Illustration." doi:10.4324/9780415249126-M058-1. Routledge Encyclopedia of Philosophy, Taylor and Francis, https://www.rep.routledge.com/articles/thematic/illustration/v-1.

Wartenberg, Thomas. 2023a (forthcoming). "Philosophical Works of Art." In *The Routledge Companion to the Philosophy of Painting and Sculpture*, edited by Noël Carroll and Jonathan Gilmore. New York: Routledge.

Wells, H. G. 1898. *War of the Worlds*. London, William Heinemann.

Whitehead, Alfred North, and Bertrand Russell. 1910–1912. *Principia Mathematic*, 3 vols. Cambridge: Cambridge University Press.

Wicks, Robert. 2010. "Using Artistic Masterpieces as Philosophical Examples." *Journal of Aesthetics and Art Criticism* 68 (3): 259–272.

Wicks, Robert. 2020. *Introduction to Existentialism: From Kierkegaard to "The Seventh Seal."* London: Bloomsbury Academic.

Wilde, Carolyn. 2007. "Matter and Meaning in the Work of Art: Joseph Kosuth's *One and Three Chairs*. In *Philosophy and Conceptual Art*, edited by Peter Goldie and Elisabeth Schellekens, 119–137. Oxford: Clarendon Press.

Wittgenstein, Ludwig. 1961. *Tractatus Logico-Philosophicus*. London: Routledge and Kegan Paul.

Wittgenstein, Ludwig. 1967. *Lectures and Conversations on Aesthetics, Psychology, and Religious Belief*. London: Basil Blackwell.

Wittgenstein, Ludwig. 1969. *On Certainty*. G.E.M. Anscombe and G.H. von Wright, trans. London: Basil Blackwell.

Wittgenstein, Ludwig. 1977. *Remarks on Colour*. Berkeley: University of California Press.

Wittgenstein, Ludwig. 2009. *Philosophical Investigations*. Chichester, UK: Wiley-Blackwell.

Wittgenstein, Ludwig, and Mel Bochner. 1991. *On Certainty*. San Francisco: Arion Press.

Wollenbecker, Genevieve. 2013. "Lessons from Maria Bussmann." *Bottom Line*, March 29, 2013. http://thebottomline.drawingcenter.org/2013/03/29/lessons-from-maria-bussman/. Accessed August 8, 2020.

Wollheim, Richard. 1987. *Painting as an Art*. London: Thames and Hudson.

Young, James O. 2001. *Art and Knowledge*. New York: Routledge.

# Index

Note: The plates are located between pages 150 and 151

Figures are indicated by an italic *f*; notes will be indicated by an n followed by the note number

Abbott, Edward, *Flatland*, 267
Abstract Expressionism, 15, 136–53, 154–6, 159, 160, 197
Achilles, 85, 86, 89, 91–93
Adorno, T.W., 137
*Adventures of Huckleberry Finn, The*, see Twain, Mark
African–Americans, 50
　artists, 138, 149, 153, 155
Alexander the Great, 104
*Alice's Adventures in Wonderland*, see Carroll, Lewis
Alighieri, Dante, *Inferno*, 27–31, 35–40, 64
　illustrations of, *see* Botticelli, Sandro; Doré, Gustave; Phillips, Tom
*All American Men of War*, 256
Alpers, Svetlana, 125
ambiguous images,
　*My Wife and Mother-in-Law*, 194
　*Rubin's Vase*, 193
　*The Duck-Rabbit*, 4*f*, 190–1, 195–6
*Antrum Platonicum*, see Saenredam, Jan
Apolline, *see* Nietzsche, Friedrich, *The Birth of Tragedy*
Appiah, Kwame Anthony, 156
Arion Press, 211–2, 230
Aristophanes, 65, 245
Aristotle, 9, 52, 59, 65, 68, 74, 75, 102–4, 133, 151, 208

*Categories*, 74
　French translations of, 58–9, 75, 291, 296, 298–9
　logic, 69–71
　metaphysics, 72, 229
　*Nicomachean Ethics*, 13, 58, 60–1, 63, 75
　*Poetics*, 103
　*Politics*, 13, 58, 61–3, 75
　substantial change, 72
　substantial generation, 72–3
　syllogism, 13, 70
　three forms of friendship, 60–1
　　illustration of, plate 3, 60, 291, 294, 296, 298–9
　types of justice, 61–4
　　illustration of, plate 4, 61, 296, 298–9
art,
　as philosophy, 70–4, 158–9, 160, 291
　Conceptual, 16, 161–2, 167–73, 210, 237, 295
　Confrontational, 157
　Cubism, 154, 161, 298
　Euroethnic, 153
　Installation, 174
artform, 51, 56
artistic medium, purity of, 143–5
aspect seeing, *see* Wittgenstein, Ludwig, seeing-as
Austen, Jane, 10

# 314 INDEX

Bacon, Francis, *The Great Instauration*, 78
Barsalou, David, *WHAMM!, Deconstructing Roy Lichtenstein*, plate 27, 256–7
Bechdel, Alison, *Fun Home: A Family Tragedy*, 16, 277–89
    Albert Camus, *The Myth of Sisyphus*, 279–80
    Closet, 278, 284–5, 287
    epistemological crisis, 282–4, 285–7
    father's suicide, 277–8, 280, 284, 286–7
    illustration of philosophy, 282–7
    images in, 280–1
    Russell's Paradox, 278–9
    sexual orientation, 277–8, 281, 287–8
    skepticism, 282–4, 285–8
    truck-driving bulldyke, 280–1
    use of philosophy, 278, 280
Beck, Jeff J.S., 94n. 11
Bell, Clive, 151
Berger, Susanna, *The Art of Philosophy*, 9, 66, 69, 70–4, 80n. 4, 83
Berkeley, George, 214
Bernstein, Roberta, 195
Berwick, Thomas, 242
*Biozoics*, 240
Bochner, Mel, 16, 162, 195, 210, 211–37, 293, 295, 299
    *Asterisk Branch*, 229
    *Counting Alternatives: The Wittgenstein Illustrations*, 18, 185, 211–2, 223–9, 230
        matrix in, 224, 228–9
        rules for constructing, 225–6
    *Diamond Branch*, plate 23, 228, 235
    *Fourth Range*, plate 24, 212, 230, 232, 234–7, 292

    exception to rule, 235
    mistake in, 234–7
    *If the Colour Changes # 1*, plate 16, 185–90, 212
    illustration of Wittgenstein's *On Certainty*, 6, 16, 188, 223–37
    *Language Is Not Transparent*, 224
    *Measurement Room*, 224
    numbers-game, 16, 225, 226, 229, 230, 234, 292–3
    *Range* (silkscreen), plate 25, 212, 230, 232
    *Range* drawings, 212, 230–7
        basic sequence, 232
        block, 232
        closure, 232, 234
        rules for constructing, 230–4
    *"T" Branch*, plate 22
bold thesis, the, 10
Bonheur, Rosa, 19
    *Plowing in the Nivernais: The Dressing of the Vines*, 142
Bosse, Abraham, *see* Hobbes, Thomas, Frontispiece to *Leviathan*
Botticelli, Sandro, 64, 68
    illustration of *The Schismatics*, 28f, 28–30
Bredekamp, Horst, 34*n*
Brenson, Michael, 155
broadsides, 129, 290, *see also* Gaultier, Léonard and Martin Meurisse
Brown, Keith, 80n. 5
Bußmann, Maria, 162, 199–203, 292, 299
    *Allerdings*, 202–3
    *Drawing to Wittgenstein's "Tractatus"*, plate 18, 199–201
    *Tractatus 3.324*, plate 19, 201–2
bust, 52–3, 75

## INDEX 315

Campbell, Stephen J., 44–6
Cantor, George, 263
Carravagio, Michelangelo Merisi da,
 *David with the Head of Goliath,* 31
 *The Death of the Virgin,* 11
Carrier, David, 203, 254
Carroll, Lewis (Charles Dodgson),
 *Alice's Adventures in*
 *Wonderland,* 25–7, 32, 246
Carroll, Margaret Deutsch, 104
Catalan, Maurizio, *America,* 172n. 5
Cavell, Stanley, 284n. 30
Cavendish, Mary, *Philosophical and*
 *Physical Opinions,* 78–9
Cezanne, Paul, 198n. 18
 *Still Life with Apples and a Pot of*
 *Primroses,* 132–3
Chagall, Marc, *Daphnis and Chloe,*
 245
Charles V, 58–9, 61, 299
Charles VIII, 69
China, 296
Christianity, 113, 131
cinematic philosophy, 10
Circé, engraving of, *see* Rousseau,
 Jean-Jacques
Clark, Kenneth, 144n. 6
*Classics Illustrated* comics, 249
Colette, Sidonie-Gabrielle, *Earthly*
 *Paradise,* 287
color, artists of, 18–9
comics, 12, 238
 as arguments, 272
 image-text relationship in, 249–
 51, 258, 270, 276
 no illustrations in, 239, 259, 288
 pictorial images in, 239, 253
 simple theory of, 249
 single- or one-panel, 239, 252–3
 terminology,
 frame, 252
 panel, 251
 sequence, 251

 speed lines, 254
 text-balloon, 254–5
 text in, 254–8
 textless, 240–1
 time in, 257–8
 use of text in, 240–1
 visual style of, 273, 275–6
Conan Doyle, Arthur, 248
Conceptual Art, *see* Art, Conceptual
*contrapasso, see* Alighieri, Dante
Cooper, James Fenimore, *The Last of*
 *the Mohicans,* 249–51
 *Classics Illustrated* version, 249–51
Copernicus, Nicolaus, 267–8
Cornelisz, Cornelis, *Antrum*
 *Platonicum,* 6, *see also*
 Saenredam, Jan
Courbet, Gustav, 142
Coxie, Michiel, *De Grot von Plato,*
 6n. 3, 34n. 6
crystallization, 121, 292
Cubism, *see* Art, Cubism
culture, low, popular, 297

Daedalus and Icarus, 287
Dante, *see* Alighieri, Dante
Danto, Arthur, 6, 212
 on Andy Warhol's significance, 11,
 15, 151
Darwin, Charles, 124
David, Jacques-Louis,
 *Death of Socrates,* plate 7, 101,
 105–6, 133, 295
de Bron, Bertram, *see* Alighieri, Dante
DeCruz, Helen, *Philosophy*
 *Illustrated,* 260
de Kooning, Willem, 139, 149
*Dennis the Menace,* 239, 253, 255
Derrida, Jacques, 11
Descartes, René, 79, 124, 128, 166,
 214, 219–20, 262, 266, 270,
 282–3
Dia:Beacon, 224

316 INDEX

diagram, 1, 33–5, 82
Dickens, Charles, *Pickwick Papers*, 33
Dionysiac, *see* Nietzsche, Friedrich,
    *The Birth of Tragedy*
Disneyfication, 248
*Doonesbury*, 255
Doré, Gustave,
    illustration of *The Schismatics*, 28,
    29f, 36, 38
doubt, *see* Wittgenstein, Ludwig,
    conditions for doubt; *On
    Certainty*; Bochner, Mel
Doxiadis, Apostolos, et. al.,
    *Logicomix*, 16, 261–6, 267,
    276, 294
    Barber "Paradox," The, 264–5, 294
    Frege, Gottlob, 262
    Godel, Kurt, incompleteness
        theorem, 262
    Logicism, 262–3
    Russell, Bertram, 261–6
    Russell's Paradox, 263–5, 278, 284,
        *see also* self-reference
Dowd, J.H., 248
drawing, 170, 224*n*
Dreyfus, Simeon, 268
Dryden, John, 23–4
Duchamp, Marcel,
    *Bicycle Wheel*, 172
    *Bottle Rack*, 172
    *Fountain*, 171–2
Duns Scotus, John, 69–70, 71

Eaton, Anne, 41n. 10, 43
Eisen, Charles, 83, *see also* Rousseau,
    Jean-Jacques
empiricism,
engraving, 78, 80, 84–5, 93–4
    wood, 242
Enlightenment,
*episteme*, Foucault's use of, 122–3,
    125, 128
Escher, M.C., 3, 265

etching,
Euclid, 102
Europa, 255
    myth of, 41–3, 192
Evans, Michael W., 64n. 6
*Far Side, The*, 239
felicity, *see* norms, felicity
fidelity, *see* norms, fidelity
film, 10, 242–3, 251, 258
*Fliegende Blätter*, 191
Flynt, Henry, 168n. 2
Forms, *see* Plato, theory of Forms
Foucault, Michel, 14, 100
    analysis of *Les Meninas*, 125–9,
        130–1, 134
    limits of representation, 126–7
    *The Order of Things*, 122–5, 127
    *This is Not a Pipe*, 122, 149, 272
Foucault's pendulum, 200
Frankenthaler, Helen, 138–9, 146n. 7
Freedberg, David, 3
Frege, Gottlob, 163, 209
    *see also* Doxiadis, Apostolos, et.
        al., *Logicomix*
French Revolution, 106
frontispiece, 14, 37, 77–98, 290
    *see also* Hobbes, Thomas and
        Rousseau, Jean-Jacques,
*Fun Home*, *see* Bechdel, Alison

games,
    language-, *see* Wittgenstein,
        Ludwig, language-games
    number-, *see* Mel Bochner,
        numbers-games
Garden of Eden, 243–5, 291
gardens, French formal, 69
Gardner Museum, 44
Gaultier, Léonard and Martin
        Meurisse, 66
    *Artificiosa totius logices description
        (Descriptio)*, 66, 67f, 69–71,
        74, 80, 83

INDEX 317

broadsides of Aristotle's
philosophy, 66–74, 75, 229,
293, 296, 299
*Clara totius physiologiae
synopsis(Synopsis)*, 66, 68f, 72–3
Gentileschi, Artemisia, *Salome with
the Head of John the Baptist*,
31
geometry, 2, 3
Gombrich, E.H., 27n. 4, 191
Gödel, Kurt, see Doxiados, et. al.
Goodman, Nelson, 168n. 4
*Gospels, The*, 111
Goya, Francisco, *The Disasters of
War*, 154
Grandenetti, Jerry, *see* Barsalou,
David
graphic novel, 12, 238, 297
graphic philosophy, *see* philosophy,
graphic
Grau, Donatien, *Plato in L.A.*, 8n. 5, 179
Greece, Ancient, 9, 13, 52–3, 55, 75,
103, 100, 290
Greek mythology, 85, 108, 110,
144–5
Greek philosophers, 53, 55, 102–3
Greeks, 12, 296
Greenberg, Clement, 15, 137, 159,
160, 299–300
criticism of, 148–50, 153–4
flatness as painting's essence,
145–52
"Modernist Painting," 139,
141–152
Modernism, 15, 139, 146
Grootenboer, Hanneke, *Pensive
Images*, 11,
Gutenberg, Johannes,
invention of movable type, 64, 77
translation of the Bible, 64

Hamilton, Andy, 219
Haring, Keith, 153

Hegel, G.W.F., 107, 114n. 6, 126
Heidegger, Martin, 11, 14, 100, 109n.
4, 115, 122, 123, 129, 131–2,
151
being and beings distinction,
116–7
*Being and Time*, 119
earth, 120, 294
equipmentality, 119, 120
interpretation of van Gogh's *Shoes*,
115, 117–22, 134, 293
"The Origin of the Work of Art,"
115–120, 167, 294
strife, 120
theory of truth, 115, 121
world, 118–9, 131–2, 294
Held, Julius, 104
Hepworth, Barbara, *Mother and
Child*, 143–4
Hesse, Mary, 74
Hill, William Ely, 194
Hobbes, Thomas,
*De Cive*, 78
*Leviathan*, 85
frontispiece to, 14, 78, 79–84, 80f,
97–8, 99, 101, 209, 292, 296
Hollar, Wenceslas, 80
Holmes, Sherlock, 248
*Holy Bible, The*, see Moser, Barry, *The
Holy Bible*
Homer, 79, 96, 103–4, 133
*Iliad*, 41, 104
*Odyssey*, 96
Hume, David, 128, 219

idealism, 214
ideology, 296
illuminated manuscripts, 56–64,
65, 75
illuminations, 56, 59
illustrated books, 242–6
primacy of text over images in,
245–6, 258

318 INDEX

illustration,
  allegorical, 94, 96, 106
  analogical, 39, 69, 73, 74, 75, 202,
     213, 229, 293
  canonical, 246–9
  concept-based, 5–6, 13, 35–41, 49,
     63, 71, 101, 104, 159, 171, 174,
     179, 213, 227, 236, 292, 293
  contribution to philosophy, 71,
     74, 76
  counter-textual, 95
  definition of, 20–2, 32
  denigration of, 13, 41–51
  doing philosophy dichotomy, 610
  function of, 45
  Greek and Roman, 52
  Inferiority to painting and
     sculpture, *see* illustration,
     denigration of
  norm of,
    appropriateness, 249
    consistency, 27, 31, 32
    felicity, 13, 23–35, 39, 43, 47,
     49–50, 64, 68, 75–6, 88, 96,
     103, 105, 245, 250, 261, 266,
     291
    fidelity, 13, 23–35, 39, 43, 47, 58,
     64, 66, 75, 88–9, 95, 101, 111,
     177, 227, 243–5, 246, 247,
     249, 291
    pedagogical use of, 6, 13–4, 65,
     73–4, 161, 289, 294, 296
    personification in, plate 3, 13, 59,
     61, 62, 63, 75, 292
    philosophical, 9, 21, 160, 291, 298,
     299–300
    pictorial, 9, 61, 65, 74, 75, 94, 97,
     229
    quotation-based, 179, 185, 187,
     190, 192, 197, 295
    similarity heuristic, 31–2, 46
    source text, 21, 23–7, 32, 34, 89,
     92, 101

  supplementation of, 27, 31, 45–6
  symbolic, 82
  target, 21, 23–7
  technology, role in, 21, 295–6, 297
  text-based, 5, 9, 13, 22–35, 40, 49,
    58, 63, 65, 75, 86, 88, 89, 105,
    145, 179, 188, 192, 202, 204–
    5, 227, 243, 245, 246, 260,
    266, 291
  theory-based, 15, 50, 99–100, 106,
    122, 132–4, 293
  tradition of, 300
  typology, 20–35
  utilitarian function of, 8
  visual, 1, 12, 20, 43, 52, 121, 300
  word-image relationship in, 16,
    74–6
illustrations of philosophy,
    pre-Modern,
illustrator, 31, 32, 45, 51, 171
  Norman Rockwell as, *see*
    Rockwell, Norman
*Inferno, see*, Allegheri, Dante, *Inferno*
intention, 21, 99, 130–4, 236

Jastrow, Joseph, *Duck-Rabbit*, 4, 191
Johns, Jasper, 162, 190–8, 299
  duck-rabbit in, 190–2, 194–7
  *Fool's House*, 197–8, 209
  *Montez Singing*, 196
  *Seasons ("Spring")*, plate 17, 192–5,
    196, 209, 231
  *Untitled (Harvey Gantt Portfolio)*,
    195–6
  *Usuyuki*, 195
  *see also* ambiguous images
Jordaens, Jacob, *Apollo and Marsyas*,
    130
Joyce, James, *Ulysses*, 287

Kandinsky, Wassily, 148
Kant, Immanuel, 124, 139, 141–2,
    152

INDEX 319

*Critique of Judgment*, 45
*Critique of Pure Reason*, 71–2,
 139–41, 155, 201, 214
Kanter, Albert Lewis, "Hist! Look
 There!" *Classics Illustrated
 "Last of the Mohicans"*, plate 26
Kenny, Anthony, The Oxford
 Illustrated History of
 Philosophy, 3, 52n. 1
Ketchum, Herb, 253
Kline, Franz, 149
Kosuth, Joseph, 16, 162, 173, 173–85,
 187, 190, 196, 208, 295, 299
 *276. (On Color Blue)*, plate 14,
 175–9, 180, 188, 209
 critique of Plato, 174
 *Intellect to Opinion*, 179
 *One and Three Chairs*, plate 13,
 173–4, 180, 198
 *Play of the Unsayable, The*, 175
Kripke, Saul, *Wittgenstein on Rules
 and Private Language*, 222
Kuh, Katherine, 132

language-game, *see* Wittgenstein,
 Ludwig, language-games
language, in illustrations, 161, 209
language, in twentieth-century
 philosophy, 163, 209, 297, *see
 also* Wittgenstein, Ludwig
Langer, Suzanne, 151
*Laocoön and His Sons* (Unknown
 Artist), 144–5
Leibniz, Gottfied Wilhelm, 79
Lessing, Gotthold, *Laocoön*, 143–5
Lewis, Norman, 149
LeWitt, Sol, 154–5
 "Paragraphs on Conceptual Art,"
 168
 *Wall Drawing 118*, 169f, 169–70
 *Wall Drawings*, 146, 168, 231–2
Lichtenstein, Roy, 198n. 18
 *WHAMM!*, 256

literature, 10, 32–3
Livingston, Paisley, 10
Livy, 93
logic, 163, 261–6, *see also* Aristotle,
 logic
*Logicomix, see* Doxiadis, Apostolos,
 et. al.
Longus, 245
Lopes, Dominic McIver, 35–6, 38
Loran, Earl, 198n. 18

Magritte, René, 122, 149
 *Treachery of Images, The*, 272
Malcolm, Norman, 166–7, 204, 206
Manet, Édouard, 15, 142, 147
 *Dejeuner sur l'herbe*, 154
 *Olympia*, 177
manuscripts, illuminated, *see*
 Illuminated manuscripts
Marcuse, Herbert, *One-Dimensional
 Man*, 267
*Mark Trail*, 255–6, 266
Marquise du Châtelet, *Institutions de
 Physique*, 79
matrix, *see* Bochner, Mel, *Counting
 Alternatives: The Wittgenstein
 Illustrations*
McCloud, Scott, 16, 283, 285
 Abstraction, 274–6
 definition of comics, 239–41, 274
 icon, 274
 Magritte, *This Is Not a Pipe*, 273f,
 272–4, *see also* Margritte,
 René
 philosophical argument, 272–7
 *Process of Abstraction, The*, 274–6,
 275f
 *Understanding Comics*, 16, 240,
 271–7
McDaniel, Spencer, 91n. 10
McGrath, Elizabeth, 65n. 9
Meinong, Alexius, 181
Mendelssohn, Moses, 141

320 INDEX

metaphysics, 9, 79, 140–1
Micchelli, Thomas, 200*n*, 201n. 21
Miller, J. Hillis, *Illustration*, 10
Milne, A.A., *Winnie-the-Pooh*, 246, 268
Modernism, 15, 17, 135, 139, 142, 184
Modernity, 52, 125, 267
Modernist Painting, 290, *see also* Greenberg, Clement
Mondrian, Piet, 147
Monet, Claude, *Water Lillies*, 143
Moore, G.E., 183, 214–23, 283
    critique of idealism, *see* refutation of skepticism
    Moore's paradox, 283
    refutation of skepticism, 183, 214–5, 222
mosaics, 53–4, 54*f*, 75
Moser, Barry,
    *The Holy Bible*, 242–6, 244*f*, 247, 291
Most, Glenn W., 102n. 2
Motherwell, Robert, *In Plato's Cave*, 8n. 5
movable type, 64, 77, 296
Mulhall, Stephen, 10

Nadler, Stephen and Ben, *Heretics!*, 266
Nancy, Jean-Luc, 11
Nauman, Bruce, 16, 162, 180–5, 187, 190, 195, 295
    *A Rose Has No Teeth*, plate 15, 180, 183–5, 295
Nehamas, Alexander, 60n. 5
*The New Yorker*, 47
Newman, Barnett, 136–7
Newman, James R., 204
Newton, Isaac, 79, 266
Nietzsche, Friedrich, 14, 100, 107–14, 121, 129, 131, 134
    Apolline and Dionysiac, 107, 108–10, 112–4, 131, 134
    *The Birth of Tragedy*, 107–110, 113–4

Nochlin, Linda,
    "Why Have There Been No Great Women Artists," 19, 148
    *Realism*, 142
norm of felicity, *see* illustration, norms of
norm of fidelity, *see* illustration, norms of
numbers-game, *see* Bochner, Mel, numbers-game
Nussbaum, Martha, 10

Ockham's razor, 181
Odysseus,
Office of War Information, 48
*On Certainty*, *see* Wittgenstein, Ludwig, *On Certainty* and Bochner, Mel, *Counting Alternatives*
Oresme, Nicole, 58–63, 75, 299
    creation of new terminology, 59
    translation of Aristotle's *Nicomachean Ethics*, plate 3, 58
    translation of Aristotle's *Politics*, 58
Ovid,
    *Fasti*, 41n. 10
    *Metamorphoses*, 41–6, 51, 101, 192

Paget, Sydney, 248
painting, 100, 133–4, 252
    essence of, 143
    as illustration, 43–7, 101, 113, 129, 134
    as philosophy 150–2
Palmer, Donald, *Looking at Philosophy*, 260
panel, *see* comics, terminology, panel
Paolozzi, Eduardo, 193, 201, 203–8
    *As Is When: A series of screen prints based on the life and writings of Ludwig Wittgenstein*, 203–4
    *He Must, so to Speak, Throw Away the Ladder*, plate 20, 204–6

INDEX 321

*Parrot (#7)*, plate 21, 186, 206–7
*Wittgenstein at the Cinema*
 *Admires Betty Grable*, 207–8
parallax, 267
Paris, 91
*Peanuts*, 256
personification, *see* illustration,
 personification in
perspective,
 multiple, 270
 vanishing point, 100–1, 135, 147
 rejection of, 147–8
Philip II, 44
Phillips, Tom, 6, 35
 illustration of *The Schismatics*,
  plate 1, 36–40
philosophical art criticism, 114
philosophy, 156
 Analytic, 166, 181, 266
 Continental, 166
 elitist nature of, 298
 graphic, 16, 17, 238–9, 259–89,
  290, 297
 in visual form, 14, 271–2
 ordinary language, 166
 racism, 156
 Western, xiv, 52
photorealism, 274, 285
Picasso, 153,
 *Guernica*, 154
 illustration of *Lysistrata*, 245
 *Minotaur Moving His Home*, 195
 picture books, 246–7
 image and text equally basic, 247
Pillow, Kirk, 168n. 4
Piper, Adrian, 15, 19, 137–8, 149,
  152–9
 "The Logic of Modernism," 153–5
 *A Synthesis of Intuitions,*
  *1965–2016*, 152
 *Cornered*, plate 12, 157–8
 *Self-Portrait Exaggerating My*
  *Negroid Features*, 156–7

Plato, 9, 17, 52, 53–5, 103, 105–6,
  133, 208
 Academy, mosaic of, 54f, 53–5
 "Allegory of the Cave," 1f, 1 5, 6, 7,
  33–5, 208, 260
  etching of, *see* Saenredam, Jan,
   *Antrum Platonicum,*
  textbook diagram of, 1, 2f, 8
 *Dialogues*, 55, 65, 75
 *Euthyphro*, 158–9
 Joseph Kosuth's critique of, 174
 metaphysics, 1, 3, 33, 173–4, 208
 *Phaedo*, 105–6
 *Phaedrus*, 65
 *Protagoras*, 102n. 2
 *Republic*, 1, 3, 6, 34, 65, 142, 179
 *Symposium*, 53, 65
 "The Divided Line," 1, 3, 179–80
 theory of Forms, 2, 3, 33, 174, 184
 *Timaeus*, 57f, 57–8, 63
plural images, 69, 70, 80, 84
Plutarch, 107n. 3
Pollock, Jackson, 138, 147–8, 149, 159
 *White Light*, plate 11, 148, 159
 Pompeii, 53
Poochigian, Aaron, 23
portrait, 52–3
poststructuralism, 260
pottery, 53
*POW!*, 256, 257f
pre-Socratics, 120, 260
*Principium Individuationis*, *see*
  Schopenhauer, Arthur
proposition,
 unity of, 71
 visual representation of, *see*
  Gaultier, Léonard, *Descriptio*
*Puck*, 194

race, 156–9
racism, 156–9
*Rape of Europa*, *see* Titian, *Rape of*
  *Europa*

## 322 INDEX

Raphael,
    *School of Athens*, plate 5, 9, 101,
        102–3, 133, 297
    *Transfiguration*, plate 8, 110–4,
        121, 131, 134, 297
Rawls, John, *A Theory of Justice*,
    156
re-visioning, 24, 39
reader-viewers, explanation of use
    of, xiii
Realism, in painting, 101, 134–5,
    142, 161
Rembrandt,
    *Aristotle Contemplating a Bust of
        Homer*, plate 6, 101, 103–5,
        133, 290, 294
Renaissance, 134, 147, 209, 297
Richardson, Brenda, 223n. 8
Rinder, Lawrence, 159
Rockwell, Norman, 47–51
    *Freedom of Speech*, 13, 50
    not merely an illustrator, 47–8
    *The Four Freedoms*, 48
    *The Problem We All Live
        With*, 50
Roe, Cynthia, 44n. 13
Romans, 296
Rome, Ancient, 52, 53–4, 290
Roosevelt, Franklin Delano, "The
    Four Freedoms," 48–9
Rosenberg, Harold, Action Painting,
    149
Rousseau, Jean-Jacques, 84–97
    analysis of courage, 91–2
    *Emile*, 14, 78, 80, 84–97, 101
        frontispiece to Book I, *Thetis*,
        86f, 86–95, 97, 98
        frontispiece to Book V, *Circé*,
        85, 95–97, 98
    *Julie or the New Heloise*, 84
    mothering, view of, 89–94
    signs versus language, 93
    theory of education, 85, 92–5, 97

Rubens, Peter Paul, *Athene and
    Arachne*, 130
Russell, Bertrand, 163, 261–6
    logicism, 262
    theory of definite descriptions, 181–2
Ryle, Gilbert, 10

Saenredam, Jan, *Antrum Platonicum*,
    6–8, 7f, 34–5, 65
Sanzio, Raphael, *see* Raphael
*Saturday Evening Post*, 47–8
Schapiro, Meyer, 117n, 118, 119n, 148
Schjeldahl, Peter, 47–8
Schopenhauer, Arthur,
    pessimism, 108
    *Principium Individuationis*, 109
    *The World as Will and
        Representation*, 108
Scott, John T., 86, 94
Sculpture,
seeing-as, *see* Wittgenstein, Ludwig,
    seeing-as,
seeing, 4–5, 178, 186, 189, 191–7, 267
    ambiguity of, 186, 189
    versus observing, 186, 189
self-reference, 126n. 12
    in *Fun Home*, 126n. 12,
    in *Logicomics*, 126n. 12, 261–2,
        263–4, 266
    in *Understanding Comics*, 272–7
    Russell's Paradox and, 263, 265
Sendak, Maurice, *Where the Wild
    Things Are*, 95n
Seymour, Robert, 33
Shepherd, E.H., 248
Sherman, Claire Richter, *Imagining
    Aristotle*, 9–10, 58n. 3, 59
*Shoes*, *see* van Gogh, Vincent, *Shoes*,
    and Heidegger, Martin,
Silenus, wisdom of, 107–9
similarity heuristic, *see* similarity
    heuristic
skeptic, 1–6, 222, 227, 235–6

## INDEX  323

skepticism, 166, 183, 213, 219, 220, 221–2, 270, *see also* Bechdel, Alison
Skinner, Quentin, 77, 80n. 4, 83n. 7
Sobel, Janet, 148
Socrates, 34, 52–3, 105–6, 110, 133, 158–9, 295
 death of, *see* David, Jacques-Louis, *Death of Socrates*
Solomon, Deborah, 47
Sophocles, 114n. 6
Sousanis, Nick, *Unflattening*, 16, 266–71,
 amphibious, 270
 illustration of Herbert Marcuse, *One-Dimensional Man*, 267
 philosophical argument in, 277
 unflattening, 267–9
  defined, 267
  illustrated, 269f
Spiegel, Hendrik Laurenszoon, 7
Spiegelman, Art, *Maus*, 238
Statiad, *Achilleid*, 88, 95
Stoichita, Victor I., 126n. 13, 126n. 14, 130, 131
Strayer, Jeffrey, 22n. 2, 39n. 9, 132n. 18
Styx, 86
substantial generation, 83
Surrealism, 149–50

Tarquin, 83
Taylor, Paul, 9n. 6
technology, 52
 role in illustration, *see* illustration, technology, role in
Tenniel, John, illustrations of *Alice's Adventures in Wonderland*, 25–7, 26f, 32
terminology, xiii
text, 58, 61–2, 70–3, 101
text-image relationship, 12, 33, 90, 178–9, 240–59, 269–70, 289, *see also* illustration, word-image relationship

Thetis, see Rousseau, Jean-Jacques, *Thetis*
thought experiment, 33, 176–7, 260
Titian, 51
 *Rape of Europa*, plate 2, 13, 50–1, 147, 191, 192, 291
  as illustration, 41–7, 101
Tolstoy, Leo, 151
*Transfiguration*, *see* Raphael, *Transfiguration*
translation, 187–8
 theory of, 13, 23–5, 27
truism,
 in G.E. Moore, 215–6, 218
 in Ludwig Wittgenstein, 216
Twain, Mark, *The Adventures of Huckleberry Finn*, 247–8

Ulysses, engraving of, *see* Rousseau, Jean-Jacques, *Circé*
unflattening, see Sousanis, Nick, *Unflattening*
universities, 56

van Gogh, Vincent, 153
 *On the Threshold of Eternity*, 39n. 7
 *Shoes*, plate 9, 115, 117–21, 131–2, 134
van Rijn, Rembrandt Harmenszoon, see Rembrandt
Vecelli, Tiziano , see Titian
Velasquez, Diego,
 *Las Meninas*, plate 10, 122, 130–1, 134, 148
  Foucault's analysis of, *see* Foucault, Michel, analysis of *Las Meninas*
vellum, 296
Vermeir, Koen, 5n. 2
Vico, Giambattista, *The New Science*, 79
Vinken, P.J., 34n. 7
Virgil, 30–1
 *Aeneid*, 23, 145

## 324 INDEX

visual arts, 17
visual definitions, 59
visual image in an artwork, 191, 192, 198
visual images and verbal description, different nature of, 271, 294, 299
psychological research on, 73–4, 129–30, 144
Voltaire, *Elements to the Philosophy of Nature*, 79

Wagnerian opera, 110
Walton, Kendall, 285
Warhol, Andy,
Arthur Danto on, 151 *see also* Danto, Arthur, Andy Warhol's significance
*Cow Wallpaper*, 146
Warner, Marina, 23n. 3, 24, 39
Wartenberg, Thomas,
*Existentialism: A Beginner's Guide*, 295n
"Illustrating Philosophy: Mel Bochner's *Wittgenstein Drawings*," 211n
*Mel Bochner: Illustrating Philosophy*, 18, 211n. 2, 225, 229
*Nature of Art, The*, 151n. 9
Westerhoff, Jan, *Twelve Examples of Illusion*, 290
Wicks, Robert, 124n, 127–8
*Winnie-the-Pooh*, see Milne, A.A.
Wittgenstein, Ludwig, 16, 17, 160, 161–210, 211–37, 272, 297, 299
aspect seeing, *see* seeing-as
*Blue and Brown Books*, 162
Conceptual artists' illustrations of, 162
conditions for doubt, 218, 219–21, 225, 227, 229, 236
criticism of G.E. Moore, 216–23
distinction between a mistake and an exception, 235

*Duck-Rabbit, The*, 4f, 4–5, 190, 195
hinge propositions, 218–9, 222, 228–9
language-games, 16, 165–6, 219, 220–1, 225, 229, 292
*Lectures and Conversations*, 161
life of, 166–7, 207–8
meaning is use, 164, 198
Mel Bochner's illustrations of, 185–90, 223–37
mistake, possibility of, 221
*On Certainty*, 162, 166, 211–23, 282
*Philosophical Investigations*, 4, 90n. 9, 164–6, 176, 175–8, 180, 182, 190–1, 197, 295
philosophical method, 186–9, 201, 207, 223, 229
picture theory of language, 163–4, 197–8
private language argument, 176
*Remarks on Colour*, 179, 185–6
rules, 221–3
seeing, different senses of, 186–9
seeing-as, 190, 195
standard empirical propositions, 217, 218–9
*Tractatus Logico-Philosophicus*, 162, 163–4, 165, 175, 193, 197–8, 199–203, 204–5
writing style, 164, 167, 262
*Zettel*, 211n. 1
Wollenbecker, Genevieve, 201
Wollheim, Richard, 191
woodcuts, 78
women artists, 18–9, 148
words and images, differences between, 84, 114; *see also* visual images, text
work of art-illustration dichotomy, 47

*Yellow Kid, The*, 240
Young, James O., 5n. 2